THE WOMEN'S LAND ARMY
A PORTRAIT

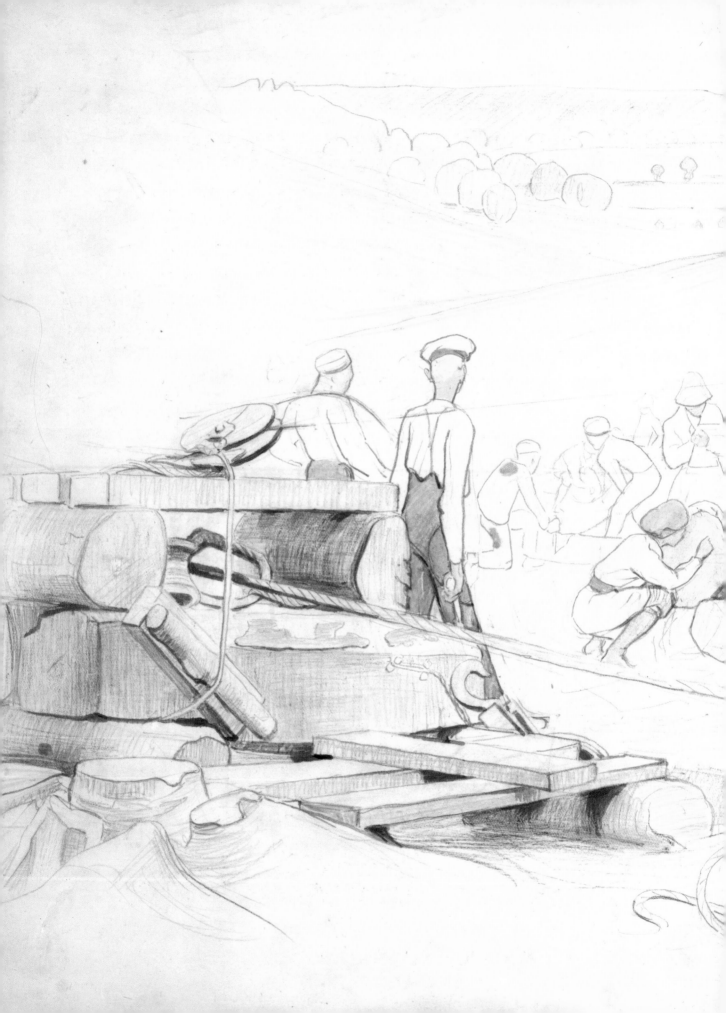

THE WOMEN'S LAND ARMY
A PORTRAIT

Gill Clarke

Sansom &
Company

First published in 2008 by Sansom & Company Ltd.,
81G Pembroke Road, Bristol BS8 3EA
www.sansomandcompany.co.uk
info@sansomandcompany.co.uk

© Gill Clarke

ISBN 978-1-904537-87-8
British Library Cataloguing-in-Publication Data
A catalogue record for this book is available from the British Library

Design and typesetting by E&P Design, Bath
Printed and bound by The Charlesworth Group, Wakefield

Front cover: Randolph Schwabe, *The Women's Land Army and Germany Prisoners* (Imperial War Museum)
Rear cover: Fougasse, *WLA Benevolent Fund Poster* (Private Collection)
Title page: Ursula Wood, *The Canadian Timber Camp, Wendover* (Imperial War Museum)

CONTENTS

ACKNOWLEDGEMENTS

The crucial work of members of the Women's Land Army has long been of interest to me since I first heard my mother, Florence Clarke, talk movingly about her experiences as a Land Girl during the Second World War in the East Riding of Yorkshire. She would recount in great detail tales of the varied jobs she undertook, often on her own and under harsh conditions, and explain how when out in the fields she kept her spirits up by singing all the hymns and songs she knew. Unfortunately, one weekend whilst cycling to the station from her home in Muston, near Filey, south of Scarborough, to return to her posting, she was knocked off her bicycle by a bus and spent several weeks in hospital. Due to the injuries sustained she was unable to return to the Land Army and as she said 'so ended what was a very happy career'. *The Women's Land Army: A Portrait* is dedicated to her and all the Land Girls who proudly and stoically served their country.

Researching the history of the Women's Land Army (WLA) has occupied me for over a decade, a slight interlude along the way was occasioned by my writing of *Evelyn Dunbar: War and Country*. Artists' and illustrators', portrayals of the Women's Land Army, including memorable paintings by Evelyn Dunbar have become an increasingly important part of this story. Thus, I gratefully acknowledge receipt of a Publication Grant (Author) from The Paul Mellon Centre for *Studies in British Art* to assist with the costs of reproducing many of the images presented here.

Given the length of this research there are many people who have assisted me and to whom I extend my thanks. While space precludes my naming them all I am indebted in particular to all those former Land Girls who shared with me their memories of life on the land in the Second World War.

Ida M. Webb, former Principal of Anstey College of Physical Education and Assistant Director at Brighton Polytechnic must get a special mention for her invaluable research assistance (and friendship) over many years, be it visiting museums, attending Land Army meetings, working in various archives to collect WLA material and/or conducting preliminary analyses of the Land Girls' life stories. Wendy Mould conducted a number of in-depth interviews with Land Girls for me in Derbyshire for which I am most appreciative. Evelyn Paine, who worked on the land during the Second World War has been of great support, loaning me original documents and artefacts from both wars and also importantly allowing me to attend the meetings of ex-Land Girls that she and her husband Geoff have hosted over the last few years. The expertise of John Martin, De Montfort University, in matters agrarian has greatly benefited this text and where possible his helpful suggestions have been incorporated.

In addition the following helped in various ways throughout the project: Derek Bales; Edith Barford; Alice, Lady Barnes; Janet Barnes; John Bentin; Joyce Blair; Bill and Dee Bourne, Bill Bourne Associates; Mildred Bowden; Ina Brash; Mark Bryant; Elizabeth Bulkeley; Agneta Burton; Camilla's Bookshop, Eastbourne; Ciss Collins; Ann Cooper; Peter Copley; Joan Cowderoy; Janet Cragg; Lilian Day; Isla Duncan; Maeve Edwards; Frieda Feetham; Roger Folley; Michael Gornall; Emily Gwynne-Jones; Rosemary Gwynne-Jones; Richard Harris; Roy Heron; Mary Hood; John Lavrin; Lymington Growmore Club; Kate Morgan; Ann Meo; Iris Neel; Pam Newson; Stuart Olsson; Rosemary Penn; Sue Perks; Joyce Poynter; Catherine Robinson;

Edna Stephenson; Eileen Strong; Dorothy Taylor; Chris and Wendy Thairs; Peg Turner; Gladys Wheatland; Phyllis Wyatt; Karen and Michael Yden, Key Print.

Research such as this requires assistance from archivists, curators and librarians, amongst those who have provided invaluable help are: Hannah Neale, Abbot Hall Art Gallery; Dennis Archer, Bedales School; Brenzett Museum; Trish Hayes, BBC Written Archives Centre; Eastbourne Library; Lesley Adkin, Lindsay Jerome, Jenny Treagust and Jen Veitch, Emsworth Library; East Sussex Record Office; Easton College, Norwich; Forge Museum; Frances Collinson, Collections Officer, Norfolk Rural Life Museum, Gressenhall, Norfolk. Staff at the British Library (and also BL Newspaper Library); Bridgeman Art Library; Archives of Chelsea School, University of Brighton, Eastbourne Campus; Centre for Kentish Studies; Courtauld Institute Library; Ditchling Museum; Forestry Commission Scotland; Hampshire Record Office; Hulton Archive/Getty Images; Liddell Hart Centre for Military Archives; London Library; Dorothy Sheridan, Mass Observation Archive, University of Sussex; The Muckleburgh Collection, Norfolk; The Museum of English Rural Life, Reading; National Art Library; Paul Johnson, National Archives, Kew; Newhaven Fort; Norfolk Heritage Centre; Norfolk Record Office; Northampton Record Office; NRM/ Science and Society Picture Library; Emma Floyd, The Paul Mellon Centre for Studies in British Art Library; Plumpton Agricultural College; State Library of Victoria, Australia; Michael van Diggelen, Tangmere Military Aviation Museum Trust; Tate Library and Archives; The Women's Library, London; West Sussex Record Office; University of East Anglia, East Anglian Film Archive; and Anne-Marie Butler, University of Southampton Library.

Thanks are also extended to Ulrike Smalley, Jenny Wood, Pauline Allwright, Sara Bevan and colleagues at the Imperial War Museum, London; Chris Beetles, Chris Beetles Gallery; Bernard Horrocks, National Portrait Gallery; Ann Danks, Stanley Spencer Gallery, Cookham; South Wales Evening Post.

Any errors of fact and/or interpretation arising out of these various researches and communications are of course, all mine.

Clarke Willmott have provided generous support for the exhibition. It has been a great pleasure to work with Steve Marshall, curator at St Barbe Museum & Art Gallery.

The exhibition would not have been possible without the collaboration of the following lenders: Government Art Collection; Harris Museum & Art Gallery; Imperial War Museum; Laing Art Gallery; Manchester City Galleries; National Archives; Russell-Cotes Art Gallery & Museum; Tate, London and those private lenders who preferred to remain anonymous.

Members of the Centre for Biography and Education at the University and the British Sociological Association Study Group on Auto/Biography have provided valuable feedback on parts of this work.

Finally, I should like to thank Sarah Gilroy who as ever has been greatly supportive, generously reading and commenting insightfully on drafts of this text. I continue to gain from both her scholarship and partnership.

Dr Gill Clarke
Centre for Biography and Education, University of Southampton
July 2008

INTRODUCTION

This portrait of the Women's Land Army reveals their vital contribution to keeping the nation fed in the First and Second World Wars. Land Girls dressed in their distinctive uniforms became an iconic image, symbolising Britain's triumph in winning the domestic battle to raise food production. With the exception of the official history compiled by Vita Sackville-West published under the auspices of the Ministry of Agriculture and Fisheries in 1944 and Carol Twinch's *Women on the Land: Their Story during Two World Wars* (1990), the history and role of the organisation has been largely overlooked. Yet, the work Land Girls undertook to maximise levels of productivity from the land was crucial to the success of the war effort.[1]

Official recognition of their role has been woefully late in coming. When the Women's Land Army was disbanded in 1950 the members were shabbily treated, receiving neither medals nor gratuities, and being required to return most of their uniforms. It was not until the new millennium that members of the Women's Land Army and Women's Timber Corps were allowed to join the annual Remembrance Day march in London to the Cenotaph, despite the fact that other national service organisations had for some time been part of the parade. It took a further eight years of pressure before the British Government agreed to officially recognise the efforts of Land Girls in 2008 and award a specially designed badge to commemorate their service.[2]

Although the two World Wars created new opportunities for women and a degree of social and economic independence – in many cases temporary – this should not be over romanticised, nor seen as adding greatly to women's emancipation.[3] The use of auto/biographical sources and in particular the life stories written by former Land Girls provide fresh insights into the actuality of their experiences, thereby avoiding the homogenisation of the contributions of members of the Women's Land Army to the 'Battle of the Fields'. Extracts from their life stories illuminate events and experiences that have not previously received the attention and recognition they warrant.

Uniquely, *The Women's Land Army: A Portrait* also focuses upon wartime paintings, posters and cartoons to portray the life of the Land Girls. Although few of these evocative works are strictly portraits, the artists, subject though they were to censorship, engage with the challenge of presenting a record of the experiences of those who worked on the land and 'with ideas of identity as they are perceived, represented, and understood in different times and places.'[4] The formation of the Women's Land Army in the First World War and its reforming in the Second World War afforded opportunities for artists to document the work Land Girls were undertaking, and in so doing interpret its impact on their identities in what was for many a strange and hostile environment.

Part 1 – *Holding the Home Front: The Women's Land Army in the First World War* – traces the emergence of women's land-based societies and corps and the formation of War Agricultural Committees. Farmers' reluctance and prejudice to employing women on the land is examined, as is the establishment of The Women's National Land Service Corps which preceded the

formation of the Women's Land Army in March 1917 under the directorship of Dame Meriel Talbot. This is followed by a discussion of the work of the three sections of the newly formed Women's Land Army: agriculture, forage and timber.

Part 2 — *Back to the Land: The Women's Land Army in the Second World War* — reveals how the WLA 'sprang into being even before war had been declared'.[5] This ordered planning led by the Honorary Director, Lady Denman, was in sharp contrast to the improvisation of the First World War, where all 'had to be carried through at breakneck speed, with no precedent and no time for preparation.'[6] In discussing the contribution of the WLA both autobiographical and biographical evidence is drawn on, including extracts from interviews with Land Girls, a WLA administrator and an assistant secretary. In addition, life stories written by Land Girls illustrate the realities of life on the land.[7]

Part 3 — *Recording Life on the Land* — provides biographical portraits of the lives of selected artists and illustrators who recorded the activities of the Women's Land Army and Women's Timber Corps, the life and work of a number of whom has hitherto received scant attention. These 'portraits' reveal the artists' not insignificant contribution to twentieth-century British Art and cultural history and provide valuable insights into the commissioning and production of their distinctive wartime drawings and paintings.

1 I do not attempt here to assess the contribution of the WLA to the war effort vis-à-vis other types of workers, an exercise which is problematic – see section V in Gill Clarke (2007) 'The Women's Land Army and its recruits 1938–50', in Short, B., Watkins, C. and Martin, J. (eds.) *The front line of freedom. British farming in the Second World War.* Readers are referred in particular to the research of H.T. Williams who, in an influential article written after the war, reported his attempts to quantify the contribution of the WLA to the war effort. The article 'Changes in the productivity of labour in British agriculture', *J. of the Agricultural Economics Society,* X, 4 (1954) was endorsed by K.A.H. Murray (1955) in *Agriculture,* p.243. I am grateful to John Martin for bringing this to my attention.

2 Application forms are available at www.defra.gov.uk/farm/working/wla/ Telephone: Defra Helpline 08459 335577.

3 See Summerfield, P. (1988) 'Women, war and social change: women in Britain in World War II', in Marwick, A. (ed.) *Total war and social change,* Summerfield, P. (1995) 'Women and war in the twentieth century', in Purvis, J. (ed.) *Women's History: Britain, 1850–1945* and Summerfield, P. (1998) *Reconstructing women's wartime lives: discourse and subjectivity in oral histories of the Second World War.*

4 West, S. (2004) *Portraiture,* p.11.

5 Sackville-West, V. (1944) *The Women's Land Army,* p.9.

6 Shewell-Cooper, W.E. (c.1941) *Land Girl. A Manual for volunteers in the Women's Land Army,* p.10.

7 My research over the past decade has also involved extensive documentary analysis and attending reunions of Land Girls and Services of Commemoration for the WLA and WTC veterans at the Cenotaph. The women involved in the study were aged between 17 and 29 at enrolment, and served from just over one year to 11 years; they are now aged between 77 and 96. For specific detail about the biographical research see Gill Clarke (2001) 'Lives on the home front: the Women's Land Army', *Auto/Biography,* IX (1&2), pp.81–8.

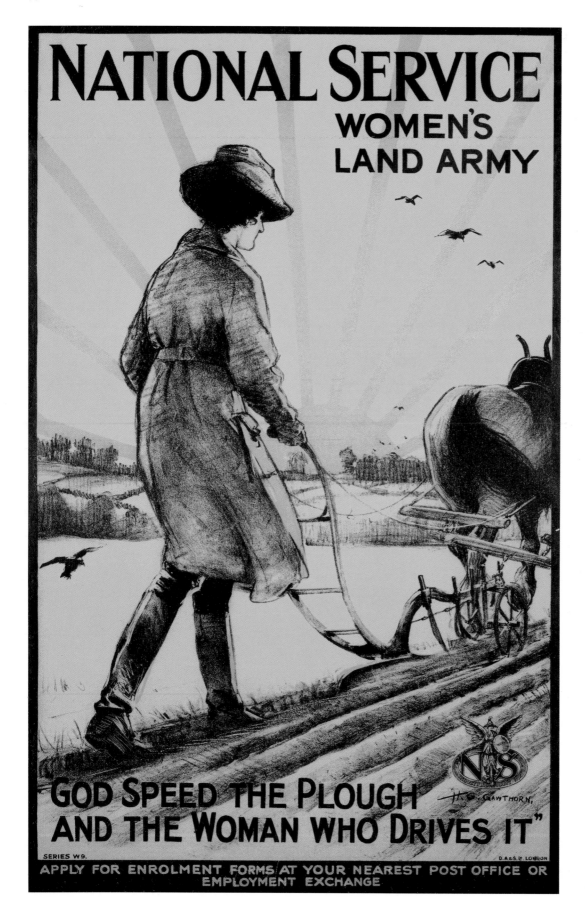

HOLDING THE HOME FRONT
THE WOMEN'S LAND ARMY IN THE FIRST WORLD WAR

THE OUTBREAK OF WAR

The corn harvest had just begun when Britain declared war on Germany on 4 August 1914. It was one of the earliest harvests for several years and also one of the most quickly gathered. Farmers had more than their usual supplies of nearly every crop and it was regarded as a good year agriculturally.[1] Although many of the younger men had enlisted, and horses and fodder from farms near military centres had been requisitioned, the country would not have been in imminent danger of starvation had Germany blockaded Britain. A casual visitor to the 'harvest fields would have detected nothing very different from usual.'[2] The prevailing view was that the war would be over by Christmas.

By the end of January 1915 it was apparent that the war was going to last much longer. Although over 100,000 agricultural labourers had joined the Colours, this depletion of labour was not acutely felt by farmers until the spring and summer when farm work fell behind. The Army made arrangements that special agricultural leave be given to a limited number of soldiers to assist with the hay harvest. However, even this was 'not to exceed fourteen days and was only to last for such time as [the soldier] was actually required for haymaking.'[3] Such employment assumed that suitable labour could not be found in the locality and similar arrangements were made for the autumn cultivation. It soon became clear that such solutions, on their own, would be insufficient. Indeed, so great was the depletion of young, physically fit, permanent male labourers that the dual problem of food production and distribution made inevitable the use of women's labour.

THE EMERGENCE OF WOMEN'S SOCIETIES AND CORPS

With the outbreak of war a plethora of women's societies and corps, often competing for recruits and overlapping in intentions, sprang into existence. The Women's Defence Relief Corps (WDRC) was formed on 9 September 1914 by Mrs Dawson Scott 'primarily to relieve the defenders i.e. undertake any work which would set free a man for the fighting line and secondarily to induce women to prepare for whatever might be coming by making themselves practically efficient.'[4] The report on the activities of the WDRC during 1916 made clear that it was non-political, non-sectarian and democratic. Miss Conry, a founder and member of the Sub-Committee for Land Work, believed that healthy strong women willing to undertake farm work would only require three days under the direction of a capable farmer to acquire what knowledge was necessary.[5]

The WDRC sent out 'bands of women to work at haymaking, harvesting, market-gardening and fruit-picking, stipulating a minimum wage of 18s. per week.'[6] The work was advertised on posters as being 'A free holiday. Spend your Holiday in the sun doing National Work and enjoying your vacation, earning enough to pay the cost of it… Come singly, or in parties… All who do it are happy and return fitter for having spent a healthy, vigorous holiday, and with the satisfaction of knowing that they have done their bit. Make up your minds now. We can fix you up if you will tell us when you can start.'[7] The women who responded were mainly teachers, students, clerks, shop assistants and servants, the majority being Londoners,

PAGE 10
Henry Gawthorn
Recruitment poster
(1917)
lithograph on paper, 723 × 466 mm
IMPERIAL WAR MUSEUM

who were able to devote a few weeks to labouring on the land. Finding suitable accommodation was a difficulty, as was the low wage. At its peak, in the summers of 1916 and 1917, the WDRC had placed only 500 women on the land.[8] The WDRC believed its work had been hampered by lack of funds, a problem that was partially eased in January 1917 when the Corps received a grant of £50 from the Board of Agriculture.

Also founded in 1914 – in December – was the Women's Legion, with The Marchioness of Londonderry as its Commandant. The organisation formed a Military Cookery Section and an Agricultural Section which aimed to further the employment of women in agriculture. Although it received an annual grant of £200 from the Board of Agriculture, the Secretary to the Board 'glumly concluded in the autumn of 1916 that [it] was expensive to run in comparison with the results it had achieved.'[9]

Perhaps initially more successful was the National Political League (NPL) which sought to help professional middle-class women (and men, particularly disabled soldiers and sailors) find suitable work on the land and to further other social reforms on a non-party basis.[10] The NPL formed a Land Council shortly after the outbreak of war to act as a centre for information and as a means to develop the use of available land and extend fruit farming, general market gardening, cattle and dairy work and intensive gardening to increase the country's food supply. It 'had grandiose notions of promoting land settlements where trainees could learn poultry farming and similar tasks on a co-operative basis.'[11] The NPL reported that since the

war, about 2,000 women had been registered. Some received two years' training, others trained for a short period of time and a third class were sent out fruit-picking, haymaking and hay-baling.[12] The grant they received from the Board of Agriculture was later stopped (as was that to the Women's Legion) on the grounds of their inefficiency and ineffectiveness. Further, the League was sharply 'criticised for pursuing its objectives through the use of unspecified "mischievous" methods.'[13] Like the Women's Legion, the NPL was perceived to be inefficient and of little practical value.

More significant was the pioneering Women's Farm and Garden Union (WFGU), established in London in 1899 as a result of the International Congress of Women. Originally known as the Women's Agricultural and Horticultural International Union, the WFGU[14] did much valuable work before the war looking after the interests of all professional women workers in agriculture, horticulture and allied fields through offering training courses and placing women on the land. Rowland Prothero,[15] Member of Parliament for the University of Oxford, addressed members and friends of the Union in July 1915 on 'Agriculture as an industry for women' and acknowledged that although the farmer was presently not short of labour there would be great changes in farming. He pointed out that the interruption of foreign supplies would become a pressing danger and commented, 'On every national ground there must be a serious strenuous effort to increase the arable cultivation of the country, the growth of wheat, and the output of food generally. That meant increased labour. If the war went on the labour the farmer had would be taken from him for

the Army. There was the women's opportunity. It was a national need, and to meet the need the women must be trained and the union would throw the whole weight of its authority into the endeavour to secure adequate training.'[16]

The Union launched an experimental training course for educated women. One of the first was held in Essex at Little Baddow Hall, Chelmsford on one of the two farms made available by the Hon. Edward Strutt.[17] A training centre was established and a woman superintendent, Miss Grey, was appointed who had experience in farm processes. The training lasted for 12 weeks and covered all forms of farm work. The students paid for their maintenance but the cost of their training was met by the Union. An earlier attempt to train women as substitutes for male agricultural labour had been undertaken by the Board of Agriculture and Fisheries, with scholarships for the training of milkers and farm workers by Farm Institutes and Agricultural Colleges. These courses were considerably shorter; initially of two weeks duration they were found to be woefully inadequate and subsequently extended to four weeks. The experiment demonstrated that women could, after a short period of training, play a crucial role on the land.

THE FORMATION OF WAR AGRICULTURE COMMITTEES

'Official encouragement for women's work developed further in the autumn of 1915 with the formation of the WACs [War Agriculture Committees]. Lord Selborne [President of the Board of Agriculture] encouraged them to pay particular attention to organising women for farm work.'[18] The scheme for the establishment of WACs had arisen out of recommendations made by the Milner Committee[19] which had been charged in June 1915 with considering what steps should be taken, legislative or otherwise, to maintain, and if possible, increase the production of food in England and Wales on the assumption that the war might be prolonged beyond 1916. However, in the counties where War Agriculture Committees existed, 'their activity and efficiency varied greatly.'[20]

COMBATING THE PREJUDICE OF FARMERS

The results of the WACs were disappointing, with farmers largely unwilling to avail themselves of the services of women. Much of this reflected the farmers' prejudices and conservatism but also the attitudes of rural women themselves. Many saw work on the land as degrading, and this together with the low wages offered for the hard work demanded did little to encourage women to offer their services. Further, in certain rural areas 'the woman land worker was considered as socially inferior to the domestic servant.'[21] In addition, few women had practical experience of actual farm work. Although there was a variety of work that women on family farms had always done, it tended to be limited to milking, butter making, haymaking and tending poultry. Village women were also loathe to undertake the work because of a lack of suitable clothing that did not inhibit movement and in particular suitable footwear, the purchase of which was nigh on impossible given the prohibitive price of boots. To combat this it was agreed by the Treasury that

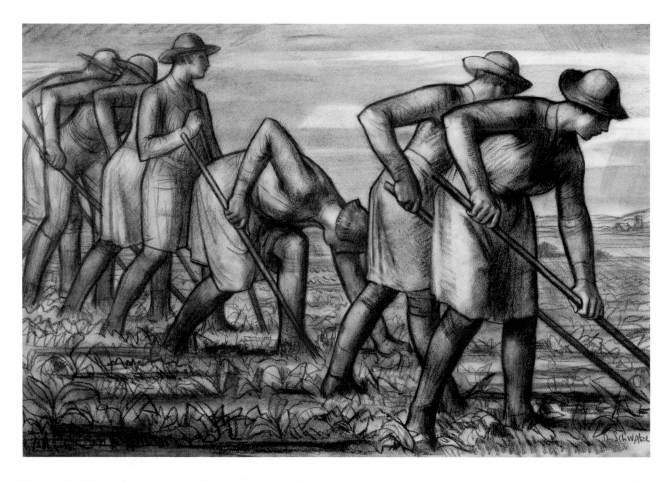

Randolph Schwabe
Hoeing
black chalk on yellow paper, 342 × 508 mm

boots could be bought wholesale and an arrangement was made with the Co-operative Wholesale Society that women who had worked on the land twenty-four hours in the week for a given period would be allowed to purchase them at a reduction of 5s.[22]

Many farmers believed that women did not have the will power or stamina to take on the hard work in all weathers and further, they were reluctant to ask 'ladies' to do the essential rough work. They thought women would not be of much practical use, believing that they 'might be as great pests on the land as the weeds.'[23] Farmers were also concerned that if they employed women they would lose the few remaining skilled and experienced men they had working for them. Some reassurance was forthcoming when in January 1917 the Army Council decided to treat female labour as supplementary rather than as a substitution for male labour.[24]

DEMONSTRATIONS AND COMPETITIONS: TRAINING FOR THE LAND

However, it was not only about changing entrenched attitudes and encouraging women to take an interest in working on the land but also about offering training. Through training they could work more efficiently and extend their knowledge, and for those unfamiliar with farm work gain some confidence. The Board of Agriculture began a more active propaganda campaign and published in their official Journal articles about the successes of women's training schemes and employment on farms to give evidence to sceptical farmers that women really could cope. The December

issue of the *Journal of the Board of Agriculture* for 1915 included a lengthy article about 'Women's work in agriculture in peace and war' and described in detail the experiments carried out in different parts of the country to train women. One such experiment was Cornwall County Council's scheme whereby they formed women's committees for every parish and compiled a register of women willing to work on the land and appointed local instructresses to give classes in subjects such as milking. The following month readers were informed how a group of eight girls obtained through the Birmingham Labour Exchange, none of whom had done any farm work before, had successfully 'side-hoed and singled roots, topped and carted them, hoed, lifted and clamped potatoes, helped thresh, helped with hay and harvest, whitewashed sheds, mended bags, harrowed before and after drilling, cut thistles, carted manure with the result that Mr Vickers [the occupier of the farm] expresses himself as being more than satisfied with the work and with the keenness they have displayed.'[25]

With a view to further breaking down the farmers' prejudices and to show women's potential and aptitude for farm work, demonstrations of women at work on the land were organised by County Agricultural Committees. Competitions were staged, covering different types of farm work, including ploughing, manure spreading and potato planting. The results were favourably commented on in the *Journal of the Board of Agriculture*. Lloyd George recalled in his *War Memoirs* how, nonetheless, it took some time 'to reconcile farmers to this innovation. But at last the really efficient performance of women

on the land… slowly won them acceptance and recognition by farmers.'[26]

WOMEN'S NATIONAL LAND SERVICE CORPS

Early in 1916 a deputation from the Women's Farm and Garden Union met with Lord Selborne and as a result of negotiations with the Board of Agriculture, an initial grant of £150 was made for the Union to organise the training of women. Thus, the Women's National Land Service Corps (WNLSC) was formed in February as a war offshoot of the Union, under the direction of Mrs Louisa Wilkins to deal with problem of emergency war work as opposed to permanent employment.[27] Five full-time organisers and trained speakers were appointed. The objects of the WNLSC were:

1. To speed up the recruitment of all classes of women for work on the land, in order to ensure the maintenance of the home-grown food supply.
2. To create a favourable opinion as to the value of women's work in agriculture by supplying a body of workers capable of making a good impression, and thereby breaking down the prejudices of those of the agricultural community who are opposed to the employment of women.
3. To use members of the Corps, not only as units of labour, but as organisers of the work of village women, and as an example and encouragement to these women to come forward.
4. To help in the work of general propaganda by supplying County Committees with organisers and trained speakers where these cannot be obtained locally.[28]

In the same month that the Corps was formed the Board of Agriculture issued a circular to all WACs urging them to form Women's Farm Labour Committees, later known as Women's War Agriculture Committees, in each county. These committees were to work closely and cooperate not only with the WACs but also with the myriad of existing women's organisations. It was recommended that when they were set up they appoint district committees or local representatives and village registrars to make a register of women who were willing to offer their services either full or part-time. They were to arrange, canvass and invite women to meetings to be addressed by women speakers approved by the Board of Agriculture.[29] Between February and the end of September some 161 meetings were addressed. Women who registered and started work were issued with a certificate for women's agricultural service emblazoned in colour with the royal coat of arms on with the patriotic text 'Every woman who helps in agriculture during the war is as truly serving her country as the man who is fighting in the trenches, on the sea or in the air.' After 30 days' work or 240 hours of service, the women landworkers and any girls over school-leaving age were entitled to wear on their left arm a green baize Government armlet bearing a red crown.

The Women's National Land Service Corps issued a recruiting poster in full colour for display on public hoardings in the London area which said: 'Wanted 5,000 educated women between 18 & 35 for war work on the land. Apply 50, Upper Baker Street.' The emotive image depicts a soldier bound for the Front tenderly taking leaving of his wife, while his young son seems

oblivious to the parting, intent on eating a hunk of bread. Behind the boy is a wheelbarrow, all is set against a tranquil rural landscape, the scene is emblematic of the country idyll his father is going to fight to save. In the corner of the scene is stated 'I leave the land to you'. The 'you' is emphasized by larger print. The message is clear: women are expected to serve, to do their duty for king and country in its hour of greatest need and thereby keep the children in particular fed. Notices and advertisements were issued in the press encouraging women to enrol for service on the land. The response was varied but during the first two months some 4,500 letters were posted from the WNLSC Head Office and by the end of the first year 2,000 volunteers, mostly middle-class women from urban districts, had enrolled. It was envisaged that they would serve as shining examples for rural women in local villages to emulate. Given that it was village women with their valuable local knowledge who would undertake most of the farm work the importance of positive images of womanhood was crucial.

Although the WNLSC Objects indicated that they were seeking to recruit all classes of women, in reality they sought 'the right type of women' who 'would create a favourable impression on the farming community'.[30] The WNLSC Selection Committee which comprised members of the Executive and the WFGU met in London acutely aware of the harm that could be done by sending out unsuitable workers. To insure against this candidates were required to supply the names and addresses of two referees and undergo a medical examination. Candidates living outside London were interviewed by members of the Head Mistresses' Association. Initially, the Government had asked all those involved in the selection process to concentrate on recruiting women of the professional classes for short courses as forewomen. These courses cost between 15–25s. a week, and for which a limited number of bursaries were made available. The forewomen who had undertaken these courses were placed in charge of detachments of women workers and acted as officers and arranged work for them with local farmers.

Recruiting meetings were held across the country, including the suburbs of London, towns and seaside resorts. Speeches were made at public institutions and at meetings held by various organisations and societies involved with women's work. All hockey and lacrosse clubs were circulated and secondary schools contacted via the Head Mistresses' Association. The Corps wanted young, strong, healthy, educated women fond of animals and the outdoor life. The assumption was that such institutions would have women of the right moral character and physique who would understand what was expected of them. In particular they would understand the drawbacks and physical discomforts associated with the work, the relatively low wages, the fact that they might not be able to find suitable lodgings and have to put up with makeshift, rough accommodation and the possibility of cooking for themselves after working long days in the field.

Training facilities were listed in the WNLSC's *Interim Report* which covered the period from the formation of the Corps to 30 September 1916. These facilities included training on 14 private farms for 53 members

together with training at centres in Essex, Northants, Surrey, Berkshire and Norfolk where wealthy land-owners had offered their farms. Hostels were in these cases used to house 12–15 women. Accommodation was inspected by district representatives or if this were not possible, local organisers would check suitability and make suggestions to farmers.

County training was held, for example, in Devon at Seale Hayne Agricultural College, Newton Abbot; in Gloucestershire at Pensyle, Nailsworth; in Lancashire at Warrington; in Monmouthshire at Usk and in Wiltshire at Shaw Farm, Lockeridge. Other colleges also held six-week training courses often at much reduced fees including Cambridge University; Sparsholt Agricultural College, near Winchester, Hampshire; Swanley Horticultural College, Kent and South-Eastern College, Wye. While it was recognised that a thorough training was impossible in such a short timescale (training was sometimes only of three weeks' duration), recruits could learn the principles of hand-milking, acquire a rudimentary knowledge of handling tools and some understanding of the care of animals. A further purpose of these courses was to toughen up recruits physically as well as to weed out those unfit and of unsuitable character to cope with such exacting and uncongenial work. Indeed, the loneliness of some of the volunteers led the Corps to keep in touch with members by correspondence and personal visits.

By September 1916 nearly 800 women had been trained under the auspices of the WFGU and the WNLSC, and placed on the land as permanent workers. 'Besides this 1321 women [had] been placed either as permanent workers with previous experience and therefore not requiring training, or as untrained workers in gangs.'[31] Those trained were found posts with individual farmers sometimes singly, in pairs, or groups according to demand as farm hands. They were employed to do milking and field work; to look after horses; drive tractors; as gardeners in private gardens or working as forewomen to gangs of village women. But as the WNLSC pointed out there was no question of their supplying cheap labour or of ousting local workers; rather their aim was that women should take the place of men who had enlisted in the Army and prevent the decrease of the food supply. For those who took the place of men the average wage was 16–20s. a week with lodgings, but for exceptional workers like good milkers and carters who were much in demand, *The Times* reported that 25s. had been obtained, in addition to a cottage or free lodgings.[32] The Corps acknowledged that many of those entirely dependent on their earnings were deterred by the levels of pay from taking up the work.

A dearth of women available for training as forewomen was apparent, and this led the Corps to telegraph to South Africa for the assistance of 200 women. Some also came at their own expense from the other Dominions including Australia, Canada and New Zealand to assist with work on the land. Three of these women acted as superintendents of training farms.[33]

THE 'FOOD PROBLEM'

The Liberal MP David Lloyd George, former Minister of Munitions and Secretary for War, became Prime

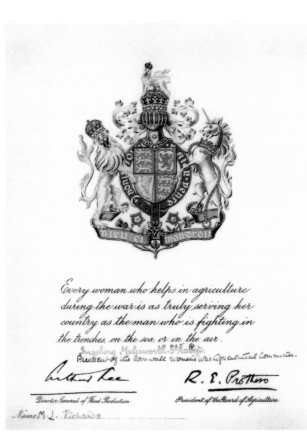

Certificate for women's agricultural service
COLLECTION OF EVELYN PAINE

Minister in December 1916 of a new Conservative-dominated coalition government replacing Herbert Henry Asquith who had been the Prime Minster since 1908. In his maiden speech as Prime Minister to the House on 19 December he spoke at some length about the seriousness of the 'food problem', highlighting the poor harvest, not only at home but also in the United States and Canada. Rowland Prothero was appointed as President of the Board of Agriculture and five new departments of state were created almost immediately, including on 1 January 1917 one for Food Production, under the direction firstly of T. H. Middleton and later of Sir Arthur Lee. This Department was to be responsible for increasing the supply of food and in particular the provision and distribution of labour, machinery, implements, fertilizers and feeding-stuffs and for securing the orders issued by the Committees.[34] The 'laissez-faire' farm policy of the past was to be replaced by a more interventionist and decentralised system of direction based on local committees. The so-called 'plough policy' was designed to markedly extend the area under tillage. The success of this would depend on adequate supplies of labour, fertilisers, machinery, and horses.[35] The Corn Production Act became law on 21 August 1917 and guaranteed a minimum price for wheat and oats and a minimum wage for agricultural labourers, restricted the raising of agricultural rents by landlords and gave powers to the Board of Agriculture to enforce the proper cultivation of land.

By early 1917 the character of the war was changing, and with heavy shipping losses Britain was becoming beleaguered. Germany's declaration on 31 January 1917

of unrestricted submarine warfare 'doubled the rate of losses which had been incurred during 1916, and these losses rose rapidly to a climax in March and April.'[36] Increasing the production of food and raw materials at home was now imperative. Conscription had been introduced in early 1916, although groups of skilled labourers such as agricultural workers were protected.[37] The need for women landworkers was becoming ever more necessary. However, it had become clear by the end of 1916 that the demands placed on the WNLSC were greater than it could possibly meet, and in the 'Scheme for the Organisation of Women's Service on the Land' they estimated that an additional 40,000 full-time female workers were needed. In December a deputation from the Corps led by Mrs Louisa Wilkins met Rowland Prothero, and suggested that the Government instigate a Women's Land Army of mobile workers.[38]

THE WOMEN'S LAND ARMY

Early in January 1917 a Women's Branch was established within the Board of Agriculture, 'charged with the special duties of increasing the supply of women workers on the land, and of securing their efficiency and employment.'[39] Miss Meriel Talbot[40] was appointed Director with Mrs Alfred Lyttelton as her deputy, and Mrs Bayne as Chief Woman Inspector. Later in the year Lady Denman agreed to take on the role of Honorary Assistant Director of the Women's Branch, responsible for the newly formed Women's Institute Section. As well as being involved in general headquarters work for the Land Army, Lady Denman actively participated in the recruiting drives in 1918

in the southern counties.[41] The previous January Miss Talbot had been appointed by Lord Selborne (at that time Minister for Agriculture), as the first woman inspector of the Board of Agriculture, authorised to appoint to the Women's Branch a staff of women inspectors, and paid women officers were assigned in each county. In March 1917 the Women's Branch became a division of the Food Production Department. In the same month an appeal was made to women to enrol in the Women's Land Army (WLA) 'for the all-important work of maintaining and increasing the Food Supplies of the Country, so seriously menaced at the moment by the enemy.'[42] Help was sought from able-bodied women aged 18 and over to assist with milking, care of stock, and general work. An advertisement was placed in *The Times* on 14 April by the Women's Section National Service, the WLA and the Women's Branch of the Board of Agriculture, appealing for 10,000 Strong Healthy Women as Milkmaids on Dairy Farms in England, Scotland and Wales. The advertisement also said 'Mothers of England, give your girls a chance – urge them to enrol to-day in the Women's Land Army'. The response was swift and by the first week in April 2,473 enrolment forms had been received,[43] and the number would soon reach 5,500. It was reported in *The Times* that it would be advantageous if women enrolled now as they would be able to follow the growth of the crops from when the land is ploughed and planted until the harvesting, and as a consequence, that they would be more valuable next year than those who joined up later. Over 30,000 responded to these patriotic calls, and by the middle of July 1917 2,000 women had been placed on farms.

Volunteers under 21 and single had to indicate that they had obtained the consent of their parents or guardians to their offer of service. The forms, which could be obtained from post offices and employment exchanges, required applicants to state if they had had previous experience in land work and earned any land armlets, and additionally what school they had attended. By signing the form and returning it to the Director-General of National Service in Westminster they were consenting to attend for an interview at the employment exchange or authorised centre near their home and on receiving seven days' notice to undertake full-time work on the land wherever they might be sent and to remain in such employment for the duration of the war. This was later changed to a six- or twelve-month commitment. If accepted for service and passed as physically fit they were informed that the terms offered were:

• A free outfit, consisting of high boots, breeches, overalls and a hat (a recruit was expected to complete a measurement form if she could not go to the store room to be fitted for her equipment which would then be despatched to the relevant Training Centre).
• Maintenance during training.
• Travelling expenses in connection with the work.
• Maintenance during terms of unemployment, not exceeding 4 weeks.
• Wages at the rate of 18s. a week, or the standard rate of the district – whichever is the higher.[44]

Land Girls were paid 20s. a week after passing an efficiency test. In March 1918 the starting wage was raised to 20s. and for those who successfully passed the efficiency test 22s. was paid. By April 1919 the minimum wage after training had risen to 25s. a week.

Women were prohibited from leaving their employment without the agreement of the Village Registrar or the Women's War Agricultural Committee. They were entitled to Service Armlets on the same basis as those awarded to WNLSC members, i.e. after 30 days or 240 hours' work on the land. A badge was given after two months' approved service, to be worn on the left lapel of the overall. A stripe (to be sewn on the armlet and worn on the left arm) was awarded for every six months' work, and once a landworker had earned four stripes she was able to exchange them for one diamond to be sewn on the armlet.

The WNLSC circulated its permanent workers, now numbering 900, in April 1917 with information about the new Land Army, with the expectation that it would be able to supply a considerable number of 'tried and tested workers'. Moreover, it had been agreed with the Board of Agriculture that Corps members did not have to appear before the selection committee of the National Service Scheme, but would be enrolled automatically. Of the 530 members who replied, 88 joined the Land Army.[45] It was from their ranks that Group Leaders for the Land Army were being drawn. Many of these pioneer members were also appointed as superintendents of the new training centres being established across the country.

Group Leaders were appointed in April 1917. They received higher wages and wore a distinctive armlet bearing the word 'Leader'. They could be

recommended for promotion to Instructor in a Training Centre, receive more pay, and wear an armlet bearing the word 'Instructor'. Yvonne Gwynne-Jones,[46] sister of Allan Gwynne-Jones[47] who was to establish his reputation post-war as an artist and distinguished teacher, was a Group Leader, and like her brother educated at Bedales, the progressive and first co-educational school to be established in England. During her service in the WLA she wrote a letter to her former school via *The Bedales Record*, asking whether any girls or old Bedalians at college might become Gang Leaders. She described how she was presently travelling round Gloucester investigating the demand for gangs of women to work for 2–3 months in the spring and summer – hoeing and singling roots, haymaking, corn-weeding and harvesting. There was a fairly large demand on the sizeable and isolated farms in the Cotswolds for gangs of three or four women from June to October. Gwynne-Jones explained that she had to find accommodation for them, but the problem was that 'the farmer's cry is "send one responsible girl with each gang to supervise the workers, see they do their work thoroughly and keep regular hours" and this we cannot hope to do unless we get helpers from outside.'[48] Hence her letter asking if the *Bedales Chronicle* could also appeal for volunteers for as many months as they could spare. She informed readers that a gang leader had to get on with other girls and 'enthuse' them to put all they can into their work and have initiative so as to suggest ways of 'making do' when the conditions were difficult. Gwynne-Jones advised that the pay ran from £1 to 25s. but she thought that one could live on that sum quite decently as house accommodation was provided and sometimes extras like milk and

vegetables. If a furnished cottage were provided then the gang leader had responsibility for the catering as well but this she felt was fairly easy with three or four girls taking turns.

The Women's Land Army comprised three sections: agriculture, forage, and timber cutting. Provided recruits were signing on for a year they could choose which section to join. If signing on for a period of six months then they were not eligible to join the Forage Section. The agricultural and timber cutting sections were recruited jointly and were interchangeable. The three sections were described on a recruiting leaflet:

1. **OUR SOLDIERS MUST HAVE FOOD**
 In order to provide food for our soldiers and for the nation, women must till the land.
 Agriculture Section
 Milking, ploughing, hoeing, harvesting, care of stock and horses, general farm work and planting trees. Instruction will be necessary for those who have not done the work before, and who sign on for one year.

2. **OUR SOLDIERS' HORSES MUST HAVE HAY**
 In order to provide forage for the Army, women must help in this work.
 Forage Section
 Baling hay in the field, work at hay stores, stacking and loading bales, chaff cutting for the Army under the Forage Department of the War Office. No training required.

3. **OUR SAILORS NEED WOOD FOR THEIR SHIPS**
 OUR SOLDIERS NEED WOOD FOR THEIR RAILWAYS, THEIR SHELTERS AND THEIR AEROPLANES
 In order to provide timber for the Navy and the Army, women

must help in the work.
Timber Cutting Section
Felling trees, sawing into lengths, stacking and carting.
Training will only be given when necessary for those selected
for the post of supervisor, and will then be given free, and £1 a
week will be paid, out of which maintenance must be provided.[49]

FORAGE

A separate recruitment leaflet for the Forage Department[50] outlined why girls should join. It explained that every girl loves a horse instinctively, and stressed the importance of maintaining sufficient forage for the health and strength of the horses at home and overseas. 'Everything depends upon their health and strength – the food for our gallant fighters and the ammunition for our guns; all this depends upon our ability at home to send each theatre of War a sufficiency of Forage for the patient hard-working four-footed friend of man.'

The recruitment leaflet claimed that of all the Army Departments it was the pioneer of the employment of women and stated, 'There is hardly a village in the country in which the girls have not become a familiar sight with their "Guardsman's" breeches, three quarter overalls and green felt hats'. The Forage Corps 'had been the first real attempt by the Government to organise women volunteers … The WLA inherited [it and]… from its formation in 1915 [it had] suffered the effects of a dual administration.'[51]

As girls in the Forage Corps worked 'more closely with the home Army camps, the contract of employment

was much stricter, and there were penalties for misbehaviour or slackness.'[52] They were informed that they would probably be part of a gang of eight, including three soldiers, who would travel from farm to farm with steam baling machine, baling hay or straw, or they might be found work in a Chaffing Depot where they chopped hay or straw into short lengths for feeding horses or at a Forage Store. Gladys Wiles, writing about *Life on a hay bailer*, explained the value of their work and commented, 'each bail that is finished means food for a horse that carries provisions for the Tommies in the trenches.'[53] Horace Nicholls'[54] photograph, from his series of women workers, commissioned for record purposes by the Women's Work Sub-Committee of the Imperial War Museum, shows the dirty, dusty work made worse by thick, black smoke belching from the steam engine driving the baler.

Girls could rise to become conductresses, who accompanied the loads of hay from the farm to the railway and issued the food, wire and oil required by the balers. They could also gain promotion to forwarding supervisor who received the hay at the railway station, despatched it and advised regarding its destination and reported to the Department for accounting purposes. In each gang there was a woman 'corporal' in charge of the girls and who acted as their mouthpiece and intermediary. Every girl was guaranteed a minimum of 21s. per week. After a month's satisfactory probation she was entitled to an additional 2s. 4d. per week 'proficiency pay'. In addition, she could earn a 'bonus' of an additional 3s. per week or more if the baler on which she was working produced bales more than a stipulated tonnage.[55]

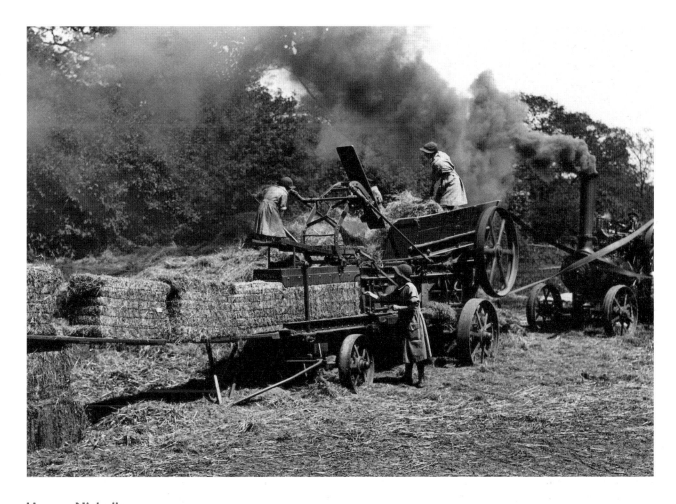

Horace Nicholls
Members of the Women's Forage Corps feeding a hay baler,
Middlesex, summer
(1918)
P.A. PHOTOS

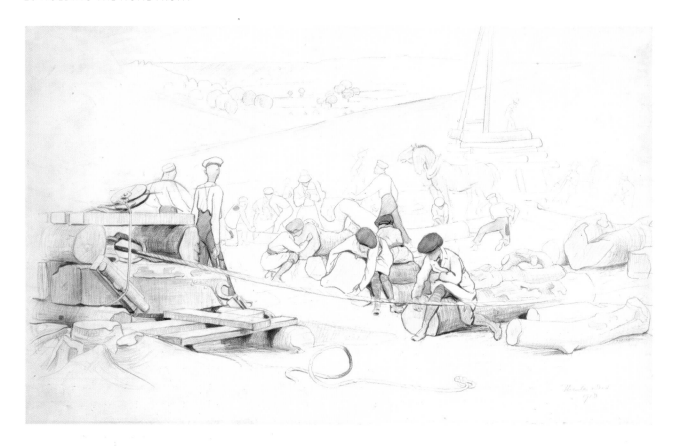

Ursula Wood
The Canadian Timber Camp, Wendover
(1918)
pencil, coloured chalk and watercolour, 279 x 438 mm

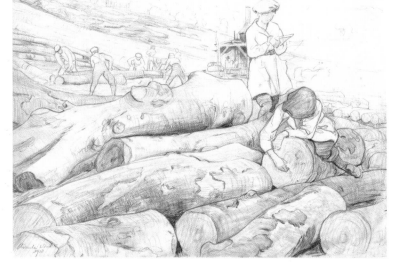

Ursula Wood
Girls Measuring ('Girthing') and Marking Timber
(1918)
pencil and coloured chalk, 209 x 279 mm

In March 1918 the Forage Department had enrolled over 5,000 women workers. These numbers reflected the unprecedented quantities of baled fodder required to feed the horses on the Western Front. At its peak the Army had over 600,000 horses in action as mounts for cavalry, haulage of artillery, and ambulance and regimental transport wagons.[56] Following the formal termination of military hostilities in November 1918, the arrangement with the Forage Committee of the War Office ended and the Land Army included two sections only – agricultural and timber cutting. The Forage Corps thereby became independent of the WLA and was constituted by the Army Council as a new branch of the Army Service Corps. The Corps was divided into two parts – supervisory and industrial, those doing similar work in the WLA were given the option of enrolling.[57] The organisation of the Corps had been difficult because the women had been so widely distributed and there had been problems of housing and ill-discipline.[58] By the end of 1919 when it was disbanded, 8,000 women were working in Great Britain and Ireland under the supervision of Mrs Athole Stewart.

TIMBER WORK

In the winter months with general land work slack some Land Girls were transferred to timber work. Short courses were held during the winter of 1917–18 in the Woodmen's School at Lydney, Gloucester to train forewomen planters to deal with the gangs of unskilled women being recruited locally and who were working at afforestation. Practical work was undertaken in the Forest of Dean, organised by the Office of Woods; the forewomen were then drafted out to private or crown estates where they supervised the nursery and planting work.[59] Land Girls were employed across England on timber work, including wood sawing at Rothbury in Northumberland for Lord Armstrong. Gangs of women were also employed in Norfolk and Suffolk for pit prop cutting and in Lyndhurst, in the New Forest, thirty girls were employed clearing and planting young trees.[60]

The foundations for the Women's Forestry Corps (WFC) were laid by Doris Stapledon, who in 1916 had been appointed as organising secretary for the WLA in Radnor and Brecon, and finding little demand for Land Girls on the small farms 'conceived the idea of employing them in gangs on forestry work in conjunction with the National Land Service Corps.'[61] As well as seeking to increase food production at home, measures had been taken to develop the supply of home-grown timber. In the autumn of 1915 the Home Grown Timber Committee was set up as a branch of the Board of Agriculture and had purchased woods and erected saw mills which were operated by labour directly employed. A Timber Supplies Department was later created which took over the work of the Committee and in May 1917 the Department was transferred from the War Office to the Board of Trade and James Ball appointed Controller of Timber Supplies.[62] By January 1918 there were some 400 women foresters, and the following year The Forestry Act established a Forestry Commission for the United Kingdom.

An open-air training camp with newly-built hostel was established at Wendover in the Chilterns for women timber measurers, the only one in England. Here for

4–6 weeks from 9 a.m.–5 p.m. 50 trainees learnt their craft. They were expected to enter with a good general education and preferably some previous professional or business experience and to be able to cook and clean for themselves. Minnie Sherriff Mott visited the camp for the weekly magazine *The Lady* and reported that there were two long dormitories, cubicled (with real beds), wash rooms and bathrooms plus a mess room and a recreation room. A senior pupil at Wendover, who like many of her fellow workers was a school teacher, was reported as saying, 'we learn first to girth the trees immediately after felling, finding their cubic contents to decide the wages to be paid to the fellers; then we mark where they are to be sawn. Sometimes we also superintend the stacking of the logs by the rail-side, and the loading by crane on to the tractors which take them to the station. We also check them, calculating the cubic contents and measurement-weight to determine the cost of carting by the contractor.'[63] They were paid from 30–40s. per week, 37s. 6d. being the average rate. Sheriff Mott explained that the 'man-labour' of the camp was carried out by Portuguese men except for the felling which was done by Englishmen.[64] The women foresters had to be prepared to move from place to place as instructed by Caxton House. Women fellers earned a minimum of £1 a week but as they usually worked on piece rates they could earn from 23–28s. per week. They were expected to arrange their own board and lodging which usually could be obtained for 16–17s. a week. Forewomen of gangs earned from 25–35s. per week.[65]

Sheriff Mott in her Wendover article commented that women between the ages of 23–35 from the educated and professional classes were found to be the most successful timber measurers. *Girls Measuring ('Girthing') and Marking Timber* (page 26) at Wendover in 1918 was drawn in pencil and coloured chalk by the artist Ursula Wood, who was a member of the WFC. She depicts two members of the Corps diligently engaged in their task, one sitting astride a tree trunk in the process of girthing or girting: this was the operation of measuring the length of the tree from butt to tip and the quarter girth of it at the middle. The tree was then marked with red paint on the butt, to show that it had been measured. Her colleague meticulously records the figures so that the cubic contents of the tree can be worked out, for which a 'hoppus' is used. A 'hoppus', Sheriff Mott informs readers of *The Lady*, is a ready reckoner, 'showing at sight the solid contents or superficial area of square or round timber.'

Ursula Wood's *The Canadian Timber Camp, Wendover, 1918* (page 26) shows 'the "donkey" [engine] in the foreground [which] is used for drawing down timber from the hills. The girls are seen measuring and marking, and the Canadians are drawing timber over the slips to stack, load on trollies and send down the road.'[66] The German POWs in blue uniform trousers with distinctive red patches sewn on for identification are mostly busy sawing logs.[67]

Certain mills were operated by Canadian lumber battalions, the first of which at Virginia Water Camp, Surrey, started work in May 1916. These battalions expanded into the Canadian Forestry Corps (CFC) in October 1916 and detachments, numbering 1,609 in total, also operated elsewhere in England and Scotland.

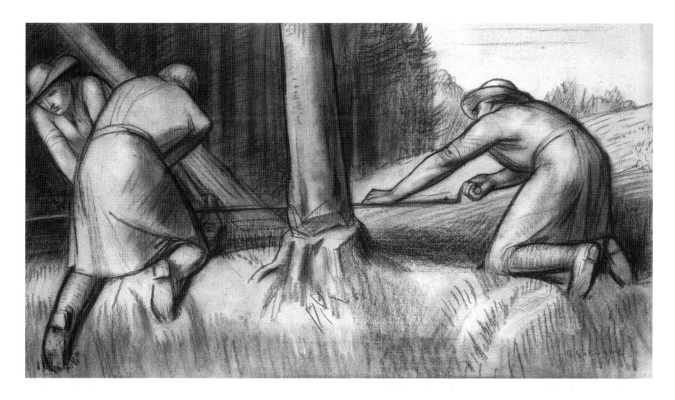

Randolph Schwabe
Tree Felling
black chalk on grey paper, 330 x 609mm
IMPERIAL WAR MUSEUM

FACING PAGE
Ursula Wood
The Old Banqueting Hall, Hatfield:
Girls of the Women's Forestry Corps, Dancing to a Gramophone
(1918)
pen, pencil, coloured chalk and watercolour, 406 x 317mm
IMPERIAL WAR MUSEUM

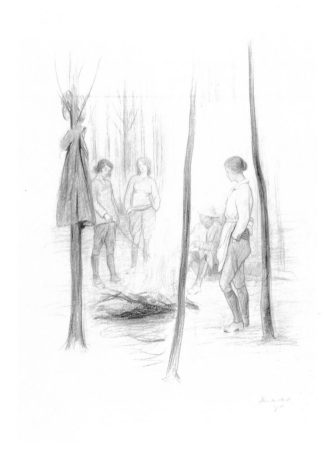

Ursula Wood
Girls of the Women's Forestry Corps:
The Timber Camp, Hatfield, December 1918
(1918)
pencil, black and coloured chalk, 381 x 279mm
IMPERIAL WAR MUSEUM

An additional 5,000 lumbermen were requested by the government in November, 1916 and a base depot was established at Windsor Great Park.[68]

The Women's Forestry Corps also had a base in Hatfield where the girls lived in dormitories and had their mess-room in *The Old Banqueting Hall*. Wood's sketch shows the girls in a rare moment of relaxation 'dancing to a gramophone: the ghost of Queen Elizabeth in the background.'[69] In *Girls of the Women's Forestry Corps* she records a scene 'with four forestry workers grouped around a small fire in a wood. There are three girls in the background, one holding a stick into the fire, another standing with her hands in her pockets, and the other sitting resting her arms on her knees. Three spindly trees stand in the foreground. A jacket hangs from a branch of the tree on the left, and the fourth girl stands opposite, her hands in her pockets and her face turned towards the fire.'[70]

RECRUITMENT AND TRAINING

Recruitment for the Women's Land Army was initially the responsibility of the National Service Ministry but from August 1917 it would be conducted by the Women's Section of the Food Production Department of the Board of Agriculture.[71] Applicants were rigorously questioned about their health, physical capabilities and reasons for wishing to become a landworker. It was believed that 'As the women are doing men's work it is of utmost importance that they should be of good constitution and vigorous.'[72] The Selection Committee members were advised to give priority to women with previous experience in agricultural work and to those

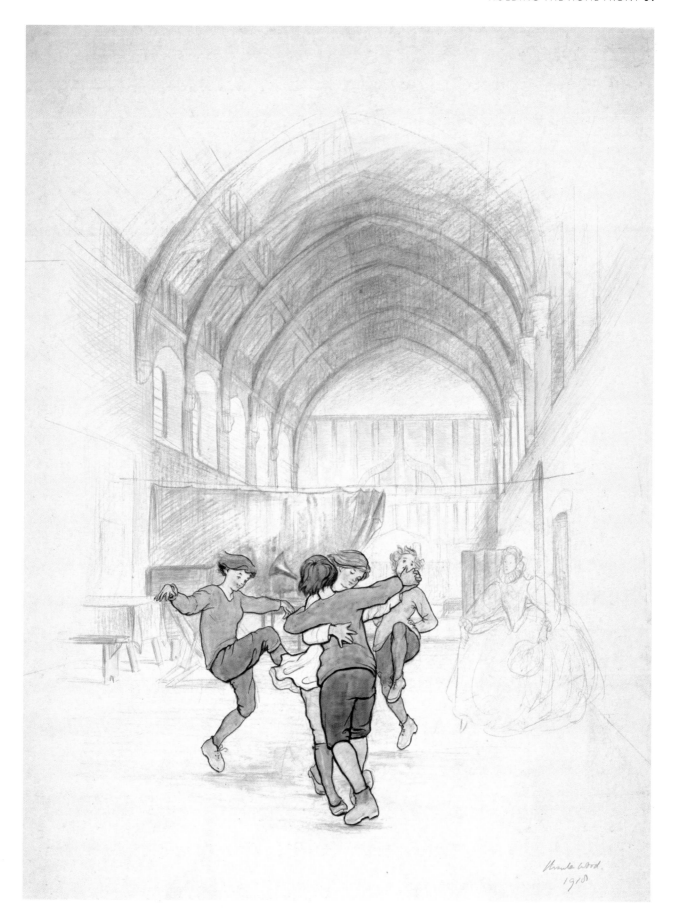

RIGHT

Sketches by Yvonne Gwynne-Jones
The Landswoman, April 1918

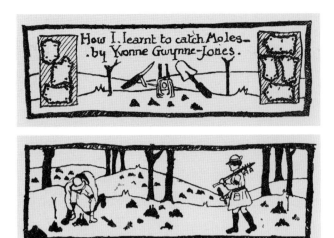

not already in work. The Board of Agriculture also pointed out that only in very exceptional cases were girls under the age of 20 to be accepted. Selectors were instructed to pay particular attention to temperament, as it was felt unwise to send young girls considered not yet stable in character to work on isolated farms. The selection process was deemed a key factor in building a cadre of women workers who would enable the scheme to be perceived as successful. The guidance stressed that 'Too much care cannot be given to the original selection of recruits. The whole success of women's work on the land depends upon the suitable women, and only the suitable women, being selected. This is specially the case in the beginning, when the farmers have to be convinced that women's labour is valuable, but it is always advisable for the sake of the women themselves.'[73]

A decision would then be made whether the recruit was sufficiently skilled to go straight to a farm as a paid worker; or required training at an organised centre; or suitable for a bursary and allocated direct to an approved farm on which she would work and be trained in that work, although the farmer would not pay her wages for three weeks, rather the Land Army would make an allowance for the maintenance of the recruit; or whether she was to be sent to a practice farm where the farmer trains one, two or more women for four to six weeks, the Land Army giving them maintenance, but at the end the farmer did not employ his own trainees; or finally, it was decided whether she was quite unfitted for agricultural work.[74] The bursary and practice farm system were of course dependent on the farmer's ability and time to impart

and supervise instruction. In the case of the bursary system the recruit was often only trained for one particular task and once the season for that process was over she required additional training before she was of value to another employer. On the whole the most successful method was found to be where recruits were sent to a central hostel under the supervision of an instructress.

Training began on 26 March 1917, for some of the hundreds of women who had applied for agricultural work. By the middle of September a survey showed that there were 247 training centres and 140 farms registered for such work.[75] 'For four weeks they [were] fed, lodged and trained at the country's expense.'[76] In some cases the women were housed in large private houses, in others they were grouped in hostels and trained in surrounding farms. After a fortnight the instructor at the Training Centre sent a report about the recruit's progress to the Instruction Committee and if her progress was satisfactory, the Selection and Allocation Committee arranged, if possible, to place her locally on a farm. Once she started work her wages were paid by the farmer. If such placement were not possible then her papers were sent for reallocation preferably in the same county. Parents were reassured that their offspring would be under the care and protection of supervisors so that they should have no anxiety about their welfare. Speed of allocation was of the essence as women were needed urgently on the land to take the place of men on furlough who were shortly to be recalled to the ranks of the Army. The intention was that these women and girls would become the officers and leaders of those who joined later in the year.

Randolph Schwabe
A Girl of the Women's Land Army: Miss Yvonne Gwynne-Jones
(1918)
black chalk with touch of colour on toned paper,
482 × 241 mm

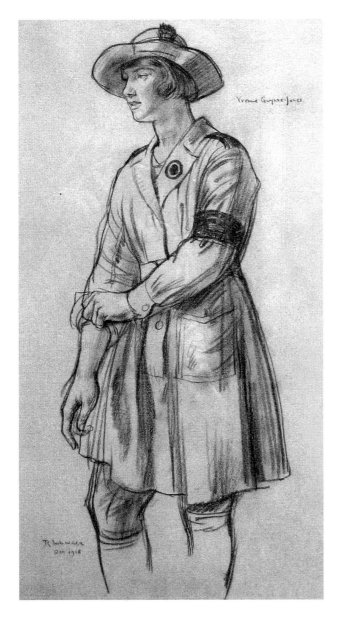

During the first six months of the WLA, training was restricted to four weeks which offered little time for practice and as Lord Ernle noted did little more than harden muscles. This was later extended to six weeks and 'efficiency tests' instituted, 'with objects of encouraging the recruits to make every endeavour to become competent, and of giving the organising secretaries some idea of the skill of the candidate, so that women could be suitably placed.'[77] The additional two weeks' training was found to have a marked effect on the confidence of the inexperienced recruit and her ability to adjust to the demands of the different life and climatic conditions in the country. In most cases the training was devoted to the correct use of farm implements and the care of young stock or horse work, although it was recognised that in some counties the general farm labourer was most in demand and a little of both types of work was needed.[78] Special classes were organised where it was found necessary to supplement the training with instruction in tasks such as thatching and hedging. Thatching was one of the most highly skilled and important harvest tasks, since unthatched corn and hay ricks exposed to the weather and in particular the wet were liable to considerable damage.

Ploughing with horses was another skilled job, also not traditionally done by women but one that they did extremely efficiently. Henry Gawthorn's recruiting poster (page 10) featured a woman ploughing, and the words 'God speed the plough and the woman who drives it.' It is likely that when Land Girl Kathleen Hale, later a well-known artist and author of books about *Orlando*, the marmalade cat, commenced ploughing she was less than efficient, as she – like many other Land

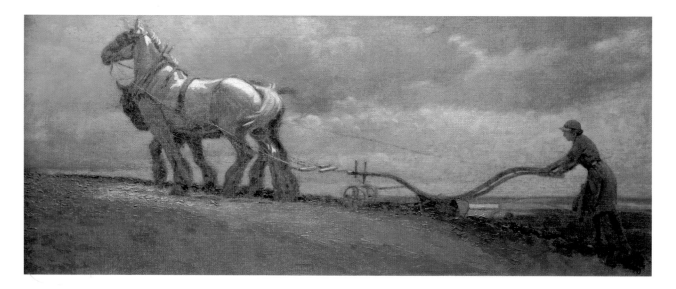

Girls – had never seen a plough, let alone used one, but she remembered hearing that the traces of the last ploughing would be visible. She described in her autobiography *A Slender Reputation*, how she harnessed her horse to the plough, 'and was lucky enough to find a rut and follow it. The plough was a huge wooden thing, very heavy – the labourers called it "the man-killer" – and when [she] came to turn it round at the end of [her] first furrow, it knocked [her] flying'. The Land Girl featured in Cecil Aldin's *A Land Girl Ploughing* appears to have mastered her 'man-killer'. Hale would clearly have benefited from instruction from the likes of Margaret Billson (page 36) who had trained at Studley Agricultural College in 1912, Warwickshire and later taught ploughing while an instructress at the government hostel for Land Girls at Ivinghoe, Tring. Billson was another former Bedales School pupil, and one who most likely knew Yvonne Gwynne-Jones, as they overlapped at the school from 1908–10.

Kathleen Hale joined the Land Army in June 1918 not out of patriotism – she was a pacifist – but probably because she 'had developed a passion for animals during her childhood and kept numerous pets.'[79] As she acknowledged, it hadn't occurred to her that her work would release a man for military service. Hale hated the thought of hoeing and weeding and stated in her application that she wished to enlist as a carter even though her experience with horses was limited. She was sent to a market garden at Barnes, near Hammersmith and worked with another carter and eight Land Girls who hoed and gathered the vegetables which she transported on an articulated wagon to Covent Garden market. Prince, her horse,

appears as Vulcan in the *Orlando* books. Having sold the vegetables she was instructed to fill her empty wagon with manure from Cadby Hall, the headquarters of Lyons & Co. for the return journey.

Mole-catchers were also needed urgently in different parts of England and in February 1918 Meriel Talbot had written to Organising Secretaries suggesting that girls be trained in such work, which should not take more than a week, and informing them that the Department would be prepared to sanction the purchase of traps. In April 1918 Yvonne Gwynne-Jones contributed an article to *The Landswoman*, 'How I learnt to catch moles'. She outlines how she killed the moles which had overrun an estate and were spoiling the pasture. She details where and how to set a trap and how to disguise traces of human interference with the earth by the application of bottled worms, kept corked until turned to jelly, and then smeared over the traps. Gwynne-Jones goes on to explain what to do when the trap is sprung, including, as illustrated in her sketches (page 32), how after the mole has been skinned the skins are stretched out on a board with tin-tacks. She describes how the skin is washed over with a weak solution of alum and water and then left to dry in the open air. These skins would be quite supple once dry and could be sent to the furrier to be properly dressed and made into all sorts of nice things. 'The work [was] usually paid by the number of moles caught, as a rule – a skin.'[80] In three days Gwynne-Jones caught fourteen moles with nine traps.

Man-power and horse-power shortages necessitated increased use of labour-saving machinery, both petrol

LEFT
Cecil Aldin
A Land Girl Ploughing
(1918)
tempera on canvas, 914 × 2286 mm
IMPERIAL WAR MUSEUM

*Women's Land Army
Good Service Ribbon*
COLLECTION OF
EVELYN PAINE

and steam, in order to maintain the harvest of 1917. However, tractors were also in short supply, there being barely 200 on the land before the war started, and farmers still regarded them with suspicion as new-fangled contraptions. The Food Production Department ordered tractors from the United States but delivery was slow; nonetheless, 'tractors gave valuable aid in the late spring and summer cultivation of 1918'.[81] Of the 500 or so steam-ploughing sets known to exist a considerable number were not in use for a variety of reasons, including shortages of skilled labour. To overcome this, men experienced in the use of steam cultivators and steam tackle were, once they had been traced, released on furlough from the Army and arrangements made for the repair of machinery.[82]

Special training centres and schools were established for women tractor drivers, including one in Oxted where 30 girls with some knowledge of motors were given preference. Women trainees were entitled to an extra outfit which consisted of a mackintosh coat and trousers, two pairs of bib trousers, two dungaree coats, a motor cap and a pair of gloves. They were taught to drive, undertake minor repairs and instructed in cultivation, specifically the field operations of tractor ploughing and harrowing. At the Harper-Adams Agricultural College, in Newport, Shropshire candidates received theoretical instruction mostly in the evenings, when theory lectures were given on topics such as the Internal Combustion Engine, the Magneto and Fuel and Oils and the Use of implements connected with tractor work. A variety of tractors were used including the Mogul, Titan and Samson Model. The machine mostly employed was the Fordson.

The fluctuating and uncertain demand for women's labour created difficulties (as did withdrawal of soldiers' labour) as it resulted in a larger number of women in training at one time than at another. Between March 1917 and May 1919 some 23,000 women passed through the training centres.[83] An employment return, though incomplete, shows the types of work 12,639 members of the WLA were engaged in the autumn 1918. The vast majority were working as milkers (5,734) and field workers (3,971), with only 129 employed as forewomen.

Occupations of Women in the Land Army, Autumn 1918

- Milkers: 5,734
- Field workers: 3,971
- Carters: 635
- Market gardeners: 515
- Private gardeners: 260
- Ploughwomen: 260
- Tractor drivers (Food Production Department): 256
- Forewomen: 129
- Threshers: 101
- Thatchers: 84
- Tractor drivers (with private farms): 37
- Shepherds: 21
- Bailiffs: 3
- Other branches: 653

Total: 12,639

However, the total number of women working on the land in 1918 was 300,000.[84] The Women's Land Army therefore constituted a small, yet not insignificant, part of a much larger labour force.

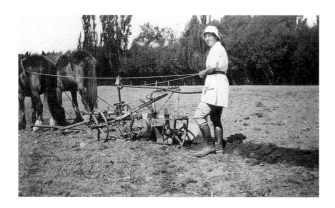

Margaret Billson, WLA Instructress
COLLECTION OF BEDALES SCHOOL

EFFICIENCY TESTS AND AWARDS OF MERIT

Efficiency tests were introduced to encourage recruits to become proficient in different forms of farm work and to give some indication to organising secretaries of their skills and qualifications to aid their placing on the land. Three classes of workers were allowed to qualify: Class A for experienced women, Class B for those women who had about six months on the land and Class C for women who had about three months on the land. For a Class A award a worker had to obtain 90 marks out of a possible hundred and on gaining such a mark could apply for promotion to a forewoman or instructress. Members of the WLA were encouraged to take the efficiency tests to see whether their work was in need of improvement. The WLA L.*A.A.S.* [Land Army Agricultural Section] *Handbook* informed them 'that it is not sufficient to work on the farm, but it is necessary to work well, and to do every job they undertake as thoroughly as possible. By so doing they will help not only the country but themselves. A good worker helps food production, and a farmer is always willing to pay more to a good worker than a poor one.'

Later efficiency tests were revised with the outcome that they no longer affected wages. While the three classes remained the same, the standards were raised for Class A and B, with the former now requiring the candidate to obtain 95 per cent. Members could take Elementary tests in Horsework (taking one horse and cart), Milking (two cows essential), Ploughing (simply ploughing round). The next group of tests came under the category of Field Operations; these included hoeing (by hand), hoeing (horse hoe), harrowing, rolling, loading and spreading manure, pulling, cleaning and filling roots, trussing, hedge brushing and scything or mowing. Before a certificate could be granted at least three operations had to be successfully undertaken. The next subject was Advanced and Special. This also covered milking, but included the machine-milking of at least six cows. Also examined was ploughing but this time the candidate had to include opening, finishing and ridging. Other tests included motor tractor driving and riding plough behind tractor. The final subject was Garden Operations. As in Field Operations, three operations had to be taken from: digging, trenching, planting, hoeing, seed bed cultivation and cuttings.

Two awards of merit were inaugurated for members of the WLA. Firstly, the Good Service Ribbon (page 35) was issued after six months' satisfactory work and conduct, both in and out of working hours. The background was bright 'grass-green', and the crown and letters were embroidered in yellow and red. It was to be worn on the left arm, well above the armlet. By October 1919 just under 8,000 had been awarded.[85] Secondly, the Distinguished Service Bar (DSB) was awarded for acts of courage and any special act of devotion to duty. This award could only be granted by the Director of the Women's Branch. The L.*A.A.S. Handbook* pointed out that either award could be withdrawn temporarily or permanently in the event of misconduct. The first DSB was awarded to Miss Ethel Nicholas who, aged eighteen, 'was in charge of a cutting-machine drawn by two horses, when the leg of her employer was caught by the knife. Stopping the horses immediately [she] put the machine out of gear, and with her handerkerchief and belt skilfully tied up

the wound. Next she secured the help of a neighbour-
hood farmer, and assisted the doctor to operate. The
doctor reports that but for [her] presence of mind…
her employer would have run serious risk of losing
his life from bleeding, and would almost certainly
have lost his leg.'[86] Of the 46 awarded, 24 were given
for 'deeds of splendid courage and endurance, while
22 were awarded for really exceptional skill in such
unaccustomed work as rearing bulls, driving tractors
[10] and shepherding.'[87] Shepherds were becoming
difficult to obtain and among men it was snot a
popular branch of farming; however a shepherdess was
awarded a DSB for her skill in caring for a flock of 200
sheep since 1917 on a Cornish hill farm.[88] Of those
other Land Girls who gained their awards for their
unselfish devotion to their animals some were also
awarded the medal or the certificate of merit of the
Royal Society for the Prevention of Cruelty to Animals.

APPEALS TO WOMEN TO SERVE
ON THE LAND

Another major appeal to women to join the Land Army
followed in July 1917. Farmers' prejudices were steadily
being overcome following the success of recruits already
working on the land and the actions of the President
of the Board of Agriculture to draw public attention to
the value of this source of labour. The appeal was aimed
specifically at girls living in the suburbs of large towns.
Women were reminded that the organisation sought
recruits of not only good physique but also intelligence
who realised that their service on the land supplemented
and supported the service of the men in the trenches.
Further, they were informed that promotion and higher

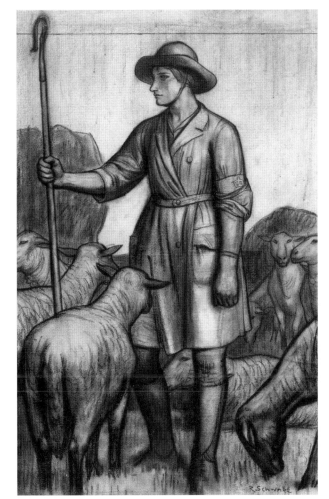

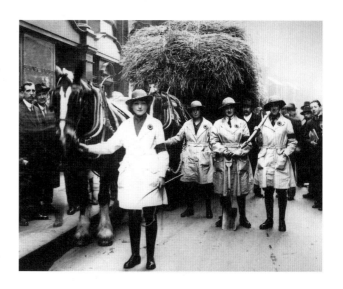

pay was possible for those who gave good service. A campaign was launched with public meetings, distribution of leaflets and a poster specially designed by the artist J Walter West appeared on hoardings and at stations. The poster with its image of a young uniformed Land Girl delicately feeding a horse and foal next to a wooden trough presents a picture of rural tranquillity. The appeal was clearly successful, *Building News* reporting how a young woman was attracted to the work because of the poster, although she confessed 'that she has only now learned that hay won't pour.' The reporter commented, 'The artist was a humourist, the official who approved the poster a pure-blooded cockney – no doubt lent by the Board of Agriculture.'[89] Further, 'nothing in these idealized images suggested any contradiction between the Land Army's costume and bourgeois, urban femininity, or hinted at anything except a sanitized version of agricultural work.'[90]

Women were urged to enrol for service on the land as field workers, milkers, plough women, carters, cow women and market gardeners, a recruitment leaflet stating:

> If you are healthy and willing YOU can be taught, YOU can wear the uniform, YOU can earn the wages. We must have
> Milk for the babies
> Bread for the children
> Food for the sailors and soldiers…
> The land is calling YOU. Your country needs YOU.
> The harder the work the greater the service.[91]

A documentary film demonstrating the work of the Women's Land Army was made for cinema audiences.

The film featured beauty queen and film actress Ivy Close together with Violet Hopson. Volunteers from local committees were encouraged to attend with a supply of enrolment forms.[92]

By the middle of September 1917 the WLA had 6,000 members, and it was also reported that the drop-out rate was virtually negligible thanks to the careful selection process.[93] Any members not working were drafted to the Forestry and Forage Department of the War Office and the Timber Supply Department for deployment. It was, however, the 200,000 part-time workers who were the mainstay of food production. Some 975,000 more acres than in 1916 were under the plough and of these 286,000 acres were in England and Wales, 49,000 in Scotland. The chief contributor to the increase was Ireland with 638,000 acres.[94] The increase in England, Wales and Scotland 'was due either to a patriotic response to appeals for more ploughing, or to "peaceful persuasion" by local committees.'[95] While there was a poor yield from the corn crops, the potato crop, some of which had been planted on the grass land ploughed up in the spring of 1917, was most satisfactory.

About 100 members of the WLA participated in the Lord Mayor's Show in London on 9 November 1917, ten of whom were Group Leaders. Helen Bentwich was one of their number, formerly a forewoman in a munitions factory at Woolwich Arsenal, she had been convinced 'that its female workforce was overworked and underpaid, she attempted to form a trade union and was either dismissed outright or compelled to resign.'[96] Shortly after in April 1917 she signed on for the Women's Land Army. At interview she was asked if

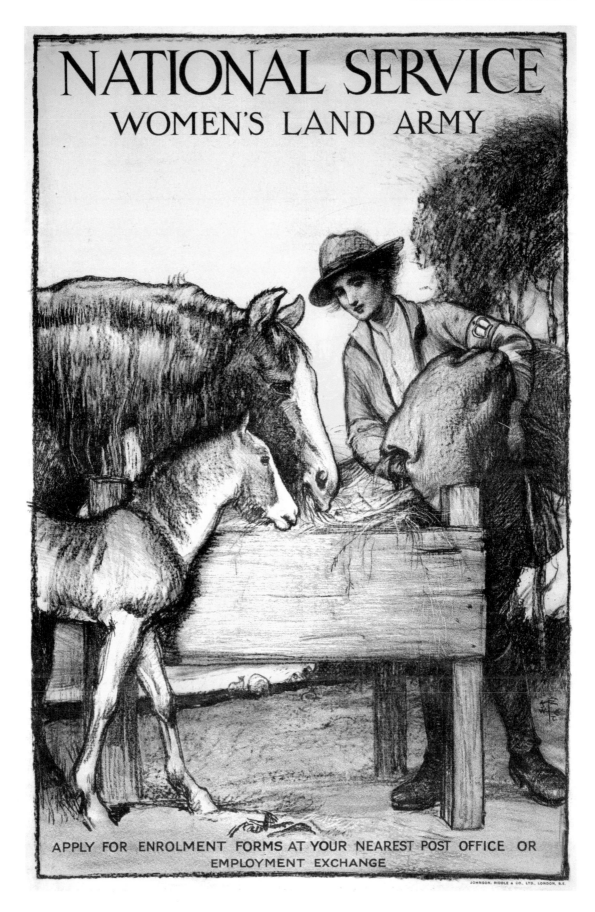

she would be willing to be a peripatetic Group Leader
and be paid 25s. a week, she agreed, and some seven
months later was stationed in Hertfordshire. With her
contacts with 'Head Office', she found herself leading
the contingent of Land Girls in the parade. In her
autobiography *If I Forget Thee* she describes how they
assembled at Drapers' Hall, in the City, at 9 a.m., all
in their cleanest uniforms and marched behind the
band of the Grenadier Guards. Many of the Land Girls,
she recalled, carried hoes and milk-stools and at the
rear was a farm-wagon, full of straw, with four girls
leading the horses, and some sitting on the straw. She
commented that the 'crowd was lovely; they cheered
us all the time, and there was no laughing or jeering,
as we feared there might be, as girls in breeches are
something new to the City.'[97] Such a public display
by Land Girls in the heart of the city, was yet another
means of raising public awareness of their existence
and was a useful recruitment strategy to complement
the posters and film campaign.

UNIFORM AND CONDUCT:
A QUESTION OF BREECHES

Land Girls in breeches with their bobbed hair had
shocked the sensibilities of country folk, and were
viewed with suspicion and hostility. Some like
Yvonne Gwynne-Jones were stoned by villagers
simply because they wore breeches. She also reported
that the hostility extended to being sworn at and
her horse being interfered with, so that when she
drove the milk float suddenly the normal peaceful
trot turned to a mad canter; she later discovered
that ginger or pepper had been put on its rear.[98]

Edward C. Caswell
Frontispiece, A Land Girl's Love Story
Berta Ruck, 1918

Berta Ruck the popular novelist who wrote largely for and about young girls, in *A Land Girl's Love Story*, one of her early novels, tells how her heroine Joan, a clerk in a Government office in London, joins the Land Army for the farm idyll with her chum Elizabeth. Out shopping they are jeered at by a group of local louts on account of their uniform and in particular their wearing of breeches, but spiritedly Joan responds, 'A good job for the country that we do! As for you, it's a pity they can't take and make you,' raising her voice to a shout, 'wear petticoats!'[99] The reviewer in the *Times Literary Supplement* commented of Ruck's work not being quite up to form, 'her sprightliness runs rather thin, and one gets the impression that her literary conscientiousness has been a little interfered with by an eagerness to recruit for the Land Army.'[100]

The wearing of breeches, then, created tensions in local communities, and while a practical necessity, they conflicted with prevailing views of femininity and womanhood. Indeed Land Girls who wore their breeches off duty were reported to their superiors. However, their superiors 'refused to intervene, their opinion being that the dress was a decent and honourable uniform which the public should respect as it respected the uniform of a soldier.'[101] Nonetheless, the *L.A.A.S. Handbook* issued to all members in 1918 reminded Land Girls to treat their uniform with respect and make it respected. Although they were dressed rather like a man they were advised to 'take care to behave like an English girl who expects chivalry and respect from everyone she meets.' Mrs Alfred Lyttelton, the Deputy Director of the WLA, 'a charming person, kind and sympathetic but with not the… remotest idea

of land-work, probably thinking it just consisted of ploughing and reaping and milking and collecting eggs',[102] addressed over 100 girls and 400 village part- and whole-time workers at a rally in Hereford in January 1918. She reminded them that they were pioneers, and that in a sense the whole reputation of their sex lay on their shoulders. Certainly, the breeches they wore were controversial and to some a symbol of indecency and depravity.[103]

Strict rules about behaviour and conduct were enforced. As the *Handbook* noted, 'Every worker should remember that the honour of The Women's Land Army is in her keeping.' She was exhorted not to enter the bar of a public house, smoke in public, wear her uniform after work without her overall, or walk about with her hands in her pockets. The writer Edith Olivier, who had been responsible for establishing the WLA in Wiltshire, recalled in her autobiography the stringent rules and how she had to convene a court martial in a training school when a girl one night got out of bed and clambered out of the window.[104] Meriel Talbot was also concerned that recruits upheld the good name of the Land Army and wrote several reports on the subject including *The Women's Land Army: Need for More Effective Control*.[105]

THE LANDSWOMAN

As the Land Army numbers increased so too did the need to develop a means of communicating with members. *The Landswoman*, the official monthly magazine of the Land Army and the Women's Institutes, was launched in early January 1918, priced initially at

FACING PAGE
J Walter West
Cover for The Landswoman

Bunty Daniel
'Our club page'
The Landswoman, July 1918

2d.[106] and 16 pages in length. The original colour cover of two landswomen and their carthorses by the artist Walter West was used throughout the war years and beyond. The exception was the special Christmas Double Number (priced at 6d.) when the cover was drawn by Kathleen Hale while she was working on a farm in Middlesex. She had previously studied art at Reading University College before moving to London to paint maps for the Ministry of Food. Hale's cover (page 47), also reproduced in colour, was in stark contrast to West's, as it portrayed a rather glamorous-looking Land Girl standing casually hand on hip, as she watches her horse languidly drinking water from a barrel. Hale found that the heavy land work often in bitterly cold weather caused her hands to tremble such that it was impossible for her to hold a pencil to draw scenes of her experiences.

The Landswoman was available from branches of W.H. Smith & Son, County Secretaries or via personal subscription and it was also sold at recruiting rallies. Started by private enterprise and edited within the Women's Branch of the Board of Agriculture, it proved a great success,[107] and in April 1918 40,000 copies were sold. Meriel Talbot began her foreword to *The Landswoman* by informing readers of royal interest in the new venture, describing how the Queen had sent for her to hear what women were doing in land work, and about the conditions of work and housing and in which operations women were most proficient. Talbot pointed out that the Queen was particularly interested in the effect of the work on their health and the arrangements made for the provision of suitable clothing. In the same edition Prothero acknowledged the loneliness of the

lives of many women working on the land, and in particular those who had been accustomed to living in towns or who had trained in agricultural classes. As he noted, 'They pine for some congenial soul with whom to compare notes. We hope that the Magazine will be a companion, and that woman workers will talk to one another through its pages.'

In seeking to be a companion and bind members 'into one big family',[108] the magazine contained news and photographs about the Land Army, technical articles about different aspects of farm work and other features of special interest to the landworker. The editor, Mrs Hughes, who was also the Chief Welfare Officer for the WLA, invited contributions from members in the form of short stories, verses, photographs and essays on farm work. There were regular competitions and prizes awarded, including in the first edition a shilling given for each of the five best hints on 'How to Cure Chilblains'.

The magazine also featured 'Our club page', the header for which by Bunty Daniel depicted Land Girls marching and was used from June 1918. For those members who could not buy the things they needed locally Mrs Hughes offered to assist with shopping or to advise anyone in the LAAS if they wrote in to her. She said 'Dear Girls… I want you to take me on as a friend, and to write to me, every one of you and tell me about yourselves and your doings.' Other clubs included sewing, the expectation being that 'girls' would be doing lots of needlework during the long winter evenings. The correspondence club was designed so that girls could compare notes about

The LANDSWOMAN

APRIL : 1918
No. 4 ❖ Vol. I

Price
2d

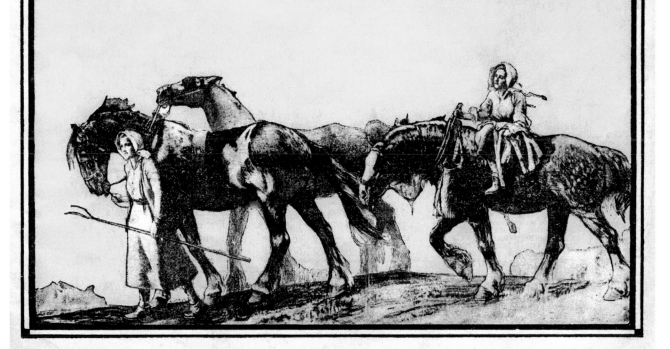

their work and find out through the editor information about 'their boys' if they were in hospital in London, or how to send a parcel to them in France. For those interested in knitting and in particular making comforts for the troops there was a separate club. There was also a 'Notes and queries column' penned by an expert, a poultry expert conducting the first of these. In the section 'Employment for winter evenings' the editor offered to help with the setting up of plays or concerts and to receive suggestions for other clubs amongst the members such as the making of toys, baskets or articles for sale.

The Landswoman was an attempt to encourage the patriotism of its readers and like the *Journal of the Board of Agriculture* it sought to counter the prejudices and stereotypes still held by farmers about women's abilities to labour successfully on the land. Prothero explained in the first edition of *The Landswoman* that the work of the pioneer Land Girls was 'not only useful, but... vital to national existence... They are helping to hold the home front as the men are holding the lines by the sea and land.' Meriel Talbot in the same edition reminded the Land Girls 'what a splendid privilege it was to be allowed to take part in this great struggle for freedom and right. [and] How glorious [it was] to think that the women on the land were sharing the hardships of their men at the front. How it should encourage them to stick to their work, however monotonous and hard and muddy it was, when they remembered that they were fighting to keep from starvation the wives and children of the men who were giving their lives for England.' Such messages were clearly designed to minimise attrition from the

WLA and to reinforce in Land Girls' minds that their labours, although often unseen and unheralded, were highly valuable to the nation.

While appealing to the patriotism of the Land Girl it was also made clear to the readers of *The Landswoman*, in the advertisements in particular, that 'this did not require the sacrifice of femininity, even on the land.'[109] The advertisement for Premier Vinolia Soap shows the head and shoulders of a young, smiling, healthy-looking Land Girl holding a pitch fork, beneath which it states:

Beauty on Duty has a Duty to Beauty

After a hard day's work on the land, the woman worker experiences with delight the soothing cleansing properties of Premier Vinolia Soap.

It is particularly comforting to the tender skin which has become rough and raw by exposure.

Alongside the text a Land Girl is shown undertaking a range of farming tasks, including leading horses; wearing a yoke carrying pails of milk; as well as milking and feeding poultry. The March issue carried an advertisement for 'Vinolia for the woman worker's toilet'. Here the Land Girl is engaged in the strenuous physical activity of ploughing. The text reminds her that although she is willingly toiling in the time of the nation's need she can still preserve the softness and beauty of her hands and the wholesome purity of her mouth and sound condition of her teeth.

To plough and sow, to reap and mow,
And be a farmer's girl,
With skin so soft, and white as snow,
And teeth as pure as pearl.

These advertisements and others like them in contrast to the recruitment posters more closely recognised the reality of land work and the impact of hard work and exposure to the elements.

A common theme of the articles was the urgent need to increase food production and that more women were needed in even greater numbers for this vital war work. With the start of the spring sowing season the March club page for 1918 announced, 'The most important subject which we have to discuss this month is the recruiting of new soldiers for our Land Army. We want 12,000 more recruits before the end of this month, and *we must have them*. Let us show the Government that we, being such happy members of this Army, are the very best people to persuade others to join us. Every girl who brings in five new recruits will wear in her hat a cockade of red and green ribbons, the colours of the Land Army badge, to show that she is a recruiting sergeant for our Army.' Owing to the German spring offensive in France the expected return of soldier labour did not happen and the demand for women's labour had risen to 30,000 by April 1918. 'Save the harvest! An urgent call to brave women' was the headline of the opening article in *The Landswoman*:

No soldier can now be spared from France. The harvest, which alone can save us from defeat, is in the hands of our women. To every able-bodied woman in England who is idle, or who is doing merely decorative work, or who she thinks she is serving her country by doing half a day's polite toil in a comfortable hospital... the call comes for sacrifice... the precious grain will wither on the stalk, and the straw will rot in the ground...

FACING PAGE
Kathleen Hale
Cover for The Landswoman

Edmund Dulac
The Sisters
(1917)
watercolour, 158 × 139 mm
IMPERIAL WAR MUSEUM

It is up to the women of England to show Germans that there is such stuff in this nation that not all the guile and cunning of their statesmen, not all the atrocities of their soldiers, and not all the ruthlessness of their Gothas and U-boats can hope to bring us to our knees. Thirty thousand women can save us.

The 7,000 WLA members now employed on the land were reminded that they were holding the thin line of the Home Front and that they had to do so until reinforcements could be brought up. In June the Prime Minister appealed to women to come forward for part or whole-time work, saying 'This is no ordinary harvest; in it is centred the hope and faith of our soldiers that their own heroic struggle will not be in vain.' By September there were 16,000 Land Army women at work, the highest number at any stage of the conflict and despite the wet and the influenza outbreak, 'Four-fifths, and more, of the largest harvest of modern times was saved in one of the worst seasons available, and in the face of labour difficulties…'[110] Land Girls, often parodied by artists and cartoonists in magazines and newspapers, were congratulated in *Punch* for their efforts. *Harvest Home* (page 48), 1918 was drawn by Frederick Townsend,[111] who in 1905 became *Punch's* first art editor and was reproduced by special permission in *The Landswoman* in November 1918. Leading home the happy band of harvesters, rather like the Pied Piper, is the Minister for Agriculture clad in smock, behind him dancing Land Girls carrying pitch forks, one of whom holds the hand of a school master. Also depicted are others who helped to save the harvest, including a soldier and Boy Scout, while in the background two horses pull a heavily laden hay cart.

HARVEST HOME, 1918.

WITH MR PUNCH'S JOYOUS CONGRATULATIONS TO THE MINISTER OF AGRICULTURE.

Frederick Townsend

Harvest Home

(1918)

from *Punch* reproduced in *The Landswoman*, November 1918

Rallies and speeches made by eminent figures at open-air meetings – sometimes upwards of eight or nine were held a day – were widely reported in the press and in *The Landswoman* and were one of the main means of recruitment. In the processions recruits would carry banners indicating the different branches of the WLA and others 'calling town lasses to come to the land'.[112] *The Landswoman* in April 1918 reported that 'The Great London Rally' held in Trafalgar Square led to 1,000 girls enrolling in the Land Army and the selling of nearly 5,000 magazines.

Another major rally was held in Woolwich in April to enlist women munition workers (or as they were nick-named 'Tommy's sisters'), who were no longer required in the Royal Arsenal. Twenty-five-thousand mainly working-class women were employed in munitions work in 1917.[113] It had been difficult to attract munitions workers to undertake land work, given the lucrative wages they received and their new-found independence. Edmund Dulac's painting *The Sisters* (page 46) portrays something of the variety of roles that women occupied in wartime. Three uniformed women holding hands are from left to right a Land Girl, nurse, and munitions worker. Of the three roles, nursing was considered to be the more acceptable and socially sanctioned profession for upper- and middle-class women.

The poster advertising the Woolwich recruiting rally contained stirring words by the author and journalist Harold Begbie,[114] who after farming moved to London and joined the *Daily Chronicle* and later the *Globe*. In '*Up, Ladies, Up!*' one of the recruiting poems he wrote, he exhorts women to respond to England's call and:

Come to the land and make it strong,
To keep our England free.

Up ladies: play a soldier's part,
On this sunstricken field,
That by the valour of your heart,
England may never yield.

Lord Goschen, head of the Labour Division of the Food Production Department, addressed a meeting 'thousands of extra acres had been added to the corn and wheat growing area, and the women of England must not allow that work to be wasted for lack of labour to bring in the harvest. This increase of home production was urgently needed in order that ships now used to import food might be liberated to bring reinforcements and munitions for the Army from America.'[115] In the same month appeals were made to women with agricultural experience to serve as 'village forewomen' to lead and arrange the work of gangs of women on the land during the coming season. Women who met the criteria had to enrol in the WLA for six months and be prepared to be sent wherever required in England and Wales; for their labours they were to receive a minimum of 25s. a week.

SEASONAL WORKERS
The Women's National Land Service Corps organised emergency gangs of untrained workers for seasonal work including harvesting, hop-picking and lifting potatoes. Workers had to supply their own blankets, mattresses and crockery. Newnham College for instance supplied relays of students to help on a small-holdings colony in Norfolk.[116] In late June 1916 an urgent request

Cover of the report of The Flax Harvest of 1918

was made in *The Times* for 400 women for fruit picking the following week, the work usually being paid at piece rates. It was pointed out that 100 women from the University of London were joining and other groups could be formed from colleges or businesses where the holidays were starting.

The WNLSC, in both its private capacity and from February 1917 as the appointed Agent for the Board of Agriculture, continued to supply mobile seasonal workers. In the autumn of 1917 the Corps was charged with recruiting educated girls between the ages of 18–20 for potato harvesting and late fruit picking and other kinds of temporary unskilled agricultural work in Berkshire, Herefordshire and other counties. The girls had to be strong and active as the work involved much ladder lifting and stooping. Of the workers sent out the previous year only 30 per cent were available – some had become permanent workers, a number of the university students were taking examinations and unable to volunteer, but the majority of workers had made private arrangements with the employers to whom the Corps had introduced them previously. In 1917 a total of 1,090 workers were sent out to 88 employers, the greatest demand being in June and July when 75 per cent of these were for workers for periods of six weeks or less.[117]

The WNLSC also supplied seasonal workers for the flax harvests of 1917 and 1918, the first small contingent of 200 being sent out in July 1917. In December the Corps was approached by the British Flax Growers' Association to provide 2,000 flax pullers for the next harvest and to organise them in fixed camps. Flax was a cultivated

Randolph Schwabe
Voluntary Land Workers in a Flax-Field, Podington, Northamptonshire
(1919)
oil on canvas, 1066 x 1524mm

RIGHT
Walking gangs, near Ilchester, Somerset 1918

FACING PAGE
*Students from Chelsea College of Physical Education
gathering flax and stooking, near Ilchester, Somerset 1918*

PHOTOGRAPHS FROM RUTH CLARK'S ALBUM 'FIRST WORLD WAR
C.C.P.E. HOLIDAY WORK IN A SOMERSET FLAX CAMP, 1918.'
ARCHIVES OF CHELSEA SCHOOL, UNIVERSITY OF BRIGHTON,
EASTBOURNE CAMPUS

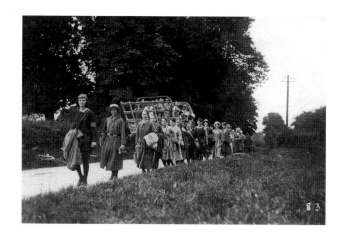

crop valuable for both the seed and the fibre. '18,000 tons was wanted for aeroplane cloth alone. Besides aeroplane wings it was needed for soldier's equipment, machine-gun belts, breech covers for guns, nosebags for horses, canvas covers for transport wagons and hospital cars, Army boots, harness and saddlery, tents and marques.'[118] The workers were well aware of the demand for aeroplanes, indeed, the camp song of the flax workers at Hinton St George in Somerset reproduced on the cover of the report of *The Flax Harvest of 1918* (page 50) proclaimed:

*We work from morn till night in sunshine, rain and dew,
We live on bread and cheese and Irish stew…*

*And all this because we knew
That Britain needed aeroplanes…*

*What matter if at night the canvas leaks?
What matter if we go about in breeks?
What matter if our backs ache as we pull flax,
When Britain's needing aeroplanes?*

The Board of Education sanctioned a scheme for recruiting from the Training Colleges for Teachers. In December 1917 an Association of University Land Workers had been formed as it was recognised that their practical help would be in great demand in the spring and summer. The Association used the Corps as its official channel to obtain work for its members. As few workers could stay for the whole six weeks, they were sent out in relays involving nearly four thousand individuals, including over 850 university women. Staff were also required to run the camps, 50 nurses gave up their fortnight's holiday to do duty in hospital tents, 81 head cooks and assistant cooks,

mostly from the Domestic Science Training Colleges, spent their holiday cooking in the camp kitchens and 137 Girl Guides did the light fatigue work in the camps. The Y.W.C.A. ran a canteen and supplied a recreation tent at each of the nine camps based in Somerset and the Peterborough district.[119]

The work was particularly arduous, and the 30 students who volunteered from Chelsea College of Physical Education would have been well suited to the task. Together with three members of staff, Misses May Fountain (booking clerk), Cicely Read (store keeper) and Ruth Clark (commandant) they were despatched to a camp in the Ivel valley, near Ilchester, Somerset where they stayed for between three to eight weeks, living under canvas.[120] Réveillé was sounded by trumpet at 6 a.m., with breakfast at 7 a.m., they worked eight hours a day and frequently longer pulling the flax. 'At 7.45 the gang leaders parade, and the commandant tells them of the flax fields to be worked. Five minutes later the gang leaders take their rolls. Each has fifteen girls under her. One member of each gang remains to act as orderly for the day, and by 8 o'clock all the workers are on the way to the flax fields, bearing their lunch with them.'[121] The students received a minimum wage of 7s. a week, but as they were on piece work they could make considerably more. The Chelsea students together with other workers succeeded in pulling 2,039 acres, and tying and stooking 2,102 acres in Somerset. The remaining acreage was dealt with by local labour, soldiers, prisoners and city workers.[122]

Randolph Schwabe's painting of *Voluntary Land Workers in a Flax-Field, Podington, Northamptonshire* shows women

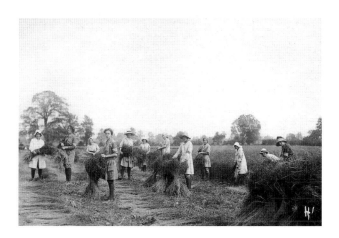

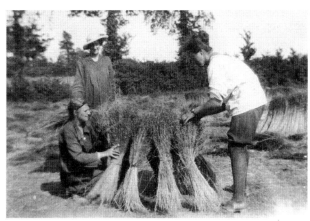

tying the flax plants in small sheaves by twisting a few stems round them just below the seed bolls while others stook them in much the same way as wheat. In the background is their camp of old army camouflaged bell tents supplied by the War Office in which seven girls would be accommodated for about two months, the women being under semi-military discipline. They were able to choose the most comfortable and practical working dress that appealed to them.

Schwabe also painted *Thatching Flax for Aeroplanes* (page 54), which depicts two of the workers perched on top of the rick on ladders, thatching. If the flax crop had not been harvested successfully, the output of aeroplanes would have been greatly restricted because of the lack of fabric to cover the wings.

The WNLSC also established a fixed camp for fortnightly holiday workers for fruit picking at Wisbech in June 1918. Two months later they sent out 500 workers to help pick raspberries in Scotland. The following year, with the war over, they withdrew the seasonal workers and by the end of September the number of permanent workers had dropped to 812. Recruiting and training ceased. Since their inauguration the Corps had placed 9,022 workers on the land. Latterly the majority were milkers and stockwomen, the demand for carters and ploughwomen having practically ceased with the return of the men.[123]

Boys from public and secondary schools helped with the summer harvests of 1917 and 1918. Farmers had unsuccessfully requested much earlier in the war

that they be released from school during term-time to help on farms.[124] Special camps were established to accommodate boys and masters; in all about 15,000 including Boy Scouts, lent a hand with the harvest of 1918 compared to 5,000 the previous year.

Corps of clergy and civil servants were also organised. Employers were asked to arrange the holidays of their staff so that relays of workers could be freed to help with the harvest. It was assumed that many would be motivated to give up their holidays to be gainfully employed serving the nation's interests. A reporter for the *Eastbourne Gazette* pointed out that 'The highest medical authorities have declared that a change of occupation is as beneficial mentally as a period of complete abstention.'[125]

OTHER SOURCES OF LABOUR

Prisoners of war were another important source of labour during the last two years of the war. Although initially farmers saw them as potential troublemakers and spies, gradually their objections were overcome. The stringent regulations that the military authorities had insisted on to avoid the risk of escape were relaxed and their surveillance left largely to local police. By the end of July 1917, 15 camps or depôts had been established and 1,476 prisoners employed on the land; the following June the number employed had increased markedly to 11,794 in 190 camps.[126] In autumn 1918 30,000 were gathering in the harvest.

Randolph Schwabe's painting, *The Women's Land Army and German Prisoners* (page 55), portrays German

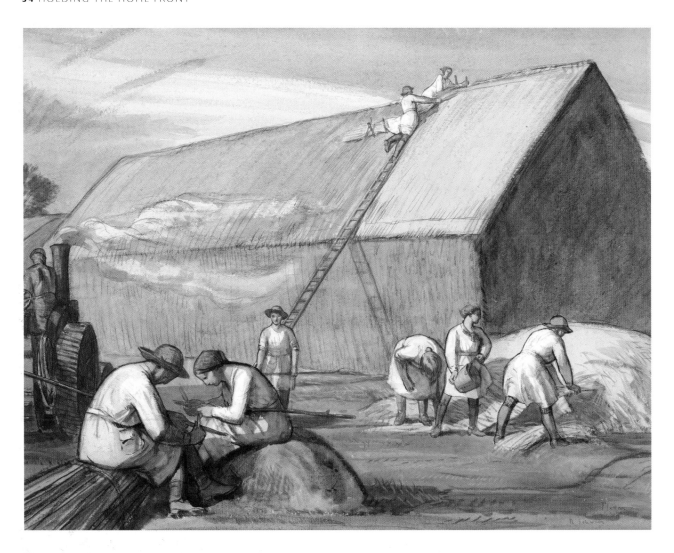

Randolph Schwabe
Thatching Flax for Aeroplanes
pen and watercolour, 444 x 577mm

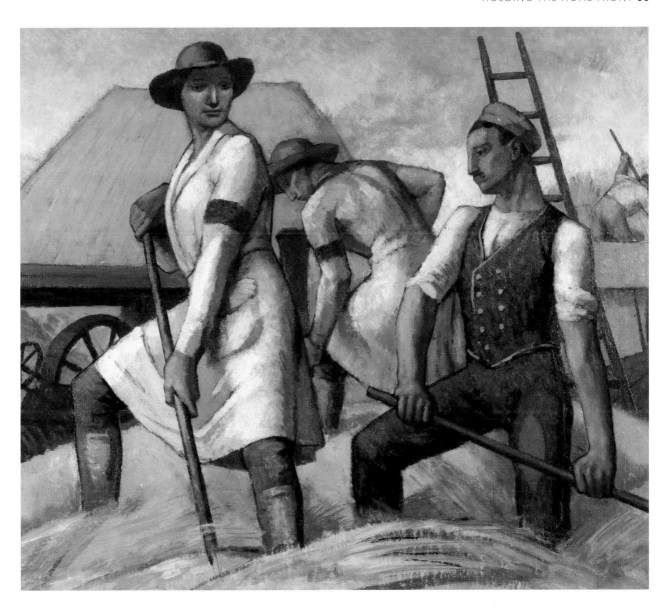

Randolph Schwabe
The Women's Land Army and German Prisoners
(1918)
oil on panel, 482 x 571 mm
IMPERIAL WAR MUSEUM

prisoners assisting with the harvest in the summer of 1918, probably at Church Farm, Podington.[127] The composition is noteworthy, particularly the close proximity of the Land Girl to the German soldier, as the Government had prohibited their use alongside Land Army women and the *L.A.A.S. Handbook* required recruits to promise 'To avoid communication of any sort with German prisoners.'[128]

Conscientious objectors were also employed on the land, but this met with little success, largely owing to the hostility of farmers and labourers. The numbers remained small, barely 200. Also not well received as supplementary labour were interned aliens or, as they were officially called, civilian prisoners of war. Even though the men selected for agricultural work were not German, public opposition remained, and the number employed was less than 2,000.[129]

RECREATION AND WELFARE

Land Girls had little opportunity for rest, and the authorities recognised that some form of recreation had to be started to relieve the tedium and isolation of their work. Village registrars were 'asked to be a friend both to the village women and still more to the woman who has left her home and is employed amid strange surrounds.'[130] The names and addresses of the village registrars were put up in post offices and land workers were encouraged to go to them for advice and information. Eighty welfare officers too were expected to befriend Land Girls, inspect their billets and training centres. Mrs Lyttelton appealed through *The Times* in autumn 1917 for a fuller social life for

Land Girls, and while acknowledging that country people in some districts were conservative and others social and friendly she thought more could be done at little trouble or cost to themselves. Those with country houses, she suggested, might offer a sitting room with possibly a piano even if only for one day a week. The following year a Club Room opened at the London office of *The Landswoman* where Land Girls in uniform could on a Sunday afternoon go and talk, read and sing songs. It was suggested that some of the West Kent girls might come on their bicycles. The intention was that Sunday Guilds would start up all over England and Wales. Those unable to make the journey from isolated farms or billets to a club were encouraged to become members of the National Home Reading Union where they could follow instructive courses on diverse topics such as 'English Agriculture and Rural Life' or the 'Home Life of our Allies'. The Challenge Library supplied parcels of books wherever a welfare officer could find a suitable librarian. By April 1918 some 40 such centres had been established. Welfare officers also started swimming clubs for those Land Girls who were near enough to the towns.

Clubs of various kinds became a feature of the later stages of the conflict for women on war work,[131] including rest clubs for landswomen where girls could get dry clothing and refreshments. The club at the WFGU and the WNLSC had a few bedrooms for country members and was designed to meet a 'widely-felt and increasing need for the educated women in rural districts, whose affairs call then occasionally to London.'[132]

Helen Bentwich, WLA Welfare Officer, near Tring, July 1917
from H. Bentwich (1973) *If I Forget Thee. Some Chapters of Autobiography 1912–1920*
LONDON: PAUL ELEK BOOKS

Helen Bentwich became a welfare officer in Hertfordshire in June 1918 which meant she no longer had to collect gangs, but rather had to visit Land Girls in their billets in the evening; this she did by motor-bike. She helped organise their spare time with concerts, plays and clubs where there were sufficient numbers to do so. Bentwich described how on August Bank Holiday thirty wounded soldiers were invited to tea in a local hall and to listen to 'a concert from a quartette', but she noted that the girls found it dull as it wasn't the sort of music they were used to. In her autobiography she pointed out that welfare officers had a difficult task settling any disputes the Land Girls had with farmers. She also recalled attending a gathering of welfare officers in London where Meriel Talbot impressed upon them the necessity of wearing their uniform as an example to the girls.

CLOSING DAYS AND DEMOBILISATION

Following the Armistice of 11 November 1918, women started leaving the Land Army. Every Land Army Agricultural Section worker in England and Wales was sent a letter from Meriel Talbot, in her capacity as Director of the Women's Branch of the Food Production Department:

> *DEAR LANDWORKER*
>
> *Now that the fighting has come to an end you will be wanting to know what is the position of the Land Army.*
>
> *Nothing certain can yet be said about the future, but one thing is certain, the whole world is very short of food, and everything must be done to produce as much as possible. Your country still needs your help...*

In May 1919 *The Landswoman* published a further letter from Meriel Talbot:

> *I want all volunteers in the LA to know that their work is of as much value now as it ever has been... When the Armistice was signed, and we all rejoiced at the great change from war to peace, many of you thought your work on the land was over... but I want to show that it is not so really at all. Many of the men who used to do farm work have given their lives for their country, or have become disabled in the service. Others are still wanted for the Armies of Occupation. So there is a serious shortage of labour, and that at a time of year when the work must be done if the crops are to be secured, and the necessary food supplied both for man and beast...*
>
> *You came out to help your country... Go on giving your best – it is of real value, and is greatly needed. I hope, then, that those of you who have reached the end of your term of service will enrol for a further period.*

Three months later *The Landswoman* announced that the Board of Agriculture had decided that the same advantages should be given to the ex-Land Girl as to the ex-soldier or sailor, both by way of providing land and cottages and in making loans of capital where necessary for stocking and equipment and also free passage to the Dominions if desired. The Bill was presently before the House of Commons and until it had been passed details of the Land Settlement could not be finally decided upon.

By October 1919 only 8,000 members of the WLA remained. Meriel Talbot wrote to them on 14 October to explain that the Government had decided that the WLA should be disbanded on 30 November. She explained:

Now that so many men have returned from the Army it would no longer be right to spend public money on the equipping and transport of the Land Army, which, in time of war was a necessity...

You have shown that for many farming operations women have a special aptitude; and you have helped to remove for all time that mistaken idea that farm work requires less intelligence than other forms of employment.

She also gave details of plans to establish in January 1920 a National Landworkers' Association to carry on the tradition and comradeship of the Women's Land Army.[133]

The Landswoman in December 1919 included Christmas greetings to the Land Army from The President of the Board of Agriculture and Fisheries and The Rt. Hon. Lord Ernle. The President expressed his heartfelt thanks for the invaluable service and self-sacrifice members of the Land Army had rendered to agriculture and to the nation as a whole. Ernle in his farewell address commented:

The Land Army may be justly proud of its record of service. It has proved its grit. At first the Army had to fight against a mass of prejudices. It conquered those prejudices by sheer hard work, stuck to in difficult conditions and circumstances. Through all its campaigns it has had to endure much fatigue, many discomforts and hardships, and not a few privations...

... farmers could not have got on without the Land Army. In that fuller sense the nation says the same, and with real gratitude. It will not soon forget that, when every pound of food and every pair of capable hands were urgently needed, the women of the Land Army worked early and late, for meagre wages, at tasks which were often monotonous and physically exhausting.

Meriel Talbot sent a further message about the disbanding of 'our dear Land Army':

We shall all certainly miss the companionship... the happiness of service in a common cause and as a corporate body...

But while we are sad at the break up of the Land Army we are grateful, deeply grateful for the opportunity for service ... and for the door opened to women to take their place in the agricultural life of the country.

By your work, your loyalty to your teachers, your employers, you have shown what women can do and be in the most important of our national industries.

While the loyalty of members of the Women's Land Army had at times during the war been sorely tested – and in spite of scant reward for their labours – they had shown what women could do, often under appalling conditions. Working on the land led to new experiences, albeit mediated by their class, income and age and for many temporary.[134] Most Land Girls returned after the war to their previous duties in the private, domestic sphere. Nonetheless, the more public and visible presence of Land Girls had challenged images of womanhood and assumptions about women's physical capabilities and the suitability of certain farming tasks for them.

1 Rew, R.H. (1915) 'Farming and food supplies in time of war', *Journal of the Board of Agriculture (JBA)*, September, pp.504-20.

2 Middleton, T.H. (1923) *Food production in war*, p.2.

3 Montgomery, J.K. (1922) *The maintenance of the agricultural labour supply in England and Wales during the war*, p.22.

4 *Report of the Land Work of The Women's Defence Relief Corps during 1916*. IWM (Imperial War Museum) LAND 4/6, p.1.

5 Ibid., p.1.

6 Ouditt, S. (1994) *Fighting forces, writing women: identity and ideology in the First World War*, p.223.

7 *A free holiday*, Women's Defence Relief Corps. IWM LAND 4/5.

8 Dakers, C. (1987) *The countryside at war 1914-18*, p.137.

9 Horn, P. (1984) *Rural life in England in the First World War and after*, p.118.

10 Tooley, S. (c.1914/16) *Training women for the land. Work of the Land Council of the National Political League*, IWM, LAND 3/1, p.329. The National Political League was founded in 1911 by Miss Mary Adelaide Broadhurst (1857/8-1928) and organised in conjunction with Miss Margaret Milne Farquharson, respectively the President and Secretary of the League. See also *The Oxford Dictionary of National Biography* (ODNB) entry for Broadhurst by John Martin.

11 Horn (1984) op. cit., p.118.

12 Tooley (c.1914/16) op. cit., p.337. Four hundred women received training for a short period of time. The *Eastbourne Gazette* in May 1916 contained a letter seeking educated women and girls (fifty or more) to join a party to go fruit picking for a few weeks in Worcestershire under the auspices of the NPL Land Council. The party was described as offering the participants the opportunity to help the nation and a chance to try the simple life in tents or barns.

13 Horn (1984) op. cit., pp.118–119.

14 Renamed after the war the Women's Farm and Garden Association.

15 Rowland Edmund Prothero (1851–1937) resigned in 1919.

16 *The Times*, 7 July 1915, p.6, col. B.

17 Edward Strutt (1854–1930) 'played a key role in determining the government's agricultural policy... and became influential in framing the Corn Production Act of 1917, which compelled farmers to plough up grassland.' (Strutt, *ODNB* entry by J. Martin). The other farm 'lent' was Ringer's Farm which was opened as a Training Centre in April 1916 with Miss Crick as Superintendent.

18 Dewey, P.E. (1989) *British agriculture in the First World War*, p.52.

19 On 23 June the Secretary for Scotland appointed a committee with the same terms of reference, five days later this same reference was given to an Irish committee (see Middleton, 1923, op.cit.).

20 (Lord) Ernle (1925) *The land and its peoples: chapters in rural life and history*, p.108. Ernle is not specific re the counties and/or the numbers, commenting simply that WACs 'had been set up in most of the Counties' (p.108).

21 MacQueen, M.M. (1918) 'The training of women on the land', *JBA*, October, p.810.

22 Courtney, J.E. (1933) *Countrywomen in council. The English and Scottish Women's Institutes with chapters on the movement in the Dominions and on Townswomen's Guilds*, p.42. Later women landworkers were allowed to buy some of the WLA uniform at cost price. These moves led to a trebling of the number of women part-time workers.

23 Ernle (1925) op. cit., p.174.

24 Ernle (1925) op. cit., p.129.

25 Anon (1916) 'Successful employment of women on farms', *JBA*, January, pp.1006–7.

26 Lloyd George, D. (1938) *War memoirs of David Lloyd George*, vol. 1, p.772.

27 Women's National Land Service Corps. *Interim Report from the formation of the Corps, in February, 1916, to September 30th, 1916*. Northamptonshire Record Office, YZ 9619/b. Mrs Louisa Wilkins (née Jebb) (1873–1929) wrote in the *JBA* as Mrs Rowland Wilkins.

28 Women's National Land Service Corps. (1916) ibid., p.7.

29 Montgomery (1922) op. cit.

30 Women's National Land Service Corps. (1916) op. cit., p.9 & p.11.

31 Women's National Land Service Corps. (1916) op. cit., p.14.

32 *The Times*, 'Women on farms', 22 August 1916, p.13, col. G.

33 Women's National Land Service Corps. (1916) op. cit., p.19.

34 Orwin, C.S. (1949) *A history of English farming*, p.82.

35 Dewey (1989) op. cit., p.98. Although the rationale behind the 'plough policy' was successful and the policy's legacy important in terms of the Second World War, the success of the food policy remains open to debate. See also Dewey (1991) 'Production problems in British agriculture 1914–18', in Holderness, B.A. and Turner, M. (eds.) *Land, labour, and agriculture 1700–1920*.

36 The War Cabinet (1918) *Report for the year 1917*, p.23.

37 Dewey (1991) op. cit., p.242.

38 See Horn (1984) and King, P. (1999) *Women rule the plot: the story of the 100 year fight to establish women's place in farm and garden*.

39 Ernle, Lord (1920) 'The Women's Land Army', *Nineteenth Century and After*.

40 Meriel Lucy Talbot (1866-1956) was appointed OBE in 1917, CBE in 1918, and in 1920 DBE.

41 Huxley, G. (1961) *Lady Denman, G.B.E. 1884–1954*, p.71 & p.75.

42 May Tennant, Director of Women's Section, National Service Department letter to Mr Chairman, 27 March 1917 Hampshire Record Office, W/C1/5/594.

43 *The Times*, 'Great demand for milkers', 7 April 1917, p. 3, col. E.

44 May Tennant (1917) op. cit.

45 *WNLSC Final Report, September 30th, 1918 to November, 1919*. IWM,

LAND 5.1/6, p.9.

46 Yvonne Gwynne-Jones (1896–1980) was a pupil at Bedales from 1908–10, she married the artist Innes Meo (1886–1967) on 3 March 1919 after he was repatriated from a POW Officers' camp at Pforzheim. He had known the family for some years, and trained at the Slade and then spent several years travelling in Italy, France and Switzerland. He joined the Artists' Rifles in 1916. Gigi, as he was affectionately known, was Head of Painting and Drawing at Bedales from 1923–40 having been recommended by Allan Gwynne-Jones for the position. I am grateful to Ann Innes Meo (b.1920), herself a pupil at Bedales, for sharing her recollections of her parents with me.

47 Allan Gwynne-Jones (1892–1982) attended Bedales from 1902–09 where he learnt book binding, calligraphy and illuminations. His friendship with the artist Randolph Schwabe dated from before the war. In 1914 Gwynne-Jones joined the Army serving in the 3rd East Surrey Regiment, then as 2nd Lt. 1st Cheshire Regiment winning the D.S.O. in the Battle of the Somme and transferred to the Welsh Guards in 1917. He attended the Slade and was from 1923–30 Professor of Painting at the Royal College of Art and later taught at the Slade from 1930–59.

48 Yvonne Gwynne-Jones, 'Gang-Leaders wanted', *The Bedales Record*, 1917–18, p.50.

49 Recruiting leaflet, IWM, LAND 6/14.

50 The Forage Department (Women's Land Army) IWM, ARMY 2/27.

51 Twinch, C. (1990) *Women on the land: their story during two World Wars*, p.21.

52 Twinch (1990) ibid., p.21.

53 Wiles, G. (1918) 'Life on a hay bailer', *The Landswoman*, April, p.88.

54 The photographer Horace Nicholls (1867-1941) had documented the Boer War 'and wanted to be a war photographer at the front but was not accepted… From [June] 1917 he was an official photographer of the Department (later Ministry) of Information, taking photographs of the "home front" for "propagandist purposes" in the United States and elsewhere; some were supplied to the British press' (Nicholls, ODNB entry by R.T. Stearn). The IWM holds over 2000 examples of his work.

55 The Forage Department, op. cit.

56 I am grateful to John Martin for bringing the significance of this to my attention. See also Jilly Cooper (2000) *Animals in War* and Juliet Gardiner (2006) *The animals' war. Animals in wartime from the First World War to the present day*.

57 *The Times*, 'Women's Forage Corps', 4 November 1918, p.5, col. B.

58 *The Times*, 'Women's Forage Corps Disband', 31 December 1919, p.7, col. E.

59 *The Times*, 'Women Foresters', 31 January 1918, p.9, col. E.

60 See 'Timber work and the Land Army', *The Landswoman*, February 1918,

pp. 25–6.

61 Stapledon, D.W. (1939) Recollections of the Land Army, *Home and Country*, July, p.249.

62 The War Cabinet (1918) op. cit., p.138.

63 *The Times*, 'Women Foresters', 31 January 1918, p.9, col. E.

64 Minnie Sherriff Mott (1918) 'Impressions of a women timber measurers' camp', *The Lady*, 21 February p.155. Lloyd George (1938) op. cit., p.754, quotes from an extract from a Report of the Timber Supply Department which records that by October 1918 there were 1,740 Portuguese, 3,035 POWs, 2,323 women fellers and measurers, 7,518 men from the Canadian Forestry Corps, and 427 men from the Newfoundland Forestry Corps.

65 *The Times* (1918) op. cit., p.9.

66 Imperial War Museum (1963) *A concise catalogue of paintings, drawings and sculpture of the First World War 1914-1918*, p.306

67 Horn (1984) points out that by early September 1916 'Over six hundred [Germans] were employed at camps in England and Wales on timber cutting' (p.144).

68 Wonders, W. (1991) *The 'Sawdust Fusiliers'. The Canadian Forestry Corps in the Scottish Highlands in World War Two*, p.1.

69 Imperial War Museum (1963) op. cit., p.306.

70 Imperial War Museum (1963) op. cit., p.306.

71 Letter from R.H.S. Butterworth, Director, National Service Department. Hampshire Record Office W/C1/5/594.

72 *The Times*, '1,000 training centres organized', 22 March 1917, p.9, col. C.

73 *How the National Service Recruit is Selected, Trained and Placed*, Northamptonshire Record Office, YZ 9619.

74 Talbot, M. (1918) 'Women in agriculture during wartime', *JBA*, October, pp.796–805.

75 Survey cited in Andrews, I.O. and Hobbs, M.A. (1921) *Economic effects of the World War upon women and children in Great Britain*, p.85.

76 *The Times*, 26 March, 1917, p.9, col. G.

77 MacQueen, M.M. (1918) 'The training of women on the land', *JBA*, October, 7, p.814.

78 MacQueen (1918) ibid., see pp.810–17.

79 Kathleen Hale (1898–2000) ODNB entry by Peter Barker.

80 Meriel Talbot, Letter to Organising Secretaries, Travelling Inspectors, Honorary Secretaries, 4 February 1918. IWM, LAND 6/78. Skins fetched 2s. 6d at the beginning of the season in 1920 and later 1s. 3d. See 'Our club page', *The Landswoman*, July, 1920, p.164.

81 Middleton (1923) op. cit., p.225.

82 See Clarke, B. (1918) 'British agriculture on a war footing' in Wilson, H.W. and Hammerton, J.A. (eds.) *The Great War. The illustrated history of the First World War*, vol. 10, p.98, Lloyd George (1938) op. cit.,

pp.774-5, and the *War Cabinet report for the year 1917*, pp.161-2.

83 Ernle (1920) op. cit., p.8.

84 *The Times, History of the War*, p.450.

85 Montgomery (1922) op. cit., p.60.

86 *The Times*, 'A plucky Land Girl', 4 January 1919, p.8, col. G.

87 Montgomery (1922) op. cit., p.60.

88 Ernle (1925) op. cit., p.189.

89 *Building News*, 29 August, 1917, IWM, Women's Work Collection, SUPP. 40/47.

90 Grayzel, S.R. (1999) 'Nostalgia, gender, and the countryside: placing the "Land Girl" in First World War Britain', *Rural History*, 10, 2, p.159.

91 Hampshire Record Office, W/C1/5/594.

92 Arthur Collins, Secretary, National Service Committee, circular letter to Committees, 5 July 1917. Hampshire Record Office, W/C1/5/594.

93 *The Times*, 'Women on the land. Need of a fuller life', 19 September 1917, p.9, col. F.

94 Middleton (1923) explains that the large increase in Ireland was due to the Compulsory Tillage Order (p.190).

95 Middleton (1923) op. cit., p.191.

96 Helen Caroline Bentwich (1892-1972) ODNB entry by H.L. Rubinstein. Post-war, Bentwich became a well known local politician.

97 Bentwich, H. (1973) *If I forget thee. Some chapters of autobiography 1912–1920*, pp.133–4.

98 Information from Anne Meo, December 2007.

99 Ruck, B. (1919) *A Land Girl's Love Story*, p.151. Berta Ruck (1878–1978).

100 Anon (1919) 'The Land-Girl's Love Story', *Times Literary Supplement*, 13 March, p.138.

101 Peel, C.S. (1929) *How we lived then, 1914:1918: a sketch of social and domestic life during the War*, p.112.

102 Bentwich (1973) op. cit., p.117.

103 Dakers (1987) op. cit., p.150.

104 Olivier, E. (1938) *Without knowing Mr. Walkley, personal memories*, p.214. Edith Olivier (1872-1948).

105 Talbot, M. (1918) cited in Meriel Lucy Talbot, *ODNB* entry by John Martin.

106 *The Landswoman* was edited in Blackheath, London, the price was increased to 3d. in May 1918 due to the rising costs of paper and printing.

107 Ernle (1925) op. cit., p.186.

108 The Editor (1918) 'Our club page', *The Landswoman*, January, p.16

109 Watson, J. S. K. (2007) *Fighting different wars, experience, memory and the First World War*, p.121.

110 Middleton (1923) op. cit., p.239.

111 Frederick Townsend (1868–1920).

112 *The Times*, 'Land Girls inspected by the Queen. Picturesque scene in London', 20 March 1918, p.9, col. E.

113 Cited in Braybon, G. (1981) *Women workers in the First World War: the British experience*, p.46. See also Braybon, G. (1995) 'Women and the war' in Constantine, S., Kirby M.W. and Rose, M.B. (eds.) *The First World War in British History*.

114 Harold Begbie (1871–1929).

115 *The Times*, 'Munition girls for the land', 8 April 1918, p.5, col. E.

116 *The Times*, 'Women at men's tasks', 2 June 1916, p.5, col. E.

117 *Report of the WNLSC on the organisation of seasonal workers*, IWM, LAND 5.4/48.

118 *The flax harvest of 1918. A report of war work done by 3,835 holiday workers from the Universities and Training Colleges through the WNLSC*, Archives of Chelsea School, University of Brighton, Eastbourne Campus.

119 Ibid. (1918) pp.6–7.

120 Webb, I. M. (1999) *The challenge of change in physical education: Chelsea College of Physical Education – Chelsea School, University of Brighton 1898–1998*, p.38.

121 *Daily Express*, 'A flax-field holiday', 24 August 1918. Archives of Chelsea School, University of Brighton, Eastbourne Campus.

122 *The flax harvest of 1918*. op. cit., p.7.

123 *WNLSC Final report*, September 30th to November, 1919, IWM, LAND 5.1/6.

124 See Dewey (1989) op. cit., p.35.

125 Anon (1917) 'Holiday harvesters', *Eastbourne Gazette*, 1 August.

126 Ernle (1925) op. cit., p.127.

127 I am grateful to Mrs Ann Cooper and her mother Mrs Phyllis Wyatt (née Wykes) for information about the harvesting of flax at Podington and Church Farm in particular.

128 Horn (1984) op. cit., p.148.

129 While these additional sources of labour, both seasonal and 'other' contributed to agricultural work the importance of the contribution of members of the Women's Land Army should not be underestimated. Land Girls were a permanent source of trained labour that could undertake skilled work and be moved if required by the Board of Agriculture to any district. Further, they were not allowed to leave their employment without the consent of the Women's War Agricultural Committee.

130 Sturmey, H. (1918) 'Women in Great Britain's trying hours saved day on the farms', *Chilton Tractor Journal*, 1 December, p.41.

131 *The Times History of the War* (1918), chapter CCLXI 'Women's work' (III): 'War services', p.451.

132 *The Times*, 'Women Land Workers' Club', 31 January, p.9, col. C.

133 The Association disbanded in 1922.

134 Braybon (1995) op. cit., p.167.

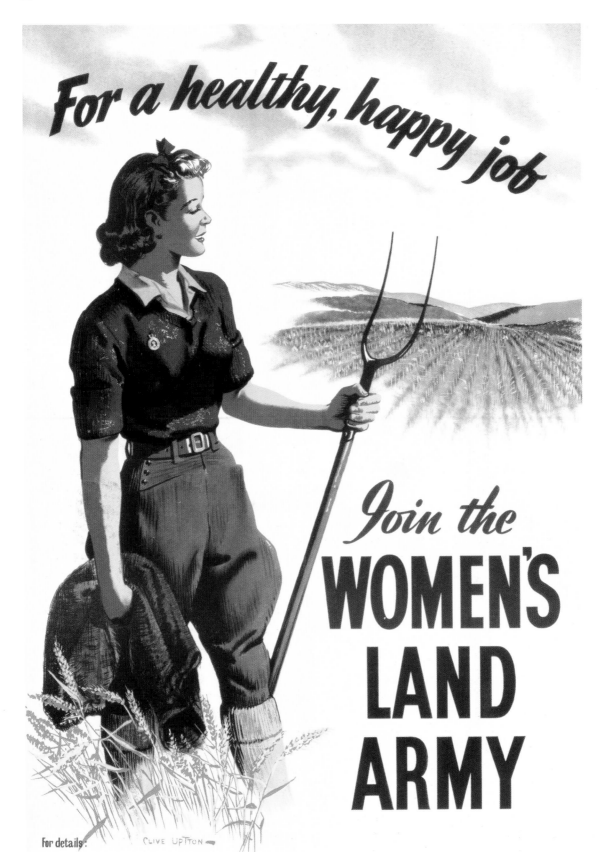

For a healthy, happy job

Join the
**WOMEN'S
LAND
ARMY**

for details:

APPLY TO NEAREST W.L.A. COUNTY OFFICE OR TO W.L.A. HEADQUARTERS 6 CHESHAM ~~PLACE~~ LONDON S.W.1
STREET

Issued by the Ministry of Agriculture and the Ministry of Labour and National Service

BACK TO THE LAND
THE WOMEN'S LAND ARMY IN THE SECOND WORLD WAR

REFORMING THE WOMEN'S LAND ARMY: AN OVERVIEW

By spring 1938 the prospect of war was becoming increasingly real, and the question of the supply of farm labour in England and Wales was discussed at a special meeting on 9 April convened by the Permanent Secretary of the Ministry of Agriculture. The only decision reached, although a significant one, was to establish a Women's Branch of the Ministry and to invite Lady Denman to take charge of it.[1] Given her previous experience as Honorary Assistant Director of the Women's Branch, responsible in 1917 for the newly formed Women's Institute Section[2] and her role in recruiting for the Women's Land Army (WLA), she was well qualified to do so. These experiences were to prove invaluable as Lady Denman began to develop a skeleton organization for a future Women's Land Army. The plans were top-secret and on 14 May she wrote in confidence to the women she had selected from Institute lists to be chairmen of each county committee. That autumn following the Munich crisis when Neville Chamberlain returned from meeting Hitler, she asked them to form 'their Committees against possible emergencies.'[3] Meanwhile a Land Service Scheme had also been organised by the Women's Farm and Garden Association: 500 women took short training courses at their own expense in their spare time or holidays, in agriculture, dairying or horticulture on approved farms and market gardens. This Scheme was subsequently incorporated into the wartime Land Army.[4] Barely six weeks after the Government handbook on National Service had been delivered to all households setting out the openings for voluntary service in the event of war,

over 4,700 women had applied to enrol in the WLA, many of whom had served in the First World War.[5]

On 15 April *The Times* reported that it had been decided to form a Women's Land Army, 'the members of which would be ready to take up farm work as a full time occupation in time of war.' Further, it was pointed out that should there be a war, the new organisation would be similar to that established in the Great War. At this stage potential recruits were asked simply to complete the enrolment form in the National Service handbook. The intention was not to recruit the thousands of women and girls already working on the land; what was being sought was a new mobile labour force willing to be trained to undertake all kinds of farm work in any part of the country. Thousands of women responded and eleven days later an article in *The Times* captioned 'Eager Recruits' noted that there was a nucleus of women accustomed to working and to the discipline work entails, who would be easier to organize than those a quarter of a century ago.

Preliminary steps were taken by the Government to prepare for an expansion of domestic food production based on policies instigated in the First World War. These included a financial incentive to farmers if they ploughed up worn-out grassland in the summer, and brought it into a proper state of cleanliness and fertility by reseeding, or by fallowing or sowing to an approved crop with a view to reseeding. The Government would contribute £2 an acre to the cost of rejuvenation.[6]

On 1 June 1939 the Women's Land Army, a civilian organisation entirely staffed and run by women,

Balcombe Place
COLLECTION OF EDNA STEPHENSON

as in the First World War, was officially re-formed. Mrs Inez Jenkins[7] was appointed as Assistant Director at a salary of £600 a year. She was well known to Denman in her capacity as General Secretary of the National Federation of Women's Institutes. Secretaries on salaries up to £250 per annum were appointed to the 52 county committees which comprised a maximum of eight voluntary members. These members 'had practical knowledge of local farming conditions and of the county generally', the chairmen by virtue of their position were automatically members of the County War Agricultural Executive Committee.[8] The duties of the secretary 'were particularly onerous and included interviewing volunteers, arranging their training and work placements, organizing the interviewing of farmers by committee members, inspecting farms, ensuring government regulations were adhered to, organising welfare provision, distributing uniforms, corresponding with recruits and WLA headquarters, arranging recruiting campaigns and publicity and conducting committee meetings.'[9] These county committees were to advise and assist headquarters and the secretary on questions of local administration and policy and the carrying out of Land Army regulations.[10] Seven regional officers (for England and Wales) were placed in charge of groups of counties. Their job was to liaise between head-quarters and the counties. Later, district representatives were appointed. They were given the right to wear the Land Army badge and armlet, and were responsible for the general welfare of the Land Girls in their area, visiting them once a month and reporting back on working and billeting arrangements. In essence they were to act as 'the Land Girl's friend.'[11]

A conference was organised in London in June 1939 for the newly-appointed county chairmen, all of whom were unpaid volunteers mostly from 'the landed classes'. The delegates included Lady Hermione Cobbold, chairman for Buckinghamshire; Her Grace The Duchess of Devonshire for Derbyshire; The Countess Fortescue for Devonshire; Lady Baring for the Isle of Wight; Dowager Lady Suffield for Norfolk; The Countess Spencer for Northamptonshire and The Hon. Mrs. Methuen for Wiltshire. These appointments and others 'provoked criticism from Labour Members of Parliament that the administration of the Land Army was "too county". Lady Denman robustly defended her choices, pointing out… that if her Chairmen were to be taken seriously they had to be figures whom the farmers respected.'[12] Following the conference, 'arrangements were made to start the interviewing and formal enrolment of [WLA] members, and to send as many as possible for short term holiday training on farms.'[13] By 8 June 8,000 women had enrolled, although a further 42,000 were sought.[14] Two months later enrolments had risen by 1,000 and another 5,000 volunteers were in the throes of being interviewed by the county committees. In addition, many hundreds of women had spent, or were spending, their holidays on farms as a preparation for training and more than 400 women had received training in tractor-driving at farm institutes.[15]

On 29 August 1939 the administrative headquarters of the new Women's Land Army was established at Balcombe Place, Lady Denman's 3,000-acre country estate in Sussex. 'There were fourteen officers and thirty five clerks and typists, mostly from the Ministry of Agriculture in London.'[16] One of those from the

Typists at Balcombe Place
COLLECTION OF EDNA STEPHENSON

Ministry was Edna Stephenson who recalled living in the house with Lady Denman and being treated like a guest. 'We ate with her in the dining room and were waited on by footmen and the butler. She was a gracious lady and we were all asked in turn to sit at her table for meals. Six of us slept in her best guest room which was very spacious. She had removed all her precious furniture and we were provided with single beds. We worked in the hall and various other rooms and the gun-room was used for despatching WLA badges. We relaxed in the music room and had country dancing there. In winter when the lake froze we skated and Lady Denman lent me her skating boots!'[17]

Five days after the Land Army staff had left London war was declared. By then 1,000 trained volunteers had been placed in immediate employment, many on the farms where they had received their instruction.[18] However, by the end of December only 4,484 women were in employment and latent criticism of the failure to absorb the women onto the land became increasingly vocal. The initial opposition and prejudice of farmers to employing members of the WLA, whom they believed would not be of any real help with land work, coupled with the fact that the outbreak of war came just a month or two before the onset of winter (the slackest season of the farming year) and the anticipated aerial bombing of urban centres did not materialise, exacerbated the employment situation.[19] Thus, 'many [women] had to join the queues at the employment exchange; some had relinquished good jobs to render national service, others had hoped for employment after weary months of disappointment.'[20]

Lady Denman admitted that 'no one foresaw that the blackout and the shortage of petrol would throw out of work men like mechanical garage hands who found employment on the land as tractor drivers'.[21]

By contrast, the mobilisation and utilisation of other sources of labour was treated more sympathetically by the farming community and wartime officials. 'Concessions were… made by the Services. Soldiers were made available for the harvest; [as were] a small number of "key men"… from the Territorial Army upon recommendation by the Ministry of Agriculture; temporary releases for up to two months were sanctioned.'[22] Regulating the supply and demand for labour in agriculture with its fluctuating seasonal variations and the difficulty of extracting from farmers their labour requirements was to remain a problem throughout the war.[23]

The winter of 1939–40 was one of the hardest in living memory, with freezing rain in February which resulted in 'severe ice formation on trees, fences and grass'.[24] Edith Barford (née Downes),[25] who had joined the Land Army aged 18 in July 1939, recalled the heavy snow and drifting in early 1940, and how 'for about a month no traffic came through the village. The water supply was frozen and my last job at night was to go about 50 yards to the village pump to prop up the handle – so that the pump did not freeze in the morning.' Those Land Girls who, like Edith, stoically worked through such harsh conditions, 'laid the foundations for the Land Army's reputation. The majority were employed singly on farms either as milkers or general farm workers.'[26] By April 1940

there were 6,000 Land Girls in employment, at which stage the largest employers according to the employment returns from 29 English Counties were Hampshire with 307 Land Girls, Kent 222 and West Suffolk 187; the figures for East and West Sussex when combined amounted to 297.[27] By the following year the total had more than doubled to 13,000.[28] Thereafter expansion continued both in numbers and in the range of the work undertaken.

To meet the increasing demand for more seasonal labour a Women's Land Army Auxiliary Force was established to provide short-term land service in the spring and summer.[29] Details of this Auxiliary Force were advertised in the Women's Institute journal *Home and Country* in May 1940.[30] Farmers had ploughed their land, sown the seed, and would now require extra hands to plant potatoes, hoe fields, harvest, pick fruit and make hay. Volunteers need not be skilled workers, the only requirements being that they were aged over 18 and could enrol for four weeks or more in the coming months, for which they would receive a minimum wage of 28s. a week. From this they would have to pay for their board which might be in empty houses, billets with local families or a camp. The work might be physically demanding, but they would be giving a most vital and urgently needed form of national service. Volunteers were asked to enroll either through the WLA committee in their county or by contacting Lady Denman, at Balcombe Place, Haywards Heath.

On 4 December 1941, Britain became the first country to conscript women. This initially involved unmarried women between the ages of 20-30 and was part of a series of initiatives announced by Winston Churchill to combat the critical labour shortage which affected virtually all sections of the economy. It had become apparent 'that nothing short of the total mobilisation of the womanpower of the country would avail, if victory were to be ultimately won. This could not be left to patriotic volunteering… and this could only be if control were firmly exercised by the Government.'[31]

The mobilisation of women also encompassed the Women's Timber Corps (WTC), a sub-branch of the WLA, which was established in April 1942 with its own officers and distinctive brown bakelite badge with fir tree instead of a wheatsheaf surmounted by the royal crown and green beret. The WTC was the responsibility of the Home Timber Production Department, Ministry of Supply (unlike the WLA which was the responsibility of the Ministry of Agriculture and Fisheries). A Chief Officer for the Corps, Irene Stevenson was appointed, with two deputies. In Scotland[32] Miss E. McConnel was responsible for five Divisions and Miss M. Hoskyn, who was stationed in Bristol, oversaw the running of 11 Divisions in England and Wales. Thirteen special welfare officers were also appointed to cover the various divisions. Italian and German prisoners of war were also assigned to forestry work and workers were recruited from several Commonwealth countries, and as in the First World War, Canadians and Newfoundlanders were employed together with foresters from Australia and New Zealand.

'Women had proved their usefulness in timber production during the last war,'[33] and by the end of July 1943 when recruitment was closed over 6,000

girls (1,500 of whom were working in Scotland) were employed in the Timber Corps felling trees, working in sawmills or travelling all over the country often in remote parts on their own, armed with pots of paint to select and mark suitable trees for felling and specifically those that might be used for telegraph poles. Sometimes mistaken for spies, the work of these Lumber-Jills or pole-cats as they were irreverently known, significantly increased Britain's supply of domestic timber.[34] Irene Stevenson wrote to Timber Corps members via *The Land Girl* magazine in February 1943 and pointed out that 'before the war, we imported more than 90 per cent of the timber we use, and now we have cut this down to less than 30 per cent. And we are going to reduce it still further.' She also reminded them, when they were feeling despondent and depressed, that like their menfolk and their girl friends in the Services they were serving their Country. She said 'Whatever the task… it has a bearing upon the successful prosecution of the war. We are part of a soil phalanx against the common enemy of civilisation and we dare not falter.'

The artist Ethel Gabain made the long train journey from London in 1941 to capture the varied tasks of the WTC in Scotland. In *Loading Logs on a Tractor at a Banffshire Lumber Camp* (page 70) Gabain portrays five WTC members as they load logs onto a trailer, pulled by a tractor which will take the timber to a collection point to be cut into required lengths, using cross-cut or mechanized saws. The timber was probably for pit props as there was a shortage of pitwood to keep the coal mining industry operating.[35] Gabain also visited Pityoulish lumber camp, near Aviemore which resulted

in *Sorting and Flinging Logs*, depicting three women sorting the timber and tossing each tree-trunk into the right heap. Camp conditions at Pityoulish were harsh, particularly in winter. Ina Brash, who received one month's training at Brechin and spent four years in the WTC, recalled the army huts they lived in were sparsely furnished, water had to be heated in a boiler and the toilet was just a hole in the ground in a small wooden hut. Another Lumber-Jill[36] wrote a poem about the camp:

When the Timber Corps camped at Pityoulish
The gales around them blew,
The snow lay thick on the trees and hills,
It lay on their bedding too!

And the rain came down in buckets,
The huts were all awash,
But as they rung out their blankets,
The Timber Corps only said 'Gosh!'…[37]

The need for more labour for agriculture became even more evident by the third year of the war. In March 1942 it was reported in the *Journal of the Ministry of Agriculture* that 'The food production campaign has now entered the most critical stage of the whole war… Briefly it comes to this: less shipping will be available for the importation of food of any kind, and more material and man power will be required for purely war purposes. It is imperative, therefore that more food should be produced at home, and all practicable ways and means found of overcoming the inevitable difficulties, real and imaginary.'[37]

The work of the WLA therefore remained crucial as bulky food imports needed to be reduced still further

and more grassland ploughed up. The December 1942 edition of the *Journal of the Ministry of Agriculture* announced that 'Agriculture is fighting the battle of the seas in the middle of the fields. In our different ways we are all fighting for victory… But let us never forget that the men in uniform are called upon to sacrifice everything, even life itself. We shall have done our full part only when we have obtained the utmost productivity from our land and animals.'[38]

Members of the WLA helped significantly raise agricultural output throughout 1943, a year that was viewed as the 'crucial year' and the time for maximum effort from all. The Countess De La Warr, chairman for East Sussex, wrote to the editor of the *Eastbourne Gazette*, 'I cannot stress too strongly the great need that exists to-day for land workers of all sorts – milkers, tractor drivers, general farm workers and market gardeners. The Prime Minister has told us within the last few days that the Allies are now ready to fight an offensive rather than a defensive war, and it is not hard to see what that will mean in terms of shipping… Last year our farmers relied to a great extent on soldiers' labour to gather in the harvest, but this year we are warned that soldier labour will not be available.'[39] Such appeals met with much success and by the summer of 1943 girls were joining at the average rate of a thousand a week,[40] and by June numbers had reached 65,000.

Women's Land Army Numbers Employed 1939–1943 [41]

- 31 December 1939 England: 4,282 *Wales*: 202
- 31 December 1940 England: 6,738 *Wales*: 284
- 31 December 1941 England: 18,756 *Wales*: 863
- 31 December 1942 *England*: 47,345 *Wales*: 1,847
- 31 July 1943 *England*: 64,480 *Wales*: 3,758
- 31 December 1943 *England*: 63,522 *Wales*: 3,709

In July 1943 conscription was extended to women not looking after children under 14.[42] By August the Government halted further recruitment to the WLA in an effort to release labour to meet the needs of the aircraft industry and to direct women into less popular war work such as munitions. Nevertheless, the attempt to maximise food production continued unabated as grave concerns were raised about a world shortage of food on the liberation of Europe and other occupied territories.

Early in 1944 entry to the Land Army was reopened on a limited scale, Lady Denman announced that 5,000 intelligent, strong women between the ages of 17–35 were sought for milking, tractor driving, rat destruction and other types of important work. By August the number of Land Girls employed had reached its peak of just over 81,000, at which stage they accounted for about half of the wartime increase in the number of land workers.[43]

CHOOSING THE LAND

Many Land Girls were attracted to the 'romance' of working on the land. Newspaper articles and the recruitment posters commissioned by the Ministry of Information, which was responsible for propaganda, exploited these idyllic images of a rural haven in an unspoiled, mud-less, warm and sunny countryside. Glamourised posters of fresh-faced, attractive,

FACING PAGE (TOP)
Ethel Gabain
Loading Logs on a Tractor at a Banffshire Lumber Camp
(1941)
lithograph, 304 × 457mm
IMPERIAL WAR MUSEUM

FACING PAGE (BOTTOM)
Ethel Gabain
Sorting and Flinging Logs
(1941)
lithograph, 352 × 542mm
IMPERIAL WAR MUSEUM

smiling young women in their smart uniform blending into their rural surroundings helped to sustain and increase women's war effort. The recruitment poster designed by Clive Uptton and captioned *For a healthy, happy job join the Women's Land Army* (page 62) was typical of this approach.

The stylish, brightly coloured posters appeared on buildings, hoardings and in shelters, and like those in the First World War were effective in attracting potential recruits to what looked like appealing and not overly demanding land work with admiring, kindly old farmers in tranquil surroundings with docile animals – an idealized view sharply at odds at with the harsh reality and drudgery of much of the work. The posters, such as Showell's *We could do with thousands more like you* (page 67), albeit less explicitly, also sought to persuade farmers to overcome their opposition to employing members of the Women's Land Army.

Town girls eager to work in the country away from the threat of bombing were lured by these cheery, vibrant images of sun-tanned Land Girls which tapped into their patriotic desires to serve their country and help plough the green fields of England. One such recruit was Molly Campbell (née Rogers) who joined in February 1941, aged 20, 'I fancied a country life, and getting out of London. The instigating event was seeing a poster in a field at Potter's Bar, where we went each night to sleep under my grandmother's table. The poster said *Lend a hand on the land* with a fetching picture of a kitted-out girl in breeches and jersey and wielding a dung fork'. Pearl Goodman (née Turner) in her autobiography *More Pearl's* reveals that she was

attracted to the Women's Land Army, having chanced to look in the window of the hairdresser in South Street, Chichester [1939] 'and there among the scents, powders and lipsticks was a startling picture of a beautiful girl in tailored jodhpurs, open-necked sweater and cowboy hat. She was driving a tractor and the broad furrows of brown earth curled behind her. It read *Volunteer for the Women's Land Army* and I knew at once what my war work would be.' Rosemary Wilson (née Lawford) was only 12 when war broke out. She joined five years later than Pearl Goodman and remarked 'although I had lovely parents the war had been going on a long time and I felt the need to do something and leave home, the posters probably had a lot to do with it!'

The recruitment posters also enticed a young Dorothy French (née Tattersall) to join before the outbreak of the war in the summer of 1939. Aged 19, she had seen pictures of 'smart girls in the WAAF, ATS, and WRENS uniform… but none of them appealed… a poster caught my eye – *Join the Women's Land Army*'. The image did appeal, particularly as after the death of her parents she had lived on a farm for four years and although she did nothing more than feed chickens she remembered that she had enjoyed the life. Prior to serving on the land she had been a house parlour maid for Ralph Stephenson Clarke, MP for a Sussex division, whose wife was involved with numerous organisations including the Women's Land Army. Dorothy remembered how 'during the summer there was an Agricultural Show being held in Eastbourne and it was decided to have a stand showing what life in the Land Army would be like thereby trying to

encourage girls to join. I was willing to be at this
stand although I knew very little about it myself…
Uniforms were not yet available so I was taken to
the Army and Navy Stores in Victoria Street and fitted
out with clothes as near as to the expected uniform…
I spent the day at this stand but was too shy to approach
anyone and just handed out leaflets to anyone who
showed interest…'.

Recruitment leaflets such as those handed out
by Dorothy French were intended to appeal to the
patriotism of women and directly linked their actions
on the land to the winning of the war. One such leaflet
released in 1943 had a photograph of a somewhat
windswept, healthy-looking nineteen-year-old
Land Girl Joan Drake (née Day), who – formerly a
dressmaker in a fashionable London establishment
– had signed up for the Land Army shortly before
her 18th birthday.[44] Ironically she had been 'a weedy
child' and had to see two doctors before one would
sign her application form, and he grudgingly said,
'it would either kill or cure her.'[45] The image is
designed to attract; it shows her smiling in regulation
shirt with turn-down collar, holding sheaves of corn,
her photograph having been taken while she was
harvesting in Devon. The text of the leaflet appealed
to women's patriotism. It was headed, 'Reap the
harvest of victory join the Women's Land Army.' The
back page stated, 'A Front Line Job of Vital National
Service awaits You in the Women's Land Army. You
will gain experience and knowledge which will stand
you in good stead all your life. This is constructive
work with opportunities for initiative and plenty of
scope for the individual.' The leaflet made it clear that:

IF YOU JOIN
*You must promise to serve for the duration of the war and to
give full-time mobile service in whatever part of the country
you are required.*

*If you cannot be offered employment in the type of work you
prefer, you will be expected to undertake any other kind of
land work for which the Land Army considers you suitable.*

*If at your interview you are considered suitable for enrolment
you will be asked to undergo a medical examination to show
that you are physically capable of undertaking land work.*

It also stated:

WHAT YOU MUST BE
*Between 17 and 40 years of age
Strong and healthy
Not afraid of hard work
Fond of country life*

To give a sense of the hard work required and
to counter the overly rosy images presented in
the popular press writers in *The Land Girl* sought
to emphasise the difficulties that lay ahead.
W.E. Shewell-Cooper, formerly Principal of
The Horticultural Education and Advisory Bureau,
Kent and Horticultural Superintendent of Swanley
Horticultural College for Women, suggested they
should 'try carrying buckets full of water for half
an hour or more at a time, and then attempt[ing]
to pitch earth onto a barrow and then onto a shelf
about breast high for another hour or so, to see
whether she can bear the aches and pains entailed.
Farming work is not spectacular, but it does mean
hard physical strain, but any girl who can endure

it finds compensation in the knowledge that she is playing a very important part in National Service.'[46]

While few Land Girls actually partook in this arduous trial many tens of thousands of young women did endure the physical strains of working on the land. An instructress at Sparsholt Farm Institute near Winchester 'bemoaned the fact that the Land Army posters showed a "pretty girl nursing a lamb or an equally ravishing blond in a picture-hat, tossing a minute wisp of hay." The reality was very different, and it was "only when the girl was sent off to the farm that she realised what farm work was like – the long hours, the monotony, the loneliness, and the incredibly hard work." '[47]

Even so, the WLA was a popular choice for young girls, many of whom joined because they enjoyed outdoor life and liked animals and saw the Land Army as a worthwhile job. Some did not want to join the Forces (a view often shared by parents) and be subject to drilling and marching and military discipline. Others did not want to work in a factory, while some joined simply because their friends had and they looked fit and well. A very small number had been rejected by the other services. Mary Doherty (née Murray) joined as she had been rejected by both the Forces and munitions in 1940 owing to her poor eyesight. Although Patricia Parkyn's (née Cater) mother had been a Land Girl in the First World War, she joined aged 17, when she found that she could not get into the WAAFS in 1943.

Joining the Land Army was a chance for freedom and to live away from home for the first time. Peggy Pickerill spent three years in the WLA, not only because she 'wanted to help in some way' but because she also 'felt [she] needed a change and a chance to live'. Joan Culver (née Laker) also wanted to get away from home and as the war had been going on for 3½ years she believed that if she didn't get into action it might soon end. She remained in the WLA until 1947.

Despite being keen to join the Land Army some women were prevented from doing so because they were in reserved occupations. Ruth Desborough (née Buckland) had been in a protected job and had to wait for a replacement before she could join up in May 1943. She had always loved the country and thought working on a farm would be her idea of heaven. Margaret Brittain (née Smith) worked for agricultural potato seed merchants who supplied farmers, and was deferred from 'call-up' several times before eventually joining the Land Army in May 1942.

Women who were regular agricultural workers (full or part-time) were ineligible for enrolment in the WLA as was anyone who had been in agricultural employment for six months or more before applying for enrolment. Owner-farmers and farmers' wives were also not to be enrolled under any circumstances. It was stated in the WLA guidance for interviewing that 'Farmers' daughters may only be accepted provided they are now taking up farm work as their form of war service or have done so within the last six months and provided they are genuinely able to give the usual undertaking as regards mobility.'

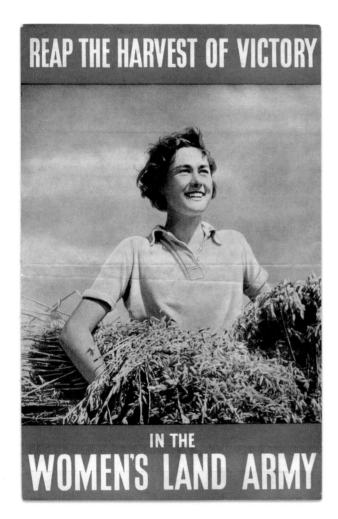

REAP THE HARVEST OF VICTORY

IN THE
WOMEN'S LAND ARMY

*Land Girl Joan Drake on the cover
for a recruitment leaflet*

COLLECTION OF LILIAN DAY

JOINING UP

Once they had submitted their application forms to their WLA county office, volunteers were interviewed by no fewer than two members of the Land Army panel. Some Land Girls recalled having a preliminary interview in their homes. However, Frieda Feetham (née Friedrich) who was aged 16, simply filled in an application form and was accepted for service in July 1943 at a crucial stage in the war, doubtless why she was able to slip through under age. The Land Army appears to have been the only service which did not insist on birth certificates being produced at interview.[48]

Interviews were designed to be friendly and the questions asked included whether they had had any experience of agriculture or horticulture, if they had any preference for any particular work and whether they could drive a car or ride a bicycle. Irene Eady (née Gascoigne) recalled that the two ladies present at her interview in May 1944 asked questions about animals and general country life and if she thought she could mix well with other people. Vita Sackville-West explained that 'privately the interviewer is of course sizing up the girl and forming her own estimate of her intelligence, physique, and general suitability'.[49] Christina Hole who had been a Recruiting Officer and Welfare Officer for the Land Army in the First World War and county secretary for Oxfordshire from 1940–41 suggested that there were 'only three main essential qualifications for Land Army membership: the girl must be strong, she must have the character and grit to adapt herself to the work, and she must be prepared to be mobile.'[50]

A pamphlet to inform Americans *How Britain lives*, emphasised how careful this selection process was, and that on average only one in three applicants was accepted.[51] This rigorous filtering of recruits also helped keep the wastage rate lower than that in industry.[52] Further, Land Army representatives were reminded that when applicants were aged between 17 and 18 they must be very carefully interviewed and only accepted if they seemed strong enough for full-time work and old enough to be treated as mobile workers. They were encouraged to obtain parents' or guardians' consent. One young recruit was Emily Richardson (née Pritchard) who applied to join immediately after her 17th birthday. She remembered going by train to Preston for interview by a very severe lady who thought she was much too young. Told that she would have to agree to go in as a hostel orderly with a view to doing work on the land at some future date, she realised that this was the only way she would be accepted and avoid being drafted into the armed forces or munitions. She agreed and shortly after, on 4 September 1944, was posted to Sutton Bridge, Lincolnshire.[53]

No volunteer was to be considered if there was any doubt at all about her physical or mental capacity. Doubts were raised about Vera Stratford's (née Auty) height and she was turned down for being too short, six months later in 1943 she reapplied and was accepted, aged 18. Muriel Berzins (née French) although a year older had a similar experience at her interview. Under 5ft. she recalled that the interviewers 'tried to persuade me that I was too small… but I insisted that I was strong'. She was duly enrolled. Dorothy

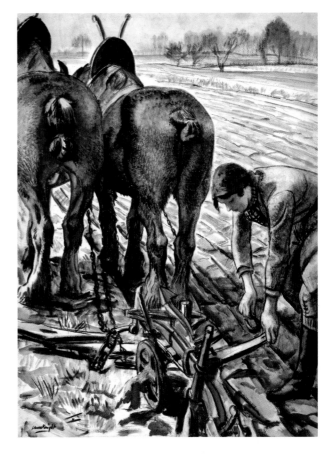

Laura Knight
Land Army Girl
charcoal, pencil and watercolour, 850 × 630 mm
NATIONAL ARCHIVES

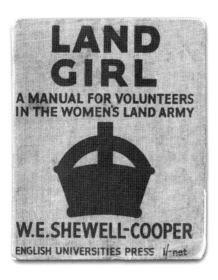

*Land Girl: A Manual for Volunteers
in the Women's Land Army*
W.E. Shewell-Cooper

Medhurst (née Maskell) was less successful initially, although she was eventually accepted in June 1940 aged 21, and served for seven years. She remembered that her first interview in Brighton didn't go well and being 'told sternly I wasn't suitable, and "It's not all boyfriends and dances"'. She vividly remembered how she was shocked by the decision. 'I loved the countryside, and spent hours cycling, and walking through little lanes and villages around my home town. I was sure I would be fine tossing bits of hay around or whatever they did on farms, I could picture myself in corduroy breeches, green jumper and little cowboy hat. I re-applied, scraping my hair back wearing a plain coat and was accepted by two different interviewers. I was determined to prove I could do hard work like anybody else.'

In their desire to help win the war and feed the nation some recruits lied about their age. Eileen Stewart (née Arnold) joined in 1942 when only 16 'after begging my father to death he sent for an application form for the WLA. We both knew I was under age – but he'd done the same thing to join the Army in World War One.' She had wanted to join the Timber Corps but was told 'My dear girl – the axes are bigger than you are!' Maureen Miller (née Roberts), who lived in Newport, Wales and was working as a shorthand typist in a timber merchants, had to travel to Abergavenny for her interview. She joined in spring 1944 because she wanted, along with many other youngsters, to 'do my bit'. She recollected that 'it was an uphill struggle as my parents refused to sign the necessary forms and I had to wait until I was 18, when I didn't need their permission.'

Recruits had to provide a medical certificate that they were fit for 'arduous and sustained physical labour in all weathers' before either they were sent to a farm or notified when and where to report for training. Medical examinations seemed to vary in their rigour. Volunteers for the WTC had to undergo a further medical examination to ensure they were physically able to undertake the heavy work. In her 'unofficial account of life in the Women's Land Army' pithily titled If their mothers only knew, Shirley Joseph described how her medical examination 'was to prove nothing more formidable than a few knocks and taps at the hands of our family doctor.' Edith Barford reported that her doctor said she looked alright and that the war would be over by Christmas, and suggested she use the time as a working holiday. Eight years later in 1947 she was still serving her country.

Volunteers were expected to provide two character references. Viola Ramsey, who served from April 1941 to January 1946, gave as her referees Langford Reed, Pilot Officer, R.A.F and M. Mudie who ran Modes, a high-class dressmakers in Hove. Mudie wrote, 'I have known Miss Viola Ramsey… for many years, & state with all confidence, she is very willing, honest, & reliable in every way, & am sure she will prove most satisfactory in the Women's Land Army'. Reed, writing from St John's Wood, London, stated that he had known her for over nine years as she was a great friend of his daughter. He commented, 'In testifying to her excellent character, I take pleasure in adding that Miss Ramsey is a girl who would be reliable and enthusiastic in any work she undertook and she should prove a very useful recruit to your ranks.'[54]

Recruits came from a wide variety of social backgrounds and for many, from London and northern industrial cities, country life was a new world.[55] As Vivienne Vick (née Leighton) acknowledged, 'The nearest I'd been to a cow was a picture in a book.'[56] Gladys Wheatland (née Senter) said of the Bristol girls she worked with that they 'were mostly from the tobacco factories and didn't know anything about the countryside. If they worked in the greenhouse they didn't know how tomatoes grew at all.' Betty Mintz (née Griffiths) acknowledged that 'having been a hairdresser it was rather different combing the rear end of a cow covered in dung to combing ladies' hair.' Vita Sackville-West noted the diverse background of the recruits. 'She has been a shop-assistant, a manicurist, a hair-dresser, a short-hand typist, a ballet-dancer, a milliner, a mannequin, a saleswoman, an insurance clerk... At a moment's notice she has exchanged all that... her working hours seem never definitely to end, for on the land there may always be a sudden urgent call, she lives among strangers, and the jolly atmosphere of homely love or outside fun is replaced often by loneliness and boredom.'

UNIFORM

Recruits were entitled to 'A free working outfit of uniform with regular renewals'. The outfit was deemed the property of the Government, to be returned to the 'county office in a clean condition, together with the badge, if the volunteer resigns or is dismissed'.[57] Land Girls at the start of their training or first job were provided with items of uniform as listed in the *Land Girl Manual*: a serviceable rainproof, a khaki overall coat, two fawn shirts with turn-down collar, a pair of corduroy breeches, a pair of dungarees, a green knitted pullover, three pairs of fawn stockings, a pair of heavy brown shoes, a pair of rubber gum boots, a brown felt hat, a green armlet with red royal crown on it, and a badge of the 'button-hole' type to wear in civilian clothes.

Margaret Mace started work as a Land Girl in 1940 when only 16. She was highly critical of the uniform, finding the breeches of poor quality and badly cut (she received a pair of whipcord breeches, corduroy she recalled came later). They were 'so short below the garter that they barely met the socks. The leather shoes were as hard as iron and nailed instead of stitched. Within a few weeks the nails came through and stuck in one's feet.' The sweater was more suited for walking out as it was made of soft wool and loosely knitted. Like many Land Girls she didn't receive all the items of uniform that she was entitled to as some were in short supply. Having not received any gum boots she appealed to the Auxiliary Fire Service and they parted with two pairs. Another Land Girl Joan Cowderoy recorded in her diary for 1 February, 1940, how she obtained her gum boots. 'I rang up the Land Army to ask permission to buy a pair of gum-boots and charge it up to them as I need them badly, they granted it, so I am going into Maidstone on Saturday to buy them.' Three weeks later she had 'received 12/6 from the Land Army for my gum-boots, I have to pay the 3/- balance which I think is fair.'[58] The gumboots situation was exacerbated when the Japanese invaded Malaya on 8 December 1941 leaving rubber in short supply. The WLA advised that gumboots were precious and should

Hilda Harrisson
A Land Girl
(1942)
chalk, 530 × 371 mm
IMPERIAL WAR MUSEUM

only be worn on really wet jobs. The *Land Girl* magazine echoed these sentiments and offered 'Uniform Tips' and a section on 'Make and Mend'. 'If you have a pair of gumboots, guard them and use them only when you must… Those of you without gumboots will wonder how to keep your legs dry. For the present it will be necessary for you to use whatever you can lay your hands on and here are a few suggestions. The tops of old gumboots make useful leggings and can be held in place with a bootlace or a piece of string tied through holes punched at the top and bottom of the leg part. Old pieces of linoleum can be utilised in the same way…'.

Towards the end of December the American Red Cross sent a gift of 800 sweaters for Land Girls in East Sussex. This caused Lady Denman some consternation as she wished to avoid creating trouble with the Board of Trade with whom she was 'having delicate negotiations over the whole question of coupon surrender for Land Army uniform and coupon-free comforts.' The sweaters had been sent following discussions between Mrs Hannah Hudson (second wife of the Minister of Agriculture, and whose family were from Philadelphia) and Mrs Margaret Biddle (wife of the American Ambassador to Poland and several other governments of occupied countries, stationed in London). They were distributed to Land Girls in East Sussex 'somewhat irregularly' when Lady De La Warr obtained blank permits covering the distribution of coupon-free clothing from her War Agricultural Executive Committee.[59]

Those joining in the winter of 1941–42 were particularly unfortunate. By this time there was

also a general shortage of cloth, and one third of Land Girls were left without greatcoats. Some were more fortunate, as a number of greatcoats were diverted from the A.T.S. but often they proved too small.[60] Lady Denman asked Charles Frederick Worth, founder of the Worth fashion house, to design the greatcoat.[61] Members were instructed to 'Sew on shoulder titles neatly. Remove mud and stains the same day. Keep a watchful eye for loose buttons. NEVER sew anything on your greatcoat except the official W.L.A. on the shoulder.'

County secretaries and uniform departments received a letter in early December 1942 informing them that 'the uniform position is now steadily improving and supplies of the more essential items are going out to counties in quantities sufficient to cover the greater part of the arrears due.' The letter explained that 'all future supplies of oilskins will be of very heavy type and should be completely waterproof.' This must have come us a great relief to Land Girls like Margaret Brophy who, having joined in June 1941, said initially 'the macs were servicemen's rejects – not waterproof!!' However, Hazel Robinson (née Williams) who enrolled two years later aged 17, having briefly been a receptionist for a French hairdressers, found that 'the ones they issued you with were diabolical. They were black and they were like stiff oiled silk. They stood up themselves, particularly when the weather was cold, they froze and you couldn't bend in them… It wasn't rubberised but it was heavy as rubber, and you had to cycle in these.' Members in certain jobs needed the oilskins to protect them in bad weather and in the interim resorted to farm-workers'

usual rainwear of old feed-sacks tied on with binder twine. *The Land Girl* in January 1943 reported the good news that uniform was now available after the shortage and especially oilskins. Marjorie Bennett (née Fairbrother) was greatly relieved for although the uniform was 'absolutely fabulous' and that she 'was the cat's whiskers in it', she felt they were poorly equipped. 'We had a devil of a job. It was quite common to get stuck in a field in a morning and be absolutely wet through because we didn't have any wellies or anything…'.

As in the First World War there were strict instructions about how and where the uniform should be worn. An official leaflet stated, 'The purpose of uniform is to ensure that all wearers belonging to the same force shall have the same distinctive appearance… Every member of the Land Army should take pride in wearing her uniform correctly. No volunteer should never wear a mixture of civilian attire and Land Army uniform at any time whether working or off duty.' Further, it was prohibited for a member to cut up, mutilate, dye, or alter in any way any item of uniform. Many Land Girls disregarded these instructions and put their own touches to what they wore and most took great pride in wearing their uniform at parades and rallies. The brown felt slouch hat was generally unpopular, being in Shirley Joseph's view 'neither smart nor serviceable, nor in keeping with the rest of the outfit', but it did afford scope for individuality, as it could be pulled into different shapes, and worn at different angles to suit personal taste. Beryl Gould (née Geoghegan) shaped her hat with the use of a steaming kettle. Shirley Joseph also

'learned that it is a point of honour with every land girl to appear as dirty and unkempt as possible, presumably to show what hard work she has to do.'

Shirley Joseph found it took her a while to get used to the new uniform. 'After all, it was a bit of an ordeal, even in those enlightened days, to put on breeches for the first time.' She wasn't alone in this concern. According to Clarice Edmond (née Cann) the residents of Ipswich complained about girls in trousers and noisy boots. She 'bought some gabardine jodhpurs from the WLA in Ipswich as they were more comfortable than the corduroy and they didn't whistle when you walked.' Sheila Newman (née Jacobs) didn't share these anxieties, she said 'we worked (in experimental gardens) in khaki overalls but with so many workers wearing overalls we didn't feel in the least conspicuous.' Nonetheless, 'more elderly members in local communities often deplored these casual styles of wear.'[62]

TRAINING – IF NECESSARY

Training was provided for Land Girls only when their county secretaries felt they needed it to fit them for employment. Lady Denman was adamant by 1940 that 'The object of the training is to give the girls some knowledge of general farming and care of stock, and latterly the majority of the recruits have been concentrating as far as possible on learning to milk in order to meet the increasing demand for women milkers. ... It will be realised that a month's training, even when followed by a second month on a farm, cannot and does not attempt to produce an

experienced agricultural worker, and no such claim is made for any of the Land Army girls. All that is hoped is to give some practical knowledge of life and work on a farm, enough to enable a willing girl to be of some use to an employer who recognises that she has much to learn and is ready for his part to teach her.'[63]

Land Girls were not expected to take over the work of skilled farm workers but merely to provide a source of semi-skilled labour. They were young, physically fit and energetic workers who were able to carry out many of the jobs on the farm. Agriculture did not require all workers to be experienced and skilled. As a consequence the extent and quality of the training that Land Girls received varied considerably; indeed, some received none and many simply learnt on the job.

The Principals of the Farm Institutes and Colleges received a letter in April 1939 from the County Councils Association asking them to take such action as would be necessary for the training of the Women's Land Army should the need arise.[64] Training took place at 'practically all the existing Farm Institutes and Colleges, stripped of their peace-time functions, [they] were turned over to running courses of a month's duration in general farm work, milking, poultry, tractor driving and horticulture.'[65] Over 2,000 volunteers were sent to 26 Farm Institutes and Colleges in England and Wales in the first two months of the war although many at the end of their course were left without employment,[66] often because of farmers' reluctance to employ Land Girls.

Edith Barford was sent to Monmouthshire Institute of Agriculture at Usk for four weeks' training which she

much enjoyed. Each week was divided into two periods of three days. 'We spent those three days in different departments; with horses; tractors, cows and dairy work, calves and young cattle, sheep, pigs, arable work (picking potatoes), fruit (Ellison orange apples), rural domestic economy (making jams and chutneys). Not long at anything, but a very interesting time.' At the end of the month the Institute was ready for the next intake of regular students, and she was sent back to London. She found there was little demand for Land Girls and for the only time in her life she had to 'sign on' at the Labour Exchange, but they had no work to offer.

Maureen Miller (née Roberts) was sent from Wales to an agricultural college in Bridgwater in Somerset for her six weeks' training. She received instruction in hand- and machine-milking, cleaned out cowsheds, learned how to saddle horses and brush them down. The two jobs she hated were 'squeezing maggots out of the backs of sheep and feeding the chickens as there was a rooster who wanted to pick out your eyes if possible.' Having squeezed or dug out the maggots with a penny, she recalled that Stockholm tar had to be applied to prevent infestation.

At Plumpton Agricultural College in Sussex Land Girls attended evening lectures four evenings a week after working all day on the land and after had to write up their notes. The rationale for this was that the Land Girls could 'take a more intelligent interest in their work and learn reasons for doing things on the farm.' Keeping busy would also prevent them getting too depressed about Britain's future. The College concentrated on milking and dairy work. The Principal was remembered by Joan Culver as being 'a stern, strict lady of whom it was said that any girl learning to milk, and found to have long finger nails would have said nails hacked off with a pen knife by her'. By March 1942 over one thousand Land Girls from Hertfordshire, Oxfordshire, Cambridgeshire, London, Middlesex, East and West Sussex and East and West Kent had been trained at Plumpton.[67]

Sylvia Johnson (née Wilson) was one of 1,300 women who were trained at Moulton Institute, near Northampton, where she recalled 'doing three days dairy work, three days tractoring, three days sheep, and a bit of hedging and maintenance work, lots of lectures in the evening, but mainly dairy work.' Moulton's second course in the early stages of the war was filmed by the Pathé Gazette Company for propaganda aimed at possible recruits and at sceptical farmers. Courses were also held for school children as part of a scheme organised by the *Farmers Weekly* and encouraged by the Minister of Agriculture.[68]

Michael Greenhill an instructor in agriculture at Sparsholt Farm Institute, wrote *A Book of Farmcraft*[69] in 1942, with illustrations by Evelyn Dunbar, in response to concerns about 'Land Girls always doing things the wrong way, often endangering themselves and others.' The book was divided into five sections: Hand tools and tackle; Cows, milking, and dairy work; Horses and harness; Farm implements and Farm tractors. Dunbar engaged the help of one of the senior Land Girls, Anne Fountain (née Hall), to act as a model for her drawings. The book was popular with Land Girls,

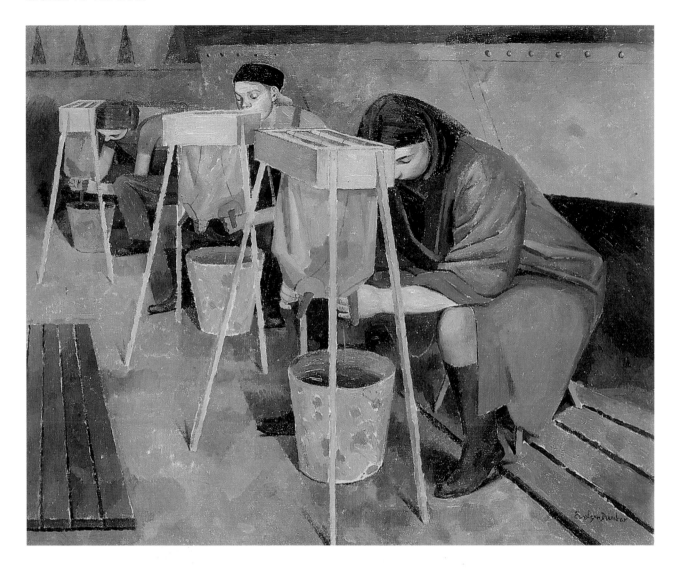

Evelyn Dunbar
Milking Practice with Artificial Udders
(1940)
oil on canvas, 617 x 766mm
IMPERIAL WAR MUSEUM

'The Uniform for the Land Girl'
from *Land Girl: A Manual for Volunteers
in the Women's Land Army*

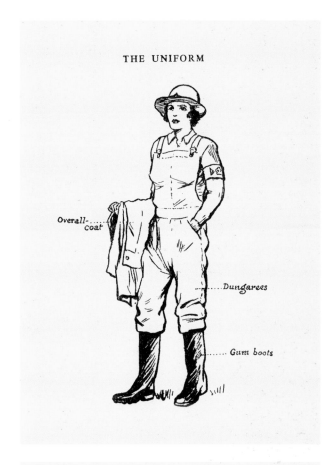

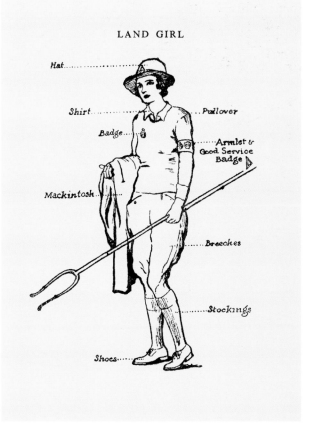

one of whom wrote to *The Land Girl* recommending
'each new member to beg, borrow or steal – or better
still buy – a copy of *A Book of Farmcraft*, by Michael
Greenhill and Evelyn Dunbar. It gives instructions
with simple illustrations on how to do everything…
It really is the most helpful book on farming I have
ever come across.'[70] The well-known farmer and
author A.G. Street wrote in the foreword, 'It was
badly needed, it has come at the right moment, and
I wish it every success, for I know that each copy in
the hands of townsfolk will mean several extra tons
of home-produced food upon their tables next winter.'

The Spectator saw it as essential reading. 'The sergeant does
not expect his recruits to fix bayonets by the method
of trial and error; then why should not the farm
recruit be as reasonably instructed?' The artist and
writer Thomas Hennell, author of the review, revealed
that at the age of sixteen he had been sent to harness
a carthorse and been greatly perplexed by the collar
that he was to place on the beast. But after studying
Dunbar's drawings he felt 'the self-congratulation of
one who has done his or her drill to perfection, solely
because the N.C.O. (in this instance a trim and gracious
instructress) has made it harder to blunder than to do
the routine correctly. Her drawings of farm machines,
the cultivator, the potato-spinner and the like, illustrate
their functions from the clearest point of view, and in
doing so become excitingly fresh, clean designs.'[71]

Dunbar, in her role as a salaried war artist, spent
extended periods of time at Sparsholt from June 1940
as she had been commissioned by the Ministry of
Information to record women's important work on

the home front. The paintings were displayed around the country in touring exhibitions intended to boost morale. In *Milking Practice with Artificial Udders* (page 82),[72] Dunbar depicts three Land Girls as they learn to milk by pulling what Land Girl Shirley Joseph described as 'weird-looking rubber udders attached to imitation "bags", which are strung from a wooden frame. These "cows" are ranged in soldierly formation… and the girls… happily squeeze water while the cow, metaphorically speaking, contentedly chews her cud.' The snag was that 'at least half the art of the expert milker consists in knowing instinctively when a cow is going to kick.'[73]

Special training for two or three weeks was also offered to those Land Girls who 'had special educational qualifications' (experience in calculation and figures) and wanted to become Timber Measurers who assessed the timber felled and checked the deliveries in and out of the timber yards. 'The essential objective was to give recruits a general appreciation of the various aspects of timber production, to show them its importance in the general pattern of the war, to give them a preliminary training in the use of tools, to find out for which branch of the work they were best suited, and to provide a transitional stage from home to the often remote life of the woods and villages.'[74] This training was provided initially at the Forestry Commission's School at Parkend, Lydney in the Forest of Dean, Gloucestershire and a second training centre was established in August 1942 in a Royal Ordnance Factory at Morlands Camp, Wetherby, Yorkshire. Smaller centres were later opened in South Wales and Kent. 'A Ministry of Labour hutted camp at Culford, Bury St Edmunds in Suffolk was

taken over for Land Army members who preferred a more active job in the woods… In Scotland, women worked as measurers from the outbreak of the war and, as their employment for general woods work was extended, an informal Women's Forestry Service was established at the beginning of 1941.'[75]

Unlike as in the First World War, where the Women's Forestry Corps was a separate organisation, Lady Denman stated that it had been 'decided that the Land Army will supply the personnel required. The girls seem to take very kindly to the life in the woods, where they are engaged in lopping, trimming and clearing and, in the nurseries, in planting and tending young trees.'[76] After satisfactorily completing their training volunteers were assured of immediate employment at a starting wage of 45s. per week.[77] For some – like Sheila Newman – there was no specialised preliminary training. Her training took place 'on the job' at the large estate she was posted to run by Captain Foljambe at Osberton Hall, Worksop. She was informed that 'As accepted volunteers are needed, they are sent for training either to an approved farm or to one of the official training centres of the Ministry of Agriculture and Fisheries… during training the volunteer is provided with free board and lodging and receives a weekly personal allowance of 10/- less National Health and Unemployment Insurance contributions. After training, if immediate employment offers, the volunteer is sent fare paid to her employing farm where she works as an employee of the farmer and under the ordinary conditions of employment of agricultural labourers. When in employment she is put in touch with the nearest local representative of the Land Army who

is available to give help and advice in any personal difficulty.'[78]

Sheila Newman's 'Notification of training' from the Nottinghamshire County Secretary, Norah Moore, advised her that she should report on Monday 29 July 1940. A Land Army working outfit would be sent direct to Osberton where she would be billeted in a cottage with other WLA girls. She was instructed to take informal clothes, underclothes and personal necessities, including her ration book. It was made clear that a post on this or on some other farm would result, provided her training report was satisfactory. On arrival she found she was to share with five other girls aged between 17-20 and an old lady who was to cook and housekeep, two of the girls worked in the market gardens round the house, two on the farm itself, and two (including herself) in forestry. 'With so much of England's precious resources being used, it was mandatory at that time for every tree cut down, another must be planted.'[79]

Another method of training involved a 'two to three weeks' "hardening" course for raw recruits to schools for the training of potential forewomen and specialized instruction in milking, rick building and thatching, pruning, pest destruction, straw baling, tractor driving and drainage excavating.'[80] The value of such schemes lay in the fact that they could be adapted to local needs.

FOREWOMEN

While there was limited scope for promotion, Land Girls could be appointed as charge-hands or forewomen.

Charge-hands (later they were known as gangers) were expected to supervise 'a group of girls when they are sent out as a working gang, and she is responsible to the forewoman for their work.'[81] Special courses for forewomen in charge of groups of women involved lectures on agriculture, first aid, income tax, completing time sheets, leisure and recreation, social hygiene (venereal disease) and leadership. Practical operations were to be taught by a full-time ex-bailiff instructor and included hoeing and singling mangolds and setting gangs to work; haymaking and rick building and thatching; using a brake; grooming and harnessing a horse. Machinery was expected to be seen at work and explained, including cultivating machines, ploughs and hay rakes.[82]

Shirley Joseph believed that 'The only material advantage these jobs have is an increase of a 1d. and 1½d. per hour respectively, and a special armlet, to be worn during working hours only.'[83] Margaret Franklin was sent to Titchmarsh, not far from Peterborough to be forewoman in a hostel of 30 or 40 girls.[84] 'Being a forewoman was not easy work. We often worked longer than the girls did, as, when we had finished our day's work, there were still records [time sheets] to be kept and telephone calls made to farmers [to arrange work].' She had to crank by hand an almost worn-out Army van on cold winter mornings. 'It was a "bear", and sometimes I had to deal with four flat tyres in a day!'' It was her job to transport the girls in this van to distant farms. The clerical work that had to be undertaken was not supposed to occupy more than 25 per cent of her time. This often also involved reporting back early on Sunday evenings to arrange

the next day's work. Gwen Moody (née Pocklington) worked in Yorkshire from 1939–45; she was transferred to a newly opened hostel and promoted to forewoman in 1944 and received 5s. a week extra pay. The previous year, while working in Beverley, she had been presented with her four-year armlet by the Minister of Agriculture. Joan Lomas also became a forewoman; having worked in Northamptonshire for three years, she attended a forewomen's course at Moulton Farm Institute with a view to being the senior of two forewomen at Wilby Grange [now demolished], near Wellingborough. In 1945 the position of Head Forewoman was introduced. Joan spent her time teaching trainees to cycle, then supervising jobs as allocated by the farm manager. She withdrew labour from farms when she found girls working in unsafe and dangerous conditions.

PROFICIENCY TESTS, CORRESPONDENCE COURSES AND RADIO BROADCASTS

Once Land Girls were placed in employment optional additional training was sometimes available. They were encouraged to enhance their practical experience with theoretical work through lectures and courses and through joining farming clubs. Later they were able to take more specialised courses such as thatching and pest control. Members who had over one year's record of good service, including punctual time keeping, could from 1943 take proficiency tests in the various branches of land work and correspondence courses in agriculture.[85] *The Times'* agricultural correspondent commented that those girls who passed in their particular type of work should be able to command higher wages than the novice.[86]

Enid Barraud, one of the original volunteers for the Land Army, starting her training on the first day of the war, wrote of her experiences of working in Cambridgeshire in *Set My Hand Upon the Plough*.[87] She recalled being one of seven taking a WLA proficiency test. For her, the gathering of the candidates in Shire Hall was also an opportunity to feel a member of a corporate body. 'That's something people are apt to forget about the Land Army; most of us are isolated commandos with no corporate life as the other forces know it.' She added, 'These tests are not exhaustive, they can't be in that time, but they do provide some sort of nation-wide standard of efficiency and as such are useful.' Tests were arranged largely by the County organisers and examined by a farmer and a member of the War Agricultural Executive Committee. If a member failed she was not allowed to enter again in the same branch of work until a six months interval had passed.

Ruth Bowley (née Hale) recalled being thrilled to pass her proficiency test for dairy work, taken on a farm just outside Emsworth in Hampshire. She found the written exam was quite hard 'so it was a bonus' for her to be successful. Margaret Brittain was asked after about 18 months service if she would like to try for a proficiency badge. She put her name forward to take a practical test at Plumpton Agricultural College in Clean Milking and also an oral examination. She remembered one of the questions 'If a germ multiplies four times every hour, how many will there be in 12 hours?' Although she had no preparation for the exam she passed with 86 marks (75 was the minimum pass mark) and gained her

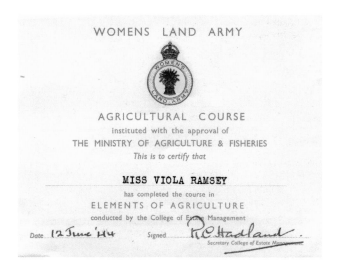

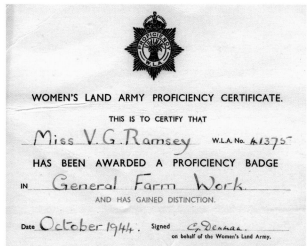

badge made of bakelite and a proficiency certificate. Lillian Harbard (née Butcher) took a horticultural course in 'Vegetables in the Open' arranged by the Royal Horticultural Society. Gwen Moody, who was promoted to forewoman in 1944 passed in the same year her proficiency test in field work with distinction. The practical test varied according to the season and/or local conditions, and each operation had to be carried out in a given time over a reasonable area:

1. Planting potatoes or cabbages by hand.
2. Singling sugar beet or other root crops.
3. Stooking.
4. Loading a wagon with sheaves or hay or straw.
5. Preparing thatching straw and thatching efficiently a given area of stack.
6. Picking potatoes, or lifting turnips or mangels.
7. Knocking and topping sugar beet.
8. Spreading farm manure.
9. Riddling potatoes by hand riddle.
10. Pitching and stack building (for members of threshing gangs).
11. Proper handling of tools in common use for field work.

The oral test was on:

1. Elementary principles of rotational farming.
2. Recognition of common farm crops and weeds.
3. The time of year and reasons for field operations.
4. Reasons for crop failures.
5. Agricultural weights and measures, and farming terms.[88]

Some Land Girls saw farm-related work as more than temporary war work and augmented their agricultural education by taking additional courses. Joyce Downer (née Martin) spent her evenings doing a correspondence course on The Elements of Agriculture run by the College of Estate Management. Eileen Holliday (née Bradley) completed a correspondence course on Farm Book-Keeping also organised by the College of Estate Management and instituted with the approval of The Ministry of Agriculture and Fisheries in November 1945. She was considering buying a car after the war and travelling from farm to farm to do paper work.

Courses were advertised in *The Land Girl* for the autumn and winter months. There were also courses in horticulture run by the Royal Horticultural Society including vegetable production, fruit production and crops under glass. Interested readers were informed that the cost would not exceed £2 plus the cost of books and postage. Certificates were awarded to over 600 girls who successfully completed the prescribed number of lessons. Further information was provided in regular Land Army radio broadcasts.

These radio broadcasts on the Home Service 'took a variety of forms ranging from announcements from the Honorary Director to inviting recruits to submit scripts for examination by the BBC for use in appeals to persuade listeners to volunteer for the WLA.'[89] There were also overseas broadcasts including one by Lady Denman to Australia on the anniversary of the first birthday of the Australian Land Army. Mary Hood (née Blackburn), who had enrolled in the Land Army

in 1942 and was one of 24 Land Girls working in the Harrow area, was employed by a pig breeder looking after a hundred pigs and a herd of dairy cattle and took part in a broadcast transmitted to North America on 16 August 1944. The programme 'Bridgebuilders: Land Army Girls' was recorded in a mobile recording van and for which she received a fee of two guineas. Participants had to adhere to the script as a failure to do so would result in the broadcast being cut off. The programme was one of a series designed to form 'a radio bridge of understanding between this country and our allies of the U.S.A.' In this case, 'the four land girls called their opposite numbers of the Women's Land Army of America' and of New York State in particular and in turn described a day in their lives on a Middlesex farm.[90]

THE ATTITUDE OF FARMERS TO LAND GIRLS

Land Girls were initially viewed with much suspicion and hostility by farmers and labourers, many of whom doubted whether 'compared with the ruddy, strong-limbed village lasses, these paler, streamlined, town-bred girls'[91] could cope with the rigours of heavy outdoor work. H.E. Bates, writing in his regular column on Country Life in *The Spectator*, described the conservatism and prejudice of the English farmer. 'He has a very deep suspicion of imported female labour… He prefers one man to half a dozen women.'[92] Sheila Newman, who had been a Land Girl from the summer of 1940, recalled that 'there was a certain amount of resentment from the men we worked with, all either old or not fit enough for the armed forces – we felt that they were thinking if we hadn't been there then perhaps their previous work mates might still be with

them. As it was, farm work was a "reserved occupation" so all those who had gone were volunteers.' Similar reactions by farmers were noted by other Land Girls and writers of the period. Joy Atkins (née Peppercorn) who was accepted for the WLA at 16½ years of age 'because I was a bonny girl!' also remembered the resentment of some of the men in the early stages of the war. She said 'if you were put in charge of anything the attitude was "Right it's your job now, don't expect help if you run into bother".' Dorothy Medhurst recalled that Land Girls were given the hardest and dirtiest jobs when they were not milking, they were expected to carry heavy sacks of meal and grain and any protest was met with: 'you are supposed to be doing a man's job – so get on with it.'

Margaret Goldsmith, author of *Women at War*, personal observations of the war work being done by English women, wrote, 'Of course, there had always been women land-workers, whose great value the farmers gladly admitted, but the idea of a Land Army of hitherto untrained girls was something quite new. Naturally the farmers were somewhat prejudiced at first, and not always willing to accept such a novel form of help except as a last resort.'[93] Lady Denman's foreword to the *Manual for Volunteers in the Women's Land Army* sought to forewarn volunteers that 'Farmers' memories are short, and in spite of the good work done on the land by women during the last war, the Land Army has had to encounter much prejudice against the employment of women's labour'.[94]

Lady Denman battled long and hard to secure official and public acceptance of the value of the Land Army.

Recognition did not come easily. The majority of Land Girls were privately employed, their 'progress watched with critical curiosity by employers and fellow workers alike.'[95] Lady Denman made it known that 'Farmers are beginning to send excellent accounts of the girls they are employing…'.[96] By spring 1940, 'the names of Land Army members were appearing high in the lists of successful ploughing contestants, and it became accepted that land girls could make first-class plough-girls, both with horses and tractors.'[97] Nonetheless, rumbles of discontent from farmers continued, and the following year, the Minister of Agriculture, speaking at a meeting of farmers, took the opportunity to vociferously state how he deplored the present state of criticism. It was the height of folly and short-sightedness. He was quite sure that farmers under-estimated the ability of women to tackle farm jobs of nearly all kinds.[98] This prompted a number of letters to *The Times* including one from a former Land Girl in the First World War who for three years had been a cowman and shepherdess. Margaret Huntington-Whiteley stressed the stoicism and abilities of Land Girls, explaining how she had thought nothing of carrying a 100lb sack of bran on her shoulder up the granary steps and could tip a cart-load of roots single-handed. Meriel Talbot, former Director of the first Women's Land Army, was also swift to reply, observing, 'At that time both criticism and scepticism were to be expected, for farmers, except in a few areas, had never employed women as whole-time wage earners and were naturally sceptical of their ability either to do skilled work or to stick to it. Yet by the end of the war criticism had vanished. The girls, carefully selected, tested, and enrolled… proved their

willingness and ability to do skilled work…'. She continued that if this was the case 22 years ago, 'can we doubt that with the extension of physical fitness, the development of motor-driving, and every kind of outdoor sport members of the Women's Land Army are capable of surpassing the pioneers?' Talbot urged the 'critics and sceptics to make themselves aware of the facts, and to help and not hinder the production of home-grown food, and the call for man-power elsewhere at this grave time.'[99] Two months later the Minister of Agriculture, Robert Spear Hudson, commented that the prejudice against the use of the WLA was disappearing and the demand was now greater than supply. The conservatism and prejudice was largely overcome relatively early on in the war for two main reasons. Firstly, the positive experiences of the farmers who employed large numbers of them and secondly, given the exigencies of war with the increasing amount of work and the inability of farmers to find male workers.[100] Further, the 'general conscription of women in 1942 made women's work in general much more acceptable across all social groups'.[101]

Land Girls had much to put up with. Lady Denman noted 'their [initial] welcome has not been very warm. Theirs has frequently been a disheartening experience for girls who have sacrificed home-life, and in many cases good posts to give service on the land.'[102] Audrey Webb (née Crouch) ran away from the farm she was working at. Whatever she did was wrong. If she took too long to milk a cow she would be told off for playing about, but if she was quick her employer said she hadn't done the job properly, and it was the same with any job she did. After two weeks she asked for a

'Well, 'ows the milkin' job gettin' on?'
'It isn't. I can't find the tap!'
from *Laughs around the Land*

Laughs around the Land
compiled by S. Evelyn Thomas

'Funny the different kinds of jobs they land-girls 'ad afore they joined up.
Would you believe it, Colonel, I've one what used ter breed Poodles, an 'airdresser
and one what calls 'erself a Topiary Expert!'
from *Laughs around the Land*

transfer and ran back to the last people she had lodged with and stayed with them for a week and then reported back to the WLA as they had been looking for her; she was then sent to another farm. Eileen Stewart who originated from Derby commented on the many culture shocks she received when working in the countryside, notably when she received her first lesson on stooking. 'This was where we were to discover that farm hands didn't hold much favour towards Land Girls. They showed us how to stack sheaves and made jibes about rolling up our sleeves to do the job. Naively we did so and it wasn't until taking a bath that evening you learned the painful truth of a thousand scratches!'

Muriel Brayne (née Page) joined the WLA in 1942 aged 19 years, remained for four years, but left because she was expecting her first child. She remembered, 'the last farm I was on had a terrible foreman, he did not like Land Army girls, he gave us all the dirty jobs if he could, and heavy work but we did not let him get us down.' Nan McFarland spent three years in the Land Army, and left her home in Glasgow to work in Ayrshire where she remembered how the 'Farmers swore at you, they had no time for the Land Girls really… and we couldn't understand what they were saying because of the Ayrshire brogue.' Others had more disturbing and unsettling experiences including Clarice Edmond who described the foreman as a sadist. He would catch her arm and twist it or twist her skin as he walked past. As there were a lot of rats and mice on the farm she kept a kitten hoping it would grow to a good rat/mouse catcher. However, she remembered that 'every time he saw it he would grab it by its tail

swing it round his head and let it go into the midden pit.'

Shirley Joseph pointed out that 'Some farmers… seem to delight in making a girl feel out of place, useless and unwanted… if it can be shown that he has treated her badly, it is quite likely that the Land Army will refuse to let him have another to take her place.' Such was the case with Joan Grace (née Spencer) who had joined the Land Army in November 1941 just after her 21st birthday; she was transferred from the farm in Knebworth where she and another Land Girl were working because of their poor treatment by the farmer.

Not only did farmers contribute to Land Girls feeling unwelcome and unappreciated but villagers were sometimes found to be unfriendly. Dorothy Medhurst found them very insular and inward-looking. '"Townies" like us were different and viewed with suspicion. We were accused of being a bad influence on village girls and of leading the remaining young men astray.' Marjorie Stanton (née Ellis) reported that 'the village wives did not want us girls in the village, they said it would bring disgrace to the village, as we had Canadians billeted there also…' and 'some [of the public] slightly scorned us.'

Land Girls were often the butt of jokes and caricatures within the popular press, as in the First World War, and often portrayed with something of a comic air about them. S. Evelyn Thomas's book *Laughs around the Land* was a compilation of jokes about land workers and Land Girls in particular taken from *Punch*, the *Daily Express*, the *Manchester Dispatch*, *Men Only*, the *Aberdeen Press*,

and the *New Yorker*.[103] Such images would have done little to help recruitment and employment.

J.B. Priestley, author of *British Women go to War*, remarked, 'Jokes about "Land Girls" are fairly frequent, and sometimes the girls themselves, when seen on holiday in their attractive green jumpers and light khaki breeches, may appear to have a musical comedy air about them, but the fact remains that service in the Women's Land Army is very genuine national service that offers hard and sometimes unrewarding work.'[104] Nonetheless, the following year the doyen of film critics C.A. Lejeune, 'writing about Bernard Miles' rural comedy *Tawny Pipit* (1944), gently mocked "the slim, selected figure of a land girl, leading a gee-gee, with the future mirrored in her brave, steady eyes".'[105]

Land Girls like others in the Services were subject to accusations and slanderous comments about their morals. As Sheila Newman revealed, 'There was always talk of Land Girls "being pushovers" but we were mostly a prim and proper hard working lot.' An early wartime witticism 'was the rumour that their motto was "Backs to the land"... All accounts, however, suggest they were particularly high-principled girls; and working almost exclusively among men many clearly felt they could not afford to give any male too much encouragement.'[106] Margaret Mace made the point that 'contraception except for men (and many of them were ignorant) was not known about or available for single women, nor for married women for that matter. There was an increase in illegitimate births, but by and large middle-class morality ruled. There was a firm belief that indulging in sex before

marriage, even giving in to one's fiancé, could lead to the breaking of an engagement.'

LIVING ON THE LAND

Recruits were accommodated on farms, hostels or billets, with a very small number able to live at home. While living on a farm might be seen as more interesting, it had its disadvantages since the Land Girl remained constantly on call. Another drawback was the isolation, for many young girls found themselves homesick. Adjusting was not easy. Many, like Betty Mintz, remembered how she and others often simply cried themselves to sleep.

For those living in hostels, as approximately a third of all Land Girls did, there was the benefit of companionship and freedom from the day's work once it was over. Further, there was a certain variety, as Land Girls seldom worked on the same farm twice running.[107] Moreover, given they had to return to the hostel each night they had to work 'normal hours' and accordingly were less likely to have to work overtime except at harvest time.

Many of the hostels that sprang up in 1942 and 1943 were far from lavish. Emily Richardson recalled that the Sutton Bridge hostel received beautifully-sewn patchwork quilts from a women's group in America. 'The effect of this colour after the drab army grey blanket was truly dramatic and very much appreciated.' Joan Blair (née Haggith) recalled reporting to a hostel in Peacehaven, Sussex but only stayed a couple of days because she found bed bugs, and asked to be

transferred. Some hostels were specially built with bathrooms, showers, electricity and other amenities not always found in ordinary billets or farm houses. 'Pioneer Wardens [were] sent by Headquarters to supervise the opening of new hostels, and to cope with any crises, either domestic or disciplinary, in hostels already open.'[108] Hazel Robinson was fortunate to be sent to a new hostel at Trusley Manor, Sutton-on-the-Hill near Derby in April 1943. She was given a railway warrant and very precisely instructed to catch the 2.35 p.m. train from her home in Sheffield that arrived at Derby at 3.37 p.m. As there were 25 girls travelling to the hostel she was told by the County organising secretary Ethel Fryer, that the War Agricultural Executive Committee would send a lorry to meet them at the station. She was reminded to take her Identity Card, National Health and Unemployment Insurance Cards, her Medical Card and her ration book and sheet complete with coupons. She was also informed that on arrival she would have to undergo a head inspection as 'infection spreads very quickly and in these days when trains are so dirty it is very easy to become infected.'

Hotels and old rectories were requisitioned and adapted by the Ministry of Works. The average hostel size was between 25–35 girls, although they ranged widely from 10–120. Marjorie Bennett lived with 30–40 girls in a big house in Repton, south of Derby, which the Land Army had taken over; she recalled the large bedrooms each with 8–10 girls. Hostels were equipped with bunk beds 'as they were regarded as more affording of companionship'.[109] Freda Walker (née Critchlow) remembered the first hostel she stayed

in at Lyddington, a small village north of Corby in Rutland. The sleeping quarters were smaller and divided into fours with double bunk beds with straw mattresses and a small chest of drawers for each Land Girl. Evelyn Dunbar's *Land Army Girls Going to Bed* (page 95) shows the interior of such quarters, two of the occupants tucked up in their bunks, overalls hung at the end of the bed ready for work the next morning. Ruth Desborough joined in May 1943, aged 19, and was sent to a hostel for 30 Land Girls in Berkshire which formerly had been a private mansion house by the river Thames now taken over by the Ministry of Agriculture. The hostel, she recalled, 'was run by a sister of Neville Chamberlain. She was quite a martinet. We slept eight to a room in bunk beds and had to fold up all our bedclothes every morning and then re-make the bed at night (talk about Army discipline!)'. Irene Eady had a similar experience in her hostel in Beaminster, Dorset, where they too were subject to inspection by two or three ladies in authority. Kit had to be neatly laid out on bunks for scrutiny.

By January 1944 there were 696 hostels, boosted by the mobile gangs of Land Girls required for labour-intensive work. Of these 475 were run by the Women's Land Army and 75 by the War Agricultural Executive Committees. The Young Women's Christian Association (YWCA) ran 146 hostels including the one Nan McFarland lived in in Scotland. Of the women running it she said, 'they were very kind maidenly ladies and old-fashioned in their ideas and such like and we didn't get a lot of fun out of it really, I mean except our own fun, but not from them.' Dora Varley (née Watson) also recalled being one of 40 girls in a hostel run by

the YWCA in Skipton, Yorkshire. 'Hostel food was mostly good and substantial bearing in mind rationing. Sandwich "makings" were available after breakfast and girls made their own, packed them in a lunch tin and ate them wherever they were working. It was usually possible to have a pot of tea (we had a little tin of tea also) made by a farmer's wife unless we were working in a remote area.' Not all Land Girls were so lucky. Joan Anderson (née Hallwood) found the food poor and remarked that 'there was never enough, the matron of the hostel was later "kicked out" when it was found that she had her mother living there against the rules and they were "eating like queens" while we were always hungry.' Freda Ward (née Frost) and the other Land Girls in her hostel in Sturminster Newton, Dorset were convinced that 'up to half our rations were disappearing from the hostel's kitchen into the black market.' She recalled being so hungry that 'at times we ate the raw mangolds we had been lifting.' Hostels were registered as Catering Establishments under Industrial category 'A', which meant that they were entitled to special allowances of rationed and priority foods. Evelyn Dunbar's painting *Women's Land Army Hostel* captures the camaraderie of hostel life as Land Girls patiently queue for breakfast; the Land Girl at the back of the queue still has her slippers on!

Not everyone enjoyed the new experience of communal living. Maureen Miller said, 'There was no privacy [in the wash room] and it was most embarrassing to a young girl when she had to undress and wash in front of others.' Brenda Penfold (née Poulton) explained that she was a bit shy 'and I just couldn't get used to

the fact that these girls that were used to it, after a day's work they'd all be – there was only one bathroom area, they'd all be stripping off and getting either into the showers or at the sinks and I didn't know what to do with myself. But I used to keep my clothes on, I couldn't be different to the way I was, so I used to discreetly try and have a shower when no one else was there.' Land Girls were often only allowed one bath a week owing to water shortages and an inadequate number of baths. Joan Cowderoy recorded in her diary in January 1940 the terrible winter conditions with the snow and blizzards, and how as it was so cold they couldn't have a bath because the 'water won't run away'.

There were strict rules about personal conduct. Wardens were responsible for the management of the hostel and staff (cooks, domestics, daily women, handymen) and for the welfare of the girls. Many took their role zealously. Hazel Robinson remembered how their hostel warden 'ruled us like at boarding school, very, very strict with us. Possibly we needed it, I don't know, but there was always one girl that was in trouble… the bell used to go and we all had to line up downstairs while she told this girl off.' Jean Kitson (née Holmes) who joined after the war, aged 18, remembered how they had to be in by 10 p.m. She said, 'Our warden was strict and rang a bell, within five minutes after 10 p.m. she had the door locked. If you had to knock her up, a lecture would follow, and you could run the risk of being confined next week.' Clarice Edmond recalled that they were locked out if they were late and 'were not allowed to talk to boys through the open windows.' Dot Eccleston recollected how she and another Land Girl were punished after

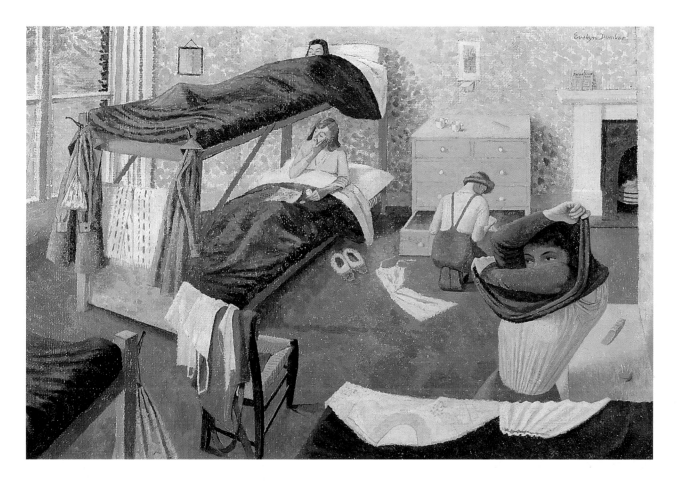

Evelyn Dunbar
Land Army Girls Going to Bed
(1943)
oil on canvas, 508 x 762 mm
IMPERIAL WAR MUSEUM

they missed the bus back to their hostel. 'We phoned the Warden and explained, and were told to go to the Police Station, which we did and it was lovely, they gave us a bed for the night and even breakfast next morning. As we were told to be back in time for work the next day (7 a.m.), the only way was to hitch a lift back in an American truck. For our crime we were not allowed out at weekends and evenings for a fortnight. Then we were sent to see a [local WLA] Rep[resentative] (the first and only one we ever saw) who told us we were being moved to a remote hostel out in the wilds away from all our friends and all because we missed a bus!' Gladys Wheatland received a letter of complaint from H.A. Myring, Assistant Labour Officer for the Gloucestershire War Agricultural Executive Committee about her conduct when she missed the train back to her hostel Medford House, in Mickleton, Campden after taking a wrong turning owing to thick fog and wasn't then able to return until the following Monday morning. She was told that a repetition would lead to her discharge without further warning.

Land Girls in hostels were also required to undertake their share of fire watching, sometimes alongside members of the Home Guard. Clarice Edmond while living in Knebworth had to take her turn and be ready to raise the alarm during the night. 'We collected a torch and equipment [sand and stirrup pump] for incendiary bombs and walked the building when the siren sounded until all clear, luckily we weren't hit.' Doreen McLean (née Cooke) was called up in January 1942, aged 23, and was a member of a fire-fighting party organised by Battle Rural District Council in East Sussex. Her membership certificate stated that

the holder 'possesses the powers of entry and of taking steps for extinguishing fire or for protecting property, or rescuing persons or property from fire, which are conferred by the "Fire Precautions (Access to Premises) (No. 2) Order, 1941".'

For those Land Girls placed in billets conditions varied markedly. 'Some were friendly and fairly free of discipline. Others were less so – such as the attic in an isolated, Welsh-speaking valley with no electricity, a well for water and only a roaring sermon on a Sunday for entertainment.'[110] As late as 1943 under a half of farms had piped water, while fewer than a quarter had electricity.[111] Dorothy Taylor (née Cann) was accommodated in one such cottage which had no water or gas/electricity or toilet at a rent of 4/- per week. She recalled that 'the water came in a 12-gallon churn. There was a well but it had rats floating and red worms in it. The toilet was an earth closet 100 yards down the field from the house. [You] had to dig a hole and bury the contents every Saturday.'

Given the large numbers of evacuees and other workers living in villages, billets were not always easy to find. Local representatives were to inquire of recruits if their billets were satisfactory as 'Uncomfortable billets are the cause of many otherwise unnecessary resignations'.[112] Local authorities were required to remove the evacuees where there were difficulties.[113] Controversy arose over billeting arrangements in Eastbourne. The *Eastbourne Gazette* on 10 March 1943 reported that 'householders wondered whether they might cause to regret the admission of Land Girls into their

homes… on the grounds that they are undisciplined and under inadequate supervision.'

Countess De La Warr responded to the critics. With the majority of the 1,700 Land Girls working in East Sussex living in private billets, she wrote 'We should like to place on record the gratitude we feel to those householders, numbering over a thousand, who have taken Land Girls into their homes, making them welcome and treating them as members of their families.' The *Gazette* editor stated, 'We believe that the suggestion that the girls are undisciplined merely exists in the imagination of those who have not come into contact with them. Naturally when women (or men) find themselves assembled in a little community one or two, or even a few, are inclined to make themselves objectionable in some way or other, for being young and full of zest their high spirits are apt to get the better of them… we do not believe that Eastbourne householders need have much cause for fear in this respect. We feel safe in saying that those who provide billets for the girls will discover that their fears are without foundation; and if they will only do what they can to help the girls they will have the satisfaction of having performed a piece of public-spirited war service and at the same time they will be serving themselves in helping to ensure that the food from British fields and farms reaches the table.'

The following month further measures were taken to ease the shortage of billets. Householders living in country districts who billeted agricultural workers, including Land Girls, were given partial or full exemption from any form of national service.

CONDITIONS OF SERVICE

The arduous work undertaken by Land Girls was usually monotonous, unspectacular and the hours long, the norm in theory being 48 in the winter and 50 in the summer. The dreary nature of the work was recalled by a long-serving Land Girl, Edith Barford. 'Most of the time was spent doing daily tasks, and the only variations came with the weather and the seasons.'[114] Another, Pauline Gladwell (née Clark) revealed that in her naivety she applied to join the WRENS, having grown somewhat listless with endless farm work, but was politely told the war effort might falter if people changed their job.[115]

The hours were often longer still during harvest time and, given the nature of the work, there were few opportunities to take leave. 'Land girls [only] had seven days' official leave a year, compared with twenty-eight days for the real military.'[116] Inez Jenkins in writing to members in *The Land Girl* in February 1943 made the point that the holiday entitlement had been included in The Land Army's 'Charter' (the minimum conditions that Land Girls could count on) and although 'Not a very long holiday to count on perhaps, but you who work in the Land Army know how hard it is for a worker to be spared from a farm for long or at fixed times.'

Many Land Girls could not remember exactly what they were paid, but Theresa Porter (née Hastings) who joined the WLA in 1941 aged 17 remarked 'I know that in comparison with the armed forces it was very poor, and we got very little by way of travel vouchers.' In 1943 the minimum gross wage for those aged 18 or

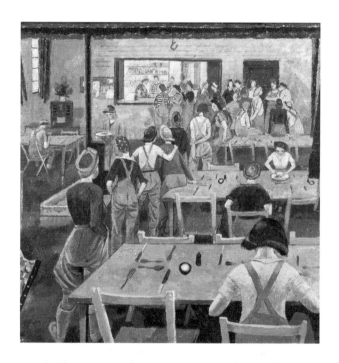

Evelyn Dunbar
Women's Land Army Hostel
(1943)
oil on canvas, 225 × 225 mm

over was 38s., and those between 17–18 years received 32s. for a 48-hour working week if billeted off a farm. The pay was inferior to that earned by women in factories, although 'women did relatively best in the buses and the railways – their average wage in those industries was over four pounds at the end of the war'.[117] Marjorie Bennett recognized that the pay was paltry and some girls barely had enough money to pay the train fare home but she said, 'we didn't really bother at the time because we were only kids anyway.'

Land Girls working in battle zones along the south and east coast were often subjected to danger – some were supplied with tin hats, but for most their only shelter from raids and machine guns was to dive for the nearest ditch. During the Battle of Britain 'the girls of the Sussex W.L.A. carried on with all kinds of outdoor work, with the "aerial navies battling in the blue" just overhead... and the same countryside being pitted with bomb craters around them'.[118] For those employed in 'Front Line Kent' and in particular those working on the cliffs of Dover within sight of enemy-occupied France and in the range of German coastal guns work could be hazardous. They too toiled in the fields as the Battle of Britain raged overhead. Nine Kent Land Girls were presented with County Badges at a rally at Maidstone Zoo Park for 'sustained courage under dangerous conditions' in July 1941.[119] Mrs F.C. Jenkins C.B.E., Chief Administrative Officer of the Women's Land Army from 1945–48 writing in the final number of the *Land Army News* in November 1950 recalled that in East Kent, five hundred Land Girls were at work and for two days, while the struggle was at its height, all communications were cut off. *The Times*

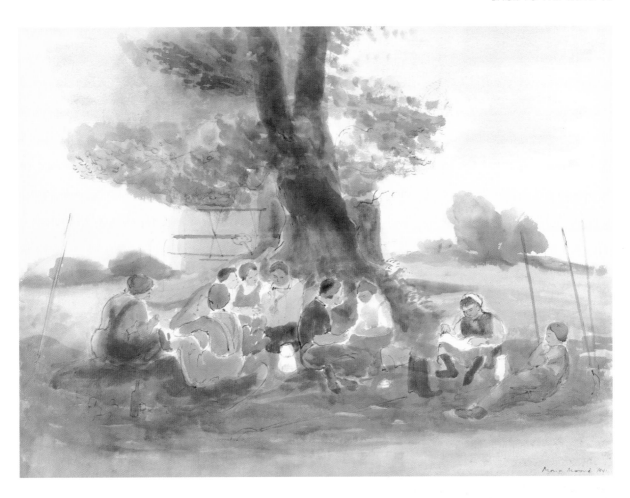

Mona Moore
Land-Girls Lunching in the Harvest Fields
(1941)
watercolour, 460 × 622mm
IMPERIAL WAR MUSEUM

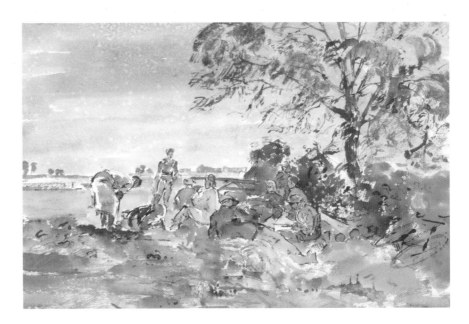

Thomas Hennell
Land Army Girls Resting
at Lunch-time
(1942)
watercolour, 304 × 469mm
IMPERIAL WAR MUSEUM

reported in May 1942 that a tractor driver, Grace Harrison, age 17, had been awarded the British Empire Medal for sustained bravery and devotion to duty in carrying on farming under the gun-fire and air attacks of the enemy. In October it was announced that 'Miss Beatrice Lark, forewoman on a farm near Dover for 12 months in spite of bombing and shelling, has received the Land Girls' Badge of Courage.'[120] As Margaret Biddle, who had been in Britain for a little over three months having left New York in March 1941 for London, wrote in *The Women of England*, 'It is painfully true that in England farming and a peaceful life are no longer synonymous. But the work goes on.'

The work did go on and Land Girls in East Anglia even had to learn to handle gas or shell-shocked animals. In the early stages of the war when gas attacks seemed imminent, 'A supply of sacks and cloths had to be kept dampened and laid over chicken coops, kennels and cowshed windows. If fields had been sprayed with lewisite or mustard gas it was the farmer's (and W.L.A.) duty to lead the injured and blistered cattle to decontamination areas'.[121] Christine Froude (née Williams) worked in East Anglia for nine years from 1941, having joined aged 17. She described how Octagon Farm, at Bixley, where she worked just 1½ miles from her home in Stoke Holy Cross, near Norwich, was completely destroyed by bombs on the night of 8–9 May 1942, the raid lasting a little over an hour as 62 HE (High Explosive) bombs fell in and around Stoke Holy Cross. In the course of the raid the farmer's wife Mrs Spruce died; lying under dairy shelves she saved the life of her son by covering him with her body.[122] Christine helped all day after the tragedy and

recalled that 'it was an awful experience as a stick of surface bombs had exploded on the park where the cows were grazing and most of them had to be destroyed as they had shrapnel wounds. It was terrible getting them up from the park with broken jaws, broken legs'. Dangers were also created in farming communities by 'the large numbers of crashing aircraft, in particular in the vicinity of airfields… Heavy bombers taking off laden with fuel and bombs represented a particular peril'.[123] A Forestry girl, Queenie Wells aged 30, was killed on 20 February 1945 by a fuel tank which had been jettisoned by a USAAF Mustang fighter, while she was working in Tangham Forest, near Woodbridge, Suffolk.[124]

From June 1944 Land Girls in southern England in 'Bomb Alley' faced a new danger from long-distance weapons, the so called V.1 and V.2 bombs. It was the V.1 (the British name for Vergeltunsgwaffen-retaliation weapons) or doodle-bugs that many remembered hearing. Peg Turner (née Burnham) recalled the distinctive rasping engine noise of these small pilot-less jet-propelled aircraft as they flew over on their way to London; a few she remembered were shot down and crashed locally. Jean Goodwin (née Richmond)[125] recollected how doodlebugs came down in several places on the farm she was working on, one blowing the roof off the cowshed.

Audrey Webb, who was billeted with a farm worker and his wife near Mayfield, Sussex, had vivid memories of a plane that crashed in a wood nearby. She recounted how 'in the night we heard cries for help outside the house from two airmen who had been badly burned.

This was quite a shock… The airmen were sent to the McIndoe Ward at the Queen Victoria Hospital, East Grinstead. The one who was burnt on the face was a wireless operator and an American in the Canadian Air Force. The other English.' She and another Land Girl visited them at the hospital where Archibald McIndoe was carrying out pioneering plastic surgery on aircrew.[126] Margot Bettles (née Gurl) remembered bombs dropping and being machine-gunned, and 'doodle bug-encounters' which were a particularly terrifying sight. As a result her nerves shattered and caused her to stutter for a month. The doctor recommended discharge from the WLA, and she duly left in July 1944.

WORKING ON THE LAND

The increasing wartime mechanization meant that women were required to take on jobs that hitherto had been considered beyond their capabilities. 'The idea of girls operating new modern machinery like tractors was quite revolutionary and newsworthy'.[127] In 1942, Pat Murphy's article 'Praise the land girls' in the *Daily Mail* pointed out that the 'highly mechanized condition of farming these days has rather worked in favour of the Land Army, for it is easier to teach an intelligent girl to drive a tractor drawing a plough or harrow or cultivator, which is like driving a car slowly, than to teach her to handle a team of horses. Also it is less laborious.'

Training at the Tractor School at the local farm in 1942 in the West Riding of Yorkshire lasted for 2–3 weeks where, apart from driving, a Land Girl was introduced

'to some implements and tractor engines – Standard Fordsons…[They] were then allocated to depots in villages where implements and tractors were stored and a forewoman was in charge. Occasionally one could be "loaned" to a different depot.'[128] Some Land Girls were trained at the Henry Ford Institute of Agricultural Engineering. A problem with the standard Fordson was that it had to be started manually by turning a starting handle, which proved physically demanding for Land Girls.

Land Girls were urged to 'study the makers' handbook, look over the nuts and bolts regularly, attend to lubrication, water and oil levels, and be able to supply clean fuel'.[129] Joy Atkins took a tractor test in which she 'had to answer questions on maintenance, start and drive the tractor, hitch up to a trailer and reverse round a course to show you could get into difficult places in reverse.' She recalled that 'as the war progressed we had to plough up more and more ground, and I was on a farm in Herefordshire with many cider apple orchards. So we had to start to plough between the trees and try to get a crop. Of course the old Fordson tractors had exhausts which stuck up in the air and got caught up in the branches. So we managed to find a few more furrows by using a horse plough, and a pair of horses.'

Shirley Murray (née Noble) joined the Land Army in September 1943, just a couple of months before her 18th birthday and served for nearly five years. In June 1944 she was sent to a farm in Breamore, near Fordingbridge, Hampshire where she learned to drive a Fordson tractor as the driver had been called up, and remained at the farm until he was demobbed.

FACING PAGE
Evelyn Dunbar
Threshing, Kent
(1941)
oil on canvas, 225 × 750mm
CROWN COPYRIGHT / UK GOVERNMENT ART COLLECTION

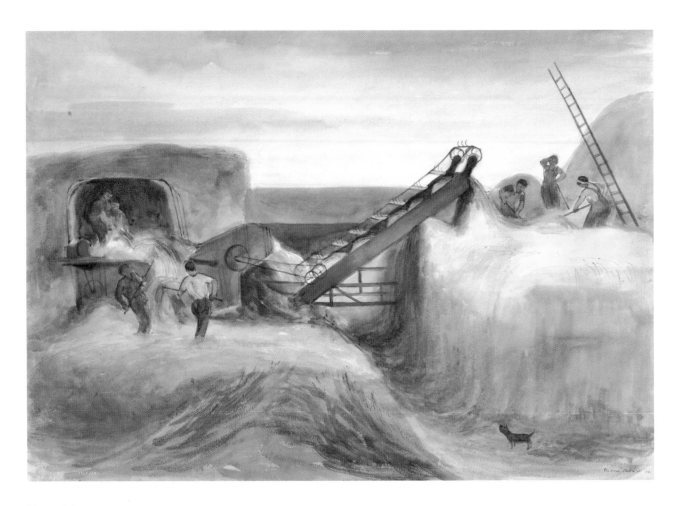

Mona Moore
Land-Girls and Soldiers Threshing at Maldon, Essex
(1941)
watercolour, 533 × 768mm
IMPERIAL WAR MUSEUM

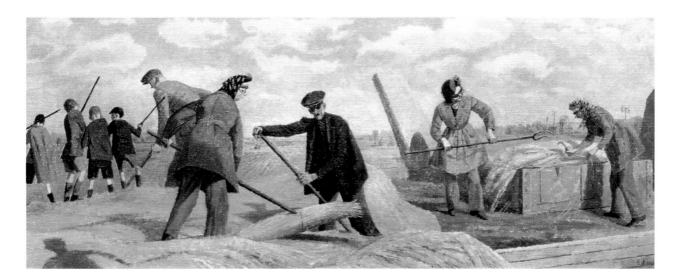

She recalled how in the winter the radiator had to be drained at the end of each day to be re-filled at the start of the next day. She was taught to use the whole range of implements for all cultivations. The plough was a two-furrow Oliver. The grass cutter was originally pulled by horses but had been adapted with a drawbar for use with a tractor. The binder or reaper was towed behind the tractor with a person sitting on a high seat at the rear, behind the flails, watching the corn stalks being cut, carried up into the binder by canvas sheets and thrown out tied into sheaves with binder twine on to the stubble; when the knotter failed to work or the twine broke, the corn stalks were thrown out loose. The sheaves were picked up by hand two at a time, heads together and butts apart and eight sheaves formed one stook. When dry, the stooks were tossed up into large wagons with high ladders at each end. As at haytime, one person stood in the wagon distributing the load evenly and those pitching used two-tine pitchforks. The fully-loaded horse-drawn wagons were then led to the rickyard where they were off-loaded on to a bed of hazel faggots. Corn stacks and hay ricks thus made were later thatched with straw by a journeyman thatcher who travelled from farm to farm. In addition 'Special gangs of girl thatchers were trained by the War Agricultural Executive Committees and sent about the counties under their own forewomen to thatch the stacks.'[130] Mary Doherty undertook a month's training at Rye, Sussex. She then spent several months each year travelling from one farm to another thatching their stacks after the harvest to keep out the rain. For each stack thatched she received a small bonus which supplemented her low pay. East Sussex had thatching schools at East Grinstead, Friston and Rushlake Green. At the end of the course Land Girls were expected to be able to thatch a rick from start to finish. Mr M.L. Harmer who undertook the teaching explained that they were taught to make straw 'mats' to act as temporary covering for the ricks until the proper thatching could be carried out. This was done by feeding straw into a machine which sewed it into lengths of about six feet which enabled the mats to be handled easily.[131]

Specialist tractor-driving units were created to meet the increasing demand for greater food production and dimmed headlights would be fixed so that relays of drivers could work all day and through the night. Stettinius writing about the Lend-lease scheme commented 'A tractor from the United States is a weapon just as a gun or a bomb is. It helps to feed British soldiers... Tractors are also weapons on the shipping front... It saves many tons that can be used instead to send to our allies.'[132]

THRESHING

The largest employers of Land Girls were the County War Agricultural Executive Committees. By November 1943 26,000 girls were working chiefly in gangs and for most, threshing was their main task from September to April. Iris Newbould (née Faulkner) was a member of a mobile threshing team of five, the contractor's machine was usually looked after by two men and the team were hired out to within a 12-mile radius of the base. She referred to this as 'Tramp Threshing', it lasted from September to April and they cycled to wherever the team was needed.

The Wiltshire Committee reported employing 26 mobile threshing gangs in 1942.[133] Kent in 1944 employed nearly 400 Land Girls threshing and they were seen as something of a pioneer Committee since before the beginning of each threshing season a one-day school for the instruction of gang leaders was held.[134] Evelyn Dunbar's *Threshing, Kent* shows some of the Land Girls in action, while a small group of school boys armed with pitchforks are watching and waiting excitedly ready to strike when the rats emerge from the sheaves.

Employing Land Girls in this activity was vital for the war effort, as unlike the early stages of the war, farmers could no longer rely to any great extent on help from soldiers, as recorded in Mona Moore's *Land-Girls and Soldiers Threshing at Maldon, Essex* (page 102) completed in 1941. The work was physically demanding, in noisy, dirty and dusty conditions. The dust penetrated everything, eyes, ears, mouth and hair were smothered. Land Girls wore head scarves, often made from slings purchased from the chemists for 6d., as well as goggles if they could obtain them from the War Agricultural Committee's limited stocks for 4½d. a pair. Freda Ward was filmed while threshing in Sixpenny Handley, Dorset by a unit from the Ministry of Information.

In threshing, cooperation and organisation were needed for a gang to be efficient. Regular groups helped and Land Girls would change places so each had a share of the clean and dirty work. A steam engine or tractor supplied the motive power.[135] A girl was usually employed cutting the bands, the strings around sheaves, before the sheaf was fed into the top of the threshing drum. This was less physically demanding but considerably more dangerous than other tasks on the threshing team. Not all WLA recruits coped with the work and some of the girls from the north who had been sent south to work in threshing gangs became homesick and simply returned home.[136] Vita Sackville-West pointed out that 'threshing did offer a chance of promotion to the most competent girl. She could become the forewoman, which meant better pay and the responsibility of keeping the time-sheet and the wages-sheet. It gave her some authority over comrades.'

Margaret Mace recalled spending time muck-spreading when she was not threshing. She described how this 'entailed digging out a year's accumulation of muck from the farmyard midden, loading it on to a cart, taking it to a field, dumping it in well spaced heaps on the stubble; then with a pitch fork, distributing it evenly over the ground.' She found it 'hard, blistering work as the dung could be very heavy and claggy.' At other times of the year Land Girls would be engaged in mangle pulling, potato planting and picking, hop tying and cleaning sheds.

HEDGING AND DITCHING

Another task during slack periods in the winter months was hedging and ditching. In addition to cutting back overgrown hedges Land Girls had to lay them too. Dorothy Medhurst recalled 'weaving the lower branches across gaps to keep the hedges cattle-proof.' The editorial in the *Journal of the Ministry of Agriculture* in December 1940 pointed out that 'The tens of thousands of waterlogged acres, ill-conditioned and sour, are a challenge to our resolution. Ditches

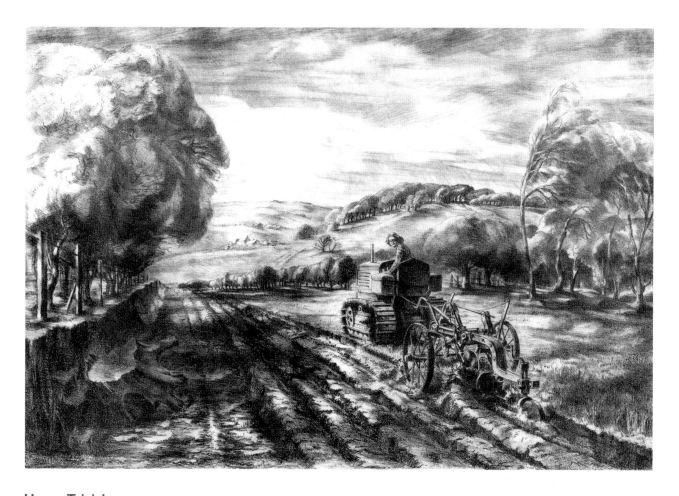

Henry Trivick
Women's Land Army Reclaiming Land for the Buckinghamshire War Agricultural Committee
(1944)
lithograph, 366 × 501mm

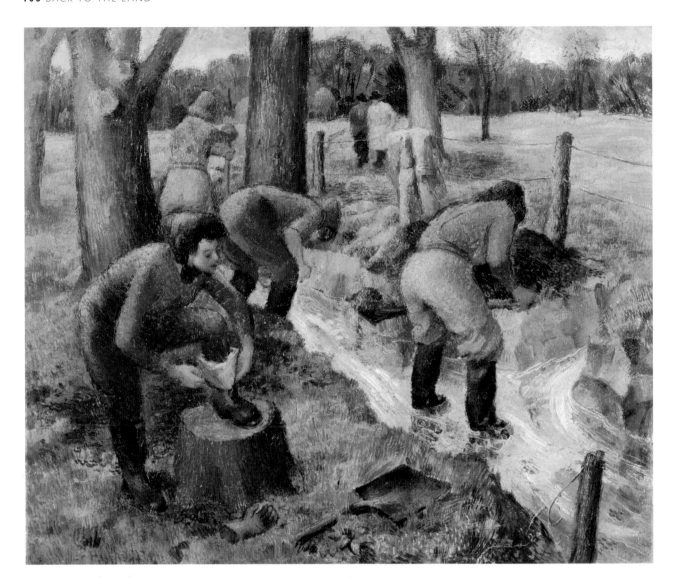

Leonard Daniels
Women's Land Army: Ditching
(1943)
oil on canvas, 508 x 609 mm

and drains must be tackled.' Land Girls tackled ditching with gusto, and for Jean Brace who worked in Much Hadham, it was her favourite job. 'Armed with a bagging hook and a bill hook, [she] cut the sides of the ditch and then tackled the hedge… it gave you a sense of satisfaction looking back at a nice hedge and ditch.'[137] Joan Anderson's first job was ditching. She had been sent to Newport Pagnell in 1943 and stayed in a hostel as part of a labour pool in Buckinghamshire. She recalled how she spent several months digging ditches: it 'was cold, wet, and very hard work, we didn't have formal training. We learnt as we went along, supervised by a lovely elderly countryman, just like a father to us.' Elizabeth Smith-Wright's post-war efforts were less satisfying. 'We used to get really mad because we couldn't make the bill hooks cut. We collected them from the "War Ag" in Chichester and one of the men told us afterwards that they deliberately didn't give us any sharp things because they thought we'd do more damage than good.' She remembered how one afternoon she and a friend got bored stiff and built a dam. 'We were miles away from everybody else and we built a little dam and the water stopped flowing. It took a long time before the girl in charge of us came bustling up and saying we don't know what's happened, the water's stopped flowing and we had to admit what we'd done. It made her laugh.'

With miles of ditches to be cleared several hundred men from the Pioneer Corps were drafted in to assist with the task. An editorial in *The Times* reported 'they are proving themselves as handy in a ditch as they are in clearing up débris after bombing in the towns.'[138] Later several thousand Italian POWs were employed

in land drainage. Increasing the productivity of waterlogged land remained vital and the Ministry of Agriculture's *Weekly News Service* Letter in December 1941 drew attention to the issue. 'Wet land will not grow good crops. … The Government and the War Agricultural Executive Committees are ready to help with advice, labour and machinery.' Land Girls drove Priestman Cub excavators to aid and speed up the clearance of neglected and overgrown ditches. H. Roby from Cumberland described in *The Land Girl* in July 1943 how it was 'a truly wonderful machine which lifts all the mud, clay and weeds (and frogs and eels)'.

Leonard Daniels' painting *Women's Land Army: Ditching* shows uniformed Land Girls reliant on their own labours to dig out and firmly bank the sides of the boundary ditch so that the water can get away. Two men stand in the field in the background watching the women at work, while for the Land Girls there is no luxury of mechanical assistance.

Great emphasis was placed on land reclamation particularly as the available areas that could be ploughed up for arable cropping diminished. Land reclamation and drainage came to be regarded as normal work for women, and there was 'nothing unusual in the sight of Land Army tractor drivers poised perilously against the skyline where foothills and steep Downland were being brought under the plough.'[139] Land Girls drove big powerful 'Gyrotillers to clear scrub from permanent pasture,'[140] although, in Henry Trivick's lithograph *Women's Land Army Reclaiming Land for the Buckinghamshire War Agricultural Committee* of 1944 (page 105), the tracked tractor

the Land Girl is driving is probably an Allis Chalmers Model M jumbo track plough giving a single furrow.[141] These were used for breaking up the 'greens' or lawns in the New Forest for planting during the war. 'Turned over on good time, preferably before the end of July, the soil gets the advantage of the summer sun and some preliminary tillage before the time comes to sow wheat in late September or October.'[142] Audrey Webb did not use machinery, and worked clearing the land of brambles by hand so that it could be reclaimed for food production. 'It was nice in the winter if it was cold as we could keep warm by the bonfire on which the rubbish was burnt.'

MILKING

The chief demand, however, was for milkers, tractor drivers and general farm workers. The decline in milk production which was particularly evident in the early stages of the war caused grave concern and on 27 February 1942 the Minister of Agriculture in a speech in Exeter stated, 'The men in the fighting line and in the factories and the women and children need every drop of milk you can produce. It may mean life or death. Every gallon counts.'[143] The *Eastbourne Gazette* reported in February 1943 that the WLA county office had a waiting list of over 50 farmers needing milkers.

Women's Land Army and Timber Corps, Employment Analysis, December 1943[144]

- Milking and other farm work: 20,159
- Other farm employment, not including milking: 12,251
- Horticultural employment: 10,817
- Other jobs: 1,674
- Employed by WAEC (War Ag Executive Committees): 26,374
- Timber Corps: 4,339

Milking was an important and exacting job. Many Land Girls excelled at it, particularly 'former typists, music students, and hairdressers, with their suppleness of wrist and finger.'[145] By September 1943 more than 20,000 Land Girls, or more than a quarter of the WLA, were employed milking.[146] In winter this involved getting up in the pitch dark, often in the wet and cold, and walking or cycling alone down unlit country lanes, guided only by the natural light of the moon and stars with just a torch for company, sometimes frightened by the silence, to be ready to start milking frequently before 5a.m. Milkers had not only early rising to cope with but it was more difficult to arrange holidays because as Dorothy Taylor commented 'You can't leave a cow unmilked'.

Many milked by hand. Vivienne Vick recalled, 'I'd never been up and about so early before. I found the farm, and hence the cowstall where milking had begun and was asked to stand back and watch for a while. Eventually I was given a milking overall, a bucket and stool, and placed beside one of the 22 cows. It was a case of "squeeze and suffer" for both of us. However after a few mornings and afternoons it all came right.' Alison Fishenden (née Huxford) was more fortunate; she was sent to Sparsholt Farm Institute for a month's training and was taught 'to hand milk, and how to use the milking machines. This included taking them to bits to clean them.' She remembered being 'a bit

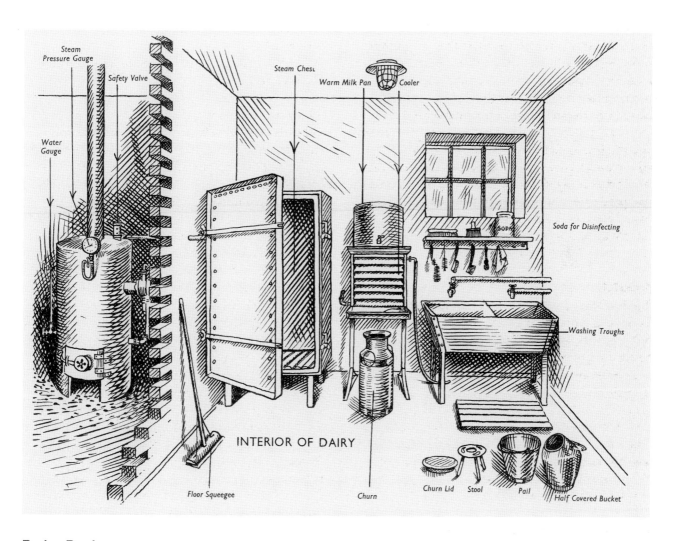

INTERIOR OF DAIRY

Evelyn Dunbar
'Interior of dairy'
from *A Book of Farmcraft*

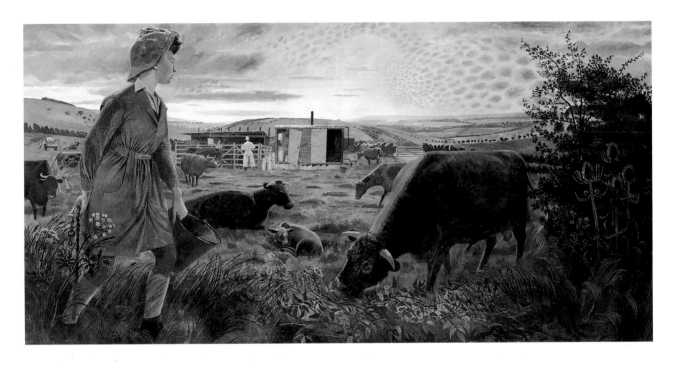

Evelyn Dunbar
A Land Girl and the Bail Bull
(1945)
oil on canvas, 900 × 1800 mm
© TATE, LONDON 2008

worried about this' and wondered what would happen if she 'didn't get it back together correctly.' She also 'had a turn at the milking bail (out in the field)' which features in Evelyn Dunbar's *A Land Girl and the Bail Bull*. Dunbar wrote the following brief description: 'It is an imaginative painting of a Land Girl's work with an outdoor dairy herd on the Hampshire Downs. The bail is the movable shed where the milking is done. Soon after dawn in the early summer the girl has to catch and tether the bull: she entices him with a bucket of fodder and hides the chain behind her, ready to snap on the ring in his nose as soon as it is within her reach – a delicate and dangerous job.'

While undergoing training at Sparsholt Alison Fishenden was also instructed in working in the dairy, where she learned about milk and its products and their preparation before they were sent away to be sold. The interior of the dairy is spotless to avoid 'germs or dirt spoiling the milk before it reaches the consumer'[147] and is accurately presented by Evelyn Dunbar in *A Book of Farmcraft*. Her painting *Women's Land Army Dairy Training* depicts in the foreground a dairymaid at Sparsholt moving the heavy milk churn by rotating it. The dairymaid was José Loosemore (née Smith). José recalled how Dunbar seemed to revel in farm machinery and 'instructive action' studies.[148]

Many Land Girls undertook machine milking, including Margaret Brittain who worked in Sussex. 'After the cows were in the milking shed and their feed put in the byres, the first job was to light the boiler for hot water and steam for the sterilising unit… I had not been on a working farm before and was surprised to find that

I had to wash the cows' udders before machine milking began. Putting on the milking machines was quite an exercise but they were very efficient and the cows didn't seem to mind overmuch with the occasional exception… Then the milk was carried into the dairy and poured into the Milk Cooler which had a large container on top with a corrugated metal surface underneath like a hollow old-fashioned wash-board over which the milk ran down the outside into a churn, while cold water was run through the inside. Before breakfast the cows had to be turned out into the field and the heavy 16-gallon churns had to be humped up on to a big wooden platform about a metre high ready for the milk lorry to collect.'

Not all milk was collected from the farms, as about one in three were producer-retailers who sold their milk directly to consumers. Sylvia Reeves (née Eyre)[149] worked on a small diary farm on the edge of Arthington, a few miles north of Leeds. She delivered the milk around Ilkley by pony and float, seven days a week with a half day off, with very occasionally a weekend off, although sometimes on a Sunday she had help from a village boy and was able to finish sooner. The float had no protection from the elements and 'When there was snow and ice Mr Garnett (farm manager) hammered frost studs into Doll's (the pony) shoes to stop her from slipping.' After completing her round she returned to the farm and washed and sterilised the bottles before undertaking general work such as hoeing or lifting roots, hay and silage making, stooking corn and in the winter putting mangolds and swedes through a chopper, or when the threshing gang came working as part of that team.

Milk production was a priority and a National Milk Recording Scheme was introduced from 1 January 1943. 'Milk Recording Societies had been in existence for many years before the war, but their membership had barely exceeded 4,000.'[150] Sylvia Reeves was asked by her supervisor if she wanted to be considered for milk recording as the Milk Marketing Board was recruiting girls who could cope with the paper work. By April 1945 nearly 200 Land Girls were employed in such roles. Sylvia Reeves explained that farmers were encouraged to join the scheme to improve the performance of their dairy herds and thereby make the best use of feeding stuffs. She worked as a milk recorder for 3½ years before leaving to get married in 1947. Edith Barford requested a change in employment and was offered a job as a milk recorder earning £3 a week based in the small town of Bridgnorth. This involved 'keeping a record of the amount of milk each cow gave in a location. From these records the farmers could choose to breed from the higher yielding cows, and so build up a more profitable herd. The recorder's work was to visit each enrolled farmer six times a year – with no warning – and check the weighings of milk from each cow, and take samples of milk for butter-fat testing if requested. A "visit" was for the afternoon milking and the following morning milking. A few farmers milked three times a day, so three visits in twentyfour hours was very tiring. Then there were the recording books to be checked; and records to be sent to the office in Shrewsbury.' To facilitate this process cows and calves had to be earmarked, requiring 'the punching of a number in their ear and then rubbing in black ink'.

A late development in Land Army work was the Relief Milking Scheme, whereby 'specially skilled milkers were employed by the War Agricultural Executive Committees to relieve the regular workers on the small dairy farms.'[151] Hazel Hobden recalled that the general idea was that she would go to six different farms a week, so that the regular milker had a day off. 'Some County Committees also employed Land Army gangs of emergency milkers, available to take over at short notice in times of illness or to substitute for regular workers away on their annual holiday. Both in the case of relief and of emergency milkers, a particularly careful choice of girl had to be made by the supplying Land Army organization, so that special milking skill and an adaptable personality might ensure her acceptance by farmers – and cows – of varying temperament.'[152]

Joyce Wardle, an early recruit to the WLA in 1939 when only 16, learned to hand and machine milk. She was confined to Motcombe Farm, Dorset owing to an outbreak of foot-and-mouth disease which was rife and struck the dairy herd she worked with. She described how deep pits had to be dug to bury the cows that had been shot. These pits were filled with quick lime as night bombing raids meant that the burning of the carcasses was not allowed. Some years later there were further outbreaks and Joan Thompson, who joined the Land Army post-war in August 1946 aged 17, recalled how 'The animals caught foot-and-mouth disease, the gate was manned and a bath of disinfectant put by it. No one came in or out, until German POWs were brought in to dig lime pits and bury all the slaughtered animals.' She was prohibited

from leaving the hostel, although two girls were eventually allowed to go shopping in Yeovil two miles away, but they had to wear Wellington boots and disinfect at the gate. When the animals had all gone the POWs and Land Girls scrubbed and whitewashed all the outhouses, stores, cowsheds, and pig sties.

LIVESTOCK

Land Girls were also expected to look after livestock. One of the tasks Freda Ward assisted with was the medical welfare of the animals. She was excused ram castrations and lambs' tail shortening but had to pare the nails and scrape the rot away from their feet where foot rot was obvious and administer cough mixture to the cows when they were unwell. Joan Anderson was for ten months in charge of 4,000 heads of poultry, feeding, collecting eggs, and sorting them in sizes ready for market.

Some Land Girls were involved in looking after pigs. Although the numbers of pigs declined during the course of the war, they remained an important source of meat. Frieda Feetham said, 'We had a very competent boar, although at the time I did not realise the full significance, only that by moving him around the pens we would eventually have litters of piglets.' Her ignorance of animal husbandry was not unusual amongst Land Girls.

The piggery run by women and depicted in James Bateman's *Women's Land Army at Work* (page 115) was very modern for its time. The pig depicted in some detail on the far left is a saddleback. The sows and

piglets are shown being fed probably crushed barley or a 'wet mix' of soaked barley, fish meal, bran or oats. Oats were produced in great quantities and mainly fed to horses. Mona Moore recorded *Land-Girls Carting Oats at Southminster, Essex* (page 118) in 1941. Grace Adamek (née Whitehead) hated feeding the pigs and piglets, describing how 'as soon as [she] entered their pen with the food they literally charged and once knocked [her] over in all the filth.'[153] Mary Hood fed the pigs she looked after on swill she collected by lorry from cafés and the 100 salvage bins in the streets of Harrow. The swill was cooked in two large tanks the day before. 'You just put cold water on it and mix it up because the pigs don't like it too hot.' Michael Greenhill and Evelyn Dunbar reminded Land Girls in *A Book of Farmcraft* that 'Pigs don't like their food too wet.' Pigs were also fed 'pigs' potatoes' – smaller or damaged potatoes that were rejected for human consumption. They were sprayed purple (a powder mixed with water issued by the 'War Ag') to prevent them finding their way back to the human food chain.[154] After feeding, the pig sties had to be cleaned. Mary Hood described how in the afternoon she had to 'wash them down with a hosepipe because the farm was in a built up area with houses all round it.' The farm 'had swine fever a year ago. That was a nasty time. We lost about 30 young ones, but we didn't lose any sows and they said that was because the sows were so well looked after.'

Although Bateman was well-known as a cattle painter, his farming background doubtless enabled him to capture the essence of this scene in the early summer of 1940 where Land Girls are making silage, a valuable winter feed mainly for cattle. The Government made a

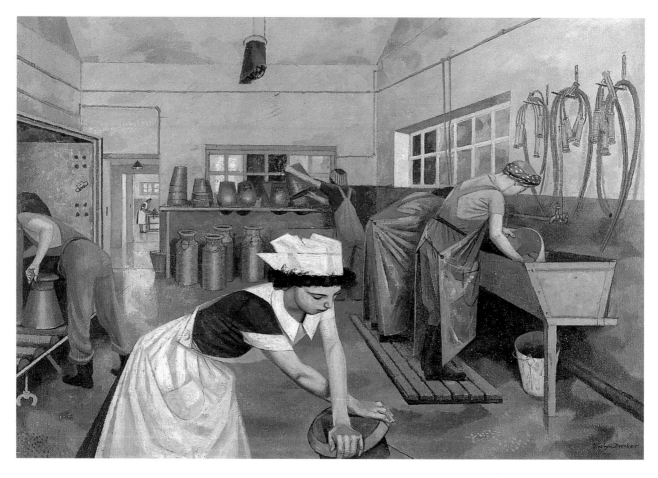

Evelyn Dunbar
Women's Land Army Dairy Training
(1940)
oil on canvas, 508 × 762 mm

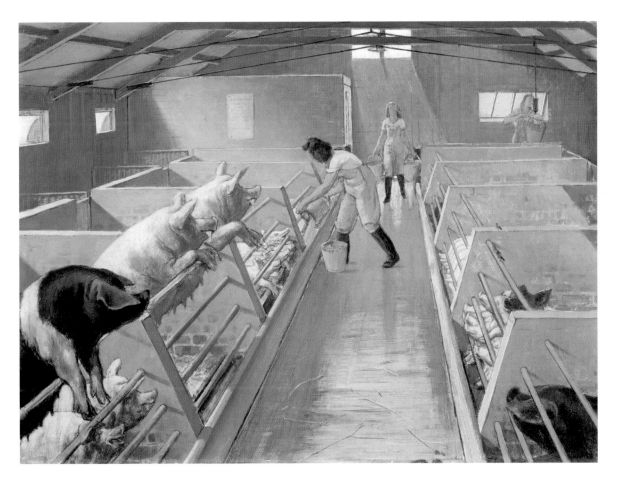

James Bateman
Women's Land Army at Work
(1940)
oil on canvas, 457 x 610mm

concerted effort to persuade farmers to take up silage-making during the war as shipping space could be ill-afforded for importing animal foodstuffs. The slogan 'Make Silage, Make Sure' was coined.[155] In Bateman's *Silage*, a Land Girl climbs up a ladder on the outside of the silo while those already inside help the farmer unload the cut and still green grass from the horse and cart into the drum-shaped container made of wire mesh and lined with tarred paper. 'It must be watched continually to prevent evaporation and over-heating, and the addition of molasses must be adjusted carefully to its condition. When you saw land girls dancing round the top of the silo, they were not merry-making, but treading the grass to compress it; this is a process rather like treading grapes and must be carried out with equal care.'[156] Once compressed, more grass would be added the following day, and the process repeated until the container was full. It was then covered to keep it airtight so that the grass could ferment. The smell was unmistakable, like a very strong figgy pudding fermenting, it pervaded the whole area and the fumes made some Land Girls feel ill. When the process was complete the mesh could be removed and the silage cut with a hay knife and fed to the farmer's herd.

PEST EXTERMINATION

Over a thousand Land Girls were involved in exterminating pests. This included rabbit-gassing, mole-trapping, work with traps or terriers, and gas and poison, but as Vita Sackville-West wryly commented, 'in plain English it usually means killing rats.' She pointed out that 'One rat will eat one hundredweight of food in a year, so a simple calculation shows that our fifty million rats will eat two and a half million tons of food in a year.' It was estimated that rats cost farming £25 million annually.[157] The Ministry of Agriculture issued leaflets 'to put an end to this pest' and launched a campaign against the rural rat. There was even a National Rat Week.[158] Trainee rat exterminators took special courses. In Sussex they were trained by Major Phillips, a Ministry of Agriculture expert and one of the most successful rat exterminators in the country. He taught them how to recognise rat trails, how to track down their lairs and how to kill them using dogs and also more scientific methods. 'The work entailed much work, patience, perseverance and forethought… The best results [were] obtained by unpoisoned pre-baiting – probably two applications, with a day interval between; that is, pre-bait on the first and third days and poison bait on the fifth day.'[159] *The Land Girl* reported that on 14 April 1945 two Land Army Pest Operators in Lindsey, Lincolnshire picked up 498 rats between 8.30a.m. and 3.30p.m. and asked readers if that was a record. Pam West (née Floyd) recalled that one of the girls in the hostel where she stayed was a rat catcher; they 'all looked up to her immensely, hanging on her every word.' Hilda Kaye Gibson spent two years rat and rabbit catching. Gwen Moody was offered a job driving at Driffield for pest destruction which she accepted as the work was much lighter. She went round farms baiting and poisoning rats and moles. In same year 1945 she was presented by the Queen with her 6-year arm band. Moles were troublesome pests. M. Foy and F. Ryding in Lancashire – like Yvonne Gwynne-Jones in the First World War – used to trap them and then skin each one; they then hung

the carcass on the barn or gate so that the farmer could see the record of their kills.[160]

HORTICULTURE

Over 10,000 Land Girls chose to go into horticultural employment, but most of those employed in private gardens had to be withdrawn in 1943 because of the farmers' prior claims.[161] Nina Vandenberg (née Hanke) volunteered for service in 1941 in Berkshire at the age of 27. She worked in horticulture as, at her interview, she was told that they 'couldn't put you on a farm as one puff of wind would blow you over.' Lillian Harbard,[162] who also joined in 1941, aged 26, had been working in the offices of the match-makers Bryant & May in Bow, London. For her, working at the old-established seed firm Suttons took some getting used to, but she began to enjoy working in the open air especially harvesting the flower and vegetable seed. She recalled that they were still allowed to grow a small amount of flower seed to keep up their stocks. She pointed out that 'Quite a lot of flower and vegetable seed was harvested by hand, picking into sacks tied around the waist, things like beetroot and cabbage, cut and stacked in "stooks", the seed was roughly cleaned and then sent to Reading to be finished off and packeted.' After a year of hoeing and hand weeding onions, she was given more responsible jobs in the greenhouses and frames and 'the special job of pollinating. This meant going round with a small brush and bottle of meths.' Joan Rackley (née Enfield) was called up for war service in November 1941 when she was 21 – also working for Suttons – she lived at home and cycled to work daily.

She grew and harvested seeds for distribution to people who were encouraged to 'Dig for Victory' and become self-sufficient in vegetables and fruit. She recalled that extra land was allocated to growing tomatoes and marrows for the local jam and pickle factory.

ORCHARDS: FRUIT PICKING

Land Girls also worked in orchards, pruning and fruit spraying, fruit picking, grading and packing. Gladys Benton (née Hellyer) was called up in 1942 aged 19 and given the choice of going to Sheffield to a munitions factory or joining the ATS or the Land Army decided on the latter. She particularly enjoyed fruit picking, first cherries, then plums and apples and pears. She worked at Gulson Farm, Boxted, near Colchester for 4½ years, and had to take her turn in the barn grading and working on the machine that sized the apples which was quite a new technique for those days. In the autumn and winter months her attention, along with the other 40 Land Girls from her hostel, was directed to pruning and spraying the trees. Margot Bettles recalled how apple-tree pruning made a change from tedious field work. *A 1944 Pastoral: Land Girls Pruning at East Malling* (page 122) in Kent by Evelyn Dunbar records Land Girls undertaking such a task.

Joan Culver was sent from Plumpton College to an apple farm with a small plum orchard in the village of Kirdford. She lodged in a farm house with another Land Girl and they both cycled to work ready to start at 7 a.m. They worked with three men all of whom, including the boss, were well over 50. She described how their year started with pruning and how she and

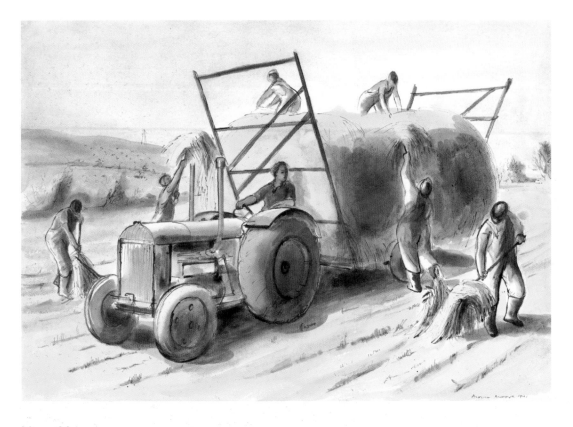

Mona Moore
Land-Girls Carting Oats at Southminster, Essex
(1941)
watercolour, 381 x 552mm
IMPERIAL WAR MUSEUM

James Bateman
Silage
(1940)
oil on canvas, 510 × 710 mm
LAING ART GALLERY

Dorothy, the other Land Girl, were sent in under the high branches to prune the low branches and their boss seemed to delight in working above them with a 'long arm,' especially when it had been snowing, so with every cut they had a shower of snow on them. Very wet days were spent at work in the barn cutting sacks into narrow strips to make grease bands for trees. In spring spraying and other cultivations started.

Margaret Mace worked in Worcestershire. She remembered the plum harvest and spending days picking different varieties of plums including Czars, Purple Pershores, Egg Plums, Victorias. She recalled that later gypsies were brought in by the farmer to pick the remaining crop. The big round fruit baskets they used held a 'pot' of plums. 'I believe a pot was approximately 70lbs. It took two of us to lift a basket up onto a gatepost; from there one put one's head under it, lifted it and carried it to the collecting point.'

GROWING VEGETABLES

Many Land Girls helped to grow vegetables for market. One universally loathed job was sprout picking on icy, bitterly cold winter mornings. Evelyn Dunbar's painting *Sprout Picking, Monmouthshire* (page 123) shows Land Girls bent double in ankle-deep, mud-sodden fields hardly able to look up from their back-breaking task as they work up the rows harvesting the sprouts from dawn till dusk. Peggy Moule (née Parfitt) who joined in 1943 remembered the ignominy of icicles drooping from their noses, while Jean Brace recollected the bitterly cold winds and how she made gloves from old socks, cut down and sewn up. As Sheila Newman

commented, 'The brussel sprout requires a little force to break it from its plant and in no time our hands were soaked and frozen, there were no gloves on the market that were adequate protection.' In spite of their Wellington boots they would get soaking wet from the stalks as they worked between the plants thick in ice and sometimes snow-covered, such that the knife would freeze along with their gloves in their hands. Molly Horne (née Day) remembered many of the girls crying with the cold. In order to protect themselves from the wet stalks they would tie thick old brown sacking around their waists. Once the sprouts had been picked over for the last time the tops were slashed off with bagging hooks before being ploughed in.

Sprouts, like other vegetables, were supplied to canteens and hotels and all had to be harvested and delivered irrespective of the weather. Vera Green (née Parker) delivered the vegetables in a very old van. On one occasion she and a friend had a lucky escape, the air raid siren started and as they entered a hotel they could hear the planes overhead. They hurried as fast as they could back into the van and tried to get away as far as possible. 'We hadn't gone far when we heard a terrible bang, and found out later the hotel had had a direct hit.'

Some Land Girls in Hampshire were employed to grow vegetables for the Navy. A.S. Hartrick portrays a group in a field on the south coast of England, harvesting and packing cabbages into small slatted wooden crates ready to be sent to Naval hospital ships. In the background there is a ship out at sea, and in the distance the Isle of Wight can be glimpsed.

Archibald Standish Hartrick
The Land Army Growing Vegetables for the Navy
(1940)
lithograph on paper, 444 x 570 mm
PRIVATE COLLECTION

FACING PAGE
Evelyn Dunbar
Potato Sorting, Berwick
oil on canvas, 300 × 750 mm

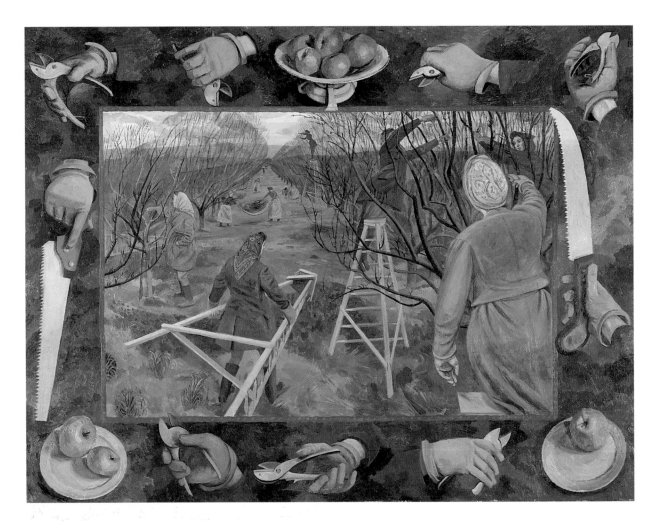

Evelyn Dunbar
A 1944 Pastoral: Land Girls Pruning at East Malling
(1944)
oil on canvas, 910 × 1210 mm

War-time privations coupled with the fall in imports increased the demand for potatoes, together with wheat and milk. The potato acreage nearly doubled during the war and although mechanization of planting and lifting provided some relief the burden had to be met largely by Land Girls, school children and later prisoners of war.[163] Edith Barford spent six weeks picking potatoes in the black fen soil of Bourne, Lincolnshire, and then moved on to carrots for two weeks. When the work ran out she was sent to another farm. Joyce Wardle remembered what a substantial task farming potatoes was. 'Planting in the spring, weeding during the growing season, picking them in the autumn and storing them in huge mounds which were then covered until they were required for the shops. They then had to be dug from the mounds, "riddled" for size and then sacked up and tied.' She had on more than one occasion to take cover as German bombers machine-gunned them or jettisoned their unused loads of bombs on their return journey from Bristol docks.

The Land Girls in Evelyn Dunbar's *Potato Sorting, Berwick* are fortunate to have the benefit of the machine for sorting. For others like Joyce Wardle this labour-intensive process was done by hand. Patricia Parkyn commented, 'every potato had to be picked up, looked at to make sure there were no blemishes and then bagged in sacks of exactly one hundredweight.' Muriel Berzins had constant back-ache during what she described as five weeks 'spud bashing'. Dunbar's Land Girls are lifting potatoes with large forks with flattened prongs and blunt enlarged ends from the clamp (the roof-shaped pile of potatoes). One is

Evelyn Dunbar
Sprout Picking, Monmouthshire
oil on canvas, 228 × 230 mm
MANCHESTER CITY GALLERIES

caught in action, as she throws the potatoes into the machine which has a base with holes of different sizes and is constantly vibrated by the Land Girl turning the handle, which allows the potatoes to go through the holes as most of the soil is shaken off. The hoops round the machine form a protective guard. The smallest potatoes fall out first into the wire baskets and the larger, and best ones, go onto a small elevator and into the sacks the men are holding. The two Land Girls leaning against the machine watching the elevator pick out any diseased or damaged potatoes that can be fed to cattle.[164]

FLAX

Land Girls also provided an important source of labour for the growing, harvesting and stacking of flax ready for processing in the factories. The advent of war saw an increase in the acreage devoted to its cultivation. In 1939 the total area of flax for fibre and linseed in the United Kingdom was 65,000 acres; by 1944 it trebled. In 1931 its cultivation had dropped as low as one experimental plot on the Royal Estate at Sandringham.[165] Flax traditionally had been imported from Russia, the Baltic States, Holland, Belgium and northern France but this was no longer possible. The revival was necessitated by demands from the fighting services, particularly for canvas, aeroplane linen, parachute webbing, fire hose, threads and twine.

Flax growing and harvesting was not without its difficulties, as it required fertile soil and much labour, ideally a core of which were experienced flax workers at a busy season of the year. Land Girls, although inexperienced, assisted with its careful pulling by hand. Irene Eady recalled 'the chain harrowing, dragging and rolling the flax fields meant an awful lot of walking behind them or along-side the team. At that time acres of flax were grown in the Bridport district in west Dorset, this plant had to be pulled up by the roots.' She said, 'There was a machine to pull the clean fields, we got the weedy and over-ripe fields. This was extremely tough on the hands, like pulling knotted wire. Our hands were often bandaged. At one point we were working from 8a.m.-8p.m. but thankfully this didn't last very long.' She recalled that nearby at Slape was a flax mill. Previously derelict, this was rebuilt and refurbished between spring 1939–41 by Rolf Gardiner, ecological campaigner and youth leader, who was involved in developing the Wessex flax industry. The mill lay in the folds of the Brit valley below the village of Netherbury. 'With a core of experienced flax workers and a host of school children, Women's Land Army members and even troops drafted in at harvest time, he tried to create a thriving rural craft industry based on independent growers, processors, spinners and weavers with the aim of organising them into a regional guild under the slogan "Wessex fabrics from Wessex fields".' Gardiner tried to instigate flax feasts and harvest festivals with accompanying folk song and dance, but was thwarted by the Home Flax Directorate who wanted to see a highly mechanised, centrally controlled flax industry and in the end left him no choice but to part company with them in 1942.[166]

Nora Lavrin completed a series of four paintings of flax workers in 1943: *Dressing Green Flax*;[167] *The Rugging Machine*

in a *Flax Factory*; *Flax Workers at the Deseeding Factory* and *Land Girls Unloading Flax*. In the latter painting the elevator the Land Girls are unloading was probably connected to a drier as there are large ducts coming out of the side of this building. Paddy Gilbert (née Laker) who had joined the Land Army in the summer of 1942 aged 16, and served for three years, started work at a flax mill in Sussex. Her job was to accompany the lorries when once a week they collected from the flax farms in Kent and Sussex. When not doing this she worked at the factory, 'feeding flax on runners up to the mill'. She admitted that this 'came to an end when most of us got fed up having to take turns on the night shift and asked for transfers.'

CYCLING TO WORK

Some Land Girls were provided with bicycles, for many their only form of transport. Freda Ward, in an unpublished memoir, *Work, Laughter and Ardship*, described how she was issued with a bicycle from the Ministry of Agriculture and Fisheries. The machines were heavy and black all over and virtually thief-proof. The badges bore the gold-coloured letters 'M.A.F.' The farms Freda worked on, with one or two exceptions, were reached by bicycle. Batteries were hard to get, 'so when cycling after dark in the vicinity of Sturminster Newton in Dorset the first girl in the gang, Barbara James, had a front light and the last in the group a rear one – with the remaining twenty four girls without any lights at all. It was always Barbara who was caught because she had no rear light. While she was being questioned we all rode swiftly past her. She made several court appearances on behalf of us all and the five-shillings

fines that she had to pay were financed by collections in the hostel.'

When cycling, Land Girls would often be offered lifts in passing Army lorries, who would take both cyclist and bicycle. Molly Horne joined post-war in 1947, aged 19, and remained for two years. She was issued with a bicycle but this was for use only when working within a three-mile radius of the hostel. Further afield they were transported by lorry. Hazel Lamb (née Waite), joined in 1942 at the Sheffield Labour Exchange, aged 18. 'If we had to cycle more that 10 miles each day we received an extra one shilling per day'.

LEND A HAND ON THE LAND

As in the First World War the demands placed on increasing food production meant a larger substitute farm workforce particularly given that many had abandoned farming for more lucrative employment prior to the outset of the war. Between January and June 1939 10,400 regular and 65,000 casual workers were lost to other occupations, including in the early stages of the war construction industries.[168] The subsequent mobilization was far better organised than in the First World War. 'Survival on the home front depended above all on the successful gathering of the cereal and root crop harvests by the regular workforce enhanced by a remarkable combination of local and urban volunteers, reservists, students, youth service volunteers, voluntary labour clubs, schoolchildren, and of course the Women's Land Army, prisoners of war and displaced persons of varying nationalities.'[169] Joan Anderson worked with displaced persons from

Nora Lavrin
Land Girls Unloading Flax
(1943)
watercolour, 450 x 577mm
IMPERIAL WAR MUSEUM

Hungary and remembered how all they talked about was how soon they could be sent to Canada. Muriel Berzins worked alongside Latvians and Estonians and married one. Land Girls were also assisted by conscientious objectors who as a condition of their exemption from military service were required to take up agricultural work. The agricultural correspondent of *The Times* wrote, 'Some of the intellectuals will be of little use on farms, but there are a good many others who are genuinely anxious to give national service in this way, and who will put their backs into helping the food production campaign.'[170] Molly Campbell worked with several conscientious objectors and did not recall any trouble. Margot Bettles remembered working with prisoners from Lewes Gaol in East Sussex. Soldiers on leave also assisted with the harvest.

Posters exhorted those in the cities to help bring in the victory harvest. One by John Holmes Jnr[171] urged workers to spend their holidays helping with the harvest, be it bringing in fruit at the end of July and early August, grain in mid-August to September or potatoes in October. A poster by Showell was emblazoned with the slogan:

> Whatever your front line job
> This is your second line job
> Lend a hand on the land

Many did respond to the call to lend a hand. 'The Ministry of Agriculture was initially keen to promote Emergency Land Corps of locally based rural volunteers. It soon became apparent, however, that far greater numbers of seasonal volunteers would be required

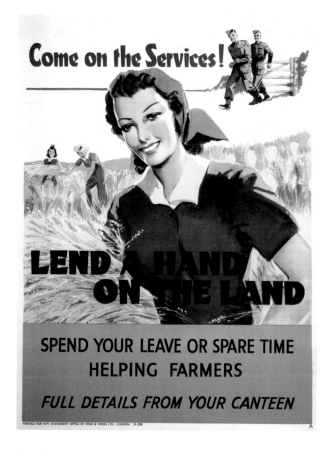

Recruitment poster
NATIONAL ARCHIVES

for harvesting to which end urban Voluntary Land Clubs and, in particular Adult Harvest Camps were vigorously promoted throughout 1940 and 1941.'[172]

Gladys Wheatland had been exempt from National Service as she was looking after an elderly lady until she died, although she was for several years a member of the Worcestershire Federation of Voluntary Land Corps. She recalled being involved in trying to attract more recruits. A special leaflet was produced which explained that Voluntary Land Corps were operating all over the country and eight were already in existence in Worcestershire. The first had been started in Altrincham in 1939 'by an enterprising bank clerk and barber, and its members were recruited mainly from town-dwellers engaged in normal indoor occupations common to urban life.'[173] The movement spread rapidly throughout the country and particularly in the provincial centres. Members did not need any experience of farming, and worked evenings and weekends undertaking a variety of farming operations. Gladys said, 'I sat outside a shop in Worcester for a week trying to get people to join. Some picked it up… but it was mostly office girls who volunteered.' Those that did volunteer worked in teams with a skilled leader. While farmers paid for their labour, all earnings less expenses were given to charities nominated by members. It was reported that in one year over 2,000 members in the county did 26,138 hours of labour on local farms and £700 was earned. Gladys worked 103 hours[174] around Worcester in a small party of 6–8, doing all sorts of jobs including pea picking, hoeing, and hop tying before joining the WLA in July 1943, and was one of 14 awarded a special badge

for completing 100 hours. At a meeting of the County Federation of Voluntary Land Corps the work of all women workers in agriculture was praised but the members of the Voluntary Land Corps, 'The "Territorials" of the Food Production Army', were singled out for also performing a valuable social service in bridging the gulf which had existed, and which should not exist, between town and country.[175]

HARVEST CAMPS

One of the difficulties of using urban workers was the shortage of accommodation. This was overcome by adult harvest camps, although it was not until 1943 that large numbers of volunteers attended when servicemen, who had helped the previous year with the harvest, were withdrawn. In that year 35 counties established camps, attended by 80,000 volunteers, London and Manchester being two of the most prolific sources of volunteers. Harvesting was now suddenly everyone's business and in order to handle these large numbers recruiting offices were set up.[176] The Middlesex Agricultural Committee established an office at Uxbridge for Londoners to register for work in the Home Counties; others were in Leeds, Manchester, Bristol, Birmingham and Cardiff. The Labour Correspondent for The Times wrote 'Holiday farm work will constitute the third line on the agricultural front. In the first line are farmers, farm workers, war agricultural committee work gangs, the Women's Land Army and Italian prisoners. The second line is composed of the rural reinforcements and country children. Holiday helpers and "loaned" agricultural workers make up the quite important third line.'[177]

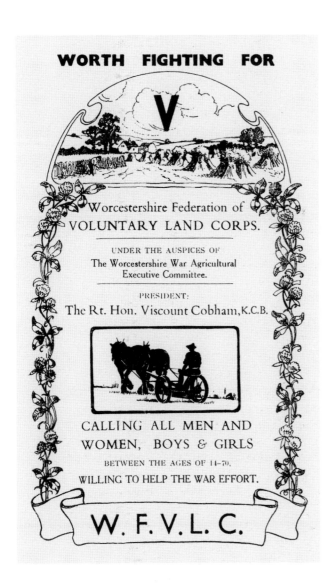

Voluntary Land Corps recruitment leaflet

Harvest camps were established for men and women over 17 years of age, two thirds of whom were women of all classes and occupations, and were held largely under canvas. Although some premises were requisitioned by the government, they were run on similar lines to the flax camps of the First World War. Publicity campaigns including posters and advertisements had to be organised, equipment ordered, staff engaged and travel arrangements made. Many firms and factories arranged to stagger staff holidays for 'those members of their staff who had volunteered to attend a camp, so that parties could attend in successive weeks.'[178] Campers were charged the bare cost of their board and men received at least one shilling an hour and women 10d. an hour. The work undertaken included market garden-type work and harvesting.

The editor of *The Sussex County Magazine* in August 1940, in discussing the need for 'Man Power for the Land', pointed out that more willing help was needed. 'Holiday labour is being offered for the hay and harvest periods, and University students and boys, as well as many young teachers, are coming forward, especially for the school and university holiday periods.' Students at Bedford College of Physical Training worked for the Land Army Emergency Scheme in their free time. Those at Newnham and Girton Colleges volunteered as seasonal workers with the Women's Land Army.

SCHOOL CHILDREN

School children across the country made a major contribution, particularly during summer and autumn

FACING PAGE
Eileen Evans
Recruitment poster
lithograph on paper, 753 × 500 mm
IMPERIAL WAR MUSEUM

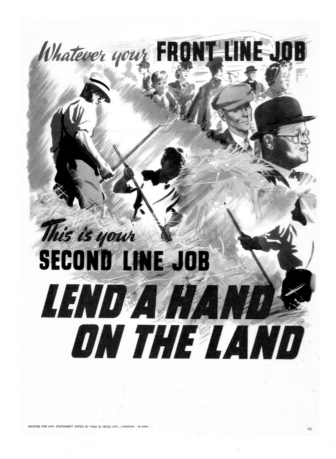

Showell
Recruitment poster
lithograph on paper, 504 × 379 mm
IMPERIAL WAR MUSEUM

harvest work. Farmers appealed to the Board of Education from the beginning of the war for a relaxation of the attendance and child employment legislation. 'It had long been the practice… for country children to take time off school to help with root-crop hoeing, haymaking and potato-picking, and after war broke out this became almost an informal element in the curriculum of rural schools.'[179] In September 1939 the Isle of Ely authority announced that local children could be exempt from school to help with the harvest. Huntingdonshire gave whole schools potato holidays so that a small proportion of pupils could work on the farms.[180] Warwickshire War Agricultural Executive Committee had run for a number of years an extensive and successful School Harvest Programme. The Australian artist Norma Bull drew *Children Helping with the Harvest, near Coventry*. She wrote, 'Potato harvest with Warwickshire school children helping. Some prefer this paid war-work [9d. an hour] to unpaid lessons.' The children are bent down working their way up the field. In the background are thatched ricks and a camouflaged tower. Floating overhead are a number of barrage balloons to protect the residential areas. Ellen Chambers who joined the Land Army in 1941-2, and lived at home, recalled potatoes being harvested in late September with assistance from boys from Shaftesbury Grammar School. 'We had to go behind them to pick up what they had left!' Nonetheless, without the assistance of children, 'it would have been impossible to plant and lift over 1 million acres of potatoes… before 1944 when prisoners of war became relatively plentiful.'[181]

School children assisted in a variety of ways. A Boys' Land Army to be recruited from the elementary and

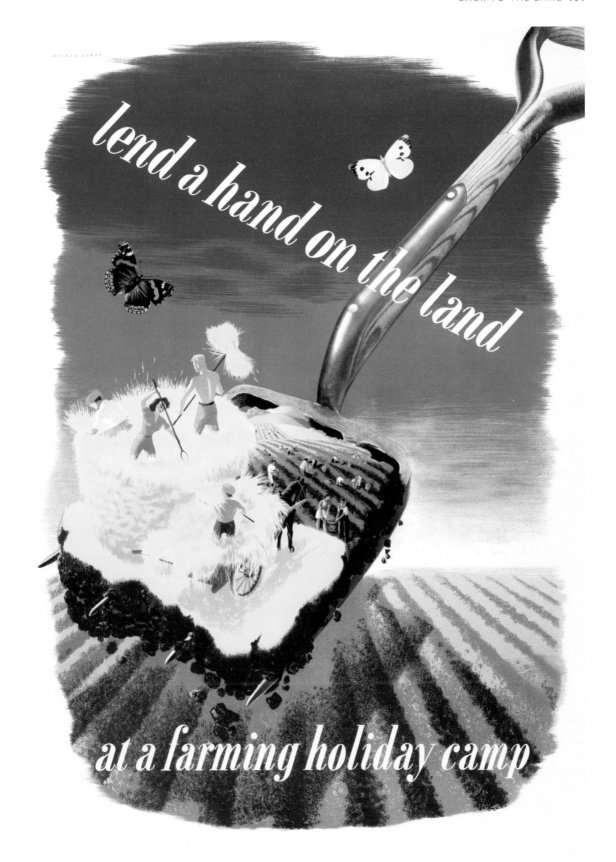

PRINTED FOR HM STATIONERY OFFICE BY CHROMOWORKS LTD LONDON 51 3727

ISSUED BY THE MINISTRY OF AGRICULTURE

secondary schools from boys aged 5–16 along the lines of the women's was even proposed in November 1939 by Lady Doris Stapledon who had been involved in the organization of the WLA in the First World War. Several public schools involved their boys in harvest camps. Harold Clarke, a boarder at Chigwell School in Essex on the north-east borders of London, recalled in the spring of 1941 being asked by his teacher whose brother had a farm in Dorset and was short of labour, if he and a small group of boys were willing to offer assistance. They would be provided with accommodation and food. He and five other boys readily agreed and spent their six weeks' holiday helping with a variety of tasks. Some of his tasks involved assisting the Land Girl milking and cleaning the cow stalls when not required to help with the harvest. He said 'The Land Girl I worked with was very efficient and was always willing to help me when milking …and her humour was also a great asset at times. On one occasion the electric generator broke down and I remember her comment, "When the machine works I am in charge, but when it stops it is master of me".' Another vivid memory was of the 'excitement towards the end of cutting a field of wheat, for the rabbits had no room to hide and had to bolt for cover, the local village adults and children were aware of this and would arrive in numbers to try and catch the escaping rabbits, as rabbit pie was not on the ration list.'[182] Rabbits were also prized by Land Girls. Freda Ward while also working in Dorset sent dead rabbits home through the post. She remembered how she tied the rabbits' back legs together complete with label and they arrived the next day, none stolen.

Fifteen-year-old Viola Smailes also helped on the land during her school summer holidays in 1942. At this stage there were 569 camps for boys, 75 for girls and 10 which were mixed, attended by 31,000 children. The previous year there had been only 12,000 volunteers.[183] She remembered having no idea what land work meant but was pleased to get out of London after the restrictions on travel. As she and the other children were all unskilled, they did jobs such as apple picking and potato bagging, working from 7a.m.–5p.m. The following year she undertook a second holiday harvesting. This time her jobs included milking, feeding the pigs and collecting the eggs from the hens. 'This meant the experienced WLA members could get on with the harder jobs.' Following this experience some of her fellow school girls volunteered to join the Land Army after they left school.

PRISONERS OF WAR

Increasingly prisoners of war (POWs) were employed on the land; at one stage there were over 100,000 working in the countryside.[184] Their use 'raised critical issues of safety, security and accommodation.'[185] The influx of Italian POWs led to an article by a *Daily Mail* reporter headlined 'Land Girl code', the subtitle of which read 'Don't be Friendly with Italians'. The article related particularly to new young recruits aged 17 and 18 who would have to work in the fields side-by-side with Italian prisoners. These concerns were similar to those raised in the First World War which were also largely unfounded.[186] Lady Denman was quoted as saying, 'no incidents of "over friendliness" had been reported…'. However, she acknowledged that some

of the new recruits would need guidance. Girls should be courteous but not over-friendly. Iris Newbould worked with Italian POWs based at Malton,[187] and believed that they would be in trouble fraternising with the enemy so they 'used to pretend to be deaf or not interested… [when they were passed] love letters written on toilet rolls'. Freda Walker recalled that the Italians 'were alright. They lived in a camp up the road. We weren't allowed to frat with them but they were friendly and would write notes and leave them in a bucket, we would read them if we could understand them, then burn them.' For Rosemary Wilson and other Land Girls this was definitely not the case. 'As far as working with POWs – many girls had brothers and boyfriends some away for years fighting in Europe etc, so we did not become friendly and usually the men worked in different fields.' Audrey Webb, who only saw an Italian POW once, recalled that when he came over and spoke to them they felt a bit scared. Such a reaction was not unusual. Betty Cornish (née Marshall) who joined in 1942, aged 17, was petrified when she saw her first POWs (Italians) wandering about in fields near the farm in Barcombe, Sussex where she was working. 'They were easily recognised by the dark brown battle dress with large dark green patch on the back and legs. They were obviously miserable and homesick and wanted to talk… [she] told the farmer, who said "don't worry, they work on the next farm, they won't come in here. I've got a shot-gun handy!"' Ruth Desborough who worked near German POWs revealed that one of the group was 'always working on his own and we began to feel sorry for him after our initial prejudice. Some spoke a little English and occasionally they would meet up with us in the course of the day.'

Land Girls in general felt that the German POWS were hard workers, although some like Joan Anderson found them arrogant and 'always put us and England down', whereas Italian POWs were lazy. As Elsie Cowley (née Ward) commented, the Italians 'left us to do the heavy work, we found we could lift and carry 18-stone sacks of corn and chaff from the machine and hoist them onto lorries with no trouble at all once we were used to it.'[188] Kay Lawson (née Radcliffe) worked with both Germans and Italians potato picking. She 'went round with the horse and cart picking up sacks as they were filled… the Germans were particularly efficient and helpful'.[189] A.G. Street wrote in the *Farmers Weekly*, 'from the little I have seen of the work of the German P.O.W. to date, he seems to be worth three average Italians; since the way in which many of the latter cycle and laze around the countryside is little short of offensive.'[190] *The Times* and other regional newspapers received numerous letters from readers complaining about the indiscipline, idleness and comfortable living conditions the Italians enjoyed.[191]

Freda Ward believed the Italian POWS nearby were not only better fed and clothed than Land Girls were but also they had more conducive working conditions. She revealed how 'on one occasion part of the ditch of one field was dammed off for their use as a latrine. For their work they were issued with long waders over the knees. We had just Wellington boots. We were working downside of them and they were clearing the same ditch. Eventually they undammed their ditch letting everything surge along in the foul water and filling our boots which was most unpleasant.' She also recollected how 'At the first sign of rain the prisoners

Norma Bull
Children Helping with the Harvest, near Coventry
(1941)
pen and wash, 571 × 774mm
IMPERIAL WAR MUSEUM

Michael Ford
Italian Prisoners of War Working on the Land
(1942)
oil on canvas, 762 x 914 mm
IMPERIAL WAR MUSEUM

would be escorted to a nearby barn to shelter, whilst we had to work on and stop only when conditions became impossible. There was no shelter for us and the only protection we had against the rain was our overcoats. No waterproof clothes were issued to us.' Dorothy Medhurst was also aware of the contrast in working conditions and recalled a gang of Italian POWs brought to the east Sussex farm where she worked for potato lifting. 'They arrived at 9 a.m. I had started 7.30, first thing they would do was go round the rabbit snares they had set the day before. The rabbits caught were handed over to two men who would raid the farmer's barn for root veg, they would get out the big cooking pot they carried on their lorry and get the fire going.' Dorothy recalled how 'at lunch time I would be sat in the shelter of a hedge eating a cheese sandwich while the aroma of rabbit stew wafted around.' She too remembered how the prisoners stopped work at the slightest hint of rain and returned to their camp at 4.30 p.m. She said, 'Looking at their clothes, clean every morning and my muddy trousers and jacket made me wish the Geneva convention covered Land Girls as well as POWs.' She described how the farmer she worked for was concerned that the potato yield was so low and 'when the POWs were gone he found potatoes just under the soil. The Italians had picked up a few and scuffed soil over most of the crop. I spent hours going over that field again to get out the potatoes that had been left.'

The gang of Italian prisoners depicted in Michael Ford's painting of 1942 appear more industrious as they pick potatoes and fill wicker baskets to carry to the waiting horse and wagon.[192] At the time Ford was recording

this scene there were 20,000 Italian POWs working on the land who were paid a small wage for their labours. The prisoners are shown supervised by a single soldier at the edge of the field. Some prisoners were later billeted on farms and worked unguarded. On the skyline a tractor, probably a Fordson – the colour had been changed from orange to green because when they arrived in quantities as part of the Lend-lease scheme they made an obvious target for German bombers at the docks – is using a Ransome potato spinner to turn out the potatoes from the ridge of the soil prior to gathering by the prisoners whose clothes are marked with a distinctive red spot.

RECREATION AND WELFARE

Land Girls often had little time, money or perhaps, more importantly, little energy for leisure activities. Those living in spartan billets or on remote farms often had no transport to travel to the nearest village for the local dance. The editor of *The Times* pointed out that Land Girls were 'not living a communal life like the ATS or the WAAF, and furthermore they have so far been denied the use of the NAAFI and other canteens established in many rural districts for the benefit of men and women in the services. When a member of the Women's Land Army spends her half day in the local town she may have nowhere to go for recreation except the local cinema or a teashop or a public house. She has her official uniform, but this does not give her entry to the canteen where she would enjoy meeting other young people in the services.'[193] The matter was twice raised in the House of Commons in March and April 1942 but to no avail.

It was an issue that incensed Land Girls. Frieda Feetham recalled, 'there was only one WVS service club in Norwich which welcomed and served Land Girls. The manageress Molly Kent at the outbreak of the war volunteered for the WLA but had to resign because she was not physically strong enough. Knowing how demanding agricultural work could be, Molly allowed chocolate to be sold to Land Girls. Before long two policemen called to warn Molly that if she continued to sell chocolate to Land Girls she would face prosecution and imprisonment, ludicrous as this sounds… Land Girls were allowed to keep their sweet-ration coupons, whereas other service girls were not issued with coupons but could buy confectionery at NAAFI and general service clubs from which Land Girls were barred.' Dorothy Medhurst had vivid memories of trying to circumvent the injustice of the NAAFI ban. 'We would try wearing WLA uniform going in accompanied by a couple of soldiers but we couldn't get served, we weren't Armed Services we were told. We were welcomed into the YMCA canteen further up Lewes high street although we were the wrong gender.'

ENTERTAINMENT

Land Girls in hostels fared better, given that it was easier for the officers to organise amusements and entertainments for the girls when they were all together in one place.[194] Hostel wardens were advised by the County Office 'to make the hostel the centre of the social life of the neighbourhood, and to throw it open, not only to the villagers, but also to other Land Girls accommodated in private billets.'[195]

The more sympathetic and enterprising local Land Army representatives did try to bring isolated Land Girls together in their own houses for organised tea parties and evening meals. It did not always work out. Margaret Mace described how 'social life was very limited. Our off-duty time was taken up with the horses, washing smalls and writing letters.' Further, she felt that 'as far as the W.L.A. was concerned we did not exist. From the day that we signed on at Shrewsbury, we had neither seen nor heard from anybody. I felt utterly depressed and disillusioned. I wasn't homesick, but the feeling of isolation and uselessness was overwhelming.'[196]

For those in hostels there was home-made entertainment and competitions such as whist and beetle drives. For Dora Varley leisure time comprised sewing, knitting and reading around the two hostel stoves. There were three cinemas in the town where she was living, and dances 'were occasionally organised at the hostel, we had a good hostess in our warden. We had a small local band and a good supper. They were very popular amongst local boys.' Dances were also held quite frequently in the town 'but lots of overtime at busy seasons and a hostel 10.30 p.m. curfew (one late a week) regulated outings.' Land Girls attended dances at army and air force camps; they would be collected in draughty trucks with canvas top and sides flapping. Freda Ward remembered being taken to a nearby American Air Force base where they taught the airmen ballroom dance and in return they were taught to jive. They looked forward to the company, the food and jitterbug music and dancing to recordings made by the ballroom dancer and band leader Victor Silvester.

Madeleine Barnett (née Poole) also went to dances with airmen. 'We would dance with young airmen one week and then on our next visit, would find out that many of them were missing – prisoners of war and worst of all dead – such a waste of young lives.' Molly Horne went to the occasional Saturday dance in Borehamwood where there were Polish servicemen; she revealed that 'a few of our girls married them and German POWs'.

The local representative was responsible for putting volunteers in contact with the nearest Women's Institute whose members had been encouraged by Lady Denman through their magazine *Home and Country* to befriend Land Girls and invite them to meetings and for tea and a chat or, where needed, to offer them a hot bath. The Land Girl was cautioned to 'try to fit in naturally. Don't push yourself, and so spoil things. Take part in all such activities in a humble manner, and help to break down any prejudice there may be against women on the land.'[197] Securing the good name of the Land Army as in the First World War was deemed crucial and accordingly girls were rebuked through *The Land Girl* when there were 'complaints from several counties that some volunteers indulge in so many very late nights that their work, their health and their landladies all suffer… An eight to nine-hour sleeping night is the proper preparation for an eight to nine-hour working day. Nowadays work must come first.'[198]

Although work had to come first the local representative was instructed to 'try to make her [the Land Girl] as happy as possible in her new surroundings.'[199] Dorothy French who joined the Land Army in 1939 recalled meeting up with her local 'rep' once a month to hear

of any troubles or complaints the girls had. The reps also suggested to Land Girls that they join clubs such as the Young Farmers' Clubs with outings to colleges, research stations and farm institutes. They were reminded that 'it must not be thought that the Land Girl is constantly going about on trips, but it does make for "esprit de corps" and it does give a girl a feeling of being a member of an important army'.[200]

THE LAND GIRL

Another method of promoting esprit de corps and a sense of unity among the widely-scattered individuals who made up the Land Army was through the publication of their own magazine, *The Land Girl* launched in April 1940.[201] Lady Denman explained that 'the magazine will help us all to keep in touch with one another… This has been a hard winter. Snow and ice, as well as hard comments from some people, have made things difficult.' She closed by stating 'Nowadays it is the whole nation, not only the army, that fights a war, and nothing is more important than the care of the nation's food supply. This is the Land Army's particular job – this is the job which I am convinced the Land Army will do.'

Representatives were asked to encourage Land Girls to both contribute and subscribe to *The Land Girl* magazine and they were advised to take the magazine themselves for the useful information it contained. Published mid-monthly and priced 3d., it comprised 16 pages and contained signed articles on a Land Girl's work; local news from the counties; correspondence; official news from headquarters; Land Army jokes

Mrs Jenkins, Mrs Pyke and Lady Denman
COLLECTION OF EDNA STEPHENSON

(which had to be strictly original) and gossip and helpful hints. Some counties also distributed free newsletters with it such as *The Kent News Sheet*, a mimeographed bulletin edited by Vita Sackville-West.[202] The first cover design for *The Land Girl* was provided by the artist Eliot Hodgkin,[203] who during the war served as an air-raid warden and painted pictures of the home front. *The Land Girl* editor commented, 'Although Mr Hodgkin is one of our younger artists, one of his pictures [*October*] exhibited at the Royal Academy was bought a little while ago [1936] for the Tate Gallery under the Chantrey Bequest, and it was with some trepidation that we asked him if he would design a title picture for the Land Girl.'[204] Hodgkin agreed and said of the drawing that it was the only comic drawing he had ever done.

Throughout its life *The Land Girl* (1940–47) was edited by Mrs Margaret Pyke[205] who had moved to Balcombe Place when war broke out. She was well known as a campaigner for family planning, and from 1939 was honorary secretary of the Family Planning Association. Each month she wrote a leading article which she signed M.A.P. On the cover page of her inaugural article 'How shall I begin?' she revealed that the magazine was not an official publication and would have to stand or fall on its own legs. Stand it did, and later it was officially sponsored by the Ministry and eventually enjoyed a circulation of 21,000.[206]

The *Land Army News* replaced *The Land Girl* in June 1947. The incoming editor wrote: 'In her leading article in the final number of the *Land Girl*, the editor reminded us how the magazine had reflected the character and activities of the war-time Land Army. *Land Army News* sets out to do the same for the peace-time Land Army and as the peace-time Land Army is smaller and perhaps less formal than the war-time service, so *Land Army News* is smaller and rather less formal than its predecessor.' Free of charge and only four pages in length it was given to each Land Army member in private employment while those in hostels were asked to share to help the paper-saving campaign.

RALLIES AND PARADES

The holding of county and national rallies and parades was seen as essential for morale and recruitment, and employers were asked to release their girls to attend. Public and notable figures were often present to make stirring speeches, and Lady Denman endeavoured to attend as many as possible. They were also used for the presentation of certificates, long-service armbands and half-diamonds for sewing on for each six months' service.[207] Edith Barford described how she represented Kesteven Land Girls at a national rally on account of her long service and good employment record working on a farm in Honington. She recalled, 'it was a splendid day in 1943. The preparations were very hush-hush and I did not know where I was going in London until two days before the event. The Queen had become patron of the WLA and she invited some of the longest serving members to a tea party at Buckingham Palace for the fourth birthday of the WLA. We were given a rail pass and a new poplin shirt for the occasion. Previously my shirts had been badly-fitting aertex variety, so the smooth poplin was much appreciated. We were received in the Bow Room at the Palace by the Queen,

Princess Elizabeth and Princess Margaret. We moved into the Great Hall for tea and the Queen and Princesses came to speak to some of the lucky guests. It was rather a hot day for corduroy breeches and woollen jumpers but a most enjoyable occasion. Each visitor was made to feel very special.'[208] Ruth Bowley participated in a rally organised by the County of Sussex and recalled that keeping in step was quite a problem as they marched through Lewes. The first county rally had been held in Chichester in 1941 at the start of a recruiting drive at which Lady Denman had presented badges and a service was held in the cathedral. Ruth Bowley also took part in the largest rally held in Sussex in May 1943 at Arundel Castle – at which she remembered that the tea party was great fun. Later in the year in August a rally in Ipswich attracted over 600 Land Girls.

LAND ARMY CLUBS

By January 1944 nearly 600 Women's Land Army Clubs existed in many centres and hostels despite the difficulty in finding group leaders. Government grants were available for the purchase of equipment, games, a wireless set and gramophone. Clubs were also organised in district representatives' houses or schoolrooms, where girls met weekly or monthly. In Sussex for example there were 28 clubs in towns such as Worthing, smaller clubs with 6–8 members were established in villages, such as Chilgrove.[209] The club that Freda Ward belonged to had no gramophone records, so she wrote to the *Daily Mirror* with a touching story and in due course received a few records including 'Tiptoe through the Tulips' and 'Abide with Me' – 'but both were unsuitable to dance to!'

A new Women's Land Army Club was opened in Chesham Street, London, close to its headquarters, on 14 June 1944 by the Minister of Agriculture, R.S. Hudson, in order to provide a central meeting place for members from all over the country and somewhere that they could spend their annual week's holiday at a cost of £1 10s. for bed and breakfast. It provided much needed residential accommodation for 20 Land Girls visiting or passing through London and canteen facilities for 100. Annual membership was 2s. 6d. and bed and breakfast 5s., lunch (three courses) could be purchased for 1s. 6d. and supper for 1s. 4d. The club was established with part of a gift of $60,000 (£14,500) presented by labour groups in the United States through the British War Relief Society of America. The canteen was designed by Mrs Hudson with its self-service counter adjoining a dining room decorated with murals by the Danish artist, Tage Werner, as his tribute to the Women's Land Army.[210] The canteen was temporarily closed because of the threat of doodlebugs but reopened in November 1944.

REST-BREAK HOUSES

Three Rest-break Houses were also funded out of the gift from the labour groups in the United States – St Elmo in Torquay, Devon where 25 volunteers could be accommodated; Llandudno, which was slightly smaller but still had room for 15 volunteers; and in Edinburgh. These houses were established to enable 'volunteers who by reason of strain are specially in need of a short holiday.'[211] Ida Jühe (née Human) visited St Elmo on two occasions. In December 1946 on the back of a postcard of St Elmo she recorded that

WLA Rest Break House, Torquay

'the WLA is overstepping itself. A representative was at Padd.[ington] to see would-be visitors to St Elmo off, a carriage had been reserved for us which was good, as the train was full. Mrs Lake welcomed one, it was just like returning to old friends. Last night I was very tired, I was in bed and asleep by 9.30 p.m. Tonight there is a New Year's Dance at the Spa… Several girls are going and I probably will if I have enough energy left after these… ills.' Joan Culver was also sent to St Elmo. 'Only milkers got Wellingtons, we had boots, and walking in the long grass in the orchards, our feet got wet. I seemed to having nothing but colds and sore throats, and eventually was sent to Torquay to recuperate.'[212]

THE WOMEN'S LAND ARMY BENEVOLENT FUND

The Benevolent Fund was established in July 1942 under the patronage of the Queen, to raise £100,000 through public subscription. The Queen made the first annual donation to the war charity which was designed 'as a safeguard to Land Army members in times of special need… Help is given in all cases of hardship and the need to supplement National Sickness Benefit and National Assistance is taken into account.'[213] It was administered by a Committee appointed by Hudson, the Minister of Agriculture, with Lady Denman as Chairman. *The Land Girl* provided regular updates about the total of the Fund and details of how counties had raised monies through activities such as dances, concerts, fêtes and whist drives, as well as listing individual donations. Land Girls played a large part in building up the Fund and by March 1943 the total raised stood

at £15,700 which included a promise of £10,000 from H.M. Treasury. At the regional WLA Conference held in Shrewsbury that same month one of the items for discussion was the Benevolent Fund. It was reported that members of the Land Army and its administrative staff had raised just over £3,000 chiefly by means of entertainments which had been well supported by the public. One of the major donations was £250 from the Ford Motor Co., *Farmers Weekly* contributed £105, *Farmer and Stockbreeder* £100 and the Royal Agricultural Society promised £105. Many smaller donations were also made by sympathetic members of the public. The paper noted: 'Our immediate programme is to approach firms and societies interested in agriculture throughout the country.' Lady Denman had annotated her agenda with the comment 'Ask for intensive work on this.'[214] A number of grants had already been authorised including the covering of 'Maintenance at home during long convalescence. Payment of parents' travelling expenses to see their daughters on the danger lists in hospital.' Also handwritten was the statement: 'Grants will be given to help with illegitimate babies.' Iris Tillett, county secretary for Norfolk, noted that this was a standard grant, and in her county, and possibly everywhere, the Women's Voluntary Service was generous in providing layettes.

Money was also raised from the royalties and profits from sales of Vita Sackville-West's *The Women's Land Army* and from the Ministry of Supply *Meet the Members: a Record of the Timber Corps of The Women's Land Army*. A further source of funding came from the sale of WLA Christmas cards which were advertised in *The Land Girl* in September 1944 priced 6d. each and calendars by

the cartoonist and illustrator Fougasse for 2s. Fougasse also designed two posters for the Benevolent Fund.

Fougasse contributed a drawing of a Land Girl ploughing up a steep hill for the cover of a leaflet about the Benevolent Fund, captioned *Lonely Battle*. The text inside read:

'In this War our Land Girls have tackled all kinds of tough and lonely jobs. Most of them have flourished. But some have tried too hard and some have had bad luck – and that's why the Land Army Benevolent Fund has been set up. Land Girls, of course, come under National Health and Unemployment Schemes and Workmen's Compensation. If hurt or ill, they're taken in by any hospital in the official Emergency Hospital Scheme. But in a hard world that does not cover everything. One Land Girl was on the danger list in a hospital and her mother was unable to pay the fare to come and see her. Several girls have had to be taken considerable distances in ambulances. One member of the Land Army recently had her clothes burnt and they were not insured. For a girl in hospital and whose parents are poor, the Benevolent Fund can make all the difference between having something in hand and having no money at all. Some girls have financial responsibilities at home which worry them when they are ill.'

The leaflet explained that 'Things like this are happening every day. The Navy, the Army and the Air Forces have Benevolent Funds to deal with these problems. But the WLA is a new service – and that is why the Benevolent Fund is so urgently needed…

it is helping now and it is going to help in the future.' In the section entitled 'A Career for Women', it stated that 'Land Girls have their lives before them – they join from 17-years old upwards. Many of them have given up good jobs to fight the Battle of the Field. Many of them find they have learned to love the land – and the land is going to need them. The end of the War will not end the need for good brains and stout hearts in agriculture. It is going to mean the beginning of a greater need than ever before. If a Land Girl wants to make a career on the land, it means specialised training, and training means money to send girls to agricultural colleges and farm institutes and horticultural colleges; money to help or give them a start, either in this country or in the Dominions. Many Land Girls will want to return to their pre-war occupations or will have to find new openings. For these also, help and training will often be essential. To meet these needs, both present and future, £100,000 is needed. This gives us all an opportunity to pay part of the debt we owe to the WLA which has served our country well.'

Another leaflet for the Women's Land Army Benevolent Fund advised on its cover 'Keep this you may need it'. Inside it made it clear that long-service members could apply for training expenses, equipment or resettlement. 'Special attention is paid to those who served during the War, and to members who decide to stay on the Land.' Emily Richardson stayed on the land and recalled receiving 10/- a week from the Benevolent Fund while out of work during January 1947. The previous April Daphne Bryne – who had been in the Land Army in West Sussex – received an *ex gratia* payment of £30

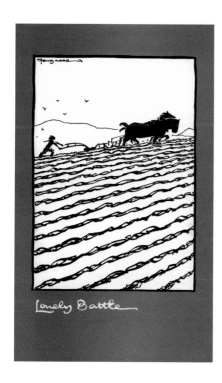

Fougasse
WLA Benevolent Fund leaflet cover
PRIVATE COLLECTION

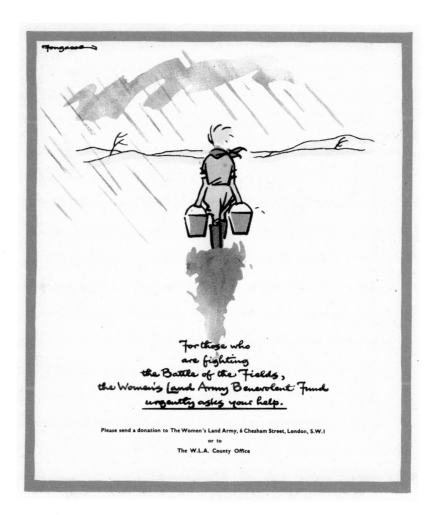

Fougasse
WLA Benevolent Fund poster
(1941)
380 x 255 mm
PRIVATE COLLECTION

towards training together with a loan of £50. The letter informing her that the Grants Committee, which made over a hundred grants every week,[215] had agreed to her request, stated the terms of the interest free loan: 'The Committee will not expect you to commence to repay this loan until two years after you start earning. You are then asked to repay at the rate of £15 per year for the next two years, and £29 during the third year.' She was able to return the grant early as she was successful in obtaining a grant through the Further Education and Training Scheme.[216]

RELEASE AND DISBANDING

Before a Land Girl was allowed to leave the WLA, a release certificate had to be obtained. This would be on a first in, first out basis. Not only were Land Girls denied many of the privileges of the armed forces during the war, but there was much dissatisfaction in 1945 when it was realised that Land Girls were to receive no monetary gratuity or de-mob clothing, and unlike women in the other services they were excluded from post-war benefits and training. Churchill and Bevin refused to give them any official recognition claiming they were only civilians. This sparked a storm of protest and two strikes by Land Girls in the Midlands. Lady Denman resigned in anger and frustration, writing that 'The Land Army is a uniformed service recruited on a national basis by a Government department and the work which its members have undertaken, often at considerable financial sacrifice, is in my view as arduous and exacting as any branch of women's war work and of as great importance to this country. Yet they have been refused postwar benefits and privileges accorded to other uniformed and nationally organized services.'[217] Nearly 200 Members of Parliament signed their names in support of Motions put down by Mrs. Cazalet Keir, Mrs. Mavis Tate and Sir George Courthope.[218] The Queen, as Patron of the Women's Land Army, made people aware of her view that Land Girls had been hard done by, and the Government was eventually forced to compromise. Resettlement grants of £150 were agreed, and £150,000 promised to the Land Army Benevolent Fund in England and Wales and £20,000 for Scotland. Members on release were allowed to retain some items of their uniform, including the greatcoat, dyed navy blue, one pair of shoes and a shirt.

On 31 August, 1946 the WTC was formally disbanded, the remaining 450 members who were engaged in operations for the Home Timber Production Department remained members of the WLA until the work was finished, although no longer part of a separate Corps.[219] The WLA continued to recruit until 31 March 1950, and serving Land Girls were asked to remain on the land in view of the seriousness of the food situation. In January 1948 the Land Army still had over 26,000 members who had been asked by the Minister of Agriculture to continue for another two or three years. 'A new agricultural expansion programme was planned and the women were needed to ensure its success.'[220] One new recruit was Elizabeth Aspinall (née Wood) who joined in August 1948, aged 21. She revealed that 'at the time I was working on laundry vans, but men returning from the war needed their jobs back. Further, after being in the Blitz I wanted to get away from the city for some peace.'[221]

The popular weekly magazine *Women's World* on 9 April 1949 carried a column headed 'Asking us… Women's Land Army. What qualifications would I need in order to join the Women's Land Army?' The article made it clear that recruits had to be 'willing to consider taking on land work for at least twelve months.' Just over a year and a half later, in November 1950, with a membership that had dwindled to 6,800, the Land Army was disbanded.

Numerous parades and rallies were held in every county and at Westminster Abbey. The final parade was at Buckingham Palace on 21 October when the Queen presented long-service badges and addressed 800 women 'The story of the Land Army has been one of a great response by the women of our country to the call of duty in the nation's hour of danger and need… By their hard work and patient endurance they earned a noble share in the immense effort which carried our country to victory. Yet their task did not end when the war was over, for they stayed at their posts through the difficult years that followed.'[222]

The arduous work of members of the Women's Land Army had been central to the war effort on the home front and the winning of the 'Battle of the Fields'. Land Girls were an invaluable source of additional labour for the agricultural sector. Like their predecessors in the First World War they had demonstrated that they were capable of undertaking a variety of jobs. Their efforts contributed to the net increase in agricultural output and self sufficiency at home and thereby the reduction in imported foods and bulky feeding stuffs. It is important that the diversity of experiences of those in the Women's Land Army as well as the effects of prejudice and discrimination of officialdom are acknowledged, for respect and recognition of their achievements did not in many cases come easy. The Women's Land Army was considerably more than an iconic image and clearly justified its formation. As Inez Jenkins remarked in 1950, 'Britain owes a debt to its army of girls in green jerseys.'[223]

1 Huxley, G. (1961) *Lady Denman, G.B.E. 1884–1954*, p.151.
2 Lady Denman remained chairman of the National Federation of Women's Institutes until she retired from the role in 1946.
3 Huxley (1961) op. cit, p.153.
4 See *The Farmer's Home*, 5 September 1939.
5 *The Times*, 'Women's Land Army recruits. Preparation for service', 6 March 1939, p.21, col. D.
6 *The Times*, 'Agriculture and defence', 4 May 1939, p.17, col. C.
7 Mrs Inez Jenkins (1895–1981).
8 Denman, Lady (1940) *The Women's Land Army*, p.47. See also Iris Tillett's (1988) short memoir, *The Cinderella army. The Women's Land Army in Norfolk*, in which she details her experiences as county secretary. She received a mileage allowance for necessary car journeys and later a subsistence allowance if she had to be away from home (p.6).
9 Bullock, M.H. (2002) *The Women's Land Army 1939–1950: a study of policy and practice with particular reference to the Craven district*, p.86.
10 *Information for Women's Land Army Representatives*, February, 1943, p.2. (Liddell Hart Centre for Military Archives, King's College London, University of London.)
11 Bullock (2002) op. cit., p.87.
12 Tyrer, N. (1996) *They fought in the fields. The Women's Land Army: the story of a forgotten victory*, pp.89–90.
13 Jenkins, I. (1950) 'They served the land: a tribute to the work of the Women's Land Army, 1939–50', *Journal of the Ministry of Agriculture (JMA)*, 57, 9, p.403.
14 *The Times*, 'Four months of recruiting', 8 June 1939, p.9, col. A.
15 *The Times*, 'Women's part in emergency', 28 August 1939, p.7, col. E.
16 Huxley (1961) op. cit., p.154.
17 Edna Stephenson, pers. comm., 12 January, 2005.
18 This chapter draws on G. Clarke (2007) 'The Women's Land Army and its Recruits, 1938–50', in Short, B., Watkins, C. and Martin, J. (eds.) *The front line of freedom. British farming in the Second World War*, British Agricultural History Society, pp.101–116. I am grateful to the publishers for allowing me to use extracts from the paper.
19 See *The Times*, '4,000 Land Girls at work', 20 February 1940, p.5, col. D. The figures in Vita Sackville-West's (1944) official history of the WLA are higher, see p.95.
20 Burton, E. (1941) *What of the women: a study of women in wartime*, p.55.
21 Schofield, S. (January 1940) M-O Report No. 26: 'Women in wartime', in Sheridan, D. (ed.) (1990) *Wartime women: an anthology of women's wartime writing for mass-observation 1937–45*, p.77.
22 Murray, K.A.H. (1955) *Agriculture*, p.82.
23 See *The Times*, 'Expenditure on Agriculture', 20 March 1941, p.5, col. C.
24 Stratton, J.M. (1969) *Agricultural Records A.D.220–1968*, John Baker, p.152.
25 Edith Barford (née Downes) was one of over 200 Land Girls who wrote to me about her experiences in the WLA during the Second World War.
26 Jenkins (1950) op. cit., p.403.
27 See *The Land Girl*, April 1940.
28 Huxley (1961) op. cit.
29 Carol Twinch (1990) makes the point in *Women on the land: their story during two World Wars*, that 'The Auxiliary Force caused some confusion on paper as it distorted the official figures and made assessment of WLA membership impossible at times' (p.72).
30 Details could also be found in the first issue of *The Land Girl*, April 1940.
31 Parker, H.M.D. (1957) *Manpower: a study of war-time policy and administration*, p.279.
32 A Chief Officer for Scotland was appointed in 1944.
33 Meiggs, R. (1949) *Home timber production (1939–1945)*, p.193.
34 Sackville-West, V. (1944) *The Women's Land Army*, p.61. See also the Foreword by Sir Gerald Lenanton, Director of Home Timber Production Department, Ministry of Supply in *Meet the members. A record of the Timber Corps of the Women's Land Army* (1946), p.4.
35 See Meiggs (1949) op. cit.
36 I.M.S. (1946) The new camp in *Meet the Members*. op. cit., pp.69–70.
37 Anon. (1942) *Journal of the Ministry of Agriculture*, XLVIII, 4, p.189.
38 Anon. (1942) *Journal of the Ministry of Agriculture*, XLIX , 3, p.129.
39 17 February 1943.
40 Douie, V. (1950) *Daughters of Britain. An account of the work of British women during the Second World War*, p.124.
41 Sackville-West (1944) op. cit., p.95.
42 The Women's Land Army had an age limit of 40, except in very special cases.
43 Calder, A. (1986) *The People's War*, p.428. The percentage depends on how the figures are calculated, i.e. whether it deals with only workers or whether it also includes farmers and their families.
44 Nick Warren (2000) *Express & Echo*, 'The Land Army poster girl [Joan Drake 1924–2000] who defied doctors', 31 July, E3.
45 Ivy, Joan's eldest sister instigated the idea of joining the WLA, both were later sent to Devon to work, pers comm. from Joan's sister Lilian Day (18 June 2008).
46 Shewell-Cooper, W.E. (c.1941) *Land Girl: A manual for the Women's Land Army*, pp.94-5. While the book cover states *Manual* inside it is stated *Handbook*. See also Woodeson, A. (1993) '"Going back to the land": rhetoric and reality in Women's Land Army memories', *Oral History*, 21, 2, pp.65–71.
47 Ward, S. (1988) *War in the countryside 1939–45*, p.41.
48 Joseph, S. (1946) *If their mothers only knew. An unofficial account of life in the Women's Land Army*, p.7.

49 Sackville-West (1944) op. cit., p.16.

50 Goldsmith (c.1943) *Women at war*, p.113. Christina Hole (1896–1985) wrote several books including *English Folklore*.

51 Levy, J. (1942) *How Britain lives: three years of war*, p.28.

52 Lynn, V. with Cross, R. and de Gex, J. (1989) *We'll meet again: a personal and social memory of World War Two*, p.152.

53 Emily Richardson served in the WLA for 3½ years.

54 I purchased these documents together with Viola's logbook from a now defunct second hand-book shop in Lewes and regrettably was unable to find out any further information about her life.

55 Sackville-West (1944) op. cit., p.8, p.15.

56 Vivienne Vick joined the WLA in April 1943, aged 18, and served for three years.

57 *Information for Women's Land Army Representatives*, February 1943, p.14.

58 Joan Cowderoy, personal diary entry, unpublished.

59 Letter from Lady Denman 18 December, 1941 to J.A. Sutherland-Harris, Whitehall, London (Liddell Hart Centre for Military Archives).

60 Longmate, N. (1977) *How we lived then: a history of everyday life during the Second World War*, p.34.

61 See Tyrer (1996) op. cit., p.47.

62 Burnham Historians (1999) *A Land Girl's diary: Burnham 1948*, p.2.

63 Denman, Lady (1940) 'The Women's Land Army', in Hutchinson, W. (ed.) *Pictorial history of the War. A complete and authentic record in text and pictures*, p.51.

64 See the commemorative brochure *Moulton 1921–71*, published in 1971.

65 Brew, B.G. (1943) 'Women's Land Army training', *JMA*, November, 50, 8, p.376.

66 Brew (1943) ibid., p.376.

67 Plumpton had been established in 1919. By the time training for Land Girls terminated there on 12 August 1944 over 1,850 girls had passed through their books, normal teaching arrangements were then resumed. (School of Agricultural Sub-Committee Reports, East Sussex Record Office).

68 *Moulton 1921–71* (1971) op. cit., unpaginated.

69 For an extended discussion of the genesis of *A Book of Farmcraft* see Gill Clarke (2006) *Evelyn Dunbar: War and Country*.

70 H.M. Rowntree, 99461, West Riding, Yorks. June 1946, p.7.

71 *The Spectator*, 27 March 1942, p.308, see Clarke (2006) op. cit., p.90.

72 Rosemary Allan, as she was known professionally, also undertook a few paintings of the WVS for the WAAC, she married Allan Gwynne-Jones in 1937. A contemporary and friend of Dunbar's who had studied at the Slade School of Fine Art she provides an interesting perspective on *Milking Practice with Artificial Udders* in *Evelyn Dunbar: War and Country*.

73 Joseph (1946) op. cit., p.140.

74 Meiggs (1949) op. cit., p.196.

75 Meiggs (1949) op. cit., p.194. WTC training centres in Scotland were established near Brechin and Aberdeen.

76 Lady Denman (1940) op. cit., p.51.

77 Shewell-Cooper (c.1941) op. cit., p.39.

78 Letter to Sheila Newman, dated 4 July 1940, from Inez Jenkins at Land Army Headquarters, Balcombe Place.

79 Sheila Newman remained on the farm for one year before seeking a transfer nearer to her home and was placed at some experimental gardens belonging to Boots the chemists.

80 Brew (1943) November, op. cit., p.378.

81 Joseph (1946) op. cit., p.65.

82 Sackville-West (1944) op. cit., Appendix No. 7. A typical forewoman's course. Synopsis of lectures, pp.101-2.

83 Joseph (1946) op. cit., p.64. In April 1945 it was agreed by the WAEC, The Standing Advisory Committee of the Agricultural Wage Board and Ministry of Agriculture that, Head Forewomen would in future not receive payment for overtime but receive an inclusive wage (see Tyrer 1996, op. cit., p.98).

84 Margaret Franklin joined on 13 July 1942 aged 24 years, and was invalided out on 13 September 1945 after having broken her neck when another Land Girl lost control of the vehicle they were travelling in and they 'careered down a very steep hill... [and] turned nose-over tail three times.'

85 Sackville-West (1944) records that in 1943 1,275 Land Girls took the Agriculture Correspondence Course and 630 the Horticultural Course, op. cit., p.94.

86 *The Times*, 'Women on the land. Demand greater than supply', 19 April 1943, p.2, col. D.

87 Much of the material for *Set my hand upon the plough* (1946) had appeared in *The Manchester Guardian*. Barraud also contributed to the *Land Girl*, and wrote articles under the pseudonym of Hilary Johns for *The Daily Mirror* and *Agriculture, Britain Today, Country Life, Courier, The Countryman, The Dairy Farmer, Field* and *Good House-keeping*.

88 I am grateful to the family of the late Maisie Marshall, Land Girl 1941–46 for giving me a copy of the Field Work test.

89 Bullock (2002) op. cit., p.102.

90 I am grateful to Mary Hood for loaning me a copy of the script and a press cutting (undated) 'Local Land Army Girls in broadcast to America'.

91 Ministry of Information (1945) *Land at war: the official story of British farming 1939–1944*, written by Laurie Lee, p.89.

92 H.E. Bates, 'Women's Land Army', *The Spectator*, 12 July 1940.

93 Goldsmith (c.1943) op. cit., p.111.

94 Denman in Shewell-Cooper (c.1941) op. cit., p.iii.

95 Brew, B.G. (1943) 'The Women's Land Army', *JMA*, September, 50, 6, p.275.

96 Denman (1940) op. cit., p.51. The *Land Girl Manual* also contained a chapter amusingly titled 'The proof of the pudding is in the eating' which was devoted to Farmers' opinions – Volunteers' opinions'.

97 Jenkins (1950) op. cit., p.404.

98 *The Times*, Mr Hudson's warning to farmers, 27 January 1941, p.9.

99 *The Times*, 'A truce to criticism', Meriel L Talbot. 1 February 1941, p.5, col. E.

100 Murray (1955) argues in *Agriculture* (see p.126) that this prejudice was largely overcome during the first year of the war, but the experiences in particular of the Land Girls in my research show that there remained pockets of conservatism and hostility.

101 Howkins (2003) *The death of rural England: a social history of the countryside since 1900*, p.129.

102 Denman (1940) op. cit., p. 51.

103 Evelyn Thomas, S. (c.1940s) '*Laughs around the Land*'.

104 Priestley, J.B. (1943) *British women go to war*, p.44.

105 Lynn, V. with Cross, R. and de Gex, J. (1989) op. cit., p.150.

106 Longmate, N. (1977) *How we lived then: a history of everyday life during the Second World War*, p.242.

107 Joseph (1946) op. cit., p.65.

108 Sackville-West (1944) op. cit., p.108.

109 See Tyrer (1996) op. cit., p.25.

110 Minns, R. (1999) *Bombers and mash: the domestic front 1939–45*, p.81.

111 Waller, J. and Vaughan-Rees, M. (1989) *Women in uniform 1939–45*, p.79.

112 *Information for WLA representatives*, February 1943, p.5.

113 *The Times*, 'Aids to food production', 3 June 1940, p.7, col. G.

114 Edith Barford served in the WLA throughout the war years and did not leave until October 1947.

115 Pauline Gladwell joined c.1940 aged 19, and left 1945.

116 Calder (1986) op. cit., p.428.

117 Calder (1986) op. cit., p.402.

118 Cook, W.V. (1945) '"Green Cinderellas" of West Sussex', *The Sussex County Magazine*, 19, p.242.

119 Rootes, A. (1988) *Front line county: Kent at war 1939–45*, p.105.

120 *The Times*, 5 October 1942, p.2.

121 Johnson, D.E. (1978) *East Anglia at war 1939-1945*, pp.41–2.

122 I am grateful to Derek Bales from Stoke Holy Cross for communicating to me the details of Christine Froude's service in the WLA.

123 Foot, W. (2007) 'The impact of the military on the agricultural landscape of England and Wales in the Second World War', in Short *et al.* (eds.) op. cit. p.141.

124 Information from Derek Bales.

125 Jean Goodwin joined in 1943, aged 16.

126 See *The reconstruction of warriors Archibald McIndoe, the Royal Air Force and the Guinea Pig club* by Emily Mayhew (2004).

127 Powell, B. and Westacott, N. (1997) *The Women's Land Army 1939–1950*, p.43.

128 Dora Varley joined in June 1942 aged 20 and left in January 1946.

129 Shewell-Cooper (c.1941) op. cit., p.70.

130 Jenkins (1950) op. cit., p.405.

131 *Eastbourne Herald*, 'Women's Land Army. Interesting work offered', 15 May, p.12.

132 Stettinius, J. (1944) *Lend-lease: weapon for victory*, p.258.

133 Ward (1988) op. cit., p.38.

134 Cox, P.W. 'Front-line farming Kent's war-time effort', *J. Ministry Agriculture*, L1, 3, June, p.120.

135 See the article on threshing in the October (1941) issue of *The Land Girl* for a fulsome description. Greenhill and Dunbar's (1942) description and illustration of a Thresher is useful too.

136 Calder (1986) op. cit., p.428.

137 Brace, J. (2002) 'A good but dirty job. The memories of a Much Hadham Land Girl', *Hertfordshire's Past*, Spring, 52, pp.2–6.

138 *The Times*, 'More labour for the land', 19 May 1941, p.5, col. C.

139 Jenkins (1950) op. cit., p.405.

140 Brassley, P. (2007) Wartime productivity and innovation, 1939-45, in Short, B. *et al.* (eds.) op. cit., p.50.

141 Information from Lymington Growmore Club. This image is reversed – ploughs always turn the soil to the right.

142 *The Times*, 'Land reclamation', 22 June 1942, p.5, col. D.

143 Minister of Agriculture, cited in Murray, p.265.

144 Sackville-West (1944) op. cit., p.95.

145 Jenkins (1950) op. cit., p.404.

146 Sackville-West (1944) op. cit., p.31.

147 Greenhill and Dunbar (1942) op. cit., p.25.

148 See Clarke (2006) op. cit p.96. Information also taken from an interview with José by the author.

149 Sylvia Reeves joined the WLA in November 1941 aged 18, and served for six years.

150 Murray (1955) op. cit., p.268.

151 Jenkins (1950) op. cit., p.405.

152 Jenkins (1950) op. cit., pp.405-6.

153 Grace Adamek joined in 1942, age 17.

154 I am grateful to the Lymington Growmore Club for technical detail about this and other paintings.

155 Riley, M. (2007) '"Silage for self-sufficiency". The wartime promotion of silage and its use in the Peak District', in Short *et al.* (eds.) p.80.

156 Ministry of Information (1945) op. cit., p.59.

157 Sheail, J. (2007) 'Wartime rodent-control in England and Wales', in Short *et al.*(eds.) op. cit., p.57.

158 Lewis, J.R. (1995) *The Cotswolds at war*, p.213.

159 Dawson, A.E. (1944) Rat destruction, *JMA*, 5, August, pp.231–32.

160 Foy, M. and Ryding, F. (1943) 'Mole catching in Lancashire', *The Land Girl*, July, p.3.

161 Sackville-West (1944) op. cit., p.47.

162 Lillian Harbard sent me her life story, aspects of it have appeared previously in *The wartime kitchen & garden* by Jennifer Davies.

163 See Murray (1955) pp.255–58.

164 See Clarke (2006) pp.116–17.

165 Earl De La Warr (1944) 'Flax production in war', *JMA*, July, 4, p.158.

166 www.utopia-britannica.org.uk/pages/Springhead.htm accessed 22/11/2007.

167 Green flax satisfied Service Departments for many wartime purposes and could be used for coarser fabrics, parachute harness and naval canvas.

168 Moore-Colyer, R.J. (2006) 'The call to the land: British and European adult voluntary farm labour; 1939–49', *Rural History*, 17, 1, p.85.

169 Moore-Colyer (2006) ibid., p.85.

170 *The Times*, 'Substitute farm labour', 2 April 1940, p.12, col. A.

171 'Holmes moved to Edinburgh in his mid-twenties, working in research and teaching laboratories, with a number of his illustrations appearing in text books and scientific journals. His work often had a nautical theme.' Cited in Lewis, R.M. (2004) 'The planning, design and reception of British home front propaganda posters of the Second World War', University College Winchester, unpublished PhD thesis, p.217.

172 Moore-Colyer (2006) op. cit., p.89.

173 Craddock, F.R.W. (1943) 'The voluntary land club movement', *JMA*, 4, July, p.166.

174 Letter to Miss Senter at the WLA hostel, Mickleton, Chipping Campden, Glos. from Mrs G. Cosnett, Hon. Organiser, Worcestershire Voluntary Land Corps, 3 December 1943.

175 Mr Dalley, Executive Officer of the War Agricultural Committee. Source and date unknown, collection of Gladys Wheatland.

176 'Volunteer agricultural camps in 1943', *JMA*, 2, May 1944, p.90.

177 *The Times*, 'Helpers for the harvest', 18 February 1943, p.2, col. C.

178 'Volunteer agricultural camps in 1943', *JMA*, 2, May 1944, p.91.

179 Moore-Collyer, R.J. (2004) 'Kids in the corn: school harvest camps and farm labour supply in England, 1940–50', *AgHR* 52, 2, p.190.

180 Gosden, P.H. & J.H. (1976) *Education in the Second World War: a study in policy and administration*, p.81.

181 Murray (1955) op. cit., p.258.

182 The following year my father returned to help, in 1943 he left school and joined the Royal Marines.

183 Gosden, P.H. & J.H. (1976) op. cit., p.84. See also Murray (1955) op. cit., pp.159–60. The target for school help in 1944 was 73,000 with 1,200 camps available (Ministry of Information).

184 Murray (1955) op. cit., p.159.

185 Moore-Colyer (2007) 'Prisoners of war and the struggle for food production, 1939–49', in Short *et al.* (2007) op. cit., p.117.

186 In the First World War concerns of this type were raised principally by Mary Broadhurst who held an influential administrative position. See J. Martin's entry on Broadhurst, Mary Adelaide, agricultural reformer and radical, ODNB, 2004.

187 Their Eden Camp (No. 83) built in 1942 has been turned into a museum on its original site in Malton, North Yorkshire.

188 Elsie Cowley joined August 1942 aged 17 and left at the end of the war.

189 Kay Lawson joined in April 1943 aged 29, and left 2 February 1948.

190 A.G. Street cited in Ward, *War in the countryside 1939–45* (1988) p.47.

191 Moore-Colyer (2007) makes the important point that 'the widely-publicized myth of the work-shy Italian compared with the steadfast Teuton requires closer investigation by way of analysis of oral testimony.' op. cit., p.131. Maureen Miller 'worked quite amicably alongside them [POWs]… some had a smattering of English and we had some lovely summer days hoeing in the fields and singing along – that was something we all understood.' Alice Haynes (née White) found the Italian POWs on the estate where she worked helpful if she was in the field cutting kale. 'They would always come and help me load the trailer although there was not much conversation as they could not speak a word of English.' Barraud's (1946) chapter 'P for prisoner' provides an illuminating account of her work with Italian prisoners of war. Italians were later reclassified as co-belligerents following the Armistice with Italy. See *Eastbourne Herald* (1943) 'Prisoners of War. Thousands are employed on the land', 13 November, p.9.

192 Members of the Lymington Growmore Club pointed out that the horse and wagon are incorrectly placed – 'they would always be drawn up and down the furrows, not across because this might crush some of the potatoes.' They questioned whether this had been added from memory rather than observation on the day.

193 *The Times*, 'Editorial, Women on the land', 13 April 1942, p.5, col. D.

194 See Goldsmith (c.1943) op. cit., p.113.

195 Sackville-West (1944) op. cit., p.111.

196 Shirley Joseph was also extremely critical of local WLA representatives, op. cit.

197 Shewell-Cooper (c.1941) op. cit., p.97.

198 The Editor (1943) *The Land Girl*, November 8, 4, p.1.

199 Shewell-Cooper (c.1941) op. cit., p.73.

200 Shewell-Cooper (c.1941) op. cit., p.76.

201 Huxley (1961) op. cit., p.160.

202 Goldsmith (c.1943) op. cit., p.117.

203 Eliot Hodgkin (1905–87) had studied at the Byam Shaw School of Art and at the Royal Academy Schools.

204 *The Land Girl*, April 1940.

205 Margaret Pyke (1893–1966).

206 Huxley (1961) op. cit., p.161.

207 See Powell & Westacott (1997) op. cit., Section 14 'Rallies and Parades'.

208 Over 300 Land Girls took part – see *The Land Girl*, August 1943.

209 West Sussex WLA Souvenir programme Final Rally, Bishop Otter College (now University of Chichester), Chichester, 16 September 1950.

210 Notes on the Women's Land Army Club (Liddell Hart Centre for Military Archives), see also *The Times*, 'Land Army Club in London', 15 June 1944, p.8, col. D.

211 *The Times*, 3 February 1944, p.6, col. F. St Elmo closed in Spring 1950.

212 Joan Culver spent seven years in the Land Army from 1943–1950.

213 Ministry of Agriculture and Fisheries (1950) *To members of the WLA staying on the land*, November, p.8.

214 WLA regional Conference, 11–12 March, 1943. Agenda, item 6(d). (Liddell Hart Centre for Military Archives, King's College London).

215 Burnham Historians (1999) op. cit., p.8.

216 Imperial War Museum Archives.

217 Denman wrote to Hudson on 15 February 1945. See Huxley (1961) op. cit., p.175.

218 M.A.P. (1945) 'Rewards and values', *The Land Girl*, April, p.1.

219 M.A.P. (1946) 'Timber!' *The Land Girl*, September, p.1.

220 Twinch (1990) op. cit., p.132.

221 Elizabeth Aspinall explained that those recruits joining the WLA after the war were known as 'Rainbows'.

222 Speech by Her Majesty The Queen, at the Farewell Parade of the WLA reproduced in *JMA*, 57, 9, December (1950), p.401.

223 Jenkins (1950) op. cit., p.407.

RECORDING LIFE ON THE LAND
PORTRAITS OF SELECTED ARTISTS AND ILLUSTRATORS

This final section presents biographical portraits of some of the leading artists and illustrators who recorded the life of members of the Women's Land Army during two World Wars. Letters from the artists are utilised to provide specific details about the works completed.[1]

During the First World War the British Government employed artists at home, and on other fronts, primarily for propaganda purposes. With the formation of the Ministry of Information in March 1918 the number of official war artists was increased by the Canadian-born minister, Lord Beaverbrook. The British War Memorial Scheme was established to create a lasting record of the sites and stages of the war. When the Ministry of Information closed, the Imperial War Museum took over its responsibilities towards artists. The all-female Women's Work Sub-Committee was formed with Lady Norman as Chairman so that a record of the war work undertaken by the various organizations throughout the country, including the Women's Land Army, might be compiled.

In the Second World War, Kenneth Clark, the Director of the National Gallery and Surveyor of the King's pictures, established the war artists' scheme based on that of the First World War. Eric Newton, art critic and author, explained in the exhibition catalogue 'War pictures at the National Gallery' (1944) that 'Three purposes were served by this scheme: first, that posterity should have some notion of what these extraordinary times looked like to the sensitive eye of the artist; secondly, to show contemporaries at home and overseas something of our war effort; and thirdly, to provide employment for a section of our best painters during what would inevitably be a difficult time for the arts.' The intention was to commission pictures on war themes of the War Artists' Advisory Committee's choice. 'Approximately sixty of the committee's drawings and paintings of home front activities [from some twenty artists] show aspects of farm work… Agricultural production was better chronicled by war artists than were shipbuilding, aircraft construction and fire fighting and was also more thoroughly documented than all other natural resources subjects'.[2] This final section is testament to this and provides a unique account of the visual documentation and representation of the vital work of the Women's Land Army in two World Wars.

CECIL ALDIN
1870–1935

ROY HERON

Cecil Aldin 'who came to be regarded as the leading figure in the revival of English sporting art'[3] was born in Slough, Berkshire on 28 April 1870 one of three sons of a builder and his wife Sarah (née Windsor). He was sent as a boarder to Eastbourne College but that proved to be too expensive for his father's 'temporarily straitened finances'[4] and he transferred to Solihull Grammar School, Warwickshire. His art training commenced at Albert Moore's studio in Melbury Road, Kensington but he left after a month after finding Moore's methods of tuition complicated and tedious and not conducive to his aspirations to be an animal artist and to hunt.[5] Aldin moved to study animal anatomy at the National Art Training School, South Kensington (later the Royal College of Art). Later his father sent him to study under Frank Calderon at his summer school in Midhurst, Sussex. Calderon was founder and principal of The School of Animal Painting in St Mary Abbott's Place, Kensington where he taught drawing, painting and modelling from living animals, composition and anatomy instruction.[6] Calderon's dogs were Aldin's favourite models.[7] His time at Midhurst ended with his third dose of rheumatic fever and as he recalled in his autobiography *Time I was dead*, it left him with a jumpy heart but it was also fortuitously around that time that he sold his first drawing to a newspaper (*The Building News*)

for ten shillings. His second sale was of a dog show and was published in the *Weekly Graphic* in 1891 around the time of his twenty-first birthday. On the strength of these early successes he took a studio in Chelsea; he 'did not sell anything more for many, many months.'

Aldin spent extensive periods of time at the Zoological Gardens drawing birds and animals. He showed some of the sketches to Sir Douglas Straight, editor of the *Pall Mall Budget* and as he recalled it was this association that led in 1894 to his receiving a commission to illustrate for that periodical the serialisation of Rudyard Kipling's *Jungle Stories*. Aldin recorded that 'This event was the first real milestone towards my hunting career and marked the beginning of whatever success I may have subsequently had in the illustrated Press.' At the same time he was, as he admitted, a 'shy member' of the Chelsea Arts Club then in its infancy. Here he mixed with Whistler, William Rothenstein, Max Beerbohm, Walter Sickert and Wilson Steer. Other members whom he referred to as 'minor luminaries' included 'Henry Tonks of the Slade, Nicholson and Jimmy Pryde (the Beggarstaffe Brothers),[8] A.S. Hartrick, F.H. Townsend and Fred Pegram of *Punch*.'

Aldin was a founder-member of the London Sketch Club where at its weekly meetings some twenty to thirty artists would in silence from 7–9 p.m. engage in 'the practice of rapid memory sketching by gaslight from given subjects.'[9] Aldin revealed that 'After some years of Bohemian and married life my hunting complex took complete control of me, and we decided to move permanently into the country.'[10] Shortly after his return from his first exhibition of pictures in Paris

in 1908 he became Master of his first pack of hounds. Aldin's activities in the hunting field 'enabled him to draw the funny side of English country life, and his comic hunting scenes, olde world inns and dog-portraits, drawn in a jovial style, were immensely popular.'[11]

Aldin became joint-Master of the South Berkshire Foxhounds in February 1914, and shortly after the advent of war he was in sole charge when his friend Eric Palmer joined a cavalry regiment. 'Horses were wanted everywhere,' and Aldin in his role as a Remount Purchasing Officer had 'to procure a certain number of horses in a very few days in order to horse yeomanry and other units suddenly mobilized. These horses were to be of four classes known in Remounts as: H.D.s, heavy draught; L.D.s, light draught gunners; R1, cavalry, including officers' charges; R2, smaller riding horses.'[12] His own horses had to go. With the shortage of men and increasing numbers of horses, some of which were shipped over from Canada, Aldin 'decided to make one small horse depot entirely for women as an experiment.' In *Women of the War* Barbara McLaren's 1917 account of the diverse activities women were undertaking reference is made to Miss E. G. Bather who worked for Aldin. 'During the first year of her work about 500 horses passed through Miss Bather's depôt.' The artist Alfred Munnings sought a job with the Remounts after his last horses went; he wrote to Aldin and met him at Purley, near Reading and was 'placed in a village near the Bath Road, close to Calcot Park.'[13] Aldin's experiment, in which he was assisted by his wife and daughter, was a success. He said that he had 'the very highest opinion of their capabilities and the very thorough way in which they worked'[14]

and in 1918 there were 200 women working in 21 Army Remount Depôts[15] wherein they exercised, groomed and fed the horses to make them fit for active service.

From August 1914, until the Armistice, Aldin 'hardly touched a brush'.[16] Thereafter he returned to his original occupation and completed many large equestrian portraits in pastel and continued to illustrate numerous books which 'were the staple diet of country houses between the wars. His ability was in putting the spirit of an incident on to paper rather than the accuracy of it; in this he shared something with both Leech and Caldecott who clearly influenced him.'[17] In 1930 his hunting days ended when 'the ravages of rheumatoid arthritis, aggravated by falls in the hunting field, forced him to give up active participation in the sport he loved'.[18]

Aldin retired to the Balearic Isles in 1930 on orders to live in a warm climate. He stayed in Palma, and later Pollensa Puerto, Mallorca. On a return journey by ship to England in 1935 he suffered a massive heart attack and was taken on arrival to The London Clinic and died on 6 January.[19] Aldin's varied jobs are aptly captured in his own words 'From my first hunting correspondent bluff all my jobs have been experimental; I have appeared as an artist, play-producer, scene-painter, animal "property man", designer of nursery friezes, dog-fancier, remount officer, horse-show judge, comic or mongrel dog-show inventor, toy designer, Hunt secretary, M.F.H., Master of Harriers, Beagles and Bassett Hounds, inventor of the All-Children's pony shows, painter of golf courses, cathedrals, and old inns and manor houses, maker of dry-point etchings and, my last experiment, designer of houses in Mallorca.'[20]

A LAND GIRL PLOUGHING

Aldin was contacted in February 1919 by Agnes
Conway, honorary secretary of the Women's Work
Sub-Committee, Imperial War Museum who were
interested in obtaining for the Women's Section
pictures of women at work in his remount depot.
The Museum acquired from Aldin for 75 guineas
Women Employed in the Remount Depôt, The Kennels, Pangbourne
and commissioned him to do a painting for posterity
of women's work on the land. Aldin in a letter to Lady
Norman, chairman of the committee, explained that
although he had previously completed a ploughing
picture he did not feel he could sell it 'for a National
Collection, as I am doubtful as to the durability of
parts of it. It was originally on an old canvas with
scene paint and all sorts of doubtful permanent
colours. I just did it in my Remount days to amuse
myself between my working hours and only used
what odds and sods of paints I had by me.' He agreed
to paint a replica in permanent tempera colour for
60 guineas. The committee was at pains to explain
to Aldin that the heads of the Land Army were most
anxious that the little details of the uniform were
correct.[21] The Land Army sent at his request when
he was ready to incorporate the figure into the picture

'a fairly tall girl', in uniform complete with armlets
and badges to his studio at The Kennels, Pangbourne.

Aldin's great sympathy for the rural environment, his
knowledge of the countryside and his deep understanding
of horses makes for a realistic portrayal of a solitary
Land Girl ploughing. The committee was delighted
and commented 'We think it a most admirable and
charming piece of work and we are hoping to show
it at our forthcoming exhibition at Burlington House.'

JAMES BATEMAN
1893–1959

James Bateman made his reputation, and enjoyed much popularity, with his pastoral landscapes and farmyard scenes of horses and cattle auctions in the 1930s. He was born on 22 March 1893 in Patton, near Grayrigg, Westmorland, the son of a blacksmith and forger of wrought iron. Two years later the family moved to Redman's Yard, Kendal.[22] Bateman received his early education at Kendal Green School. His parents encouraged his love of drawing and sent him to private lessons with a local artist.[23] 'In 1908 the family moved [again –] to Leeds where the family business was exchanged for an eating house'.[24] Bateman entered Leeds School of Art in 1910 where he remained for four years. He won a Royal Exhibition Scholarship to the Royal College of Art (RCA) to study sculpture but his studies were interrupted by the outbreak of the Great War. Bateman enlisted and completed four years' war service, two of which were commissioned. He served with Northumberland Fusiliers, Machine Gun Corps and from 1916 with The Artists Rifles and saw action in the trenches. Weakened by a gunshot wound to his spine and lung in 1916,[25] he was forced on his return to civilian life and study at the RCA to abandon sculpture for the less physically exacting art of painting. 'His feeling for form and the three-dimensional in his work owes much to his formation as a sculptor.'[26]

Bateman left the RCA after a year and, following a successful interview with Professor Henry Tonks, was accepted to study painting at the Slade School of Fine Art from 1919–21. The Slade was a great influence on his style and pictorial ideas. 'As well as Tonks, the Slade accommodated Augustus John as senior student and Wilson Steer as a visiting master. All three had a considerable influence on him personally and professionally. It was at the Slade, while hoping to gain the Rome scholarship [he was a finalist in 1920 in the category of Decorative Painting], that Bateman acquired his regard for Piero della Francesca and formed (through the guidance of the school) a regard for realistic treatments of contemporary subject matter while seeking formal and compositional precedents in the Renaissance era.'[27]

On leaving the Slade he earned a living teaching, initially as painting master at Cheltenham School of Art from 1922–28. 'While at Cheltenham he exhibited with the Cheltenham Group and Cotswold Group, cycling out to paint the local countryside.'[28] One resultant painting *Pastoral* was bought by the Chantrey Bequest for the Tate Gallery, as was his later work in 1937 *Cattle Market*. Bateman was appointed visiting master at Hammersmith School of Art and Goldsmith's College in 1929. He enjoyed his teaching and 'thought it wrong for the teacher to impose his own style on the student.'[29] Gloria Jarvis who had attended his composition and life drawing classes at St. Martin's School of Art in 1950 recalled that 'he had the knack of coaxing out the individuality of each pupil… training the eye to see an important fundamental in making one aware of tone and colour values.'

Bateman exhibited at the Royal Academy from 1924 and was elected an Academician in 1942. He was also a member of the New English Art Club, and exhibited at the Cooling Galleries and Fine Art Society. During the Second World War 'he found himself on A.R.P. fire duty and during a later evacuation, he was to be engaged in a camouflage project'.[30] He later resigned in order to undertake a commission from the Ministry of Information.

In 1957 Bateman wrote *Oil Painting* which was part of The *How to do it* series published by *The Studio*. The preface provides interesting insights into his perception of the art world, which he described as being 'in a state of confusion' with 'no positive direction.' He believed that 'There has been no period in history when such chaos existed, and when such a mass of spurious work was brought before the public.' He argued that 'there may be new forms in art, but there are no new qualities, merely novel combinations or isolations of these qualities.' Interestingly, his work post-war had taken a new direction and 'Towards the end of his painting career he started to experiment with the mythological subject matter of Ancient Greek legend.'[31] Ill health prevented further exploration of these ideas and he died in London on 2 August 1959 from 'a combination of pneumonia and liver failure'.[32]

WOMEN'S LAND ARMY AT WORK and SILAGE

Bateman was contacted by the War Artists' Advisory Committee (WAAC) in March 1940 to undertake work for the Ministry of Information. As a result he resigned from his role as Camouflage Officer at the Civil Defence

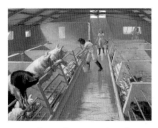 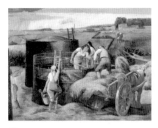

Women's Land Army at Work *Silage*

Camouflage Establishment for the Ministry of Home Security, explaining that he found it 'difficult to keep himself at Leamington and his family in the south on £400 a year.'[33] Bateman was 'very glad indeed to have been approached' and believed that he could 'make an authentic record with some pictorial value.'[34] The secretary of the WAAC Mr Dickey arranged for him to 'have a talk with the Ministry of Agriculture people' before he decided on the subjects to paint since they would wish to make suggestions as to the most suitable subject matter for war records. It was agreed that he should undertake paintings of land work subjects for a fee of 100 guineas. As with other artists, 'the property in all original paintings and all rights of reproduction in any form shall be vested solely in the Crown.' Bateman was offered travelling expenses and if he had to work away from home, maintenance allowance at a flat rate of £1 a day. He was informed that 'It will be necessary to submit all your preliminary sketches and studies, as well as finished works, for censorship. This will be done by us, and it is, of course, desirable that we should have your pictures as soon as conveniently possible after they have been completed. I must caution you not to show any of these works, even

to your friends, before they have been submitted by us to the censor.'

The Ministry of Agriculture provided Bateman with letters of introduction to Principals of University College farms. He went to Cambridge, St. Albans and hoped to visit Reading. The subjects he was to record were ensilage, mechanical milking, Women's Land Army and haytime. Bateman completed first *Women's Land Army at Work* and *Silage*. In a letter to Dickey dated 4 August 1940 he said he was happy to know that the two paintings have been approved and confirmed that the title of the one in doubt should be *Women's Land Army at work*. He proceeded to explain that 'I felt a bit guilty at the suitability of this one, but after all, the work they are doing [in a piggery] is as typical of farm work as any. I was interested to know that the sweet smelling meal they were being fed on was produced from kitchen refuse.' Bateman promised to send his third picture *All Hands to the Hay Harvest* in about ten days. He was finding this a complicated design as he had introduced about twenty figures including evacuees and soldiers on leave. Given these difficulties, he informed Dickey that he did not think he could do a fourth painting as he had been working on these pictures six days a week since he returned to town [London]. The subject matter for this painting was mechanical milking and although Bateman had been to Reading University Farm to study it he confessed that he found it very dull. 'This is not my excuse. I think you will be assured when you receive my third work that I have given good value.' Bateman also commented that 'as the subject of ensilage was given to me by the Ministry of Agriculture to encourage

and give publicity to this economic method of grass and green stuff preservation, it might be useful to send a photograph to the Farming journals for publication.' Dickey replied that he was 'sure that the Committee will be well satisfied with three pictures in the circumstances'. He remarked that he found 'The "pig" subject enchanting. It seems to me not only delightful in colour and feeling but will I think have very popular appeal to all and sundry. I can well believe that mechanical milking is not a particularly inspiring subject.'

Bateman's optimism about his haytime picture was misplaced. He later described to Dickey how it 'all went wrong and has never recovered. It is a completely different picture now and perhaps not so good as it was six weeks ago.' In the light of these changes he suggested the title should be revised to *Evacuees Assist with the Hay Harvest*.

A further commission was offered in March 1944 to undertake a picture of 16" gun experiments at Shoeburyness. Dickey, in making the suggestion to Gregory who had taken over as secretary from Elmslie Owen in July 1943, said 'He is not what one calls an artistic artist, but he did us well in some of his land girl pictures and he likes subjects with 3-dimensions. He is teaching but not I think full time'. Bateman declined due to prior commitments and the commission was carried out by Kenneth Rowntree.

NORMA BULL
1906–80

Art Gallery purchased two of her etchings, and in the same year the Poet Laureate John Masefield, who was a guest of the Melbourne Centenary Committee, gave her sittings for an etched portrait which was later hung in the Royal Academy, London in 1940.

Bull was a frequent exhibitor in the Victorian Artists' Society, Melbourne before travelling to England to further her experiences. She arrived in April 1939 shortly before war was declared in September. She served voluntarily at Pusey House First Aid Clearing Station near Oxford for the first few months of the war. There she received training in practical first aid, fire fighting and attended lectures in gas. Although she was not able to give full-time voluntary service indefinitely she volunteered to serve anywhere she might be urgently needed. Later she helped to train beginners at the First Aid Post at Ston Easton in Somerset, helped with evacuees and fire-watched chiefly in Bath where in 1941 she held an exhibition of her paintings.[35] Bull devoted her time to recording aspects of the war, commenting in a letter to Dickey at the WAAC, 'This requires some travel and a sojourn in various parts of the British Isles, in search for scenes of live historical interest.'[36] She also mentioned that as an Australian she felt 'privileged to depict in sketches something of the fine spirit of the people in their dire struggle for freedom.' Bull was invited by the BBC to broadcast to Australia, some of her war sketches already having been published there. She pointed out that her mother held fairs in her garden for the Melbourne University Women's Patriotic Fund, in aid of bombed-out children in England and the Red Cross Appeal.

Norma Bull was well-known as a painter (particularly in water-colours), printmaker and etcher in Australia. She was born in Melbourne on 7 September 1906, the daughter of Dr R.J. Bull, Director of the Bacteriological laboratory of Melbourne University and Grace Bull. Bull graduated from the National Gallery Art School, Melbourne in 1932 having won all her training through Gallery and University exhibitions, scholarships and prizes for sketching and painting. In 1934 the Melbourne

Bull was a member of the Bath Society of Artists and also the British Art Society and such was her success that in 1947 she held a 'one-man' show at Australia House, London which was patronised by the Queen who bought nine paintings. The London art critic for *The Scotsman*, G.S. Sandilands wrote in the catalogue 'The artist has also the great gift of the journalist or recorder… now and again the stories told by Miss Bull in her pictures are the popular ones: The Chelsea pensioners …or the searchlights on Victory Night repeating and again repeating the Cross of St. Paul's Cathedral against the clouds… Miss Bull is never ashamed of sentimentality when it is based on truth… the painter made such a great impression in England with her Blitz pictures of heroic cities [including Bath].' A touring exhibition lasting several years in Australia followed. Norma Bull died in Melbourne in September 1980.

CHILDREN HELPING WITH THE HARVEST, NEAR COVENTRY

In January 1941 Norma Bull was recommended to the WAAC by John Masefield. Masefield wrote, 'She is very anxious to have facilities for painting and drawing scenes of the war here. Her work in this way might be of signal benefit to the Australian press.'[37] The following month Bull applied for a 'Red' Sketching permit to enable her to sketch bombed buildings in Bristol. In a letter to Dickey, she said, 'what I most desire is to become a War Artist. I would go anywhere to record aspects of the war in either landscape or portrait work.' She continued, 'I have very good press notices, criticisms, letters which prove my art to be

sincere and progressive.' Bull had letters of recommendation including one from Thomas Bodkin, Director of The Barber Institute of Fine Arts, Birmingham and another from the Agent General for Victoria at Australia House. She concluded 'This letter sounds most egotistical, which fact I regret.' In July 1941 she wrote again, this time to thank Dickey for extending her sketching permit and to ask for an interview to show her Bristol war sketches. She said, 'the people of England are, I think, wonderful. They only realize their heroism when it is pointed out to them, or when it is recorded by the hand of the artist.'[38] The following year she wrote to Dickey to ask a question. 'I understand that those who devote their time to doing war sketches, with a Red Permit, are called "War Artists" (as distinct from the War Office Artists with a definite salary). I am surely a war artist when all my sketches depict war?… Since I am in Bath, do you think that there are any particular subjects that the War Art Committee may desire to see recorded?' Scribbled on the letter by Dickey is the comment: 'Told her "war artist" had no special meaning & that the C'tee didn't like to support subjects when no commission was given.'[39]

Bull was nothing if not persistent. In August 1942 while living in Bournemouth she sought to sketch inside The Observer Corps Post, Canford Cliffs. 'The Officer in charge gave me verbal permission, but the police regarded me with much anxiety & doubt.' Complaints were received about Bull's activities

LEONARD DANIELS
1909–98

which the Chief Constable of Dorset duly passed to the Regional Information Officer in Reading for consideration as to whether it was advisable to renew her permit to sketch when it expired on 15 September. The complaint was passed upwards to the Ministry who viewed it as 'serious matter' and wrote to Bull for an explanation. Bull replied 'What pains me is the implied injury to my good name and the slur cast on my British loyalty. This loyalty and discretion and trustworthiness I swear will never be found lacking in me, however severe the test and however close the scrutiny.' She wrote the following day, 'I am at a loss to understand the reason for a complaint... If any person looks for the credit of catching a spy, a defeatist, or a careless talker, he must look elsewhere. It is against all my ideals of right to say any good of the Axis which is obviously the embodiment of evil, or the anti-Christ. As such, though the battle be a hard one, the Axis is doomed to failure. I am eager to do anything in my power which will help the Allied cause.' The matter dragged on. Bull wrote in some desperation to Owen, who had taken over from Arnold Palmer, Dickey's successor 'would you do what you can to speed up the return of my Sketching Permit... Without it, my war effort is practically nil. Without it, my only course is to return to my home in Australia, since my efforts here do not seem to be appreciated.'[40] Bull's permit was returned and she completed further paintings including *Children Helping with the Harvest* which she presented to the Imperial War Museum in 1955. Other independent submissions were made and purchased, including for eight guineas *Effigies of Crusaders in Round Temple Church, London* after damage by enemy action.

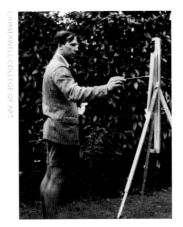

CAMBERWELL COLLEGE OF ART

Leonard Daniels 'was an influential administrator, teacher and painter, with a special interest in portraiture.'[41] He was born in London on 28 November 1909 and educated at Holloway School. Daniels began his art studies at Regent Street Polytechnic before attending the Royal College of Art to study painting from 1929–32. In his final year at the RCA he won the annual portrait prize. 'Robust, determined, civilised, a little solitary, he used to walk from the RCA in South Kensington to Battersea Park to run in the evenings.'[42] Daniels was a talented runner, having competed in inter-county athletics to near-Olympic standard.

He exhibited paintings and drawings at the Goupil Gallery in the mid-1930s but felt he wasn't ready to show his work. He did later show 'an occasional picture' including work at the Redfern Gallery in 1939.

Daniels' enjoyed teaching and he taught firstly in the 1930s at Clayesmore School, Dorset. While in Dorset he married fellow 'Poly' student Frances Joan Rapaport. In 1936 he moved to Hampshire to teach at Taunton's School, Southampton. He would take parties of students and their relatives on painting holidays to Brittany, and after painting during the day there would be discussion with the students in the evenings. Daniels did not

mince his words and most stringent criticisms were reserved for those who had not observed adequately.[43] These excursions were brought to an abrupt end by the outbreak of war.

During the war Daniels taught at the Southampton School of Art, in the new Civic Centre Campus. This was badly damaged by one of the intensive daylight air raids receiving a direct hit which killed or injured many of the staff and students who were gathered in a basement air-raid shelter.[44] The School, together with the College of Art at Portsmouth which had also been bombed, was evacuated to shared facilities at the Southern College of Art, Winchester. 'Daniels was closely involved in the organisation of this move and in the academic work of the two communities. He was an able lecturer with a secure command of his subject and an exceptional ability to guide young students in their development as artists.'[45]

Fencing without a mask in April 1942, 'the point from an épee penetrated [his] face with the horrifying result that [he] temporarily lost the use of [his] left arm and leg, and all [his] left side and spent over four weeks in the Royal Hampshire County Hospital, Winchester.[46] This accident prevented Daniels from taking up wartime military service in the RAF and put an end to his athletic prowess, which had been particularly important to him as he had been a 'delicate child'. In 1943 he was appointed Head of the Painting School at Leeds College of Art, remaining in post until 1948 when he was appointed Principal of Camberwell School of Art and Crafts. He was remembered by a former student as 'a calm, approachable person, whose

influence lay behind the disciplined approach in the studio and workshop.'[47] For Daniels, getting the right staff was paramount, and he invited Gilbert Spencer to apply for the role of Head of the Department of Painting. Spencer had taught Daniels at the RCA and Daniels had become a friend and neighbour of Spencer's whenever they were at Burdens Farm, Twyford, Shaftesbury in Dorset.[48] Spencer took the job, albeit on a reduced salary to that he had previously earned in Glasgow, but the post did allow him more time for his own painting. Daniels also appointed the distinguished artist Martin Bloch as a guest teacher in 1949, Bloch having fled Nazi Germany with his family in 1933–34, and who brought to Camberwell 'a far broader outlook than many of his peers.'[49]

Daniels spent some time at the British School of Rome, after winning a Leverhulme study bursary in 1957. In 1965 he was elected President of the National Society for Art Education. Daniels retired in 1975 and remained in London, and was persuaded to teach an informal group of adults of mixed ages at a centre for Adult Continuing Education in Maldon, Surrey. He didn't relish the idea of teaching 'amateurs' but he found he 'simply loved it and was terribly proud of the progress they made.'[50] He later moved to Midhurst, Sussex where he continued to paint, in particular portraits, including his friend Sir Thomas Armstrong. Rembrandt was his inspiration for such work.[51] Leonard Daniels died in Winchester on 24 February 1998 not long before the opening of the memorial exhibition at Winchester Cathedral of his drawings together with oil paintings by his wife, whose death in 1967 had affected him deeply.

WOMEN'S LAND ARMY: DITCHING

The work of Leonard Daniels was first brought to the attention of the War Artists' Advisory Committee in autumn 1941 when Gilbert Spencer mentioned to Dickey, secretary of the Committee, a painting of people in an air-raid shelter that Daniels had recently completed. Daniels wrote to Dickey on 2 November asking if the small painting might be shown to the Committee and that if they subsequently wished to purchase it he suggested a sum of 12 guineas. Dickey replied 'By all means send in more pictures... There is no limit to the Committee's interests provided the picture is of an activity which is clearly a war activity'.[52] The following year the Committee purchased for 15 guineas Daniels' picture of service personnel and civilians in a Communal Feeding Centre in Winchester.

Having obtained the necessary permissions, Daniels started preliminary observations in November 1942 of agricultural subjects for a number of proposed paintings for the WAAC. He saw a Land Army hostel, Land Girls potato-picking and a cub excavator at work. He wrote to Dickey 'The potato picking is a grand subject for a painting. The girls, usually in pairs, stand in a long line in the wide furrow the tractor has made in turning over the earth, their much washed khaki overalls look light against the dark earth. They wear mostly the green (regulation) jerseys, but some wear grey or pink, and some (instead of the overalls) the usual dark corduroy breeches. Most of them are wearing gum boots. This field was originally earmarked for extra playing field space for a school. Now it has been turned into production. It is in a typical half-built urban district... The WLA hostel

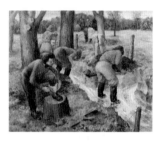

common room would be agreeable to paint. Varnished brown wood & thin panelling, stoves in the middle, black piano... girls in small groups... I should enjoy painting it, but I imagine the subject has been done rather too often. WLA rat catchers might be interesting to paint'.

Daniels eventually painted the WLA ditching which he submitted to the WAAC for consideration. He was informed that the limited grant the WAAC received meant that they had 'to be careful not to duplicate records of any aspect of War Work.' The Committee had recently commissioned a series of paintings on Women's Land Army subjects and it was possible that the subject he had submitted would be included. The painting was finally purchased in June 1943 for 15 guineas. Another painting was bought in March 1944 for 20 guineas.

EDMUND DULAC
1882–1953

Edmund (Edmond) Dulac, the multi-talented artist and illustrator, caricaturist, stage and medal designer, lecturer on art and music, was born in the suburbs of Toulouse, France on 22 October 1882. His father was a commercial traveller for a textile firm, who supplemented his salary by selling old paintings. As a teenager he drew and painted fervently, his 'liking for art had been excited early on by the Oriental collection formed by his uncle, an importer of goods from the Far East. This and other family encouragement he found invaluable.'[53] He studied first law, albeit 'unwillingly',[54] for two years at Toulouse University before studying full-time for three years drawing and painting at the École des Beaux-Arts. Dulac became a staunch Anglophile and acquired the nickname 'l'anglais' while at college. He won a scholarship to the independent Académie Julian in Paris and enrolled for six months but left after only three weeks as he disliked the teaching approach.

Attracted to book illustration Dulac left for England in 1904, 'the most lucrative field for such work.'[55] The following year he illustrated for the firm of J.M. Dent a new edition of the complete novels of the Brontë sisters.[56] His watercolour drawings were used to illustrate Hodder and Stoughton's first gift-book

Stories from the Arabian Nights (1907), which was an instant success and helped to establish his reputation as an illustrator in England and successor to Arthur Rackham. Martin Birnbaum, 'a partner in the New York firm of art dealers Scott and Fowles, and one of the earliest Dulac enthusiasts in the United States'[57] in his book *Introductions: Painters Sculptors and Graphic Artists* (1919) eulogized his work claiming it displayed 'from the very beginning fine imaginative powers, and each group of drawings disclosed greater technical achievements and an unsurpassed versatility. The daintiest draughtsmanship, a delicious humour, an amazing feeling for design, and a positive genius for rich radiant colour as applied to the pages of a book, were all coupled with the power to grasp an author's meaning, and to embody it most happily with the glamour or piquancy which pertained to the various literary works themselves'. Dulac 'made a distinctive contribution to the art of book illustration by welding together an extraordinary mix of French, English and Oriental influences.'[58] Over the course of his career he illustrated over 600 books as well as regularly providing illustrations for leading English periodicals such as *The Pall Mall Magazine*.

Dulac joined the London Sketch Club shortly after coming to London where his fellow members included Cecil Aldin and James Bateman. In 1912 – just over two years before the outbreak of the First World War – Dulac became a naturalised British citizen. In addition to being an acclaimed illustrator Dulac painted portraits and landscapes and was 'also a remarkable caricaturist, a disciplined artist in black and white who could capture a personality or situation in a very few

lines, but remain sympathetic.'[59] In 1919 he contributed weekly cartoons to the newspaper *The Outlook*.[60]

During the First World War Dulac and his second wife Elsa, afeared of bombing-raids by Zeppelins, moved out of London in the summer of 1917 to the relative safety of Cranleigh in Surrey. Returning after the war to Ladbrooke Road, Holland Park, Dulac turned his talents to designing theatrical costumes and scenery for various productions while also undertaking work for magazines. The following decade Dulac engaged in various artistic endeavours, including designing furniture and fittings for a smoking lounge in the luxury ocean liner the *Empress of Britain*. He supplied the Mint with a model for the King's poetry prize medal in 1935 and designed for the Post Office in 1937 the coronation stamps bearing the heads of both the king and queen.

In the Second World War, Morecombelake in Dorset became the temporary home of Dulac and his companion the writer Helen Beauclerk. He was visited by General de Gaulle who commissioned him to design the Free French stamps and banknotes. His success with postage stamps was repeated in 1952 when he designed the general stamps for Queen Elizabeth's reign. Edmund Dulac died on 25 May 1953 in London, after suffering a heart attack following a demonstration of his flamenco dancing to a group of friends.[61]

THE SISTERS
Confronted with the collapse of the market for illustrated gift books, Dulac undertook work for

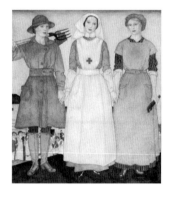

the war effort. The *Daily Mail* commissioned 'him to design a set of charity stamps in aid of the Children's Red Cross. The six stamps show Greek heroes and heroines acting out various exhortatory aspects of war: *Courage, Hope, Victory, Faith, Alliance* and *Assistance*.'[62] In 1915 he compiled *Edmund Dulac's Picture Book for the French Red Cross* which Hodder and Stoughton published in November at the deliberately low price of three shillings. 'It included condensed versions of many of the stories which [he] had been associated with... over the years, several of his book and magazine illustrations'.[63]

Dulac was granted exemption from military service as he was employed by the Department of Information, Wellington House in connection with Pictorial Propaganda. In 1917 the Department initiated a series of sixty-six lithographs by eighteen well-known artists including Dulac to illustrate *Britain's Efforts and Ideals in the Great War*. 'These lithographs were exhibited in the chief cities of all the Allied and neutral countries, with effect.'[64] The Ideals consisted of 12 mostly colour lithographs printed in a large format; largely allegorical they included Frank Brangwyn's *The Freedom of the Sea*, William Rothenstein's *The Triumph of Democracy* and William Nicholson's *The End of War*. The Efforts consisted of nine themed sets of six black-and-white lithographs of more or less uniform size depicting various aspects

EVELYN DUNBAR
1906–60

of the war effort, including A.S. Hartrick's *Women's Work*, William Rothenstein's *Work on the Land*, Muirhead Bone's *Building Ships* and C.R.W. Nevinson's *Building Aircraft*.[65] 'Dulac's original intention was to illustrate "Efforts" choosing "Women in the War", and he prepared a small, highly-finished watercolour preliminary entitled *The Sisters*, showing three young women with identical faces: a Land Girl, a nurse, and a munitions worker linked arm-in-arm. The design was unsuitable for lithographic production and he therefore decided to depict one of Britain's declared ideals, that of making 'Poland a Nation...'.[66] *The Sisters* was used to illustrate Barbara McLaren's (1917) *Women of the War*, the profits from which were given to the joint War Committee of the British Red Cross Society and the Order of St John. 'Every drawing and painting produced by Dulac in 1915 was undertaken without payment for charities.'[67] *The Sisters* was later exhibited in America and after its return Dulac in October 1919 presented it to the Imperial War Museum.

PRIVATE COLLECTION

The artist, mural painter and illustrator Evelyn Dunbar was born on 18 December 1906 in Reading, the youngest of five children.[68] Her father William Dunbar was a draper and outfitter and her mother Florence Murgatroyd, a talented amateur painter, was a major influence on the family taking them into Christian Science, which played a key part in Dunbar's life and career. She attended Rochester Grammar School for Girls and in September 1918, aged eleven, was awarded a Junior Exhibition from Kent Education Committee which exempted her from tuition fees. A gifted pupil, she was taught drawing by the landscape painter George Ward. She was awarded the first of many drawing certificates from the Royal Drawing Society and when only nine years old, in 1924, her penultimate year at school, she gained the prestigious Gold Star from the Society.

On leaving school Dunbar spent a year at home and, having been given a room as a studio, began painting. Her studio, the 'Tower', had been added to the top of her family home in Strood. While living there she made her first foray as a professional artist, both writing and illustrating short stories for children in *The Everyday Book*.

Dunbar briefly attended the local art school in Rochester and in 1927 went daily to London for a free term to

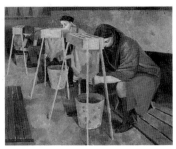

Milking Practice with Artificial Udders

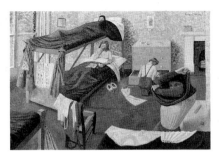

Land Army Girls Going to Bed

Women's Land Army Hostel

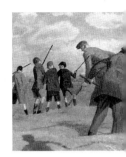

Threshing, Kent

the Royal Drawing Society, Westminster.[69] Here she attended special courses leading to the award of the Teacher-Artist's Certificate. In the autumn of the same year she attended Chelsea Polytechnic for two days a week and did lettering and illustration. She returned to full-time study at Medway School of Art and Crafts for two terms, under Harold Shimmell, who had studied at Woolwich Polytechnic School of Art and the Royal College of Art where he had specialised in mural painting. Dunbar was advised to attend the Royal College of Art and won a Kent Education Committee Higher Exhibition to do so in 1929.

At the RCA Dunbar was briefly taught by Allan Gwynne-Jones who much encouraged and admired her work. She was influenced not only by Gwynne-Jones but also by other assistants in the School – most importantly by Charles Mahoney who was in charge of the composition class and later the Mural Room. He was to be an inspiring influence on her work. One of her early student compositions, a watercolour *Study for Decoration: Flight 1930* was later purchased by the Chantrey Trustees for the Tate Gallery. In 1931 she won the Augustus Spencer prize at the RCA and had her work singled out for making 'a particularly good impression by breadth of treatment and appreciation of atmospheric envelopment – the special concerns of the painter as distinct from the draughtsman'.[70] In the same year her painting *Gardening* was shown at the prestigious Goupil Gallery.

From 1933–36 Dunbar worked on a series of murals based on Aesop's and Gay's fables at Brockley School, Hilly Fields, London under the direction of Mahoney,

who made a major contribution to this project. The murals attracted public attention. Dunbar's *The Country Girl and the Pail of Milk* was specially praised for 'its felicity of illustration, breadth of treatment and charm of colour'.[71] The other murals were painted by Mahoney (2), Mildred Eldridge and Violet Martin. The style and agricultural subject matter of Dunbar's mural anticipates her work as a war artist, depicting the working lives of women on the Home Front and in particular the Women's Land Army.

Much of the inspiration for Dunbar's early work derived from her interest in gardens and gardening. Her horticultural expertise and artistic ability enabled her to undertake with skill and understanding commissions for illustrating a variety of books and manuals between 1935–53. In May 1935, while still engaged in completing the Brockley murals, Dunbar began illustrations for the anthology *The Scots Week-End and Caledonian Vade-Mecum for Host, Guest and Wayfarer*, edited by Donald and Catherine Carswell. Her next venture was a collaborative one with Mahoney, *Gardeners' Choice* which was published by Routledge and comprised their selection of some favourite perennial plants with drawings of each and practical information on their culture and habit based on direct observations and personal experience of raising and cultivating them. Dunbar next designed and illustrated *Gardener's Diary 1938* for *Country Life*.

The outbreak of war was a major turning point in Dunbar's career. The Blue Gallery in Rochester, which she had opened towards the end of 1938 on the first floor above the shop owned by her sisters, had suffered

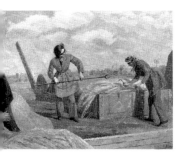

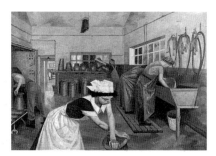

A Land Girl and the Bail Bull *Women's Land Army Dairy Training*

from the uncertainties leading up to the war, and was abandoned after a few months. She applied to be a war artist and on appointment travelled all over the country recording the activities of women on the Home Front. She continued to exhibit with the New English Art Club and in 1943 *Joseph's Dreams* was shown at the Suffolk Street Galleries. Several of Dunbar's wartime paintings appeared in the *Britain in Pictures* series published between 1941–45 as an important part of Britain's propaganda campaign.

After the war Dunbar was employed as a visiting teacher at the Ruskin School of Drawing, Oxford. In 1953 she illustrated Derek Chapman's *Farm Dictionary*, and towards the end of the year she staged her first (and only) solo exhibition which was held at Swanley Hall, Withersdane, part of Wye College, Kent where her husband Roger Folley now lectured in agricultural economics. Twenty-five paintings were shown, including six of her wartime commissions which were loaned by the Imperial War Museum. In 1956 she was elected a Fellow of The Royal Society of Arts and on the recommendation of Percy Horton, Master of the Ruskin School, was commissioned by Dora Cohen, Principal of Bletchley Park Teacher Training College to paint two murals. The murals, *Alpha and Omega* – two five-ply panels (32" x 52") – were made detachable for removal, and took over a year to complete. They were the last she worked on, and thereafter she painted mostly portraits, and gave more rein to her imaginative and allegorical work. Throughout her life she felt driven to paint and believed 'profoundly in the harmony of life and that to paint was to experience joy.'[72]

Evelyn Dunbar died suddenly on 12 May 1960 returning from a walk with her husband and within a few hundred yards of her home Staple Farm, Hastingleigh near Wye. The following year a memorial window was set in one of the large windows in Wye College Library, designed by the artist John Ward and incorporating some of her own work.

MILKING PRACTICE WITH ARTIFICIAL UDDERS

LAND ARMY GIRLS GOING TO BED

WOMEN'S LAND ARMY HOSTEL

THRESHING, KENT

A LAND GIRL AND THE BAIL BULL

WOMEN'S LAND ARMY DAIRY TRAINING

A 1944 PASTORAL:
LAND GIRLS PRUNING AT EAST MALLING

POTATO SORTING, BERWICK

SPROUT PICKING, MONMOUTHSHIRE

Dunbar's most successful and extensive body of work dates from the Second World War. On 15 December 1939 a radio broadcast outlined the aims of the War Artists' Advisory Committee and encouraged artists to make their work known. Although Dunbar missed the broadcast she wrote a few days later to Percy Jowett, a member of the WAAC and who was particularly interested in the work of younger artists, to ask 'if there were any possibility of work making records say, of women's agricultural or horticultural work or anything connected with land work; I feel I could do

A 1944 Pastoral:
Land Girls Pruning at East Malling

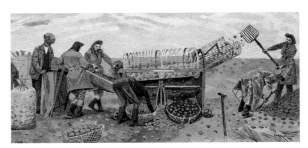

Potato Sorting,
Berwick

Sprout Picking,
Monmouthshire

this with very keen understanding.'[73] The Committee commissioned her to undertake six pictures or fewer more elaborate pictures of women's work in wartime. She was paid a fee of fifty guineas. Dunbar, like other war artists, was instructed that 'It will be necessary to submit all your preliminary sketches and studies, as well as finished works, for censorship.'[74]

Dunbar's appointment as a war artist was announced in The Times on 25 April 1940, alongside those of Dorothy Coke and Ethel Gabain, plus Richard Eurich and Duncan Grant, Kenneth Rowntree, Gilbert Spencer and Stanley Spencer. She went to Sparsholt Farm Institute[75] near Winchester for three weeks in June to record the training undertaken by Women's Land Army recruits. She found it 'quite an interesting place, having been a boys' agricultural college, but now turned into a training centre for Land Army girls of whom there are about 40 at the moment. It's rather nice country too in a simple open sort of way.'[76] Here she met her future husband Roger Folley.

Milking Practice with Artificial Udders was finished in her studio at Strood, and sent to Dickey, secretary of the WAAC, on 12 September 1940. Women's Land Army Dairy Training was also a result of Dunbar's of stay at Sparsholt.[77] For the next three months Dunbar worked on a further series of Land Army paintings, her commissions being restricted to women's occupations. In January 1943 she visited the Institute of Agriculture, at Usk in Monmouthshire, where she lived in a WLA caravan which caused her much angst. She explained to Dickey how she 'wrestle[d] with its stove, lighting, blacking out and provisioning. It is good fun and

experience, and makes one tough, but, unless I can reduce it to a system of minimum labour, I'll have to do something else in the way of living. However, I'd like to conquer it, and at the same time produce some reasonable work.' According to Dunbar it was the wettest January on record, and she had only three fine days. Having returned home, three weeks later she was again off on her travels, this time to a rural district in Gloucestershire to finish off her WLA series. In 1943–44 she was employed full-time on a series of six-month contracts at a salary of £325, under the auspices of the Ministry of Information, 'to make paintings of "agricultural and women's subjects".'[78]

By April 1943 she could report a steady, though not swift, amassment of paintings. Although nine were finished or ready to finish, she declined to bring them to London to the WAAC until they were all complete as they had bearings upon each other. At least two of these – Threshing and Baling, Monmouthshire and Sprout Picking, Monmouthshire and probably also Baling Hay – resulted from her stay at Usk. Potato Sorting, Berwick, Women's Land Army Hostel and Land Army Girls going to Bed date from this period. The latter two works provide intimate insights into the life of Land Girls in hostels. Dunbar had earlier completed Threshing, Kent which shows three Land Girls at work in the fields assisted by two older farm labourers. The Land Girls are wearing regulation overalls, head scarves and goggles to keep the dirt and dust out of their hair and eyes.

The painting A 1944 Pastoral: Land Girls Pruning at East Malling was undertaken at the fruit research station about 10 miles from Dunbar's home. She cycled

MICHAEL FORD
1920–2005

when she could but a big drawing board make this difficult. As a consequence she made an application for petrol to the Committee. After much wrangling it was finally approved and she continued with her sketching for the painting. The WAAC thought her final Land Army painting – *A Land Girl and the Bail Bull*, the initial sketches and notes for which were made at Sparsholt 'very finely seen and well conceived. In fact, the whole composition of the picture and its rather poetical mood made them enthusiastic and several members declared it was the best work they had ever seen of yours.'

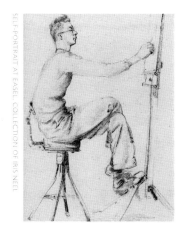

SELF-PORTRAIT AT EASEL. COLLECTION OF IRIS NEEL

Michael Ford, a freelance artist, was born in Winchester on 28 July 1920. His father Major Edward Maurice Ford MC was a soldier, farmer and managing director of a seed merchants company on the Winchester/ Basingstoke borders at Quidhampton Farm, Overton. His mother Phyllis Louisa Young contracted rubella during her pregnancy and, as a consequence, Michael was born deaf. As a child he attended, along with other children from Quidhampton, the 'Home School' which his mother started on their farm. Here he learned the basic skills of lip reading, and developed his artistic skills. His mother took the view that her son had to live in a hearing world, and thus did not teach him sign language.[79]

Ford received his art training at Goldsmiths' College Art School from 1937–40 under the Principal, Clive Gardiner, who was an excellent teacher. He travelled daily to London and was 'very popular there and in spite of his handicap entered into all that was going on with great zest', including membership of the Art Students' Association.[80]

Life on the farm ended in 1941 when Major Ford retired and the family moved in October to nearby Cobley Wood, Micheldever Station. Ford joined the

Local Defence Volunteers, later the Home Guard, on its formation in May 1940, after the fall of France and commenced three days a week coal mining.[81] He became a dispatch rider and rode both solo and side-car combination machines.

Ford exhibited in London at the Royal Academy and also with various societies including the Royal Society of Portrait Painters, Royal Society of British Artists and the New English Art Club. He would only work from live subjects, including animals. He produced detailed sketches and his wartime paintings in particular are characterised by minute observation and a naïve, narrative quality. Ford was comfortable working in several media – pastels, charcoal, inks, pencil, water colour or oils. Post-war, he had a long-standing contract with the *Farmers Weekly* magazine, to sketch a featured farmer or landowner. This involved meeting a range of interesting people while his mother noted the 'gossip'. He died in Winchester on 16 June 2005.

ITALIAN PRISONERS-OF-WAR WORKING ON THE LAND

Michael Ford's deafness precluded his entry into the Services so he worked on a farm near Micheldever in Hampshire as his contribution to the war effort whilst also being an active member of the Home Guard. He made a number of independent submissions to the War Artists' Advisory Committee, initially with a painting he had done from sketches made in a shepherd's hut where he waited for his turn of duty at night. The painting showed two members of the Home Guard 'brewing cocoa by the light of a candle with the rather

queer shadows thrown on [the] wall roof.'[82] The painting *Home Guards Brewing Tea just before Dawn* was purchased the following month for ten guineas. Ford was obliged to apply for a sketching permit as the area where he was living had recently had 'some air raid damage and not having a permit he could not sketch on the spot of course but only from memory.'[83] Ford was refused a permit by the Central Institute of Art and Design (CIAD). Dickey was sympathetic to Ford's application and noted that the CIAD were only granting permits 'to artists whose work is of a very high standard and who depend on this type of work for the major portion of their livelihood'. Mrs Ford wrote on several occasions to Dickey to seek his support to overturn the refusal which she saw as 'decidedly unfair'. She said, 'he can hardly produce a pencil or paper without someone or other questioning him… He has no intention of travelling about looking for War secrets to draw – he is very much tied here in Hampshire, but drawing of any sort in public is almost impossible as things are.' Dickey wrote to the CIAD to question the refusal but received a letter from Fennemore stating, 'I think there is very little chance that the Committee will revise its opinion. Mr Ford sent some very unimpressive work for the Committee to inspect.'

In May 1941 Ford submitted unsuccessfully a painting of a Land Girl who worked on his family's farm entitled *The Under Shepherd*. In July his painting *War Weapons Week*

FOUGASSE
Cyril Kenneth Bird
1887–1965

in a Country Town was purchased for fifteen guineas. Ford was pleased it was bought and visited the exhibition with his mother at the National Gallery where it was on display alongside other wartime paintings. Eric Newton in the foreword to the catalogue commented that it was a side of the war that no other artist had tackled. He described how Ford 'in his innocent little picture, has put into paint a charming description of the local brass band, the girl guides, the improvised platform, the Union Jack and the mildly interested handful of spectators – a glimpse of democracy trying hard to cover itself with a veneer of regimentation and ceremony.' After his visit Ford wrote to Dickey, 'I have to help with the harvest now so shall not get much time but hope to send some more work up later on.'

The following February Ford submitted another oil painting *Italian Prisoners at Potato Harvest*, later retitled *Italian Prisoners-of-war Working on the Land*. The Committee approved the purchase later that month for the sum of fifteen guineas. The Committee also agreed that he should send it to the Royal Academy for consideration for selection in the Summer Exhibition. The RA did not accept it. Ford also designed a poster in April 1942 featuring a Land Girl: 'Are you working or shirking? More women are needed.'[84] Further submissions were declined, including one of a woman chopping wood as part of the fuel saving campaign as it did not come within the category of a record of the war. Dickey explained 'The Committee are frequently obliged, by their terms of reference, to reject otherwise excellent paintings, on the ground that – as far as subject is concerned – they might have been painted pre-war.'

HOWARD COSTER © NATIONAL PORTRAIT GALLERY

The cartoonist and illustrator Cyril Kenneth Bird who designed some of the most memorable and humorous Second World War posters was born in London on 17 December 1887, the son of Arthur Bird, an England cricketer and company director, and his wife, Mary Wheen. He was educated first at Warwick House School from 1893, before attending a boarding school in Farnborough, Hampshire from 1898–1902. He finished his schooling at Cheltenham College, and although he wanted to be an artist his father insisted he train for a job. As a consequence in 1904 Bird studied engineering at King's College, London and attended evening art classes at Regent Street Polytechnic and the School of Photo-Engraving and Lithography in Bolt Court, Fleet Street. In the same year he joined the Artists Rifles and for four years acted as machine-gun instructor. He graduated in 1908 and from 1909 worked at Rosyth naval base on the Firth of Forth, just north of Edinburgh.

In August 1914 Bird applied for release from the dockyard, where he was working on submarines, and by the time of his marriage on 16 September 1914 to Mary ('Mollie') Holdwell Caldwell he was a second lieutenant in the Royal Engineers. He was sent to Gallipoli with the 52nd Division in 1915 but

'His military career was brief… he was desperately wounded in 1915, and was home in 1916 with a shattered back and little hope of survival.'[85] While recuperating he took a correspondence course in illustration from the Press Art School, Forest Hill which Percy V. Bradshaw had founded in 1905,[86] promoting drawing as a useful and therapeutic activity.[87] Bradshaw received letters and sketches from Bird in Scotland signed Fougasse. He explained that 'A Fougasse is a small mine placed underground, and charged with explosive; its effectiveness is not always reliable, and its aim uncertain. It was Kenneth Bird's modesty which persuaded him to adopt his queer pen-name; for, when once he found his aim, he seldom missed the very centre of his target.'[88] Further, the signature 'Bird' was already being used by another *Punch* contributor Jack B. Yeats whose first cartoon appeared in July 1916.

Fougasse's first of many collections of drawings *A Gallery of Games* appeared in 1921. He also designed posters for London Underground from 1925–44. His wife was also an artist, and they held joint exhibitions including one in 1926 at the Fine Art Society. In 1933 they both became Christian Scientists. He continued to contribute to *Punch* and other magazines and became its art editor in 1937, and in 1949 only the seventh editor 'since the magazine was founded in 1841, and the first to draw his way to the editorial chair.'[89]

With the advent of war Fougasse offered 'his services free of charge to any ministry who wished him to design posters,'[90] he strongly believed that 'humorous pictorial propaganda is undoubtedly one of the best means of appealing to the public'.[91] His offer was accepted by E.J. Embleton, studio manager at the Ministry of Information and over the course of the war he worked for virtually all the ministries, contributing over 1,000 drawings and posters. 'He drew masterly illustrations for the Army, and for the Air Force he evolved a hilarious series of instructional posters… For the Navy, he did hundreds of drawings for secret manuals – so secret that he used to say that he had to draw them with his eyes shut.'[92]

Fear of spies and fifth columnists was widespread. The series of eight posters that Fougasse produced for the Ministry of Information's anti-gossip campaign in February 1940 with the slogan 'Careless Talk Costs Lives', while conveying a serious message, was popular and effective in overcoming public apathy. The posters with their bright red border and white space around the simply drawn figures of 'Hitler, Goebbels, and Goering listening to indiscreet conversations'[93] were eye-catching and unambiguous. In the introduction to …*and the gatepost* Fougasse explains that the series 'had to aim at getting their message across to as many people as possible [and] they had to present it in such a way that people with space to give would not recoil from it.' The Ministry relied on the generosity and interest of organizations and individuals for the display of posters and cards. Teashops, restaurants, hotels and public-houses, he pointed out, could not in fairness be asked to display horror-propaganda for the encouragement and edification of clients. When not busy drawing he and his wife served as air-raid wardens in Kensington and 'were actively engaged throughout the Blitz with bombs and rescue work.'[94]

The year after the war ended Fougasse was awarded the C.B.E. for his distinctive contribution to wartime propaganda.

Fougasse retired in 1953 although he continued to draw for *Punch*. In 1956 he published *The Good-Tempered Pencil*, which sought to explain without being technical and tiresome pictorial humour. In the same year he illustrated *The Art of Refereeing: A Handbook for Rugby Football Referees*. Fougasse was well qualified to do so having played rugby to a high level and in the final international trials in 1913 he scored the only try and 'would have been certain of his Cap for Scotland but he got concussion and remained unconscious until the match was over.'[95] He died in London on 11 June 1965.

Leaflet

Poster

illustration for the leaflet-cover about the fund, the object being simply 'to persuade the beholder to turn over the page and to read what's inside.'[97]

WOMEN'S LAND ARMY BENEVOLENT FUND LEAFLET and POSTER

Fougasse designed two posters for the Women's Land Army Benevolent Fund, probably in 1942 when the fund was established. Like his earlier posters they are framed in red with minimal colour and designed to attract immediate attention and to inform the passer-by, on this occasion, of the arduous, solitary nature of the work of Land Girls frequently in inclement weather. 'It was perhaps the need to get across his message in the most unambiguous way that forced him to prune and pare down to the quintessence of his figures.'[96] The text – 'For those who are fighting the Battle of the Fields, the Women's Land Army Benevolent Fund urgently asks your help' – is direct and aimed at inciting to action. Fougasse also provided the simple

ETHEL GABAIN
1883–1950

REG SPELLER / HULTON ARCHIVE / GETTY IMAGES

Ethel Gabain, renowned lithographer and painter, was born in Le Havre in 1883 of mixed French and Scottish descent. She spent her early years in France and it was perhaps this time which imbued her art with its 'graciousness and elegance'.[98] Aged 14 she was sent to Wycombe Abbey girls' boarding school in England. In 1902 she commenced her art training at the Slade; in the following year she spent some time at Raphael Collin's Studio in Paris, and from 1904–06 she attended the Central School of Art and Crafts, London. There she learned the technique of lithography from Ernest Jackson who had himself recently returned from studying in Paris.

Gabain was one of a dozen or so artists – including her future husband John Copley (1875–1950), A.S. Hartrick and Joseph Pennell – who were founder members of The Senefelder Club, so named to link 'the name of the inventor and founder of the craft

with lithography once more.'[99] The Club held its first exhibition at the Goupil Gallery, Regent Street in January 1910, with Pennell as President, and the following year Copley was elected as the first secretary. In 1913 Gabain married Copley. 'In happy combination, with subtly contrasting qualities of strength and sweetness, they brought new life and vigour, and new pictorial use, to an almost forgotten method. In a period of fifteen years Ethel Gabain produced over three hundred lithographs,'[100] including those for Charlotte Brontë's *Jane Eyre* in 1923, one of the few books she illustrated. The only lithograph she produced dealing with the First World War was that of *A Munition Worker* completed towards the end of 1917.[101] Ethel Gabain and John Copley 'were among the first to print their lithographs on their own press, thereby eliminating the sometimes mechanical look of the commercial printer's work.'[102]

The Copleys moved to Italy with their two young sons on account of his ill health and from 1925–27 lived in the warmer climes of Alassio where 'Mrs John Copley' held weekly life classes which the members of the small English community attended, together with lectures on 'Sculpture Greek, medieval, modern' at the Alassio English School. The *Alassio News* reported that 'She, an accomplished artist herself, has the power of presenting a difficult question with vividness and charm.'[103]

Returning to England Gabain exhibited at the Royal Academy for the first time in 1927 with an oil painting *Zinnias*, the first of many studies of flowers. She also painted portraits including a large number of famous

actresses in character, of which *Miss Flora Robson as Lady Audley* was awarded the De Laszlo silver medal of the Royal Society of British Artists in 1933.[104] Gabain became vice-president of the Society of Women Artists in 1934 and president in 1940. Amongst other groups she exhibited with were the New English Art Club and the Artists' International Association. When finances were precarious in the 1930s she lectured on art history in girls' schools, her scripts written by Copley.[105] She worked closely with her husband, 'but not imitatively… sharing studio space all their lives'; they understood each other's work and would exchange ideas and in 1938 they held a joint exhibition of their paintings at the Colnaghi Galleries.[106]

In 1939 Gabain became seriously ill and the following year was marked with much sadness with the tragic death of her youngest son Christopher, a medical student of brilliant promise. It was a shattering and catastrophic event.[107] In the same year she was appointed an official war artist to record in particular women's work in traditionally male occupations, something which she was well suited to given her earlier choice of subject matter. As her obituarist noted, she had 'a special sympathy with and understanding of the phase between girlhood and womanhood, the tremulous condition of late adolescence with its unformulated hopes and fears.' Throughout the war years and beyond Gabain's health was poor. Increasingly frail, she suffered from arthritis and earlier had lost a kidney. Further, 'in her last years she had to paint with the brush strapped to her wrist.'[108] She continued to exhibit until 1949 and died at her home in London on 30 January 1950.

LOADING LOGS ON A TRACTOR AT A BANFFSHIRE LUMBER CAMP and SORTING AND FLINGING LOGS

Ethel Gabain was contacted by the Ministry of Information in April 1940 to undertake four lithographs of evacuation subjects and four of the Women's Voluntary Services at 12 guineas each. They were the first lithographs she had done since 1925 and were some of her most accomplished and detailed work. They were published by HMSO as two sets in folders respectively – *Children in Wartime* and *Women's Work in the War other than the Services* which included *Sorting and Flinging Logs*.

Gabain, although reluctant to leave home for very long at a time, travelled all over the country, often to remote areas under conditions of much discomfort to complete these and later commissions. She was accompanied, where possible, by her husband to look after her as her health deteriorated. She wrote from Ivybridge, Devon to Dickey in September 1940 with the proofs of two stones – *The Fire Drill* and *Evacuees in a Cottage at Cookham* – and commented 'This deep country and its people gives one the sense that against all machinations England is unassailable.'[109]

In 1941 she studied Land Army subjects and in order to achieve accuracy asked for the loan of a Women's

HENRY GEORGE GAWTHORN
1879–1941

Land Army uniform. She travelled to the Scottish Highlands to complete *Loading Logs on a Tractor at a Banffshire Lumber Camp* near Blairgowrie and to Pityoulish, to undertake *Sorting and Flinging Logs*. 'The female lumber-jacks, sand-bag fillers and pilots she drew had a place and a role for themselves, and she reflected this in a new and confident line. She did not, however, mimic the socialist-realist style of the period; her women are enjoying, not sacrificing themselves…'.[110]

In February 1943 Gabain was again very unwell and Copley, in a letter to their friend Randolph Schwabe, revealed that 'Three weeks ago no one thought she could live from hour to hour, but then with her miraculous vitality, she rallied…'.[111] In 1944 she documented the treatment of burns and other medical subjects, along with a portrait in oils of Sir Alexander Fleming, the discoverer of penicillin. Towards the end of 1945 she completed two further lithographs: *Miss Caroline Haslett, CBE, Director of the Women's Electrical Association* and *Miss Barbara Ward, Assistant Editor of The Economist*.

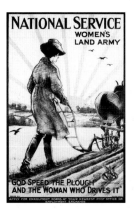

The lithographer and artist Henry George Gawthorn was born in Northampton in 1879. He studied at Regent Street Polytechnic and Old Heatherley School, winning medals and awards for draughtsmanship.

Gawthorn began his career in an architect's office but later turned to pictorial art.[112] He exhibited at the Royal Academy, the Royal Society of Portrait Painters and the Society of Graphic Art. He was a successful poster artist commissioned by the likes of Messrs. A. & F. Pears and the London and North Eastern Railway. He often included a self-portrait in his posters, complete with monocle and panama hat (see facing page). His work appeared in *Posters and their Designers* (1924) and *Posters and Publicity* (1927) and *Art and British Advertising* by W. Shaw Sparrow. Gawthorn died on 11 September 1941.

RECRUITMENT POSTER

Gawthorn designed a number of posters during the First World War including one for the Women's Land Army in 1917. The poster he designed for the Young Women's Christian Association, 'Help them to carry on', features six women wartime workers including a member of the Women's Army Auxiliary Corps and a member of the Women's Royal Air Force walking arm-in-arm across a globe followed by a Red Cross Nurse and a Land Girl who has a pitch fork across

HILDA HARRISSON
1888–1972

her right shoulder. Behind her is a munitions worker carrying a shell and lastly a professional woman.

Hilda Harrisson, the painter of landscapes in oil and pencil portraits, was born in Liverpool in 1888, the daughter of S.M. Grierson, a solicitor. She received her art training at the Ruskin School of Drawing and exhibited at the Goupil and the New Chenil Gallery and with the New English Art Club.

Harrisson is perhaps best known for being the recipient of the letters largely about literary and painting matters that the Liberal politician Herbert Henry Asquith (Prime Minster 1908–16) wrote to a friend over a period of ten years. Asquith in *Memories and Reflections 1852–1927* explained that it was in 1915 that he formed a new friendship with a young couple Roland and Hilda Harrisson who took a farm in the neighbourhood of Easton Grey, near Malmesbury in Wiltshire, which had long been the home of his sister-in-law. Roland Harrisson was a professional soldier and a Major in the Royal Artillery who was killed in France in September 1917. Following his death Hilda moved to Boars Hill, known as 'a nest of singing birds',[113] just south of Oxford, to live with her mother – only a few miles from where Asquith lived in Sutton Courtney. Harrisson became friends amongst others with the Masefields and the Robert Graves family. 'She introduced Stanley and Gilbert Spencer, then little known, to her circle which included Paul and John Nash and the sculptor Frank Dobson.'[114]

Desmond MacCarthy, who edited the letters after Asquith's death, commented that they show that their friendship was 'a source of refreshment, rest and delight to him… If he had been in the habit of quoting German… he might have said to the lady of letters, "Du bist die Ruh."'[115] [You are quietness, you are peace]. MacCarthy also explains that in their exploring new movements in art Asquith commissioned a bust by Dobson. Harrisson 'was an ideal confidante, an unworldly, unambitious and extremely sensitive woman. They had been drawn close together by bereavement in war; the death of Raymond Asquith and her husband'.[116]

Post-Second World War Harrisson held an exhibition of her paintings in Oxford. Several now hang in Oxford University Senior Common Rooms. 'Her skilful and sensitive copying of old masters was much admired. Her copy of de Wilde's *Dickie Suet* is in the Oxford Playhouse and St Edmund's Hall commissioned her to copy portraits of their ancient worthies.'[117] She died in a London hospital on 27 February 1972.

A LAND GIRL
Hilda Harrisson submitted a number of pictures in May 1943 to the War Artists' Advisory Committee, two of which were purchased for 8 guineas. These were both portraits in chalk, *A Land Girl* and *A Woman Bus Conductor*, completed respectively in February and May 1942. Although neither sitter is known, the 'features are sufficiently detailed to convince the viewer that the portrait is neither a fabrication nor a generalisation… [the] sitters had to represent diversity

in their geographical origins: a clear indication that individual heroism was a fact throughout the country.'[118] Harrisson had previously written to the WAAC to request facilities, the Committee agreed and asked her to give the secretary Gregory the name of a specific factory where she would like to work.[119]

Harrisson submitted further drawings in March 1944 but they were rejected. Gilbert Spencer had written to Gregory the last secretary to the Committee to say that he had seen the portrait of Mary Cornish 'who was in an open boat in the Atlantic for seven days & kept seven children happy.'[120] Harrisson had completed what he thought was a good portrait and asked if she should bring the drawing for Gregory to see. She did so and was especially disappointed when this was rejected.

ARCHIBALD STANDISH HARTRICK
1864–1950

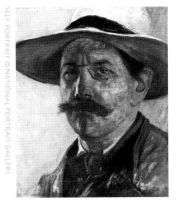

SELF-PORTRAIT © NATIONAL PORTRAIT GALLERY

Archibald Standish Hartrick had a long career spanning both world wars, 'much respected by his fellow artists' but it was only in later life that he achieved fame as both a painter and a 'delicate and sensitive draughtsman'.[121] He was born in Bangalore, India on 7 August 1864 where his father Captain William Hartrick and his mother Josephine Smith were stationed with his regiment the 7th Royal Fusiliers. Returning to Scotland at the age of two he was educated at Fettes College, Edinburgh and passed the matriculation examination to study medicine at Edinburgh University.

Hartrick studied painting under Legros at the Slade School of Art from 1884–5 where he won a prize for painting landscape. Later, with other students from the Royal Academy School, he migrated to Paris to study at the Académie Julian 1885–86 which was the largest school of art in 'the city of light,'[122] having some four hundred students. Here he was taught by Boulanger and Lefèvre. A year or so later he joined the much smaller and select Atelier Cormon with only 30–35 pupils including Toulouse-Lautrec. It was while painting in his first summer in France in 1886 in Pont-Aven, Brittany that he met Paul Gauguin, although he 'never knew him in the way [he] came to know Van Gogh' who frequently came to see him and talk about his latest impressions or theories of art.[123] Although influenced by these experiences he remained 'frankly an individualist in art, painting just as I can.'[124] Towards the end of 1887 Hartrick returned to Scotland, and through his stepfather Dr Blatherwick, made contact with the artists who would later become the 'Glasgow School' and painted landscapes although not very profitably.

Early in 1889 Hartrick successfully responded to an advertisement for 'black and white' artists for The Daily Graphic, the new illustrated daily newspaper to be published in London and for which he worked for two years. He next drew for The Graphic, the illustrated weekly newspaper and 'parent' of The Daily Graphic before working for three days a week for The Pall Mall Budget from 1893 and later The Pall Mall Magazine. Hartrick was a founder member of the Chelsea Arts Club which was established 'to supply the growing number of artists with a meeting-place where they also get meals at prices suited to their pockets.'[125] In 1896 he married the eldest daughter of his stepfather by his former marriage, the gifted artist Lily Blatherwick, who was a member of the Royal Scottish Society of Painters in Water-Colours. Towards the end of the nineties they went to live in the West Country in Acton Turville, a village near Badminton so that he might find more time to paint, although he continued with his real work of illustration. They moved shortly after to Cherry Farm, Tresham where they remained for ten years and where Lily was buried in 1934. Hartrick put a reredos in the church on which he did a painting 'as a memorial to the unnamed dead buried in the churchyard'.[126] During this period he illustrated several books

including *The Queen's Quair* by Maurice Hewlett and for his friend Hewlett's special edition of the *Forest Lovers* and also held a joint exhibition with his wife at the Continental Gallery in Bond Street, London.

Hartrick exhibited with the New English Art Club for about fourteen years showing first drawings and then small pictures as well as being on the selecting jury and later the Committee before leaving to join the International Society of Painters, Sculptors and Engravers. Through the Society he gained a silver medal at an International exhibition in Milan for his set of English country types and two medals in 1910 at the Chilean Centenary Exhibition for an oil and a water-colour painting.

Finding the winters too severe in the country for his wife's health they returned to live in London and found a house in Fulham. In November 1907 he was appointed as a visiting teacher at the L.C.C. School of Arts and Crafts, Camberwell, where he gave instruction two days a week 'in drawing and painting from the head, and drawing from the costume model for illustration or poster work, the latter being in connection with lithography and commercial art generally.'[127] In his book of reminiscences *A Painter's Pilgrimage through Fifty Years*, he describes how he 'returned to Legros's methods of teaching entirely with the point: and so pencils on white paper were the simple tools employed.' He also insisted on using the method of the Old Masters of 'drawing by the character of the contour rather than the mass'. This way he believed that the form, the object of all drawing, was more readily perceived and so learnt in this way. While

teaching at Camberwell he joined the art advisory board of the Girls' Public Day School trust, 'the idea [being] to draw up a syllabus which should be suitable for teaching art and aesthetics from a purely educational point of view in girls' schools.'[128] Around the same time he was involved in the founding of the Senefelder Club for the advancement of artistic lithography and was one of the members commissioned by Frank Pick to produce a series of posters to advertise the railway, his being a lithograph of *Morris Dancers*. In September 1914 he transferred to teach lithography at the Central School of Arts and Crafts, although he continued to teach at Camberwell until Christmas.

Hartrick sought work connected to the war effort but he was over age and with no special knowledge was turned down and advised to continue teaching. He was later approached to contribute to the series of lithographs for *Britain's Efforts and Ideals in the Great War*. His contribution was *Women's Work*, part of the Efforts series. He recalled that 'In most cases women were doing work which was usually done by men, and doing it very well.' After the Armistice, Hartrick completed a series of 12 lithographs *Playing the Game – War Work* commissioned by the 'Underground' to show the contribution of its staff over the last four years. He continued teaching and in 1921 published *Drawing. From Drawing as an Educational Force to Drawing as an Expression of the Emotions*, having been encouraged to do so by his friend Morley Fletcher, Head of the Art School in Reading, and later Director of the new College of Art in Edinburgh. His second textbook – the popular *Lithography as a Fine Art* – was published as part of The Little Craft Books series edited by F.V. Burridge in 1932.

Hartrick's interest in rural life and his love of nature made him well placed to contribute documentary paintings during the Second World War to the scheme initiated by the Ministry of Information and the Pilgrim Trust to record the changing face of Britain. 'Agricultural practices featured largely in the "Recording Britain" collection, not surprisingly perhaps, in view of the fact that with the onset of war self sufficiency had become a vital concern.'[129] Of particular note is his informed and sympathetic recording of a farmer in Tresham, his former home, pushing a long breast-plough with its broadly pointed blade, wearing "beaters" made of patches of horse-hide with strips of wood fastened lengthwise to them, to protect his thighs.'[130] This was an old and disappearing agricultural technique, which as Thomas Hennell had pointed out in *Change in the Farm* in 1934 was virtually extinct. Hartrick's work was considered 'unpretentious and drawn with sensitivity and atmosphere.'[131] He died in a London nursing home on 1 February 1950.

THE LAND ARMY GROWING VEGETABLES FOR THE NAVY

A.S. Hartrick was the first artist in the Second World War to be given a contract by the War Artists' Advisory Committee specifically for land work subjects.[132] His name had been included in the original list of possible artists at the suggestion of Sir Walter Russell. In 1940 he was commissioned to do four watercolours and four lithographs at 12 guineas each. Further works were made, including one entitled *Canning Plums at the rate of 50,000 Tins a Day*, completed in August 1940 after a visit to a fruit canning factory near Toddington,

Gloucestershire. It 'represents some of the most efficient harvesting as a war effort.'[133] He explained that the factory was using up plums by the ton that would otherwise have been left to rot, and was being blessed by the inhabitants of remote villages around for the work it brought to them. Hartrick had been in correspondence with Dickey about the subjects he might record, suggesting a scene on Clapham Common to show its break up with the plough for allotments; the ploughing up of the Royal Parks; Land Girls growing crops for the Navy near Portsmouth or Southampton – Naval vessels in sea behind, and various subjects on land in Gloucestershire.[134] The recording of the Land Army subjects took place over a few days in the middle of May; it was as Hartrick wrote to Dickey 'interesting'. He stayed in May at The Inn-by-the-Sea, Lee-on-Solent which was near Chester Lodge where the Land Girls were working.

Hartrick proposed that these lithographs be printed by the Baynard Press and circulated to schools by the Board of Education. They declined. Completed, the four subjects formed *Land Work in War-time* (originally called *Grow more Food*) and were variously titled: *Ploughing*; *Lamb Time. A Cotswold Ewe*; *Allotments at Clapham Common* and *The Land Army Growing Vegetables for the Navy*. Hartrick suggested that the small studies he made of the Land Army might be used effectively to advertise the series. It was decided unwise to order a first

THOMAS HENNELL
1903–45

printing of more than 500 of each of the four subjects as it was felt that they would not be so attractive to the general public as other aspects of the war. In the end 200 of each were printed and together with Gabain's subjects, these were put in paper folders so that they might be purchased as a set and endeavours made to sell them in America.

Hartrick provided notes on the subjects of his four lithographs and later received four sets of the Land Work lithos which he declared to be 'neat and not gaudy' and just as he would have them. *Ploughing* was eventually recorded in Kent and not the Royal Parks. Of *The Land Army Growing Vegetables for the Navy* he wrote, 'Milk, poultry, vegetables are all supplied to the naval hospital ships, mainly by the efforts of the Women's Land Army. There are all types of workers in one picture. All get up at 6.30 and go to work from the hostel on bicycles. The milkers for instance get up at 3.30 in summer to milk at 4.30. All the winter they turned out in the blackout at 6.30 and no one failed.'[135]

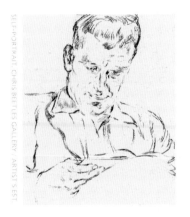

SELF-PORTRAIT, CHRIS BEETLES GALLERY, ARTIST'S EST.

Thomas Hennell – 'poet, painter and authority on husbandry and rural crafts'[136] – was born in Ridley, near Wrotham, Kent on 6 April 1903, not far from Samuel Palmer's 'valley of vision' at Shoreham and where his father Harold Barclay Hennell was rector. He was educated first at Hildersham House boarding school, Broadstairs which his elder brother attended and then at Bradfield College, in Berkshire from 1916–21. Following this he studied art at Regent Street Polytechnic for approximately four years and 'became influenced by the work and personality of A.S. Hartrick.'[137]

Hennell attended the London Day Training College and qualified as a teacher, having been taught and much inspired by Marion Richardson, whom he later asked to marry, and who played a large part in initiating the revolution which took place in art teaching methods. Several years later in 1927 he took up teaching and taught art at Kingswood School, Bath and also drawing at King's School, Bruton, Somerset for one day a week.[138] He left in 1931 in order to paint full-time and to tour the countryside to collect material for *Change in the Farm* (1934), the first book he wrote and illustrated. Regardless of weather or distance Hennell's preferred means of transport was his push-bicycle an upright, 'rather rusty machine

which he could drop in a ditch whenever he saw something to sketch. It had an unusually strong carrier, made for him by a blacksmith, on to which he loaded all his gear, including a large container which a tinsmith had made for his paper.'[139] In *Change in the Farm* Hennell expertly portrays traditional farms and farming methods and reveals his sensitive awareness and profound knowledge of country matters. He tells in the Preface of 'old ploughs, wagons and implements crumbling away … [and] old ways of sheafing, tying knots… familiar enough a generation or two ago, but now mysteries'. His meticulous drawings were 'not simply a polished technical accomplishment, consciously learned, but a spontaneous outpouring of the momentary pattern of his emotions.'[140]

In 1931 on his travels in Essex Hennell met Edward Bawden and Eric Ravilious at Brick House, Great Bardfield. Bawden recalled how he and Ravilious came down to the kitchen to wash and 'found a stranger, stripped to the waist, pumping water over his head and making quite a splash in the large slate sink… Outside, leaning against the doorpost was a heavy, khaki-coloured Army bike… Tom greeted us in the most friendly manner. Our identity was divulged in a matter of seconds and friendship established immediately.'[141] He was to be a frequent visitor to Brick House and later was persuaded to write the tale of *Lady Filmy Fern* to accompany Bawden's illustrations. *Lady Filmy Fern* was one of three characters invented to amuse themselves 'during lamp-lit evenings', the 'story developed in a manner akin to the game of Consequences; it unfolded intermittently over a period of several months.'[142] Another close

friendship that dates from that period was with Charles Mahoney who also stayed at Brick House, and on at least one occasion with fellow artist Evelyn Dunbar. Mahoney was later a neighbour of Hennell when he bought Oak Cottage in Wrotham in 1937. They shared a love of the Kent countryside and Hennell would sometimes join Mahoney on his many sketching expeditions around Wrotham, making studies of the North Downs and the brickfields at Platt.[143] He later spoke with much enthusiasm about Mahoney's mural paintings at Campion Hall, Oxford.[144]

In the autumn of 1932 Hennell underwent a mental collapse – he had been rejected by Marion Richardson, and disorientated by this he moved to London.[145] He was treated for the next three years, 'first, briefly at Stone, near Aylesbury; then on 25 October, he was transferred to the Maudsley Hospital, Denmark Hill, London, where he was diagnosed as schizophrenic. He remained there until April 1933 when he was once more transferred, this time to Claybury Hospital in Essex as a private patient. He was discharged some two years later on 31 October 1935 as "recovered".'[146] Hennell wrote about his illness in moving and vivid detail in *The Witnesses* published in 1938. He returned to Ridley and settled in Orchard Cottage with his housekeeper and much valued friend Miss Danny Nagle, and resumed his writing and painting. His poetry was published the following year. *Poems of Thomas Hennell* was illustrated with wood engravings by Eric Ravilious and contained a foreword by Gerard Hopkins who had persuaded Oxford University Press to publish a small edition of fifty copies.[147]

Hennell continued to studiously record country life in Britain and illustrated several books for Hugh Massingham in the late 30s and early 40s, including *Country Relics* (1939) and *Chiltern Country* (1940). 'The fact that Hennell only worked on books that were bound up with his own interests meant that he was never called on to compromise and his work demonstrates this integrity.'[148] Arnold Palmer, secretary to the Pilgrim Trust, recognized the integrity of his work and commissioned him to contribute to the *Recording Britain* scheme in 1940, the first volume of which was published in 1946, the year after Hennell's death. He contributed eleven water-colours which covered the Cotswolds, Dorset and his native Kent. The following year the Ministry of Information 'commissioned him to make drawings of edge-tool manufacture.'[149]

Over the course of 1941–43 Hennell wrote and illustrated a series of articles on English country craftsmen and their methods of work for *The Architectural Review*. These were republished post-humously by The Architectural Press in 1947 as *The Countryman at Work*, with a memoir of the author by H.J. Massingham. Massingham makes the point that the power of Hennell's draughtsmanship 'is seen at its most obvious in his drawing of tools and implements, of which there are many examples in this volume.' Hennell also found the time to write *British craftsmen* (1943) one of 126 books that formed the 'Britain in Pictures' series of books which were an important part of Britain's war-time propaganda.[150] In addition, he was briefly a lay preacher for the Church of England and an ARP warden.

LAND ARMY GIRLS RESTING AT LUNCH-TIME
Hennell wrote to the WAAC just two months after war was declared explaining that he wished to make drawings as war records and was 'willing to undertake any kind of subject, whether figures, landscapes, architectural or mechanical'.[151] Aware that the committee had limited funds he offered his services 'in return for food and accommodation only, and these of a private soldier, the work done to remain the property of the Ministry of Information.' His offer was refused but in 1941 one of his water-colours of land work was purchased for seven guineas. Later submissions were declined but in mid-August he was contracted to record the 1941 harvest, including threshing and baling and hedging. Seven watercolours from his sojourns were purchased.[152] Hennell's 'work was to be among the scheme's greatest successes'.[153]

Hennell received a number of successive three-monthly contracts from February 1942. In November his delicate and evocative watercolour of *Land Army Girls Resting at Lunch-time* was purchased for five guineas. Although earlier somewhat suspicious of colour as being likely to interfere with good draughtsmanship, 'he achieved a mastery of blended line and colour, while his colouring became, in a contemporary artist's words, "liquid, luminous and lovely".'[154]

In June 1943 he was invited by the WAAC to replace his friend Ravilious (reported missing off Iceland

LAURA KNIGHT
1877–1970

in 1942) for a three-month commission with the honorary rank of Lieut. R.N.V.R. and a fee of £162.10s. Hennell's Icelandic pictures were shown in the National Gallery to much acclaim. The following year he was commissioned to record 'fishing subjects' in north-east England. Other commissions followed, including being sent to Portsmouth at the end of May to record the massing of the Allied Armies for the D-Day invasion. During 1944 he was also deployed for short spells to France and Belgium. Christmas saw Hennell back in England after which he returned to Holland where he remained for a couple of months. He returned to England, this time to Chatham to undergo a hernia operation. Having worked for the Admiralty he was appointed on a six-month contract after his recovery to the Air Ministry to undertake work in the Far East. By June 1945 he was in Burma, later travelling to Java from where he was captured by Indonesian nationalists, and reported missing, later presumed killed, in November 1945 whilst on active war-artist service.

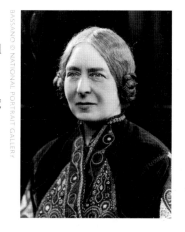

BASSANO © NATIONAL PORTRAIT GALLERY

Laura Knight 'had a natural feel for whatever medium she employed, be it oil, watercolour, charcoal, etching, aquatint, woodcut etc. Above all, and implicit in all her work, there is her virtuosity as draughtsman.'[155] She was born on 4 August 1877, in Long Eaton, Derbyshire the youngest of three daughters of Charles and Charlotte Johnson. She was educated at Brincliffe School, Nottingham, and in lieu of payment for her education her mother, who had studied at art school and in Paris, taught drawing and painting at the school for free.[156] Laura was sent in 1889 to her great-uncle and aunt in St Quentin, northern France as they had offered to educate her free, and, once she could speak French, to find her a place in an atelier in Paris. She spent a year there but returned to Nottingham because of family illness.

Instead of Paris, Nottingham School of Art was where Laura, aged 13 commenced her formal art training under Wilson Foster, who had just come back from years spent in ateliers in Paris and Antwerp, and who had a meticulous knowledge of anatomy. She enrolled as an 'artisan student, so that she would not have to pay big fees... Through [her] mother's influence she went straight into the Life Class, but for head and drapery only. Women were not allowed to draw from

the nude.'[157] Here she met Harold Knight 'who was the star student'. The following year she had to cut back on her studies because her mother was terminally ill with cancer and she had to take over her mother's teaching and private classes. In 1894 Laura won a gold medal 'for a painting of a plaster-cast from Hamo Thorneycroft's sculpture, *Teucer*',[158] and several silver and bronze medals at the yearly national competition at South Kensington College (later the RCA) for provincial art schools to submit students' work. She was also awarded the Princess of Wales's Scholarship as she had won more awards than any other woman in the United Kingdom. The Scholarship was for twenty pounds a year, for two years. Soon after, she sold the gold medal to a jeweller for £5 10s. and both she and Harold left the School of Art.

Some years later Laura visited the fishing village of Staithes where there was a small but rather scattered artists' colony, for a holiday with her sister, Sissy, aunt and Harold. The following year she and Sissy returned to live in Staithes, by which time Harold was already settled there. In April 1903 she had her first painting accepted at the Royal Academy, *Mother and Child*, which was bought for twenty pounds. Two months later she married Harold Knight. 'Their long, individual careers from this point onwards were closely connected',[159] although they never shared a studio. They made several visits to Holland studying the 'Old Masters', initially staying in Amsterdam for some weeks before going to Laran where many painters went and it was less expensive. In 1906 they stayed for a year on a large farm to draw and paint. Returning to England they missed the companionship of the other painters they had met in Holland and neither could 'contemplate another lonely winter... tired of wet and cold; a longing for the warmth and light that [they] had been assured were in Cornwall came [over] them.'[160]

In November 1907 they moved to Cornwall and worked for some years in Newlyn. Laura admired the work of the Newlyn School and while 'the heyday of the first generation of Newlyn artists was over... several of them remained in the village, including Stanhope Forbes and his wife, Elizabeth Armstrong, Norman Garstin, T.C. Gotch and Walter Langley.'[161] Later the Knights moved to Lamorna. 'These places were not just the inspiration for her painting but provided her with much of her subject matter – landscapes, harbours, children by the sea – and the years spent there saw her develop as a most accomplished artist.'[162] While living in Cornwall they always spent some months in London and in 1909 Laura had much success at the Academy with the widely acclaimed *The Beach*.

In 1915 painting any part of the coast line was forbidden. These wartime restrictions were tightened further and artists were prohibited from working out of doors at all. In her autobiography *Oil Paint and Grease Paint* she describes how, in 1916, she longed to paint a spring picture. 'Material lay at hand right behind my Lamorna Studio, so crouching among the prickly brambles and gorse, my slip of paper hidden, only now and again I showed my head in a dither of fear, just as if it were a terrible sin to draw the shape of an ivy leaf – a sin that would have meant prison had I been seen through the telescopes of coast-watcher and amateur detective, whose pleasure and duty it

was to spy perpetually for any delinquent.' Later, artists were able to obtain special permits to work out of doors. In the same year Harold was called up, but refused to serve because of his pacifism and registered as a conscientious objector. He eventually worked on the land in north Cornwall helping bring the harvest in, and when that was finished he worked alone engaged in the monotonous task of hoeing.

In autumn 1916 Laura received a commission worth £300 from the Canadian Government's War Records Scheme to paint a fourteen-foot-long picture of '"Physical Training in a Camp," men bathing in the river in sunlight' at Witley Camp, near Godalming. The nearest river was several miles away, and instead she worked on numerous studies of boxing. One of the paintings later received a medal at the Sports Pictures Exhibition at the Olympiad in Amsterdam.

In January 1919 the Knights made London their base, the move giving Laura access to other subject matter. She worked backstage at the Regent Theatre and also at the Coliseum observing and drawing the Diaghilev ballet. She observed the renowned Cecchetti teaching and drew the pupils who attended his classes. When Pavlova gave a season of her own ballet at Drury Lane they became friends and Laura drew her many times. 'Working with the ballet forced her to produce quick drawings and with practice her drawing became freer and more economical so that she was soon able to express herself in a few lines.'[163]

In the 1920s Laura took up etching and bought Sir George Clausen's old press. 'She made some 90 prints, many of them in 1923 and 1925.'[164] In 1921 she designed a railway poster to advertise rugby at Twickenham, one of seven she undertook between 1921–57. The following year she went to America for the first time as one of two European representatives on the Jury of Awards for the International Exhibition of Pictures at Pittsburgh. Laura became only the second female Associate of the Royal Academy in 1927 (Annie Swynnerton being the first). In 1929 she was appointed Dame Commander British Empire for her services to art and in June 1931 was awarded an honorary degree of LL.D. by St Andrews University. 1936 saw Laura elected as the first female full member of the Royal Academy. She had previously spent much time with the Bertram Mills Circus and toured with Carmo's Circus, and in the late 1930s she spent three or four months in a gypsy camp.

During the Second World War Laura worked for the War Artists' Advisory Committee and also completed the occasional private commission, including a portrait for Betty Jackling of herself and son in 1942. Madeline Barnett, a Land Girl who worked on the estate where Jackling was in charge, remembered seeing Laura Knight on the estate and she always knew when she was at work because she wore a red/white Fair Isle cardigan. She recollected Laura telling her stories in the evening, often until the early hours, of ballet, circus and fairs.[165]

After the war Laura returned to London and continued painting, but it was the end of her travels. Harold died in Colwall, Worcestershire on 3 October 1961. Her long career was marked with the honour of a retrospective exhibition at the Royal Academy in the

summer of 1965, another first for a woman. In the same year her second autobiography *The Magic of a Line* was published. Laura Knight died in London on 7 July 1970, and a memorial service was held at St James's Piccadilly later in the month.

LAND ARMY GIRL

Just over a month after the Second World War was declared Laura Knight was asked if she would produce a pictorial poster to publicise the work of the Women's Land Army as part of the first series of war posters. A preliminary sketch was requested for which ten guineas would be paid, and a further sixty guineas if the design was passed. Laura was reluctant to supply a sketch as she never made preliminary sketches as 'size makes so much difference to composition.'[166] R.A. Bevan, Director of the General Productions Division of the Ministry of Information, wrote to explain why this was required, 'even in the case of really distinguished artists like yourself on whose standard of work one can rely with confidence. It is not that we wish to pass judgement on the composition or artistic merits of the painting: it is quite simply a question of interpretation. As all government posters are designed to further particular policies, it follows, I think, that interpretation of any subject is in accord with the policy of the campaign.'[167] 'Knight was given ten to twelve days to produce a rough picture allowing 8" for wording, and signed a formal contract giving up the right to copyright.'[168] The design was rejected on the basis that '"the emphasis in your design is so very strongly on the horses and so little on the girl that the message which we wish to convey would not

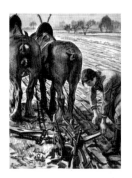

really get to the public." A new design… was produced. The illustration was changed from three girls working a plough to just one girl, entirely replacing the man's role.'[169]

In the 1940 summer show at the Royal Academy, Laura's large landscape *January 1940* of a uniformed Land Girl and team of two strong Suffolk Punches about to break up the frost-bound clod was for sale at £787. The critic H. Granville Fell writing in *The Connoisseur* commented, 'Dame Laura shows no diminution in her unceasing challenge to masculinity.' The painting was returned unsold. It was most likely composed in the countryside around the British Camp Hotel, Colwall near Malvern where the Knights were staying. They used 'to visit the Averills on their Worcestershire farm… and Laura took a great interest in discussing farming… and over the years she had painted a number of farming scenes.'[170] Further, '[d]uring the very cold winter at the beginning of the war she had hired two horses and a plough from a local farmer and despite the near arctic conditions had painted them out of doors in a frozen cherry orchard.'[171] It is likely that the Land Girl poster emanated from this.

Laura completed a number of further commissions including portraits of two Women's Auxiliary Air Force (WAAF) medal winners, Corporal J.D.M. Pearson, G.C. and Corporal J.M. Robins, M.M. The Air Ministry arranged for her to paint Daphne Pearson in Malvern

NORA LAVRIN
1897–1985

in autumn 1940 for a fee of 35 guineas. Pearson had not been in the WAAF long 'before she distinguished herself by an act of considerable courage'.[172] Serving as a medical attendant at RAF Detling in Kent and ignoring warnings from guards she pulled an injured pilot from his crashed bomber and attempted to save the wireless operator. Another of Laura's well-known and perhaps most successful portrait was of *Ruby Loftus screwing a breech-ring*. Her meticulous accuracy as an artist was most suited to recording this intricate, technical task. In the same year, 1943, she found the time to write the introduction to the booklet *Women: War pictures by British artists*. In December 1945 she wrote to the WAAC suggesting that instead of completing the subject of tanks she record the war crimes trial at Nuremberg. She felt that 'artistically it should prove exciting.'[173] Less than two weeks later the Committee agreed to her going to Nuremberg, when she became one of only three women war artists who travelled abroad.[174]

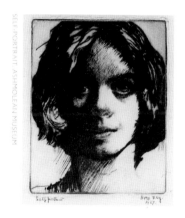

SELF-PORTRAIT, ASHMOLEAN MUSEUM

Nora Lavrin (née Fry) was a gifted etcher and illustrator. She was born in Liverpool in 1897 into a Quaker, later Unitarian, industrialist family. Her mother Lily was from the Shetland Isles and her father Ambrose 'an inventor, a manufacturer of a Borax based boiler cleaner and "Rito", a bitumen roof sealer, with a factory at Edge Lane and… a substantial urban landlord.'[175] Fry had two brothers, Sidney and Maxwell, the latter being one of the founders of modern architecture and who on graduation left Liverpool to work in America.[176] Although originally Nora had aspirations to be a dancer, her height precluded this, and she and her sister Muriel trained at the Liverpool School of Art. Muriel studied fashion drawing but did not continue with it professionally, nonetheless both 'acquired a solid grounding in traditional training. [Nora] was drawn towards classical painting in oils, copying old masters but in the end gravitated to engraving and etching.'[177] She won a travelling scholarship in 1920 and studied in Paris for a year at the 'Grande Chaumière' studio while also taking the opportunity to travel around France.[178]

In 1926 she illustrated the first of many books for different firms, a number of which were for children. *Little Grey Men* written by Betty Timms was published by Harrap as part of The Little Story Books series.

The following year she illustrated two further books for Harraps *Aesop's Fables* and *A Treasury of Tales for Little Folk* by Marjory Bruce which she illustrated with Honor C. Appleton and were well received. In September she commenced her studies at the Royal College of Art in the Engraving School headed by the distinguished etcher, Professor Malcolm Osborne. She became a pupil of the recently appointed Robert Austin, himself an outstanding etcher and winner of the Rome Scholarship for engraving, and by all accounts a 'stern and uncompromising teacher'.[179] He 'was to be an important influence on her work as an etcher, to the extent that she was affectionately dubbed "baby Austin" by fellow students'.[180] She left in July 1928 having been awarded a Certificate of Etching.[181]

Earlier in the year she toured with The Italian Marionettes, or the 'little people' as they were affectionately known, who had been brought to England by the director and administrator Amilcar Mariani. Several of her drawings of the marionettes performing a humorous sketch, *The three thieves*, at The Scala Theatre London in May 1928, were used to illustrate an article by Julia Chatterton in *The Architectural Review* captioned *The Little People Behind the Curtain or The Secret of the Marionettes*. Two months later on 28 July, after 'a whirlwind romance', she married Janko Lavrin, Professor of Slavonic Studies at Nottingham University College; they spent their honeymoon in Slovenia, 'a country she had never heard of.'[182] She recorded their travels in *Slovenia. Summer 1928* which contained amusing text and charming watercolours, this first of six or seven picture diaries was published by her eldest son John in 2004 as *Slovenija. Poletje 1928*.[183] The Lavrins

returned to live at the Villa Sava, Mapperley just outside Nottingham before moving into the countryside to The White House, Chilwell Lane, Bramcote which Nora had designed and had built. She taught art part-time at University College, Highfields and by this stage of her career her etchings and drypoints were beginning to be noticed. She was taken on by Colnaghi in Bond Street, London.

On 2 December 1930 her first son John was born. She encouraged him to paint from early childhood and in 1951, after demobilization, he entered the Slade. Eighteen months later his brother David was born. In the 1930s the Lavrins had acquired an old yeoman's farmhouse in hop fields near Pluckley, Kent where Nora would spend many days drawing the East End hop pickers on neighbouring farms, who lived in primitive shacks on the farm for the summer. Reproductions and articles on her work appeared in *The Studio*, *Creative Art*, *La Vie Moderne*, *Mladika* and various other continental publications.[184] In 1938 she illustrated three books for Dent & Sons as part of 'The Everyday Books' series and the following year, for Oxford University Press, *The Ship that Flew* by Hilda Lewis.

With the advent of war commissions ceased, and the family moved to London after Janko had been recruited to work for the BBC (European Service) at Bush House as broadcaster and language supervisor. After heavy bombing the boys were evacuated from their home in Middle Temple to various places, eventually in February 1940 to Ashbourne, Derbyshire before being sent to boarding school in Dorset. Nora

continued painting and teaching in London art schools, including the Hammersmith School of Art. During the years immediately after the Second World War she taught 'Picture-Making', a form of composition, at Camberwell on a part-time basis.[185]

After the war Janko returned to lecture in Nottingham and Nora illustrated further books including collaborating with Molly Thorp in 1952 to write and illustrate a children's adventure story *The Hop Dog* based on her own family life and observations of hop picking in Kent. Two years later this was made into a film *Adventure in the Hopfields* by the Children's Film Foundation.[186] She designed sets and costumes for a number of ballets and collaborated with her son John in 1956 on *Love and Litigation*, choreographed by the eminent Slovene Pino Mlakar and set to the music of Handel and performed by National Ballet.[187]

During her last years she suffered from angina. Increasingly painful arthritis at times made it impossible for her to hold a pencil or brush.[188] Nora's zest for work remained, though, and she completed an illustrated memoir *D H Lawrence Nottingham Connections* which made reference to her friend Jessie Chambers, D. H. Lawrence's closest friend throughout his youth. They first met when she attended a course of lectures on Russian literature given by Janko. Published after her death in 1986 it is 'part social document, part factual report, part critical observation, and partly a series of short imaginative anecdotes, the book is a literary hybrid'.[189] Nora Lavrin died in London on 30 August 1985, Janko the following August.

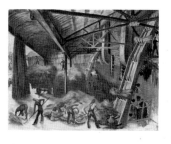

LAND GIRLS UNLOADING FLAX
The Second World War afforded Nora Lavrin the opportunity to concentrate on her art as her two young sons had been evacuated from their London home, and from early 1941 they were attending a boarding school in Dorset, John having received an art scholarship to do so. In November 1943 she submitted a series of four works related to flax growing and its processing in factories to the War Artists' Advisory Committee. These included *The Preparation of Flax. The De-Seeding Machines* (water-colour); *The Preparation of Flax. The Rugging Machine* (pen and ink); *Green Flax* (pen and ink) and *Land Girls Unloading Flax* (water-colour). These were purchased for 35 guineas.

It is likely that these works were undertaken within easy travelling distance from London. Having made numerous preliminary sketches of the workers and the flax machines she would have completed these at home, 'not having a separate studio, just one room for painting and etching. She was a fast worker, knowing instantly the effect she desired. There were no pronounced influences. She found her own way.'[190]

MONA MOORE
1917–2000

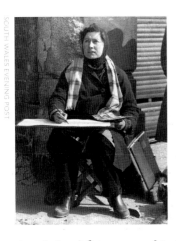

SOUTH WALES EVENING POST

The artist, illustrator and designer Mona Moore was born in London on 20 March 1917. Her parents separated when she was four, her mother lived with and much later in 1941 married Owen L. Owen, a sports correspondent for *The Times* and editor of the *Rugby Football Annual*. Aged fourteen and in her final year at school in St Martin's-in-the-Fields, Mona obtained a junior art scholarship to St Martin's School of Art in Charing Cross Road in 1931. After two years she was awarded a Wedgewood Scholarship which carried with it a small grant for materials and gave her three more years at school. Three mornings and afternoons a week were devoted to the furthering of students' general education. The remainder of the week was occupied by design and still life taught by Mr Flanagan, who also taught at the Royal College of Art. Drawing from plaster casts was presided over by Mr Lytten, who gave students a grounding in the principles of draughtsmanship which formed the foundations for her later work. The years she 'spent there were basically very happy ones… R.V. Pitchforth, Leon Underwood, Stafford Leek were some of those who really gave us a feeling of what art was all about – and Mr Morley who instructed us in the art of oil painting.'[191] She left St Martin's at the age of 19 intent on making a career as a freelance artist. She returned to study at the Central School of Arts and

Crafts, leaving in 1939, having been taught lithography by James Fitton and Clarke Hutton. She married Tony Bentin on 9 June 1939; he had studied at Folkestone and Dover School of Art and later at the RCA where he specialised in stained glass.

After war broke out, although Mona and her husband were inclined towards pacifism, he joined the Royal Artillery serving at home with an anti-aircraft regiment, feeling that this was defending rather than attacking. The war and the questions it raised started her thinking again and she wrote to Sir Kenneth Clark at the Ministry of Information seeking work, since 'Publishers no longer seemed to want jackets, publications and papers were reduced to a minimum and illustrations were out.'[192] Clark replied on 22 November 1940 saying that he liked many of the drawings she had included very much and that 'A great many of my friends suffer as you do from the isolation caused by the war, and from the feeling that they are not doing anything directly useful. Have you ever thought of becoming one of those artists who are working for the Pilgrim Trust Scheme of recording England? I am on the Committee, but can seldom attend their meetings. If however, you would like to do this kind of work I will send a note to the Secretary. I do not know if there is a vacancy.'

Moore presented her portfolio to Arnold Palmer, the secretary of the Scheme, at the National Gallery, and he suggested she chose a venue for her topographical activities. 'The pay was pathetically low even for those days – eight watercolour drawings for £24 and no expenses whatsoever – not even fares.'[193] Thus, where possible, artists looked for a location where they had

friends or relations who could provide hospitality. Moore found her 'beloved Gower Peninsular on the list' and spent two weeks recording the landscape. She returned to complete the work, arriving in Swansea 'just after the terrible fire and high explosive raids of March 1941. The almost total devastation of the comfortable old provincial town… was truly shocking.' Moore contacted London to ask if she could record it, but was told that it was not her brief and she should stick to the Gower schedule. However, she continued as she had already made a series of drawings,[194] and on returning to the same spot in Castle Street to complete these, she found it cordoned off: she had been seated on top of an unexploded bomb. A photograph of Moore on a mound of rubble recording the bomb damage appeared on the front page of the *South Wales Evening Post* on 18 March 1941.

Although artists had to have a Ministry of Information permit to work, the mere act of setting up an easel in 'a side street, a field far from anywhere or outside a picturesque cottage was likely to arouse suspicion and resulting hostility.'[195] On her next Recording Britain commission in Norfolk, while drawing on the Brecklands where a new airfield was being constructed, Moore was taken into custody by the RAF and escorted to a barrack dormitory where she had to wait to be interrogated by the local police inspector.

Following her stay in Norfolk, Moore visited Kenneth Clark at his request at the National Gallery. He asked her to undertake a commission (in secret) for him of a series of drawings and watercolours of the road leading to the disused slate quarry in the midst of a hill called Manod, near Blaenau Ffestiniog, North Wales where pictures from the National Gallery were being stored for safety. It was for her 'a remarkable experience to enter the air-conditioned interior of the slate mine, reached by its own rail track, and to see priceless Rembrandts, Van Dycks and Turners, etc., stacked in racks'. These drawings which took her three weeks to complete were given to those who had helped Clark in the removal of the paintings to the safety of Wales.

Later during the war Moore illustrated *Sea Poems* (1944) as chosen by Myfanwy Piper in Frederick Muller's 'New excursions in English poetry' series. She returned to the Central School to work on the lithographic plates before the head master stopped her as 'he could not take responsibility for having a baby in his school especially during wartime.'[196] (Her son John had been born in March the previous year.) *Sea Poems* was reviewed in the *Sunday Times* on 25 March 1945 by Stephen Potter, who asked 'Does this book help us recall the sea? The illustrations certainly do so. Within the limitations of her few colours, themselves copied from the tones of the salt pebbles on a chalk beach, Miss Moore's lithographs are wonderfully varied and romantic and bring back the delights of small houses with sea views'.

Moore was a member of the Artists' International Association, 'a body formed in the 1930s to enable artists to join together to oppose War and Fascism'[197] and during the war she exhibited with them. Towards the end of the war she entered a painting competition sponsored by Mowbray, the religious publisher and bookseller, which was designed 'to stimulate the

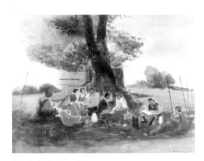

Land-Girls Lunching
in the Harvest Fields

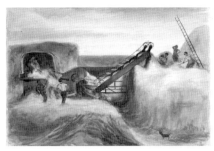

Land-Girls and Soldiers Threshing
at Maldon, Essex

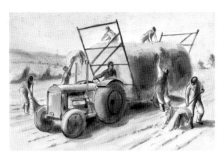

Land-Girls Carting Oats
at Southminster, Essex

production of artists' work suitable for Christmas, Easter, or other greetings cards, illustrations and so on.'[198] She submitted *The Agony in the Garden* which won the first prize of £200.[199]

Post-war she spent many years working for the *Radio Times* doing little black-and-white drawings of plays 'to jolt the visual imagination of what was still, primarily, a radio audience.'[200] She was a favourite of the art editor Ralph Usherwood as she always brought her work in on time and it was always the right size and appropriate to the subject. While working for the *Radio Times* she was commissioned in 1948 to execute several posters (*Trees* and *Autumn*) for London Transport. She also drew for the *Daily Express*, *The Listener* and *Good Housekeeping* and designed a number of book jackets including Alan Sillitoe's first two novels *Saturday Night and Sunday Morning* (1958) and *The Loneliness of the Long Distance Runner* (1959). An eye infection, which eventually led to the loss of her sight, forced her to give up her work as an illustrator in the 1960s. She died in Oxford on 20 September 2000.

LAND-GIRLS LUNCHING IN THE HARVEST FIELDS
LAND-GIRLS AND SOLDIERS THRESHING AT MALDON, ESSEX
LAND-GIRLS CARTING OATS AT SOUTHMINSTER, ESSEX

Mona Moore was commissioned by the War Artists' Advisory Committee in August 1941 to 'make a few drawings of the present harvest for a fee of 15 guineas,

the actual amount of work to be accepted for the fee to be a matter of mutual arrangement.'[201] Russell Flint had been due to paint the harvest subjects but as he had 'so much work in hand in aid of the Canadian War effort' he was unable to do so.[202]

Moore worked quickly to complete her commission of Land Girls at work in Essex. She recalled how the Land Girls were all very pleasant and helpful but she could not help feeling rather sad about them as they 'were all wearing those rather puffy overalls and they didn't look at all glamorous'. She felt somewhat guilty seeing them working and thought that she 'ought to be out wielding a pitchfork rather than drawing'.[203] The paintings were approved by the Committee in October 1941. In the letter informing her of their acceptance she was told, 'The Censors have asked me to tell you that when soldiers appear in the picture, the name of the place should not be included in the title.'

RANDOLPH SCHWABE
1885–1948

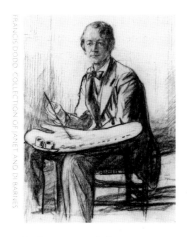

FRANCIS DODD: COLLECTION OF JANET AND DI BARNES

Randolph Schwabe was 'a scholarly artist,'[204] meticulous draughtsman and a distinguished and influential teacher. He was born in Barton-on-Irwell, near Manchester on 9 May 1885 one of two sons of Lawrence Schwabe and Octavie Henriette Ermen. His grandfather, a cotton merchant, had emigrated from Germany in 1820, his mother was born in Germany, although her father had been born in s'Hertogenbosch in Brabant before settling in Manchester in 1837. The family moved to Hemel Hempstead, Hertfordshire, when Randolph was about five. He was educated privately as a day-boy, his artistic talents soon apparent and evidenced in illustrations for his 1d. weekly school magazine *Heath Brow Chronicle* edited by his brother Eric. Naturally left-handed he was made to draw with the right and the pressure allegedly led to his slight stammer.[205]

In 1899 aged 14 he studied for just three months at the Royal College of Art, a period he referred to as 'inglorious and unhappy' largely owing to the teaching methods; for Schwabe having to imitate the plaster cast of a foot was 'interminable' and he was bored by the whole process.[206] He transferred to the Slade, becoming the youngest student, where he 'worked daily in a crowded Antique Room, seldom spending more than a day on one drawing' and where he was ably taught

by Frederick Brown and Henry Tonks. His four and a half years at the Slade culminated in an announcement in the *Morning Post* on 16 April 1904 that he had gained the Slade Scholarship; Brown had informed him previously saying, 'Of course it's much below the standard, but I don't see what we can do.'[207] Later Brown found Schwabe his first commission and bought a drawing of his from the New English Art Club.

On leaving the Slade Schwabe followed in the footsteps of other British artists and went to Paris where he studied for eight months at the Académie Julian under Jean Paul Laurens in 1906 before working for some time in Rome, and visiting Florence and other cities. 'This visit laid the foundation of a profound knowledge of Italian art and architecture which was to be of immense value to him afterwards.'[208]

Schwabe married Gwendolen Rosamund Jones on 19 April 1913 in Chelsea. They had met while both were students at the Slade. She was given the nickname 'Birdie'[209] by fellow students because of her habit of perching on a shelf to eat her lunch of sandwiches and wine as she was embarrassed that the servant had packed this for her lunch. The Schwabes rented a flat in a large house in Cheyne Row; fellow artist Allan Gwynne-Jones and godfather of their daughter Alice[210] lived above.

After the war Schwabe supplemented his income by teaching drawing at the Camberwell and Westminster Schools of Art and at the Royal College of Art. He exhibited widely including with The London Group of which he was on the executive committee and from

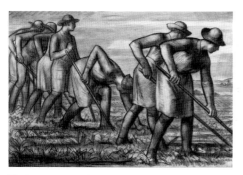

Hoeing

A Girl of the Women's
Land Army: Miss Yvonne
Gwynne-Jones

The Shepherdess

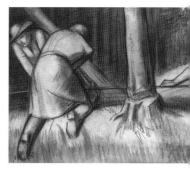

Tree Felling

1917 with the New English Art Club. Gaining in reputation he concentrated more on drawing with pen, his brown ink specially made by Stephensons, and pencil and water-colour, often using antique paper. William Rothenstein in the catalogue to his exhibition at the Redfern Gallery in 1924 commented; 'he uses drawing as a language. He has wise and interesting things to tell us and he conveys his meaning in straightforward lines and forms... [his] drawings have a quiet strength and authority which entitle them to particular respect. His etchings of London while preserving topographical accuracy, have a dramatic quality'.

Schwabe was 'a compulsive sketcher, interested in all that was around him. He was first employed in 1919 by Cyril Beaumont, the writer, balletomane and publisher, to design wooden figures, based on dancers in Diaghilev's ballet, and in the ten years 1921–31 decorated and illustrated several books issued by the Beaumont Press'.[211] He would take his daughter to watch the ballet while he made preliminary sketches. Schwabe also illustrated other books and manuals including writing two with Francis M. Kelly *Historic Costume: A Chronicle of Fashion in Western Europe, 1490–1790* in 1925 where his 'spirited and lucid drawings'[212] were much praised, and *A Short History of Costume and Armour, 1066–1800* in 1931. He also contributed notes and reviews to the *Burlington Magazine, Artwork, The Studio, Connoisseur* and *The Print Collector's Quarterly*. 'While he was intrigued by avant-garde art, he saw his art as a continuation of the English tradition, specifically the English watercolour tradition at its apogee in the late eighteenth century.'[213]

The turning point in Schwabe's career had occurred the previous year with his appointment as Professor and Principal of the Slade School succeeding Tonks. One of his sponsors for the post was William Rothenstein who made the point that, 'Drawing is the tradition of the Slade School and Schwabe is a dignified and scholarly draughtsman. He also has a wide and impartial outlook on the arts, and a generous sympathy for gallant experimentation as for disciplined achievement.'[214] Early on he appointed Allan Gwynne-Jones to take responsibility for the teaching of painting. Schwabe was well liked and much respected by colleagues and students alike. He was a sympathetic teacher and 'never inspired the terror commanded by his predecessor Henry Tonks.'[215] The art critic of the *Sunday Times*, while reviewing the first exhibition of his drawings at the Goupil Gallery since his appointment as Principal, took the opportunity to comment how it 'enables us to see how well qualified he is to teach others, and we feel that in his hands the great tradition of the Slade school for good draughtsmanship will be maintained.'

Following the outbreak of the Second World War the Slade School was evacuated from University College to the Ruskin Drawing School at Oxford, not returning to London until 1945. Early in 1941 Schwabe became a member of the War Artists' Advisory Committee replacing Percy Jowett, Principal of the evacuated RCA which had gone to Ambleside in the Lake District. Schwabe served as the art school representative until the last meeting. In 1942 he illustrated the book his brother, Eric Sykes, had written with William E. Fairbairn *Shooting to Live*. Eric had changed his surname to Sykes to avoid the German overtones of Schwabe. Sykes and

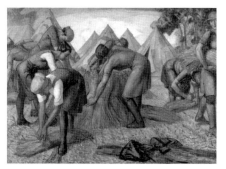
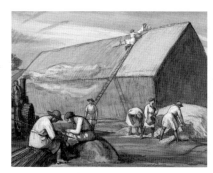
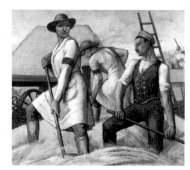

Voluntary Land Workers in a Flax-Field, Podington, Northamptonshire

Thatching Flax for Aeroplanes

The Women's Land Army and German Prisoners

Fairbairn had returned from China where they had worked for the Shanghai Police to work as instructors within the newly formed SOE (Special Operations Executive). The following year Schwabe designed the book jacket for Gerald Cobb's *The Old Churches of London* published by Batsford. The *Chicago Daily Tribune*, in the column by Charles Collins 'Line O' Type or Two', contained a paragraph of book gossip in which Collins praised the jacket and nominated it for a Pulitzer Prize in America as the best of the year. However, there was no such honour and Collins was forced to write to Mrs Batsford on 14 June 1943 to explain that this comment was intended humorously he said 'Pulitzer prizes are given for almost every other activity of the book and newspaper businesses.'

Randolph Schwabe died in Helensburgh, West Dunbartonshire after a long illness, on 19 September 1948, drawing to the end cabbages from his family's vegetable garden. A memorial service was held at St Pancras Parish Church on 12 October.

HOEING

A GIRL OF THE WOMEN'S LAND ARMY: MISS YVONNE GWYNNE-JONES

THE SHEPHERDESS

TREE FELLING

VOLUNTARY LAND WORKERS IN A FLAX-FIELD, PODINGTON, NORTHAMPTONSHIRE

THATCHING FLAX FOR AEROPLANES

THE WOMEN'S LAND ARMY AND GERMAN PRISONERS

Schwabe had a weak heart and his frail physique and uncertain health meant that he was rejected for the army 'before the introduction of conscription, and finally discharged under the Review of Exemptions Act in 1917.'[216] He was contacted by Mr Yockney, former editor of the *Art Journal*, at the Ministry of Information in March 1918 and asked if he were free of military obligations and would put aside any private work to undertake work for them. Muirhead Bone suggested that he might record 'The St Paul's Watch at Night'. This commission was eventually given to Henry Rushbury and Schwabe was invited to suggest a subject. He proposed 'Women on the land'.

Schwabe went to Wellingborough, Northamptonshire to collect material for a series of pictures of the 'more important or unusual activities of the Women's Land Army'. He received a positive response from the Committee in September 1918 who thought 'it would be good propaganda.' His drawing of *A Girl of the Women's Land Army: Miss Yvonne Gwynne-Jones* prompted a rebuke from Yockney for naming the sitter as he thought it might cause difficulties with the censor and the request that in future such studies should be anonymous. Schwabe promised to be more careful in future. For his efforts he received a salary of £40 a month. *The Women's Land Army and German Prisoners* was received in September 1919. Schwabe explained, 'What the blighters are doing is making a straw stack after the corn has been threshed. I don't see any good way of compressing this information into the title, but perhaps you have become skilful with much practice.' The title of his largest painting also caused consternation, one suggestion was 'Women's Land Army:

HENRY HOUGHTON TRIVICK
1908–1982

A Flax Camp'; Schwabe suggested something like 'Land Workers in a Flax Field' as it was volunteers who were undertaking the work. He also recalled that it was in Podington and there were several in Northants. Finally, the title settled on was *Voluntary Land Workers in a Flax-Field, Podington, Northamptonshire*. Schwabe contributed 21 pictures of work on the land.

By the Second World War 'Schwabe was an established academic draughtsman. His meticulous architectural drawings made him an ideal recorder of bomb damage.'[217] He was commissioned to make drawings of the bombed Coventry Cathedral in November 1940, for the sum of 30 guineas. However, he produced only one drawing for which he received 15 guineas. The following year he was commissioned for 10 guineas to undertake a portrait of *Miss M. P. Holyer*, and further portraits of Ministry of Home Security sitters were also completed. In January 1945 he submitted a pencil drawing of *V.2 Damage at the Chelsea Pensioners' Hospital, London, S.W.3.*

The artist, lithographer and illustrator Henry Houghton Trivick (pictured above with Stanley Spencer at Cookham Arts Club) was born in Kensworth, Bedfordshire on 2 May 1908. His mother was Dutch by birth and his father was a member of the Royal Chemical Society and was once the Public Analyst. Trivick was the great-great grandson of Benjamin West, one of the founders of the Royal Academy and its second president from 1792–1820.[218] In his middle teens he trained at the Central School of Arts and Crafts where 'after producing some drawings from the cast and hundreds of drawings from life and many paintings, he was allowed to enter the lithographic class in charge of that remarkable figure A.S. Hartrick.'[219] Trivick was much inspired and encouraged 'by the kindly help' of Hartrick and in the introduction to his book on *Autolithography. The Technique*, published in 1960, he records his debt to Hartrick for his basic training in the lithographic medium and also later to the help of John Copley. Trivick was an instructor at the Regent

Street Polytechnic School of Art from 1944, and from 1946 was in charge of the lithographic classes. He was a member, and later chairman, of the Senefelder Group in addition to being a member of the Artists' International Association.

In May–June 1940 he, like Michael Ford, became one of the first members of the Local Defence Volunteers (later the Home Guard). During autumn 1941 he was commissioned to make drawings for the *Recording Britain* scheme. Trivick exhibited with many leading societies including the Royal Academy, the Royal Institute of Painters in Water Colours, the Royal Society of British Artists and the New English Art Club. Prior to May 1944 he executed a mural for Cunard on their ship *Queen Elizabeth* and also sent a lithograph with five others at the request of the Anglo-Soviet Council as prizes for a Russian Schools Essay Competition.[220]

Trivick lived in Bourne End, Buckinghamshire not far from the village of Cookham, where his friend the painter Stanley Spencer lived and whom he first met in 1937. He commented of Spencer that it would be difficult to find a more reliable and kindly person. Trivick recalled that 'he said that if it were not for lesser artists like myself there would be no Stanley Spencer, we helped to hold him up!'[221] He showed Spencer some of his black-and-white lithographs. He was impressed with the possibilities of the medium and intended to try it when time permitted. In October 1952 Spencer visited the Polytechnic for the first time and continued to visit 'every Thursday for a period'. Trivick printed his *Marriage at Cana* on 'some quiet coloured papers'.[222]

Trivick's work was reproduced in numerous journals and magazines. He illustrated many books including Annan Dickson's *Devon Byways* in 1950 for which he contributed the frontispiece of Torbryan, the hills that led to the Moor and a number of line drawings. He published *The Craft and Design of Monumental Brasses* in 1969.

WOMEN'S LAND ARMY RECLAIMING LAND FOR THE BUCKINGHAMSHIRE WAR AGRICULTURAL COMMITTEE

Trivick first contacted Dickey at the Ministry of Information in June 1942 seeking advice about making submissions to the War Artists' Advisory Committee. He was informed that 'It is open to any artist to submit his or her pictures to the Committee with the object of securing a recommendation for purchase or for commission. Pictures thus submitted need not be framed… the War Artists' Advisory Committee as a rule meets weekly, so that it is seldom necessary for pictures to be retained for more than a short time.'[223] Shortly after receiving Dickey's response he submitted 10 drawings and indicated on each the approximate price required. He pointed out that 'Some of these drawings have not yet been censored.' The drawings were not accepted but two years later in May 1944 he submitted two lithographs of which *Women's Land Army Reclaiming Land for the Buckinghamshire War Agricultural Committee* was purchased for three guineas.

CLIVE UPTTON
1911–2006

DAILY SKETCH

SELF PORTRAIT, ARTIST'S ESTATE

The political cartoonist, illustrator and artist Clive Uptton was born in Highbury Barn, London on 12 March 1911, 'the son of Clive William Upton [sic], a touch-up artist for Swain's engravers who later worked for the *Daily Mail*. Educated at Brentwood Grammar School, Essex, at the age of 16 he studied at Southend Art School'[224] before leaving aged 19 to attend the Central School of Arts and Crafts, but turned professional illustrator before completing his studies.[225] Later he studied at Heatherley's Art School.

'Some of his earliest paid work was as an illustrator for the *Strand Magazine*… However, he also contributed regularly to *Good Housekeeping*, *Women's Illustrated*… *Tit-Bits*, *Tatler*, *Radio Times*, *Look and Learn*, *Sphere* and others.'[226] In the 1930s he had added an extra 't' to his name to distinguish between himself and another illustrator called Upton. He was member of the Chelsea Arts Club, the London Sketch Club and the Savage Club, from which in August 1942 he wrote his biographical details as requested by Arnold Palmer at the Ministry of Information.

Uptton undertook a 'fair amount of portraiture',[227] and was also the political cartoonist for the *Daily Sketch* and *Sunday Graphic* from 1940–42. He exhibited at the United Artists; his most successful cartoon '*We kneel only to thee*' appeared after Dunkirk and received a great response. Many thousands of printed copies were sold, in addition to its being used as a Ministry of Information poster. 'He later won prizes for his posters in the National Outdoor Advertising Awards in 1958 and 1959. He continued to work as a landscape and portrait painter (commissions included portraits of Harold Macmillan and Anthony Eden) and as a book illustrator (notably for Warner Press) until 1987, when his eyesight began to fail.'[228] Clive Uptton died in London on 11 February 2006.

FOR A HEALTHY, HAPPY JOB
– JOIN THE WOMEN'S LAND ARMY

Uptton worked for the Ministry of Information, producing propaganda cartoons, drawings and paintings. His poster for the Women's Land Army has become something of an iconic image. He also

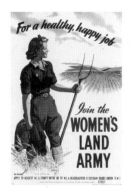

made independent submissions to the War Artists' Advisory Committee and in 1942 two oil paintings were purchased, both of bomb disposal: *Bringing up a 250 Kilo Bomb* and *Listening for Ticking*. Uptton was a member of the Home Guard and made a study of camouflage with reference to Home Guard needs.

J WALTER WEST
1860–1933

The painter Joseph Walter West was born in Hull on 3 May 1860, the son of Alfred West of Hull and his wife Sarah Ann Petchell. His family were Quakers and he was educated at Bootham School, York. He 'studied at York under Edwin Moore while working for an engineering firm, then at St John's Wood Art School 1883, at the R.A. Schools 1884–87 and at the Académie Julian, Paris'[229] (where he received various diplomas) and in Italy. While at the Royal Academy School he won the first silver medal for drawing of a head from life, and 'was proficient in many other media including tempera and lithography and practised mural painting.'[230]

West often painted landscapes in oil and these 'were made structural under their atmospheric effects by a severe training as a draughtsman.'[231] West used to spend his summer holidays in the Italian Lakes, sketching in the open air and one of his paintings *Sunshine, Breeze and Blossom: Lake Como* was purchased by the Chantrey Trustees for the Tate Gallery in 1913.[232] He signed his work with a weathercock pointing west with the letters 'WEST' at the points of the compass. He was a regular exhibitor at the Royal Society of Painters in Water Colours and his work was frequently seen at the Royal Academy. 'His elegant historical genre pictures reveal his interest in incident and narrative content.'[233]

West illustrated several books and contributed to *The English Illustrated Magazine* and the *Pall Mall Magazine*. Between 1916–17 he designed seven posters for the Underground Electric Railways Company of London. The company 'hit upon the friendly idea of sending

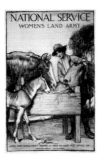

four posters for use in dug-outs and army huts to awaken thoughts of pleasant things of home. These were designed by George Clausen, Charles Sims, F. Ernest Jackson and J. Walter West [with *Harvest-Time*].'[234] Each was headed: 'The Underground Railways of London, knowing how many of their passengers are now engaged on important business in France and other parts of the world, send out this reminder of home.' All the drawings were donated by the artists. These were dispatched Christmas, 1916 at a time when the restrictions regarding paper prevented the general distribution of posters at home.[235] After the war West sold proofs of his poster through various dealers for four guineas. It was, he believed, 'the first of the Land-Women posters, being designed early in 1916 entirely on [his] own initiative.'[236]

West died in Northwood, Middlesex, on 27 June 1933 where he had lived for many years.

NATIONAL SERVICE WOMEN'S LAND ARMY POSTER and THE LANDSWOMAN
West was well suited to designing a recruiting poster and cover for the Women's Land Army magazine, *The Landswoman*, which appeared in January 1918 as two of his daughters had been engaged in land work in the early days of the war. The cover for *The Landswoman*

URSULA WOOD

appears to be a scaled-down version of *Harvest*, the poster for the Underground. The poster was produced by Johnson, Riddle and Co. Ltd, of Penge, London. West succeeded in 'making the poster a form of art answering the needs of the time, driving home its emphatic and vivid message.'[237]

The woodcut artist and furniture decorator, Ursula Wood, formerly oil painter and lithographer, was born in 1868. She studied at St John's Wood Art School and the Royal Academy Schools where in 1889 she won the Turner Gold medal and scholarship (£50) for her landscape painting *Hail Smiling Morn* which was presented by Lord Frederic Leighton.[238]

Wood exhibited with a number of societies including the Royal Academy and the Society of Lady Artists. *The Times* art critic described the Society's exhibition in April 1895 'as probably the best… that this very meritorious little society has ever had. The oil paintings show a special advance: there is less amateurishness and more evidence of serious study exhibited.' He commented, 'a young beginner, Miss Ursula Wood, sends an amusing little "Idyll" very brightly painted'.

Wood held a show with Miss E. Stewart Wood in The Twenty-One gallery in February 1923. *The Times* critic in his round-up of art exhibitions wrote, 'Miss Ursula Wood shows in three or four of her little water-colours… a quick feeling for the implicit humour of common life, especially in children. Her drawings of places are very happily chosen, and strongly as well as delicately designed; and her few colour-prints from the wood are distinguished by a soft richness of quality.'

Wood also illustrated a number of books. In a review of Christmas Books for 1897 *The Times* makes reference to *Chirupee* by E. Boyd Bayley published by Hodder and Stoughton and which 'tells the tale of a rural parish with a good deal of local patois. Some of the slight sketches by Ursula Wood are clever.'[239]

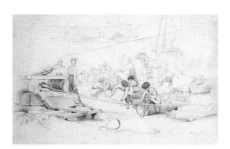

The Canadian Timber Camp, Wendover

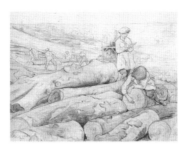

Girls Measuring ('Girthing') and Marking Timber

Girls of the Women's Forestry Corps: The Timber Camp, Hatfield, December 1918

The Old Banqueting Hall, Hatfield: Girls of the Women's Forestry Corps, Dancing to a Gramophone

THE CANADIAN TIMBER CAMP, WENDOVER
GIRLS MEASURING ('GIRTHING') AND MARKING TIMBER
GIRLS OF THE WOMEN'S FORESTRY CORPS: THE TIMBER CAMP, HATFIELD, DECEMBER 1918
THE OLD BANQUETING HALL, HATFIELD: GIRLS OF THE WOMEN'S FORESTRY CORPS, DANCING TO A GRAMOPHONE

Ursula Wood, who was a member of the Women's Forestry Corps, worked at the Forestry Camp at Wendover as did Miss E. Stewart Wood who had written to the honorary secretary of the Women's Work Sub-Committee in January 1919 to bring to her notice some five oil sketches she had completed of Women Land Workers at Wendover and Hatfield. She was asked to submit these for the Committee to see at their next meeting, although it was pointed out that hitherto they had not bought pictures but were now considering the whole question. Included with her submission was a portfolio of five chalk drawings by Ursula Wood. Stewart Wood's work was rejected on the grounds that the figures were not sufficiently large and distinct to represent the work of the women under the Timber Supply Department for the Women's Section of the War Museum.

Ursula Wood's sketches, on the other hand, were well received and deemed to be excellent records of the Timber Felling Women. Wood was asked to return the sketches and to bring further work for the Committee to see. These were also submitted to the Art Committee, 'consisting of men, who reported against them, thinking they were not particularly interesting. Our own Committee, however, did not agree with this verdict, as we consider them first-hand historical records very carefully done of work which will probably never be seen again. We could not, however, get authority to pay the price which you wanted in the face of the objections raised by the Art Committee. I have been authorised to offer you fifteen guineas for five of the sketches.'[240] Wood accepted the offer although she did not think it much for the amount of work involved.

1 The letters are located in the First and Second World War Artists' Archive, Imperial War Museum, London.

2 Foss, B. (2007) *War paint. Art, war, state and identity in Britain 1939–1945*, pp.87-8.

3 *New York Times* cited in Roy Heron, (1981) *Cecil Aldin: the story of a sporting artist*, p.8.

4 Aldin, C. (1934) *Time I was dead: pages from my autobiography*, p.6.

5 See Heron, R. (1990) *The sporting art of Cecil Aldin*, p.23.

6 *The Studio*, 15 January 1915, AD. IV.

7 Heron (1981) op. cit., p.17.

8 This was the name used for their partnership as poster artists, they had their studio on Mitcham Common – see Aldin (1934) p.26.

9 Churcher, W. (1915) 'The London Sketch Club', *The Studio*, 15 January, p.244.

10 Aldin (1934) op. cit., p.89.

11 Souter, N. & S. (2007) *The illustration handbook. A guide to the world's greatest illustrators*, p.38.

12 Aldin (1934) op. cit., p.165 & p.166.

13 Munnings, A. (1956) *An artist's life*, vol. 1, p.300.

14 Aldin correspondence, Imperial War Museum, First World War Artists Archive, File Number 30/2 Part 1.

15 Imperial War Museum (1963) *A concise catalogue of paintings, drawings and sculpture of the First World War 1914–1918*, p.131.

16 Aldin letter to Lady Norman, 27 May 1919, Imperial War Museum, First World War Artists Archive, File Number 30/2 Part 1.

17 Houfe, S. (1996) *The dictionary of 19th century British book illustrators and caricaturists*, p.44.

18 *The Times*, 'Mr Cecil Aldin. Painter of sporting subject'. Obituary, 7 January 1935, p.19.

19 Heron (1981) op. cit., p.185.

20 Aldin (1934) op. cit., p.379.

21 Aldin correspondence, Imperial War Museum, First World War Artists Archive, File Number 30/2 Part 1.

22 Barnes, J.C.S. (1993) '*James Bateman*. Centenary exhibition catalogue'. Abbot Hall Art Gallery (unpaginated).

23 Jarvis, G. (1983) 'James Bateman, RA, ARWS, Native of Kendal', *Quarto*, April, XXXI, I (unpaginated), Abbot Hall Art Gallery.

24 Barnes (1993) op. cit.

25 Imperial War Museum, Second World War Artists Archive, File Number GP/55/42.

26 Jarvis (1983) op. cit.

27 Barnes (1993) op. cit.

28 Buckman, D. (2006) *Artists in Britain since 1945. Volume 1 A to L*, p.100.

29 Jarvis (1983) op. cit.

30 Barnes (1993) op. cit.

31 Barnes (1993) op. cit.

32 Barnes (1993) op. cit.

33 Imperial War Museum, Second World War Artists Archive, File Number GP/55/42.

34 Bateman, 3 April, 1940. Imperial War Museum, Second World War Artists Archive, File Number GP/55/42.

35 See the biographical notes supplied by Norma Bull May 1942 to the WAAC, Imperial War Museum, Second World War Artists Archive. File Number GP/55/42.

36 Ibid.

37 John Masefield letter to Mrs Hamilton, 7 January, 1941. Imperial War Museum, Second World War Artists Archive, File Number GP/55/251.

38 Letter to Dickey from Bull, 19 July, 1941. Imperial War Museum, Second World War Artists Archive, File Number GP/55/251.

39 Letter to Dickey from Bull, 11 May, 1942. Imperial War Museum, Second World War Artists Archive, File Number GP/55/251.

40 Letter to Owen from Bull, 14 October, 1942. Imperial War Museum, Second World War Artists Archive, File Number GP/55/251.

41 Buckman (2006) op. cit., p.374.

42 *The Guardian*, Obituary, 25 February 1998.

43 I am grateful to Kate Morgan for sharing her memories of her father with me and for providing written detail re his career, including Edward Pullee's obituary from *The Times*.

44 *The Times*, Obituary, 25 March 1998.

45 Ibid.

46 Leonard Daniels. Imperial War Museum, Second World War Artists Archive, File Number GP/55/221.

47 Brian Chugg in Hassell, G. (1995) *Camberwell School of Arts and Crafts. Its students and teachers 1943–1960*, p.185.

48 See Gilbert Spencer's (1974) *Memoirs of a painter*, p.164.

49 Hassell (1995) op. cit., p.19.

50 Kate Morgan, op. cit.

51 Kate Morgan, op. cit.

52 Leonard Daniels, op. cit. File Number GP/55/221.

53 Felmingham, M. (1988) *The illustrated gift book 1880–1930*, p.59.

54 *Who's Who* (1946) p.790.

55 Birnbaum, M. (1919) *Introductions: painters sculptors and graphic artists*, p.70.

56 White, C. (1975) *Edmund Dulac*, p.20.

57 Ibid., p.86.

58 Spalding, J. (1982) Foreword to the catalogue, *Edmund Dulac Illustrator and designer 1882–1953. A centenary exhibition*, p.3.

59 Houfe, S. (1981) *The dictionary of British book illustrators and caricaturists 1800–1914*, p.290.

60 *The Times*, Obituary, 28 May 1953, p.10, col. D.

61 See Engen, R. (2007) *The age of enchantment: Beardsley, Dulac and their contemporaries 1890–1930*, p.40 and Edmund Dulac, ODNB entry by James Hamilton.

62 White (1975) op. cit., p.72.

63 White (1975) op. cit., p.75.

64 Hartrick, A.S. (1932) *Lithography as a fine art*, p.42.

65 See *British Printmakers 1855–1955 A century of printmaking from the etching revival to St Ives* (1992).

66 White (1975) op. cit., p.788.

67 Dalby, R. (2007) Edmund Dulac. 'Supreme illustrator "A dreamer of extraordinary dreams"', *Book and Magazine Collector*, Christmas, 289, pp.55–69.

68 This portrait draws on and is adapted from the biography I wrote of *Evelyn Dunbar: War and Country* in 2006, published by Sansom & Co.

69 The brief 'biography' of Evelyn Dunbar written by Ernest Blaikley, Keeper of Art, Imperial War Museum in the 1940s has slightly different dates to John Rothenstein, who records that Dunbar was at the RDS in 1926.

70 *The Times*, 18 July 1931, p.10, col. C.

71 *The Times*, Obituary, May 1960.

72 Sue Hubbard (2003) 'Light fantastic', *The Independent Review*, 26 August p.14.

73 Evelyn Dunbar. Imperial War Museum, Second World War Artists' Archive GP/55/44.

74 Ibid.

75 Sparsholt Farm Institute now Sparsholt College, offers a variety of full and part-time courses in land-based industries.

76 Op. cit., IWM.

77 For more specific detail about the paintings see Gill Clarke (2006), chapter 4 'War artist'.

78 Foss (2007) op. cit., p.30, p.88 & p.198.

79 I am grateful to Christopher and Wendy Thairs who knew Michael Ford and his mother for many years for sharing their memories and for the copy of the eulogy they wrote for Michael Ford's funeral.

80 Michael Ford's autobiographical notes. Imperial War Museum, Second World War Artists Archive, File Number GP/55/119.

81 The Thairs were unable to establish where the coal mine was.

82 Michael Ford letter to the Minister of Information, 22 January 1941. Imperial War Museum, Second World War Artists Archive, File Number GP/55/119.

83 Phyllis Ford letter to Dickey, 4 April 1941. Imperial War Museum, Second World War Artists Archive, File Number GP/55/119.

84 Whereabouts unknown, possibly painted over or destroyed.

85 Donald McCullough (1965) *The Times*, 18 June, p.14, col. G.

86 Hillier, B. (1977) *Fougasse*, p.10.

87 Rennie, P. (2008) 'Wit at war', *Illustration*, Spring, 15, p.17.

88 Bradshaw, P.V. (1942) *They make us smile*, p.26.

89 Hillier (1977) op. cit., p.16.

90 Hillier (1977) op. cit., p.15.

91 Fougasse (1956) *The good-tempered pencil*, p.5.

92 McCullough (1965) op. cit., p.14.

93 Bird, (Cyril) Kenneth, ODNB entry by Peter Mellini.

94 McCullough (1965) op. cit., p.14.

95 Ibid.

96 Hillier (1977) op. cit., p.21.

97 Fougasse (1946) *A school of purposes: Fougasse posters, 1939–1945*, p.11.

98 Hardie, M. (1950) Foreword, *Ethel Gabain*, Royal Society of British Artists, p.2.

99 Hartrick (1932) op. cit., p.40.

100 Hardie (1950) op. cit., p.2.

101 Strickland, A. (2006) *Three officially commissioned women war artists of the Second World War: Ethel Gabain, Evelyn Gibbs and Evelyn Dunbar*, volume 1, unpublished, PhD thesis, University of Plymouth, p.80.

102 Weber, W. (1966) *A history of lithography*, p.133.

103 *Alassio News* (printed in English) lent by Peter Copley.

104 *The Times*. Obituary Mrs John Copley, 31 January 1950, p.7, col. F.

105 Interview with Peter Copley by the author, January 2008.

106 John Copley, ODNB entry by Peter Copley.

107 Information from Peter Copley and *The Times*, Obituary of John Copley, 18 July 1950, p.8, col. D.

108 Pears, I. (2003) *Ethel Gabain 1883–1950, The lithographs of Ethel Gabain 1883–1950*, The Fine Art Society, p.8.

109 Ethel Gabain. Imperial War Museum, Second World War Artists Archive, File Number GP/55/46.

110 Pears (2003) op. cit., p.9.

111 Ethel Gabain. Imperial War Museum, Second World War Artists Archive, File Number GP/55/46.

112 *Who's who in art* (1934) p.160.

113 *The Times*. Obituary, 2 March 1972, p.16, col. G.

114 Ibid., p.16.

115 MacCarthy (1933) Introduction, *H.H.A. Letters of the Earl of Oxford and Asquith to a friend First series 1915-1922*, p.viii. He refers to Harrisson as Asquith's 'intimate woman-friend' (p.xi). Miranda Seymour's (1992) detailed biography of the literary hostess Lady Ottoline Morrell (1873–1938), who was friends with the Spencer brothers sheds light on Hilda Harrisson's relationships. She explains how Ottoline 'was vehemently on Gilbert's side in 1924 when his adored mistress, Hilda Harrisson, suddenly left him to be with Asquith.' Seymour points out that Ottoline later reluctantly forgave her old friend Asquith 'for annexing Gilbert Spencer's chosen wife, Hilda

Harrisson for his last romance' (see *Ottoline Morrell: life on the grand scale*, p.434 and p.481).

116 *The Times*, Obituary, op. cit., p.16.

117 Ibid.

118 Foss (2007) op.cit., p.65. Although Foss is referring to *A Woman Bus Conductor* the same could be said of Harrisson's portrait of *A Land Girl*.

119 Hilda Harrisson, Imperial War Museum, Second World War Artists Archive, File Number GP/55/312.

120 Gilbert Spencer to Gregory, Imperial War Museum, Second World War Artists Archive, File Number GP/55/312.

121 Garton (1972) op. cit., p.25.

122 Hartrick, A.S. (1939) *A painter's pilgrimage through fifty years*, p.10.

123 Hartrick (1939) ibid., p.29 and p.51.

124 Hartrick (1939) ibid., p.213.

125 Hartrick (1939) ibid., p.132.

126 Hartrick (1939) ibid., p.187.

127 Hartrick (1939) ibid., p.209.

128 Hartrick (1939) ibid., p.211.

129 Mellor, D., Saunders, G. & Wright, P. (1990) *Recording Britain. A pictorial Doomsday of pre-war Britain*, p.74.

130 Hennell, T. (1984) *The old farm*, p.84 (originally published as *Change in the farm* in 1934). Hartrick writes about his drawing of a breast-plough in the Cotswolds in *A painter's pilgrimage through fifty years*, p.203.

131 Peppin, B. and Micklethwaite, L. (1983) *Dictionary of British book illustrators. The twentieth century*, p.141.

132 Foss (2007) op. cit., p.88.

133 A. S. Hartrick. Imperial War Museum, Second World War Artists Archive, File Number GP/55/32.

134 Hartrick ibid.

135 Hartrick ibid.

136 Sausmarez, M. de (1947) The pen drawings of Thomas Hennell, *Alphabet and Image*, 4, p.61.

137 Chris Beetles summer show 1998, catalogue, p.122.

138 Rothenstein, J. (1984) *Modern English painters: Hennell to Hockney*, p.14.

139 Warren, C.H. (1957) Thomas Hennell, *The Countryman*, LIV, 3, Autumn, p.432.

140 Sausmarez (1947) op. cit., p.66.

141 Skipwith, P. (1980) Introduction, *Lady Filmy Fern or The voyage of the window box*, p.1.

142 Skipwith (1980) ibid., p.1. *Lady Filmy Fern* was published in 1980.

143 See the article on *Charles Mahoney (1903–1968)* by his daughter Elizabeth Bulkeley (1999) in the catalogue published by The Fine Art Society in association with Paul Liss on occasion of an exhibition of Mahoney's work.

144 Rothenstein (1984) op. cit., p.20.

145 See MacLeod, M. (1988) *Thomas Hennell: countryman, artist and writer*, pp.32–33.

146 Rothenstein (1984) op. cit., p.16.

147 See Yorke, M. (2007) *Edward Bawden and his circle. The inward laugh*.

148 Sausmarez (1947) op. cit., p.65.

149 Warren (1957) op. cit., p.431.

150 See Michael Carney's (1995) *Britain in pictures: a history and bibliography*.

151 Thomas Hennell. Imperial War Museum, Second World War Artists Archive, File Number GP/55/123.

152 MacLeod (1988) op. cit., p.75

153 Harries, M. & S. (1983) *The war artists. British official war art of the twentieth century*, p.195.

154 Massingham, H.J. (1947) 'Thomas Hennell: 1903–1945 A memoir', in *The countryman at work* written and illustrated by Thomas Hennell, p.15.

155 Sir William Russell Flint (1965) cited in Bolling, G.F. and Withington, V.A. (1993) *The graphic work of Laura Knight. A catalogue raisonné of the prints*, p.ix.

156 See Cole, M. (1938) *Women of to-day*, chapter 6 'Laura Knight', p.167.

157 Knight, L. (1936) *Oil paint and grease paint. Autobiography of Laura Knight*, p.45.

158 Dunbar, J. (1975) *Laura Knight*, p.61.

159 Laura Knight, ODNB entry by Janet Dunbar.

160 Knight (1936) op. cit., p.160.

161 Fox, C. (1988) *Dame Laura Knight*, p.25.

162 Bolling, G.F. and Withington, V.A. (1993) *The graphic work of Laura Knight. A catalogue raisonné of the prints*, p. ix.

163 Fox (1988) op. cit., p.47.

164 Garton (1992) op. cit., p.42.

165 I am grateful to Wendy Mould for conducting the interview with Madeleine Barnett in the summer of 2001.

166 Knight to Bevan, 2 November 1939, PRO INF 1/637 cited in Lewis, R.M. (2004) *The planning, design and reception of British Home Front Propaganda posters in the Second World War*, unpublished, PhD thesis, University College Winchester, p.94.

167 Bevan to Laura Knight, 4 November, 1939. Imperial War Museum, Second World War Artists Archive, File Number GP/55/74.

168 Lewis (2004) op. cit., p.94.

169 www.nationalarchives.gov.uk/theartofwar/prop/production_salvage/INF3_0108 accessed 06/09/2007.

170 Fox (1988) op. cit., p.115.

171 Ibid.

172 *The Independent*, Obituary of Daphne Pearson, 31 July 2000.

173 Knight to Gregory, 5 December, 1945. Imperial War Museum, Second World War Artists Archive, File Number GP/55/74.

174 *Shared experience art and war, Australia, Britain & Canada in the Second World War,*

(2005) p.101.

175 Connelly, W. (1999/2000) *Imaginative Book Illustration Newsletter*, 13, Winter, p.16.

176 See Fry, M. (1975) *Autobiographical sketches*.

177 John Lavrin pers. comm. to the author, May 2008.

178 Lavrin (2008) ibid. He also pointed out that his mother had been scheduled for the 'Prix de Rome' but due to funding cuts she lost it.

179 Garton (1992) op. cit., p.5.

180 Connelly (1999/2000) op. cit., p.16.

181 Lavrin (2008) op. cit.

182 Lavrin (2008) op. cit.

183 These diaries are in the Ashmolean, Oxford.

184 Exhibition catalogue (undated), Nottingham Castle.

185 Hassell (1995) op. cit., p.114.

186 See Connelly (1999/2000) op. cit. and Hassell (1995) ibid.

187 See Connelly (1999/2000) op. cit. and *John Lavrin – a brief chronology*.

188 See *The Times*' obituary for Nora Lavrin, 16 September 1985, p.16, col. C and unattributed notes supplied by John Lavrin, possibly the draft obituary text.

189 Monica Partridge (1986) Preface, pvii.

190 Lavrin (2008) op. cit.

191 Information drawn from Moore's unpublished autobiography, written under the name of Deborah Bentin. She took the surname Bentin on marriage to Tony, but kept her name Mona Moore as an artist. After becoming a member of the religious group Subud, she changed her name to Nova, a name by which she remained known officially, although later she changed her name (informally) to Deborah. Tony, also a Subud member, became 'Philip'. I am grateful to her family and in particular her son John for giving me access to this and other documents. This biographical portrait also draws on information from the author's interviews with Deborah Bentin in June 2000 and her husband Philip Bentin in November 2000, and through meeting her family at her memorial service in October 2000.

192 Deborah Bentin (u/d) Autobiography, p.21.

193 Deborah Bentin (u/d) ibid., p.23.

194 Two of these drawings were bought for 14 guineas by the WAAC.

195 Deborah Bentin (u/d) op. cit., p.25.

196 Deborah Bentin (u/d) op. cit., p.34.

197 Radford, R. (1987) *Art for a purpose. The Artists' International Association, 1933–1953*, back cover.

198 *The Times*. 1 March 1945.

199 Moore explained in her autobiography that this painting was done after what was a kind of religious conversion, a 'moment of revelation' in 1944 when she was 27. The model for the picture was her husband. 'In his outstretched hands [she] tried to convey at one and the same time, a feeling of utter submission combined with the agony of the human being.'

200 *The Independent*, Obituary of Ralph Usherwood by Nicholas Usherwood. January 2000.

201 Mona Moore. Imperial War Museum, Second World War Artists Archive, File Number GP/55/136.

202 Ibid. Letter from E.M. O'R. Dickey to W. D.H. McCullough, Ministry of Agriculture, 29 August 1941.

203 Imperial War Museum interview 1997.

204 *The Times*. 14 May 1931, p.12, col.D.

205 I am grateful to Alice, Lady Barnes and Janet Barnes for sharing their memories of their father and grandfather and for loaning me Randolph Schwabe's books of newspaper cuttings.

206 Schwabe, R. (1943) 'Three teachers: Brown, Tonks and Steer', *Burlington Magazine*, June, p.141.

207 Schwabe (1943) ibid., p.142.

208 Tennyson, C. (1951) Introduction, *Randolph Schwabe memorial exhibition*, The Arts Council, p.3.

209 Birdie was painted by Augustus John in 1915.

210 Alice was born on 11 March 1914, she married Harry Barnes (1915–82) on 19 April 1941, a former student of her father's at the Slade, who in 1964 became Director of the Glasgow School of Art, having first joined the staff in 1944. He was knighted in 1980.

211 Horne, A. (1995) *The dictionary of 20th century British Book illustrators*, pp.383–384

212 *Times Literary Supplement*, 26 November 1925.

213 Eva, R. (1994) Introduction Randolph Schwabe catalogue Bourne Fine Art, p.12.

214 Rothenstein, W. (1939) *Since fifty: men and memories, 1922–38. Recollections of William Rothenstein*, p.154.

215 Randolph Schwabe, DNB (1941–1950) entry by Stephen Bone, p.763.

216 Randolph Schwabe, Imperial War Museum, First World War Artists Archive, File Number 287/7.

217 Summerfield, A. (1989) *The artist at war, Second World War paintings and drawings from the Walker Art Gallery's collection*, p.22.

218 Information supplied by Trivick on request to the WAAC May 1944.

219 Trivick, H. (1960) *Autolithography. The technique*, p.7.

220 Trivick (1944) op. cit.

221 Rothenstein, J. (ed.) (1979) *Stanley Spencer The man: correspondence and reminiscences*, p.111.

222 Rothenstein (1979) ibid., p.114.

223 Henry Trivick. Imperial War Museum, Second World War Artists Archive, File Number GP/55/376.

224 Bryant, M. (2000) *Dictionary of twentieth century British cartoonists and caricaturists*, p.229.

225 Ibid.

226 Bryant, M. (2006) *Independent*, Obituary, 18 February.

227 Information supplied by Uptton to A.N. Palmer Esq M.O.I.
 on request on 25 August 1942.

228 Bryant (2006) op. cit.

229 Chamot, M., Farr, D. and Butlin. M. (1964) Tate Gallery Catalogue
 The modern British paintings, drawings and sculpture, Vol. I Artists M–Z, p.766.

230 Houfe (1996) op. cit., p.344.

231 *The Times*, Obituary, 29 June 1933, p.19, col. B.

232 Chamot et al. (1964) op. cit., p.766.

233 Windsor, A. (ed.) (1992) *Handbook of modern British painting 1900–1980*,
 p.279.

234 Sheldon, C. (1937) *A history of poster advertising*, p.85.

235 Hardie, M. and Sabin, M. (1920) *War posters. Issued by belligerent and
 neutral nations 1914–1919*, p.10.

236 Trivick letter to Lady Norman, 25 July 1919, Imperial War Museum.

237 Sheldon (1937) op. cit., p.85.

238 *The Times*, 11 December 1889, p.7, col. A.

239 Poems by Ursula Wood appear in Erica Marx's (1952) *Poems in pamphlet.
 A new anthology for 1952 of poets who have and have not been previously
 published.*

240 Hon. Secretary Women's Work Sub-Committee letter to Ursula Wood,
 7 February 1919. Imperial War Museum.

LAND GIRLS' STORIES

I am grateful to all those former Land Girls who shared their memories of life on the land in the Second World War; the following have been quoted from directly in 'Back to the Land':

- Grace Adamek (née Whitehead)
- Joan Anderson (née Hallwood)
- Elizabeth Aspinall (née Wood)
- Joy Atkins (née Peppercorn)
- Edith Barford (née Downes)
- Madeleine Barnett (née Poole)
- Margot Bettles (née Gurl)
- Marjorie Bennett (née Fairbrother)
- Gladys Benton (née Hellyer)
- Muriel Berzins (née French)
- Joan Blair (née Haggith)
- Ruth Bowley (née Hale)
- Muriel Brayne (née Page)
- Margaret Brittain (née Smith)
- Margaret Brophy
- Daphne Byrne
- Molly Campbell (née Rogers)
- Ellen Chambers
- Betty Cornish (née Marshall)
- Joan Cowderoy
- Elsie Cowley (née Ward)
- Joan Culver (née Laker)
- Ruth Desborough (née Buckland)
- Mary Doherty (née Murray)
- Joyce Downer (née Martin)
- Joan Drake (née Day)
- Irene Eady (née Gascoigne)
- Dot Eccleston
- Clarice Edmond (née Cann)
- Frieda Feetham (née Friedrich)
- Alison Fishenden (née Huxford)

- Anne Fountain (née Hall)
- Margaret Franklin (née Turner)
- Dorothy French (née Tattersall)
- Christine Froude (née Williams)
- Hilda Kaye Gibson
- Paddy Gilbert (née Laker)
- Pauline Gladwell (née Clark)
- Jean Goodwin (née Richmond)
- Pearl Goodman (née Turner)
- Beryl Gould (née Geoghegan)
- Joan Grace (née Spencer)
- Vera Green (née Parker)
- Lillian Harbard (née Butcher)
- Alice Haynes (née White)
- Hazel Hobden
- Eileen Holliday (née Bradley)
- Mary Hood (née Blackburn)
- Molly Horne (née Day)
- Sylvia Johnson (née Wilson)
- Ida Jühe (née Human)
- Jean Kitson (née Holmes)
- Hazel Lamb (née Waite)
- Kay Lawson (née Radcliffe)
- Joan Lomas
- José Loosemore (née Smith)
- Margaret Mace
- Alice May (Maisie) Marshall
- Nan McFarland
- Doreen McLean (née Cooke)
- Dorothy Medhurst (née Maskell)
- Maureen Miller (née Roberts)

- Betty Mintz (née Griffiths)
- Gwen Moody (née Pocklington)
- Peggy Moule (née Parfitt)
- Shirley Murray (née Noble)
- Iris Newbould (née Faulkner)
- Sheila Newman (née Jacobs)
- Patricia Parkyn (née Cater)
- Brenda Penfold (née Poulton)
- Peggy Evelyn Pickerill
- Theresa Porter (née Hastings)
- Joan Rackley (née Enfield)
- Sylvia Reeves (née Eyre)
- Emily Richardson (née Pritchard)
- Hazel Robinson (née Williams)
- Elizabeth Smith-Wright
- Marjorie Stanton (née Ellis)
- Eileen Stewart (née Arnold)
- Vera Stratford (née Auty)
- Dorothy Taylor (née Cann)
- Joan Thompson
- Peg Turner (née Burnham)
- Nina Vandenberg (née Hanke)
- Dora Varley (née Watson)
- Vivienne Vick (née Leighton)
- Freda Walker (née Critchlow)
- Freda Ward (née Frost)
- Joyce Wardle
- Audrey Webb (née Crouch)
- Pam West (nee Floyd)
- Gladys Wheatland (née Senter)
- Rosemary Wilson (née Lawford)

SELECTED REFERENCES

- Aldin, C. (1934) *Time I was dead: pages from my autobiography*, London: Eyre & Spottiswoode
- Andrews, I.O. and Hobbs, M.A. (1921) *Economic effects of the World War upon women and children in Great Britain*, London & New York: Oxford University Press
- Antrobus, S. (2008) *"We wouldn't have missed it for the world." The Women's Land Army in Bedfordshire, 1939–50*, North Yorkshire: Book Castle Publishing
- Barraud, E.M. (1946) *Set my hand upon the plough*, Worcester: Littlebury and Co.
- Bentwich, H. (1973) *If I forget thee some chapters of autobiography 1912–1920*, London: Paul Elek Books Ltd
- Biddle, M. (1941) *The women of England*, Boston: Houghton Mifflin Company
- Birnbaum, M. (1919) *Introductions: painters sculptors and graphic artists*, New York: Frederic Fairchild Sherman
- Braybon, G. (1981) *Women workers in the First World War: the British experience*, London: Croom Helm
- Braybon, G. and Summerfield, P. (1987) *Out of the cage: women's experiences in two world wars*, London: Pandora
- Buckman, D. (2006) *Artists in Britain since 1945. Volume 1 & 2*, Bristol: Art Dictionaries Ltd
- Bullock, M.H. (2002) *The Women's Land Army 1939–1950: a study of policy and practice with particular reference to the Craven district.* Unpublished PhD thesis. University of Leeds
- Burton, E. (1941) *What of the women: a study of women in wartime*, London: Frederick Muller Ltd
- Calder, A. (1986) *The people's war: Britain 1939–45*, London: Granada
- Clarke, G. (2001) Lives on the Home Front: the Women's Land Army, *Auto/Biography*, IX, 1&2, pp.81–88
- Clarke, G. (2006) *Evelyn Dunbar: War and Country*, Bristol: Sansom & Co.
- Clarke, G. (2007) 'The Women's Land Army and its Recruits, 1938–50' in Short, B., Watkins, C. and Martin, J. (eds.) *The front line of freedom, British farming in the Second World War*, Exeter: British Agricultural History Society
- Courtney, J.E. (1933) *Countrywomen in council. The English and Scottish Women's Institutes with chapters on the movement in the Dominions and on Townswomen's Guilds*, London: Oxford University Press
- Dakers, C. (1987) *The countryside at war 1914–18*, London: Constable
- Davies, J. (1995) *The wartime kitchen and garden: the home front 1939–45*, London: BBC Books
- Dewey, P.E. (1989) *British agriculture in the First World War*, London: Routledge
- Douie, V. (1950) *Daughters of Britain. An account of the work of British women during the Second World War*, Oxford: George Ronald
- Dunbar, J. (1975) *Laura Knight*, London: Collins
- Ernle, Lord (1925) *The land and its peoples: chapters in rural life and history*, London: Hutchinson
- Foss, B. (2007) *War paint. Art, war, state and identity in Britain 1939–1945*, London: Yale University Press
- Fougasse (1946) *A school of purposes: Fougasse posters, 1939–1945*, London: Methuen & Co. Ltd
- Fox, C. (1988) *Dame Laura Knight*, Oxford: Phaidon
- Gardiner, J. (2004) *Wartime Britain 1939–1945*, London: Headline
- Garton, R. (ed.) (1992) *British printmakers*, Aldershot: Scolar Press
- Goldsmith, M. (c.1943) *Women at war*, London: Lindsay Drummond
- Gosden, P.H. & J.H. (1976) *Education in the Second World War: a study in policy and administration*, London: Methuen
- Grayzel, S.R. (1999) 'Nostalgia, gender, and the countryside: placing the "Land Girl" in First World War Britain', *Rural History*, 10, 2, pp.155–70
- Hale, K. (1994) *A slender reputation: an autobiography*, London: Frederick Warne
- Hardie, M. (1950) Foreword, *Ethel Gabain*, Royal Society of British Artists, London, Suffolk Street
- Hardie, M. (ed.) (2006) *Digging for memories: The Women's Land Army in Cornwall*, Penzance: The Hypatia Trust
- Hardie, M. and Sabin, M. (1920) *War posters. Issued by belligerent and neutral nations 1914-1919*, London: A. & C. Black
- Harries, M. & S. (1983) *The war artists. British official war art of the twentieth century*, London: Michael Joseph in association with The Imperial War Museum & The Tate Gallery
- Hartrick, A.S. (1939) *A painter's pilgrimage through fifty years*, Cambridge at the University Press
- Hassell, G. (1995) *Camberwell School of Arts and Crafts. Its students and teachers 1943–1960*, London: Antique Collectors' Club
- Heron, R. (1981) *Cecil Aldin: the story of a sporting artist*, Exeter: Webb & Bower
- Hillier, B. (1977) *Fougasse*, London: Elm Tree Books/Hamish Hamilton Ltd
- Holderness, B.A. & Turner, M. (eds.) (1991) *Land, labour and agriculture, 1700–1920. Essays for Gordon Mingay*, London: Hambledon Press
- Horn, P. (1984) *Rural life in England in the First World War and after*, Dublin: Gill & Macmillan Ltd
- Howkins, A. (2003) *The death of rural England: a social history of the countryside since 1900*, London: Routledge
- Houfe, S. (1996) *The dictionary of 19th century British book illustrators and caricaturists*, Woodbridge: Antique Collectors' Club
- Huxley, G. (1961) *Lady Denman, G.B.E. 1884–1954*, London: Chatto and Windus
- Imperial War Museum (1963) *A concise catalogue of paintings, drawings and sculpture of the First World War 1914–1918*, Southampton: HMSO
- Jenkins, I. (1950) 'They served the land: a tribute to the work of the Women's Land Army, 1939-50', *Agriculture. Journal of the Ministry of Agriculture*, December, pp.403-407
- Joseph, S. (1946) *If their mothers only knew. An unofficial account of life in the Women's Land Army*, London; Faber & Faber

- King, P. (1999) *Women rule the plot: the story of the 100 year fight to establish women's place in farm and garden*, London: Duckworth
- Knight, L. (1943) *Women. War pictures by British artists*, London: Oxford University Press
- Knight, L. (1965) *The magic of a line, the autobiography of Laura Knight DBE, RA*, London: William Kimber
- Lloyd George, D. (c.1938) *War memoirs of David Lloyd George vol.1*, London: Odhams Press
- Longmate, N. (1977) *How we lived then: a history of everyday life during the Second World War*, London: Arrow Books Ltd
- McLaren, B. (1917) *Women of the war*, London: Hodder & Stoughton
- MacLeod, M. (1988) *Thomas Hennell: countryman, artist and writer*, Cambridge: Cambridge University Press
- Martin, J. (2000) *The development of modern agriculture: British farming since 1931*, Basingstoke: Macmillan
- Martin, J. (2003) 'The mobilisation of British agriculture in the Second World War', *Rural History Today*, 5, July, pp.10–11
- Mellor, D., Saunders, G. & Wright, P. (1990) *Recording Britain. A pictorial Doomsday of pre-war Britain*, London: David & Charles in association with the Victoria & Albert Museum
- Meiggs, R. (1949) *Home timber production (1939–1945)*, London: Lockwood & Son
- Middleton, T.H. (1923) *Food production in war*, Oxford: Clarendon Press
- Ministry of Information (1945) *Land at war: the official story of British farming 1939–1944*, London: Whitefriars Press
- Ministry of Supply. Home timber production department (c.1942–5) *Meet the members: a record of the Timber Corps of The Women's Land Army*, Bristol: Bennett Brothers
- Minns, R. (1999) *Bombers and mash: the domestic front 1939–45*, London: Virago
- Montgomery, J.K. (1922) *The maintenance of the agricultural labour supply in England and Wales during the war*, Rome: International Institute of Agriculture
- Moore-Colyer, R. (2007) 'Prisoners of war and the struggle for food production, 1939–49', in Short, B., Watkins, C. and Martin, J. (eds.) *The front line of freedom, British farming in the Second World War*, Exeter: British Agricultural History Society
- Murray, K.A.H. (1955) *Agriculture*, London: HMSO & Longmans, Green & Co.
- Parker, H.M.D. (1957) *Manpower: a study of war-time policy and administration*, London: HMSO & Longmans, Green & Co.
- Powell, B. and Westacott, N. (1997) *The Women's Land Army 1939–1950*, Stroud: Sutton Publishing
- Priestley, J.B. (1943) *British women go to war*, London: Collins
- Olivier, E. (1938) *Without knowing Mr. Walkley, personal memories*, London: Faber & Faber
- Ruck, B. (1919) *A Land Girl's love story*, New York: A.L. Burt Company
- Sackville-West, V. (1944) *The Women's Land Army*, London: Michael Joseph
- Shewell-Cooper, W.E. (c.1941) *Land Girl: A manual for the Women's Land Army*, London: English Universities Press
- Short, B., Watkins, C. and Martin, J. (eds.) (2007) *The front line of freedom, British farming in the Second World War*, Exeter: British Agricultural History Society
- Souter, N. & S. (2007) *The illustration handbook. A guide to the world's greatest illustrators*, Royston: Eagle Editions Ltd
- Spalding, F. (1991) *Twentieth century painters and sculptors*, Woodbridge: Antique Collectors' Club
- Stettinius, J. (1944) *Lend-lease: weapon for victory*, New York: The Macmillan Company
- Summerfield, P. (1998) *Reconstructing women's wartime lives: discourse and subjectivity in oral histories of the Second World War*, Manchester: Manchester University Press
- Tennyson, C. (1951) Introduction, *Randolph Schwabe memorial exhibition*, The Arts Council of Great Britain. Plaistow: The Curwen Press
- Tillett, I. (1988) *The Cinderella army. The Women's Land Army in Norfolk*, Fakenham: Jim Baldwin Publishing
- Trivick, H. (1960) *Autolithography. The technique*, London: Faber & Faber
- Twinch, C. (1990) *Women on the land: their story during two World Wars*, Cambridge: Lutterworth Press
- Tyrer, N. (1996) *They fought in the fields. The Women's Land Army: the story of a forgotten victory*, London: Sinclair-Stevenson
- Waller, J. and Vaughan-Rees, M. (1989) *Women in uniform 1939–45*, London: Papermac
- Ward, S. (1988) *War in the countryside 1939-45*, London and Newton Abbott: Cameron Books with David & Charles
- Webb, I.M. (1999) *The challenge of change in physical education: Chelsea College of Physical Education – Chelsea School, University of Brighton 1898–1998*, London: Falmer Press
- White, C. (1975) *Edmund Dulac*, London: Studio Vista
- Windsor, A. (ed.) (1992) *Handbook of modern British painting 1900–1980*, Aldershot: Scolar Press

INDEX

ALSO AVAILABLE
EVELYN DUNBAR: WAR AND COUNTRY
Gill Clarke

Evelyn Dunbar holds a unique position in twentieth-century British art. Described by William Rothenstein, when principal of the Royal College of Art, as one of the most promising of the younger painters, with 'real genius…', she specialised in mural painting at the RCA and carried out decorations at Brockley School, Lewisham from 1933–36 under Charles Mahoney's direction. It was at Brockley that her work first gained public notice and wide acclaim.

Evelyn Dunbar was devoted to nature and the natural world and in particular the garden, which was rooted in her affection for the Kentish landscape. That she did not seek publicity, was modest about her achievements and did not see herself as part of a clique have all contributed to the neglect of her work.

Dunbar's most successful and extensive body of work dates from the Second World War when she was commissioned by the War Artists' Advisory Committee, and so became the only woman, on a salaried basis, to record women's activities on the Home Front. It was for her lyrical but unsentimental paintings of the Women's Land Army that she is especially known. These provide an important documentary record of women's work and contribution to the war effort.

Like many other war artists she tended to fall out of sight of the mainstream, modernist art world following the cessation of hostilities. But she did much to add to the 'spirit and practice of English art' and deserves to be placed alongside her contemporaries Edward Bawden, Barnet Freedman, Charles Mahoney, John Nash, Eric Ravilious and Stanley Spencer.

This unique and authoritative biography celebrates for the first time the range of her achievement. Sumptuously illustrated, it is an essential and invaluable text for all those interested in twentieth-century British art and culture.

Drawing extensively on interviews with family members, correspondence and newly located located archives and correspondence, the author focuses on Dunbar's career from illustrator and mural painter, to war artist and teacher at The Ruskin School of Drawing and of Fine Art, Oxford. Each chapter explores a different period in her life, revealing the variety of her work and demonstrating her profound understanding and love of the countryside.

ISBN 978-1-904537-56-4
176pp softback • 50 colour and 40 b&w illustrations • £24.95
www.sansomandcompany.co.uk